Impressionist
Still Life

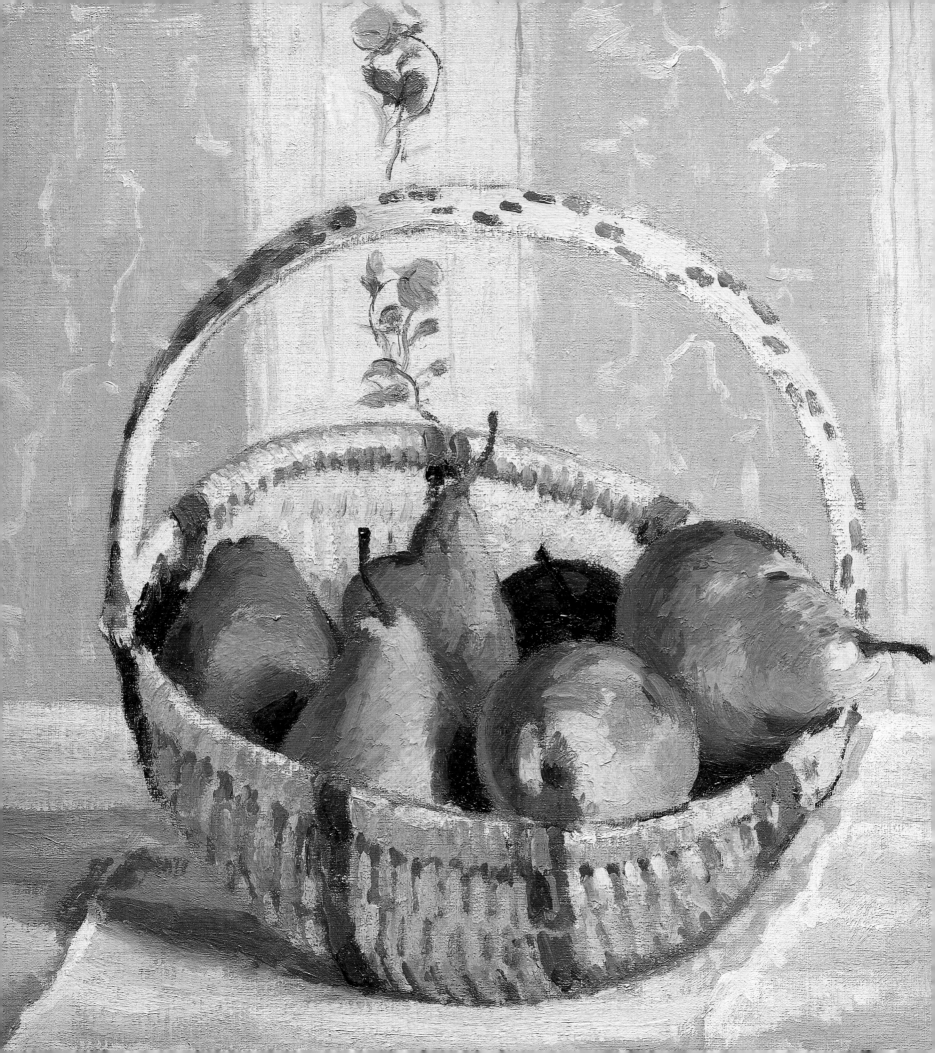

Impressionist
Still Life

BY ELIZA E. RATHBONE
AND GEORGE T. M. SHACKELFORD

ESSAYS BY JEANNENE M. PRZYBLYSKI,
JOHN McCOUBREY AND RICHARD SHIFF

WITH MARY HANNAH BYERS, SUSAN BEHRENDS FRANK,
JENNIFER A. GREENHILL, AND ALEXANDRA AMES LAWRENCE

THE PHILLIPS COLLECTION IN ASSOCIATION WITH
HARRY N. ABRAMS, INC., PUBLISHERS

FOR THE PHILLIPS COLLECTION:
Director of Publications: Johanna Halford-MacLeod
Editor: Lisa Siegrist

FOR HARRY N. ABRAMS, INC.:
Project Director: Margaret L. Kaplan
Coordinating Editor: Deborah Aaronson
Designer: Raymond P. Hooper

Published on the occasion of the exhibition
"IMPRESSIONIST STILL LIFE," organized by
The Phillips Collection, Washington, D.C.,
and the Museum of Fine Arts, Boston

September 22, 2001–January 13, 2002
The Phillips Collection, Washington, D.C.

February 17–June 9, 2002
Museum of Fine Arts, Boston

Library of Congress Cataloging-in-Publication Data

Impressionist still life / by Eliza E. Rathbone and George T.M. Shackelford ;
with Mary Hannah Byers ... [et al.] ; and essays by Jeannene M. Przyblyski and John McCoubrey.
 p. cm.
 Catalog of an exhibition held at the Phillips Collection, Sept. 22, 2001–Jan. 13, 2002
 and Museum of Fine Arts, Boston, Feb. 17, 2002–June 9, 2002,
 Includes bibliographical references and index.
 ISBN 0-8109-0613-9 (HNA cloth); ISBN 0-943044-27-8 (mus: pbk.)
Still-life painting, French—19th century—Exhibitions. 2. Impressionism (Art)—
 France—Exhibitions. I. Rathbone, Eliza E., 1948– II. Shackelford, George T.M.,
 1955– III. Phillips Collection. IV. Museum of Fine Arts, Boston.

 ND1393.F85 I47 2001
 758'.4'0944074753—dc21 2001022629

 Harry N. Abrams, Inc.
100 Fifth Avenue
New York, N.Y. 10011
www.abramsbooks.com

The Phillips Collection
1600 Twenty-First Street, NW
Washington, D.C. 20009
www.phillipscollection.org

TITLE PAGE: Camille Pissarro.
Still Life: Apples and Pears in a Round Basket, 1872,
Collection of Mr. and Mrs. Walter Scheuer

PAGE 6: Paul Cézanne.
Ginger Pot with Pomegranate and Pears, 1890–93,
The Phillips Collection, Washington, D.C.,
Gift of Gifford Phillips in memory of his father,
James Laughlin Phillips

DETAIL ON PAGES 10–11: Paul Cézanne.
Still Life with Apples, 1895–98,
The Museum of Modern Art, New York,
Lillie P. Bliss Collection

DETAIL ON PAGES 48–49: Paul Gauguin.
Still Life with Colocynths, 1889,
Judy and Michael Steinhardt Collection, New York

DETAIL ON PAGES 196–197: Claude Monet.
Camille at the Window, 1873,
Virginia Museum of Fine Arts, Richmond

JACKET FRONT: Claude Monet.
Jar of Peaches, 1886,
Staatliche Kunstsammlungen,
Gemäldegalerie Neue Meister, Dresden

JACKET BACK: Edouard Manet
Two Roses on a Tablecloth, 1882–83,
The Museum of Modern Art, New York,
The William S. Paley Collection

CONTENTS

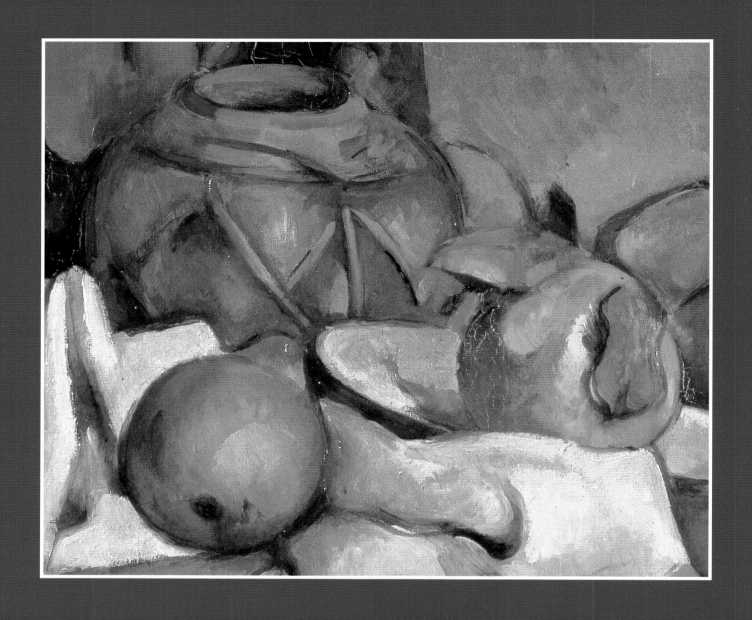

LENDERS TO THE EXHIBITION

The Art Institute of Chicago

Ashley Associates

Cincinnati Art Museum

The Sterling and Francine Clark Art Institute, Williamstown, Massachusetts

The Cleveland Museum of Art

Courtauld Gallery, London

Denver Art Museum

The Detroit Institute of Arts

The Fitzwilliam Museum, Cambridge, England

The J. Paul Getty Museum, Los Angeles

Göteborg Museum of Art, Göteborg, Sweden

Greentree Foundation, New York

Calouste Gulbenkian Museum, Lisbon, Portugal

Hamburger Kunsthalle, Hamburg, Germany

Harvard University Art Museums, Cambridge

High Museum of Art, Atlanta

Kröller-Müller Museum, Otterlo, The Netherlands

The Metropolitan Museum of Art, New York

The Minneapolis Institute of Arts

Musée des Beaux-Arts d'Orléans

Musée Fabre, Montpellier

Musée de Grenoble

Musée d'Orsay, Paris

Museum of Fine Arts, Boston

The Museum of Fine Arts, Houston

Museum of Fine Arts, Springfield, Massachusetts

The Museum of Modern Art, New York

National Gallery of Art, Washington, D.C.

National Gallery of Ireland, Dublin

The National Museum of Women in the Arts, Washington, D.C.

Nationalmuseum, Stockholm

Ny Carlsberg Glyptotek, Copenhagen

Philadelphia Museum of Art

The Phillips Collection, Washington, D.C.

Collection of Duncan Vance Phillips

POLA Art Foundation, Japan

The Saint Louis Art Museum

Collection of Mr. and Mrs. Walter Scheuer

Shelburne Museum, Shelburne, Vermont

Staatliche Kunstsammlungen, Gemäldegalerie Neue Meister, Dresden

Staatsgalerie, Stuttgart

Judy and Michael Steinhardt Collection, New York

The Toledo Museum of Art

Van Gogh Museum (Vincent van Gogh Foundation), Amsterdam

Virginia Museum of Fine Arts, Richmond, Virginia

Wallraf-Richartz-Museum, Cologne

Collection of John C. Whitehead, New York

Private collectors

This book accompanies the first major exhibition devoted to Impressionist still life. While a great deal of attention has been devoted to the study of seventeenth- and eighteenth-century still-life painting, scholars and curators have tended to overlook French still life of the second half of the nineteenth century—a category with a special integrity of its own. Taking a broad view of its subject, *Impressionist Still Life* traces the development of the movement from its origins in the realism of Courbet, Fantin-Latour, and Manet through its transformation in the late work of Cézanne. Although in the early nineteenth century, still life was not considered as important a subject for painting as history, literature, and mythology, the artists included in this exhibition reinvigorated still-life painting and found in it an unprecedented breadth of opportunity for individual expression. In the latter half of the nineteenth century, moreover, still-life painting reflected changing attitudes toward material reality as well as a new understanding of the nature of perception.

Most of the sixteen artists included in this exhibition showed their work in the Impressionist exhibitions of the 1870s and early 1880s. In addition to Monet, Renoir, Morisot, Sisley, Pissarro, and Caillebotte, all of whom are consistently identified with the Impressionist movement, van Gogh, Gauguin, and Cézanne all allied themselves with the Impressionists before developing their own independent styles. The artists in the present exhibition liberated still-life painting from many of the conventions of the past. They embraced a wider range of subject matter and in certain instances transformed the interpretation of traditional subjects through a combination of new attitudes and different approaches to composition. During the course of less than four decades, the powerful realism of Courbet and Manet gave way to a new visual language in the paintings of van Gogh, Gauguin, and Cézanne that laid the foundation for the tremendous range of interpretations of still life in the twentieth century.

Charles S. Moffett, former director of The Phillips Collection, conceived the idea for this exhibition many years ago. His groundwork and exhibition checklist laid the foundation for the present exhibition. Beginning in 1995 many individuals at The Phillips Collection devoted time and energy to the project, locating works, performing essential research, contacting lenders, and initiating correspondence and loan requests. Anne Norton Craner, Curatorial Assistant, worked closely with Moffett in the first year of exhibition planning and Lisa Portnoy Stein, Curatorial Assistant, compiled valuable research files. Former Assistant Curator, Katy Rothkopf, worked on loan requests for the exhibition in 1997 and 1998. The project has been directed at The Phillips Collection by Chief Curator, Eliza Rathbone, who found an ideal collaborator in George Shackelford, Chair of the Art of Europe at the Museum of Fine Arts, Boston. We are delighted that Jeannene Przyblyski, independent scholar, and John McCoubrey, the James and Nan Farquhar Emeritus Professor at the University of Pennsylvania, both of whom wrote their dissertations on Impressionist still life, could contribute insightful essays to this publication. It has been our additional good fortune to persuade Richard Shiff, Effie Marie Cain Regents Chair in Art at the University of Texas, to allow us to include his essay on still life by Cézanne, the artist who is fittingly represented by the largest number of works in the exhibition.

Both institutions bring to this project curatorial expertise and works of exceptional quality. Boston's paintings by Courbet, Cassatt, Fantin-Latour, Manet, Caillebotte, Sisley, Renoir, Gauguin, and Cézanne join The Phillips Collection's paintings by Cézanne and Gauguin, as well as a work by Fantin-Latour lent by Duncan Vance Phillips, grandson of the founder of the Collection. We are thrilled to be able to present these works in the larger context afforded by this exhibition. Many private collectors and individuals affiliated with galleries and museums around the world have contributed to the realization and success of the exhibition and the book that accompanies it. For their generous assistance we are particularly grateful to: William R. Acquavella, Brian Alexander, Hope Alswang, Toru Arayashiki, Julie Aronson, Gilles Artur, Martha Asher, Catherine B. Bade, Katrin Bäsig, Graham W. J. Beal, Brent R. Benjamin, the late Robert P. Bergman, Roger M. Berkowitz, Ulrich Bischoff, Edgar Peters Bowron, Helen Braham, Sylvie Brame, Rainer Budde, James D. Burke, Françoise Cachin, Jorge Calado, Gail Nes-

sell Colglazier, Michael P. Conforti, Philip Conisbee, Ina Conzen, Malcolm Cormack, Fionnuala Croke, Sylvie Crussard, James Cuno, Götz Czymmek, Diane De Grazia, Ingmari Desaix, Anne Distel, Lamia Doumato, Douglas W. Druick, Christophe Durand-Ruel, Sybille Ebert-Schifferer, Walter Feilchenfeldt, Larry J. Feinberg, Björn Fredlund, Flemming Friborg, Ivan Gaskell, Franck Giraud, Caroline Durand-Ruel Godfroy, Deborah Gribbon, Gloria Groom, Torsten Gunnarsson, Anne d'Harnoncourt, Tokushichi Hasegawa, Heather Haskell, Jennifer Helvey, Marie-Caroline van Herpen, Sjraar van Heugten, Michel Hilaire, Christian von Holst, Cornelia Homburg, Waring Hopkins, Jenns Howoldt, Randall Hunt, Lori Iliff, Diane E. Jackson, Adrienne Jeske, Lillie Johansson, Paul Josefowitz, Samuel Josefowitz, Mari Katagiri, Raymond Keaveney, Dorothy Kellett, George S. Keyes, Sarah Kianovsky, Isabelle Klinka, Toos van Kooten, Gina Koziatek, James Kronenberg, Diana Larsen, Katharine C. Lee, Ronald de Leeuw, John Leighton, Serge Lemoine, Luis de Guimarães Lobato, Glenn D. Lowry, Henri Loyrette, Ulrich Luckhardt, Nicholas MacLean, Peter C. Marzio, Evan M. Maurer, Maureen McCormick, Mary Joe McLoughlin, Darlene Miller, Barbara Mirecki, Achim Moeller, Eric Moinet, Philippe de Montebello, Mary Morton, John Murdoch, Lawrence W. Nichols, David Norman, Fieke Pabst, Maurice D. Parrish, Michelle S. Peplin, João Castel-Branco Pereira, Duncan Vance Phillips, Joachim Pissarro, Jordana Pomeroy, Earl A. Powell III, Catherine Pütz, Richard Rand, Barbara C. Rathburn, Monique Reed, Karen E. Richter, Joseph J. Rishel, Duncan Robinson, Nancy Risque Rohrbach, Allen Rosenbaum, Cora Rosevear, Timothy Rub, Tex Saito, Maria Luísa Sampaio, Barbara Schaefer, Scott Schaefer, Mr. and Mrs. Walter Scheuer, Bill Scott, David Scrase, Michael E. Shapiro, Martha C. Sharma, Lewis I. Sharp, Gretchen Shie, Molly Slattery, Thyrza Smith, Claire Durand-Ruel Snollaerts, Della Clason Sperling, David W. Steadman, Susan A. Stein, Judy and Michael Steinhardt, Pernille Stockmarr, Evert J. van Straaten, Mary E. Suzor, Tuneshi Suzuki, Gary Tinterow, Gabriela Truly, Jennifer L. Vanim, Isabelle Varloteaux, Kirk Varnedoe, John Walsh, Alice M. Whelihan, John C. Whitehead, Kate R. Whitney, Linda Wilhelm, James N. Wood, Richard B. Woodward, and Lisa Yeung.

Many individuals on the staff of both the Museum of Fine Arts, Boston, and The Phillips Collection have contributed to the successful realization of this project. We would especially like to acknowledge the key people who have devoted most of the past year to the realization of this exhibition. Susan Behrends Frank, Assistant Curator, The Phillips Collection, Mary Hannah Byers, Curatorial Assistant, The Phillips Collection, Jennifer A. Greenhill, Curatorial Research Assistant, The Phillips Collection, and Alexandra Ames Lawrence, Research Assistant, Museum of Fine Arts, Boston, have worked together as a team on the exhibition and publication with exceptional dedication. Their unflagging enthusiasm has made their hard work look easy. Elizabeth Steele, Paintings Conservator at The Phillips Collection, who has assumed the responsibility for the condition of all the loans to the exhibition, has enjoyed the collaboration and support of her colleagues in conservation, especially Jim Wright, Eyk and Rose-Marie van Otterloo Conservator of Paintings and Head of Paintings Conservation at the Museum of Fine Arts. Johanna Halford-MacLeod, Director of Programming and Publications at The Phillips Collection, obtained virtually all the illustrations for this book and coordinated the myriad details involved in its publication. Lisa Siegrist edited parts of this book and Sandy Schlachtmeyer provided invaluable support. To them all, and to Margaret Kaplan and Deborah Aaronson at Abrams, we are grateful for producing an unprecedented exhibition and a stunning and unique book. Joseph Holbach, Chief Registrar of the Phillips Collection, with the full and masterful collaboration of Patricia Loiko, Head Registrar of the Museum of Fine Arts, Boston, has brought his many years of experience to the registering of the loans and arranging details of shipping, couriers, insurance, and indemnity. We are very grateful to the National Endowment for the Arts for their exceptionally generous indemnification of this exhibition. The Phillips Collection and the Museum of Fine Arts, Boston, are fortunate in sharing this groundbreaking exhibition that brings together works of exceptional quality from collections all over the world.

Jay Gates Malcolm Rogers
Director Ann and Graham Gund Director
The Phillips Collection Museum of Fine Arts, Boston

MANET: THE SIGNIFICANCE OF THINGS

Eliza E. Rathbone

FIGURE 1

EDOUARD MANET

THE LUNCHEON. 1868

OIL ON CANVAS,

46½ x 60¼ IN.

(118 X 153 CM)

BAYERISCHE

STAATSGEMÄLDESAMMLUNGEN,

NEUE PINAKOTHEK, MUNICH

Born of a rich tradition, Manet's still lifes still strike us as new. Their freshness owes something to his original choice of subject, his rare and rich tonalities, and his lively and fluent brushstroke. Yet we also marvel at his freedom from convention and are struck by his economy of means. His images of inanimate objects defy the French term *nature morte*. For all their direct and vivid translation of reality, however, Manet's still lifes are astonishingly varied, complex, and at times enigmatic. Their complex sources in the art of the past are offset by their utter truth to the present. They are often paintings, within paintings about paintings and yet vividly real. Whether an element of a large composition such as *Olympia* (Musée d'Orsay, Paris) or *The Luncheon* (fig. 1) or a "pure" still life, these various objects, flowers, books, fruits, or articles of apparel that Manet imbues with so much life unfailingly command our attention. Their implied significance has mesmerized and challenged many scholars of his work.

FIGURE 1

Manet gave still life a new stature. In the mid-nineteenth century, to elevate still life to the importance of historical, literary, or religious subjects constituted in itself a radical move and indicated a desire to dismantle the hierarchies of the past. It was a "modern" thing to do. As a leader of the artists who created the "new painting," Manet's position is critical to any investigation of Impressionist still life. On the other hand, still life was not a subject to which the Impressionists themselves devoted most of their time and energy. For Monet, Pissarro, Sisley, Morisot, Renoir, and Bazille, still life constituted a small percentage of their oeuvres, and they approached it in much the same way they did landscape or portraiture. Manet, however, devoted approximately one-fifth of his painting to pure still life and included it as a key element in numerous figure compositions. He transformed the role of still life in painting. Inspired by artists both from the past as well as from the present, he drew on multifarious examples to create a new synthesis of old and new that

had far-reaching consequences. Having primarily focused on still life in the 1860s, the decade when he was keenly affected by Spanish painting, he returned to still life during the last years of his life before he died in 1883.

Why did Manet attach such importance to still life, and how was still life transformed in his work into an expression of the modern? Manet's art education consisted of a mix of traditional and innovative strategies manifested in the work of his teacher Thomas Couture. While Couture used pure color and a spontaneous brushstroke, his subjects were often drawn from history or mythology. For six years, 1850–56, Manet studied in Couture's studio where he must have learned from him at the very least a healthy respect for past masters as well as the goal of exhibiting at the Salon. At the same time, he constantly found himself at odds with Couture's instruction. Of his years in Couture's studio, he is reputed to have said, "I feel as though I am entering a tomb."[1] In the 1850s antiquity provided a constant frame of reference for artists and the Prix de Rome was considered the ultimate honor. As a subject for painting, still life had come to hold a position of least importance. By the 1860s, however, still life was an increasingly popular subject, whether for the rank and file or for artists submitting to the Salon, so much so that one journalist called the Salon of 1863 a veritable "garden."[2] These still lifes were for the most part far from radical and by painters who were never destined to change the course of art. The history of still life in France, which was paralleled in the Netherlands, Spain, and Italy, comprised themes from flowers and fruit to hunting, fishing, and military trophies, from *vanitas* or *memento mori* to the attributes of the arts and of sciences.[3] Still life varied from the purely decorative to subjects laden with meaning. While sometimes lavish and splendid, as a genre it tended toward the impersonal or intellectual. Where symbolism was involved, it tended to refer to abstract ideas or concepts.

An aspect of Manet's achievement lay in his ability to

counter both the decorative and the symbolic traditions. He found in still life the potential for a vivid transcription of reality as well as the opportunity for specific and personal associative meaning. In addition to Chardin, whose still-life painting is the most obvious source of inspiration to still-life artists in mid-nineteenth-century France, other artists outside the French tradition were of particular relevance to Manet. His sources of inspiration extended to the work of artists better known for human subjects, like Titian and Velázquez. Any investigation of still life in Manet's work, therefore, quickly leads to a consideration of his larger compositions with figures. Scholars as well as critics of Manet's own time have often found in his large compositions a provocative relationship between the figures and the objects that accompany them. Who can forget the rich collagelike disarray of papers, books, and prints in Manet's portrait of Emile Zola (fig. 8), or the curious arrangement on a stool that accompanies Théodore Duret in his portrait by Manet (fig. 7), or the extraordinarily disparate collection of still life objects in *The Luncheon* (fig. 1)? The literature on the subject of Manet's still life testifies to the artist's powers of invention as well as to the complexity of his stance vis-à-vis painting in his own time.[4]

Throughout the 1860s Manet's work was constantly the subject of ridicule and criticism. In the course of that decade, however, his talent as a painter of still life became increasingly recognized, and by 1872 this reputation had become sufficiently established for him to be considered an artist who excelled at this genre. As Louis Leroy wrote of Manet's Salon submission of 1872, "it is regrettable that Manet has not just exhibited one of his still lifes which, by exception, he does very well."[5] In the face of Emile Zola's staunch support for Manet's painting, other critics writing for the *Gazette des beaux-arts* consistently denied his abilities as a painter of portraits or the human figure, accusing him of rendering his subjects with indifference and a cold lack of humanity—attributes they considered much more suitably addressed to the subject of still life. Of his portrait of Emile Zola, exhibited at the Salon of 1868, the critic Paul Mantz observed that the principal interest lay in the drawings on the wall and called the portrait itself "indifferent and vague."[6] Odilon Redon described it as more of a still life than an expression of a human character.[7] The enormously influential critic Théophile Thoré acutely observed that Manet "sometimes bestows even more importance on a bouquet of flowers than on a woman's face," and went on to remark that Manet's problem was that he painted everything "uniformly, furniture, carpets, books."[8]

When Manet's *The Balcony* and *The Luncheon* were shown at the Salon of 1869, Mantz deplored the lack of apparent narrative in the former ("One doesn't quite know what these good people are doing on the balcony") and described the work as "devoid of thought," having "almost as much interest as a still life."[9] Likewise, the more sympathetic Jules Castagnary wrote of Manet's *The Luncheon*, "I see on a table where coffee has been served, a half-peeled lemon and some fresh oysters; these objects hardly go together. Why were they put there? . . . because Manet possesses in the highest degree, a feeling for the colored spot; because he excels in reproducing what is inanimate, and that, feeling himself superior in still lifes, he finds himself naturally brought to do as many as possible."[10]

Appreciation of Manet as a still-life painter was, therefore, linked to the formal or abstract properties of his painting. His "feeling for the colored spot" originally pointed out by his champion Zola directed attention away from aspects of the work related to content or meaning, and allowed critics to praise him for excelling "in reproducing what is inanimate."[11] For those who largely disparaged his achievement, this "talent," while recognized, also relegated his work to a lesser category of success.

Manet's elevation of still life to a status equal to the figure, while not well understood or appreciated in his own time, seems not only an essential underlying principle of his work but also central to his concept of the modern. Still life achieves its stature in his work by his highly selective approach and by the specificity of the objects he paints. He invites the viewer to find meaning in them. What distinguishes Manet's painting *Portrait of M. and Mme Auguste Manet* (1860, Musée d'Orsay, Paris), for example, from being simply a double portrait is the vivid presence of a basket in which the artist's mother buries her hand. In creating this unusual portrait (fig. 2), it seems quite possible that Manet drew upon his experience of copying Titian's *Madonna of the Rabbit* (1530) (fig. 3) in the Louvre. Couture enjoined his students to study the Venetians, and a number of paintings by Manet manifest his love of Venetian painting.[12] In Titian's painting the kneeling figure of the Madonna places her hand on a rabbit while on the ground beside her rests a basket, beautifully rendered. It would appear that Manet has conflated the prominent gesture of the Madonna and the very real, concrete, and particular presence of the basket to make parallel use of an object in order to bring his image into the present, and into the material world of his own time. Even the shawl that gently covers the Madonna's head seems echoed in Manet's portrait, of which Françoise Cachin has remarked that "all the vitality seems to be concentrated in the luxuriant detail— the basket of yarn, the white linen, the blue satin of the

FIGURE 2

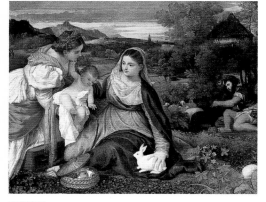

FIGURE 3

mother's bonnet ribbon."[13] It is in fact the basket of yarn that relates the two figures to each other and that provides the bright notes of color in the painting. Perhaps predictably, when it was shown at the Salon of 1861, the critics denounced Manet's realistic portrayal of his parents as heartless.[14]

Manet's readiness to borrow or make allusions in still life is perhaps nowhere more readily apparent than in his stunning response to Chardin in *The Brioche* (1870) (fig. 5), a painting directly inspired by Chardin's painting by the same title (1763) (fig. 4), acquired by the Louvre in 1869. Manet replaces the eighteenth-century master's delicate sprig of orange blossom that crowns the pastry with a pink rose of breathtaking beauty, and counters Chardin's carefully modulated surrounding tones with a brilliant white fringed napkin. Such a bravura response to the master so universally admired would not be attempted by other contemporary emulators of Chardin like Philippe Rousseau or François Bonvin. Rather than entering Chardin's world, Manet, in effect, invites Chardin into his. His innovations—a fringed napkin and the elegant table—ask us to

consider Chardin's brioche in a modern setting: the fashionable Paris of the Second Empire. Similarly the heap of contemporary clothing and hat of the still life in *Le Déjeuner sur l'herbe* (1863, Musée d'Orsay, Paris) bring the nude inspired by Titian's *Concert champêtre* (ca. 1510, Musée du Louvre, Paris) from classical Arcadia into the contemporary world in the naked persona of Manet's own quite recognizable model, Victorine Meurent. Whether figures or still life, Manet's images, couched in tradition, speak to the new and the current. In every sense Manet's contemporaneity reflects the sophisticated, well-read, well-connected Parisian we know him to have been.

It is not only the up-to-date or fashionable objects Manet chooses to include in his paintings that bring them into the modern world but also his means of describing them—means that were inspired in part by the recent revival of interest in Dutch and Spanish painting. Although in the 1850s Manet had toured Europe to see the great collections of Amsterdam, Anvers, Brussels, Haarlem, Dresden, Basel, Florence, and Venice, several factors in the 1860s brought him the opportunity for an intensified exposure to Spanish painting.[15] Foremost among these factors were the expansion of the Louvre, the new availability of train travel to Spain, and the significant increase in published articles on Spanish art. The 1850s saw the addition of new wings to the Louvre and the renovation and reinstallation of many galleries, culminating in the opening by Louis-Napoléon of the "New Louvre" in 1857.[16] The succeeding decade saw many new acquisitions to the collections. Manet frequented the Spanish galleries of the Louvre. He also had the opportunity to see works by Velázquez (or at least attributed to him) at the Galerie Martinet in Paris in 1863.[17]

Although Spanish painting was virtually unknown in France until the early to mid-nineteenth century, in the early 1860s an increasing number of articles on both Goya and Velázquez began to appear.[18] In the *Gazette des beaux-arts*, its editor Charles Blanc followed the review of the 1863 Salon with the article "Velázquez in Madrid," recounting his own recent trip and including a ringing accolade: "Truth, that is Velázquez's inseparable companion, that is his muse."[19] Blanc admired Velázquez's constant consultation of nature, his "master," and he applauded his realism. Historian as well as critic, Théophile Thoré (as W. Bürger, a name he assumed in the 1850s), collaborated on the French edition of William Stirling's *Velázquez and His Works*, which was published in France in 1865.[20] In this volume he asserts that he considers Velázquez greater than Titian, Correggio, Rubens, and Rembrandt—describing him as "today, not only in France

but in the world the most prodigious painter who ever lived."[21] It was not only Velázquez's truth to nature the critics admired but his technique, his "touch." Thoré praised his handling of paint, and wrote that "one could count the brushstrokes and follow them in all their directions."[22] In sum, Thoré (as Bürger) considered Velázquez the greatest painter who ever lived, admiring his approach to painting, which had been described as *peint de premier coup*. Thoré, who reviewed the Salons for most of the 1860s, advocated painting for its own sake, claiming that aesthetic value lay not so much in the subject as in the means chosen to express it. He had been one of Manet's earliest and most thoughtful reviewers, speaking out in support of his work in 1864. While Thoré believed that Manet was fundamentally influenced by Velázquez and Goya, he also praised his "qualities of a magician, luminous effects, flamboyant hues."[23] In addition to Thoré, Manet's friend Théophile Gautier expressed similar views in 1861: "The arts teach and moralize by their beauty alone, not by translating a philosophical or social formula. For the truly artistic person, painting has only itself as its purpose, which is quite enough."[24] The very critics who extolled art for art's sake also expounded on the genius of Velázquez and created a context for seeing his art as directly relevant to any investigation of reality and truth to nature.

The excitement over Spanish painting seemed to reach a peak in 1865, the year when Gautier wrote, "If you haven't been to Madrid, you don't know this astonishing artist . . . Velázquez alone makes the trip worthwhile."[25] Speaking practically, he advises, "now that the train makes it easy to cross the Pyrenees, our young artists would do well to go there to study."[26] Manet, who had studied at length the only works by Velázquez in the Louvre, including a work no longer attributed to him called *The Little Cavaliers*, had exhausted the resources at hand.[27] To go to Spain became for him an *idée fixe*.[28] In August 1865 Manet wrote to his friend Zacharie Astruc, whose familiarity with Spanish language, art, and culture was extensive, that he was leaving for Spain "immediately, the day after tomorrow, perhaps; I am extremely eager to see so many beautiful things and to ask the advice of Master Velázquez."[29] From Spain Manet wrote to Fantin-Latour, "How I miss you here and how happy it would have made you to see Velázquez who all by himself makes the journey worthwhile. . . . He is the supreme artist; he didn't surprise me, he enchanted me."[30] Astruc had provided an itinerary and bountiful advice about where to go and what to see.[31] Manet met Théodore Duret, who was to become a friend for the rest of his life, in a restaurant in Madrid. In the portrait Manet painted of Duret three years later in Paris (fig.

7), Manet's stylistic references to portraits by Velázquez and Goya reflect their shared experience and their mutual admiration for Spanish painting.[32] We even know that they visited the Prado together, signing their names in the guest book.[33] In his portrait of Duret, Manet directly quoted Goya's full-length portrait of Manuel Lapeña.[34] Interestingly enough, the small size of Duret's portrait was Duret's own suggestion, while the fact that he is depicted full length was Manet's idea.[35] In this painting Manet does not locate Duret in the real world but in a pictorial space, where nothing but light and air circulate around the figure, an approach Manet admired in Velázquez.

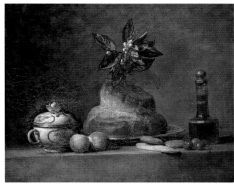

Duret's own account of Manet's addition of the still life to his portrait suggests that it was an afterthought on Manet's part and that for purely aesthetic reasons, Manet added a footstool, a book underneath it, a tray, decanter, glass, and lemon in rapid, intuitive succession.[36] *Peint de premier coup* (by Duret's account) in which liveliness of brushstroke is much in evidence, Manet's still life is also reminiscent of the still life in one of Velázquez's *bodegones* paintings, a genre scene that combines figures and objects titled *Two Young Men Eating at a Humble Table* (fig. 6). It is tempting to believe that Manet's astonishing idea of balancing a lemon on top of a glass—a unique instance in his work—was either inspired by or at least done in complete sympathy with the Velázquez, which had hung in the Palacio Real until 1813, when it came into the possession of Joseph Bonaparte, and from him passed to the Duke of Wellington. It was acquired by Wellington at the same time as the well-known *Water Seller of Seville* (ca. 1620, Wellington Museum, Apsley House, London), which had been reproduced in Blanc's article on Spanish painting, and which Manet knew well.[37] In Velázquez's *Two Young Men Eating at a Humble Table*, a spare, simple, yet precisely realized still life shares the composition equally with two young men.[38] The rustic setting (as defined by the attire of the young men, the simple table, and the earthenware pot-

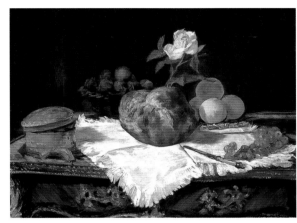

FIGURE 5

FIGURE 4
JEAN-SIMÉON CHARDIN
THE BRIOCHE. 1763
OIL ON CANVAS, 18½ X 22 IN.
(47 X 56 CM)
MUSÉE DU LOUVRE, PARIS

FIGURE 5
EDOUARD MANET
THE BRIOCHE. 1870
OIL ON CANVAS,
25⅝ X 31⅞ IN.
(65.1 X 81 CM)
THE METROPOLITAN MUSEUM
OF ART, NEW YORK, PARTIAL
AND PROMISED GIFT OF AN
ANONYMOUS DONOR, 1991

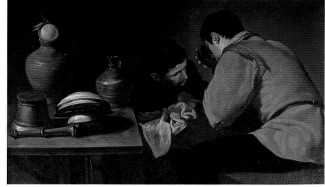

FIGURE 6

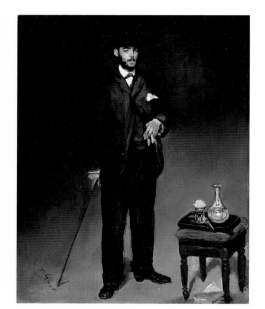

FIGURE 7

FIGURE 6
DIEGO VELÁZQUEZ
Two Young Men Eating at
a Humble Table. 1616?
OIL ON CANVAS,
25 ¾ X 41 IN.
(65.3 X 104 CM)
WELLINGTON MUSEUM,
APSLEY HOUSE, LONDON

FIGURE 7
EDOUARD MANET
Portrait of Théodore
Duret. 1868
OIL ON CANVAS,
18 ¼ X 14 IN.
(46.5 X 35.5 CM)
PETIT PALAIS, MUSÉE DES
BEAUX-ARTS DE LA VILLE DE
PARIS

tery on it), with its rich dark tonalities and strongly contrasting whites in the stack of bowls and crumpled napkin, is worlds away from the plush footstool, black lacquer tray, and crystal decanter that accompany Duret. Yet the elegant sophistication of Velázquez's still life, like Manet's, depends on his deft selection and arrangement of elements and his subtle marriage of rich tonalities and bold contrast. Manet and Duret together might have admired these qualities in other works by Velázquez in Madrid. The element that introduces the most brilliant color note in Velázquez's *Two Young Men Eating at a Humble Table* is the single whole orange that rests on the mouth of the large earthenware jug. Manet often included the half-peeled lemon common to Dutch seventeenth-century still life in his work. To rest a whole lemon on the mouth of a glass suggests his extraordinary wit (for which he was known), his selectivity, and his response to Velázquez's use of color and still life.[39]

Indeed, if we look again at Manet's *The Brioche* of 1870 we see that it has nearly as much to do with the inspiration of Velázquez as with that of Chardin. In place of Chardin's warm, subtly modulated tones, Manet introduces the dramatic contrast of the white napkin, which sets off the rich brown and ochre of the brioche, the cool gray-green of the grapes, and the rosy tonality of the peaches. Likewise, the pale pink rose is luminous against the nearly black background into which the basket of deep purple-black plums recedes in a shallow depth typical of Velázquez.[40] Similarly, Manet's *The Salmon* (plate 4) includes two lemons and a blue and white bowl, brilliant additions that contribute the color notes to a com-

position of rich tonalities reminiscent of Spanish still-life painting.

Years later Duret attributed Manet's addition of the still life to his portrait to the artist's "instinctive, almost organic way of seeing."[41] He emphasized a formal rationale for the still life that is, of course, perfectly valid. Particularly in the realm of still life, any direction that Manet took from Velázquez underwent a "sea change" into a motif particular to his own time. Nonetheless, Manet had suffered accusations of a lack of originality, and any revelation of an association with another artist could only advance the cause of those who already considered him a *pasticheur*. Indeed, Zola had written, "He has been reproached for imitating the Spanish masters. I agree that in his first works there is a resemblance—one is always somebody's child," and yet, he argued, "his canvases are too individual in character for him to be taken as nothing more than an illegitimate child of Velázquez or Goya."[42] Much as Duret's walking stick points to Manet's reversed signature in a witty allusion to the Goya portrait, so the few touches of color in the work suggest Manet's admiration for Spanish painting. These colors—the aqua-blue book, the yellow lemon, the golden gloves, and Duret's bright blue necktie—lead the eye in an opposing diagonal to the face of Duret.[43] The fact that Duret came from a well-to-do family in the cognac business is artfully conveyed in Manet's choice of objects. Man of the world, Duret is also an upper-class Frenchman of the 1860s.

Like Duret, Zola consistently emphasized formal values in Manet's painting. In response to Zola's appreciation of his work and understanding of his engagement with past masters, Manet gives us in his *Portrait of Emile Zola*, an interpretation that is equally individual, specific, and enlightening of their relationship. In his highly selective choice of still-life elements, he alludes not only to the subject, Zola himself, but also to their shared interests. The painting shows Zola surrounded by an image of Manet's *Olympia*, mounted on top of an engraving of *Los borrachos* (*The Drinkers*) by Velázquez (that Manet copied), and a specific Japanese print of a sumo wrestler, as well as by the booklet that Zola wrote about Manet.[44] These still-life elements, designed to suggest Zola's tastes and interests, are equally reflective of Manet's own. In the portrait Manet appears to celebrate Zola's early and significant support of his work. Just as in Duret's portrait, here too Manet uses still life to suggest a shared conversation between painter and subject.[45] The critics, however, deplored Manet's flat and fixed treatment of the model, finding more interest in the "still life," which Castagnary, for example, found treated in a "masterly fashion," but the sitter "a profile

affixed to a background." And Odilon Redon wrote, "it is rather a still life, so to speak, than the expression of a human being."[46]

From Zola's own account we know that his multiple sittings for his portrait took place in Manet's studio, not Zola's study as one might assume.[47] Manet's portrait of Zola, therefore, is not a depiction of Zola in an actual space that he inhabited. We are not invited to enter his study as we are, for example, the living room of Madame Charpentier in her portrait by Renoir of 1878 (Metropolitan Museum of Art, New York). Rather, Manet gives us a construct, a synthetic portrait that presents his sitter's likeness as well as his intellect, most particularly that aspect that has been addressed to Manet. It is this synthetic approach to a portrait that foreshadows future developments in the work of Gauguin and van Gogh.[48] Having explored the role of selected objects in old master painting, Manet gave life to the

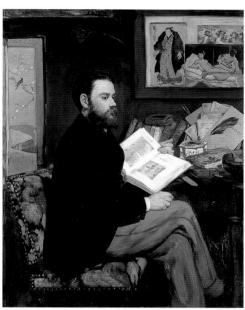

FIGURE 8

inanimate, imbuing objects in his own work with specific reference to contemporary events and style. Of the still, he made something living. In his portraits, by contrast, in making the living still, he probably considered another source that was patently modern. Responding to Baudelaire's *Le peintre de la vie moderne,* Manet not only chose specific objects to bring his painting into the present, but also made indirect reference to the rapidly developing technique of photography. In addition to the inspiration of *cartes de visite*—exceedingly fashionable in the 1860s—it is likely that Manet looked to the work of his friend, Félix Tournachon, called Nadar.[49] The immobility of his human subjects for which Manet was criticized becomes more comprehensible in light of photography and conceivably a factor of their modernity. It is as though Manet, while responding to this new mode of portraiture by mirroring it in his art, also intended to demonstrate the possibilities inherent in painting and not available to photography.[50] Manet and Nadar, each according to the properties of his own medium, worked in a space that was not the sitter's but the artist's. This synthetic pictorial reality (the reality of the painting) allowed Manet to select ideas and motifs from old masters while recognizing the necessity of direct observation. Three single portraits by Manet from the late

1860s—Zola, Duret, Astruc—situate the subject in an invented space, a construct based on particular pictorial references as well as on concepts of composition that relate specifically to the sitter and to the artist and sitter's shared discussions about art.[51]

Yet Manet's tendency to imbue still life with specific personal associations is nowhere more eloquently or directly expressed than in a small painting that is pure still life: the *Bouquet of Violets,* 1872 (plate 31), a gift and personal tribute to Berthe Morisot.[52] Charged as it is with such intimate significance, it is reminiscent of Gustave Flaubert's use of inanimate objects in *Madame Bovary,* published in 1857. Manet approaches an object with neither sentimentality nor symbolism but rather as a specific reality that bears meaning, evoking an individual or a particular relationship. Likewise, Flaubert's highly evocative and intensely observed objects are endowed with a strong personal association that gives them a heightened significance. For Emma Bovary, her own wedding bouquet of orange blossoms and that of her husband Charles's previous wife are both charged with meaning and contribute significantly to the narrative at the moment she comes upon them. Similarly, a green silk cigar case that Emma occasionally removes from the linen cupboard, described in exquisite detail, awakens in her romantic longings. Flaubert, like Manet, was greatly admired by both Baudelaire and Zola, and used prints and other pictorial images to stimulate his extraordinarily vivid powers of description.[53] Although he maintained that he did not understand Manet's painting at all and Manet did not record his special admiration for Flaubert, both understood the meaning objects can assume by virtue of association with individuals and vice versa, and they used specific objects as powerful vehicles of content.[54]

During the 1870s Manet's interest in plein air painting coincided with a diminished interest in still life. One exception, however, is a still life from the mid- to late-1870s, *The Ham* (ca. 1875–78) (fig. 10). Although working at a further remove from Spanish influences, Manet's unembellished approach to *The Ham* evokes nothing less than Goya's masterful still lifes. In Goya's stunning and stark *Still Life with Salmon* (fig. 9), three pieces of raw flesh,

FIGURE 8

EDOUARD MANET

PORTRAIT OF EMILE ZOLA

1868

OIL ON CANVAS,

57½ X 44⅞ IN.

(146 X 114 CM)

MUSÉE D'ORSAY, PARIS

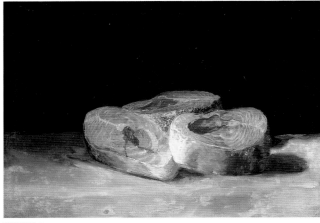

FIGURE 9

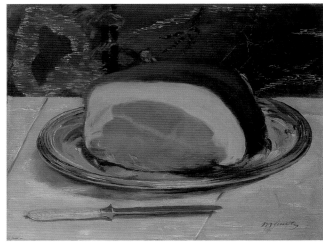

FIGURE 10

painted in gorgeous shades of salmon pink against an austere ground of black and gray, result in an image at once beautiful and terrible.[55] A trickle of blood reminds us vividly of the life that has been taken. The intensity in Goya's still life gives this spare work an uncanny power. In *The Ham,* a similarly bold conception, Manet isolates his subject and employs a like simplicity of format, devoting the upper register to the background and the lower register to the table on which he has centered a ham on a platter. However, in place of life and death, of Goya's vivid expression of brutality, Manet gives us a fact, a modern reality, visually imposing but without emotion. We are reminded of Renoir's comment when he saw Manet's *Execution of Maximilian*: "It's pure Goya. And yet Manet was never so much himself!"[56]

Manet's *The Ham*, which was in the collection of Degas, must have been known to Gauguin and probably inspired his only still life of a piece of meat, *The Ham* of 1889 (plate 77). In Manet's painting, the ham is complemented by the flat decorative wallpaper behind it, its pattern relating pictorially to the shape and veining of the ham itself. The suggestion of its mass never takes away from our primary perception of the work as a painted surface. Even its obviously bourgeois setting is minimally defined. In all its glory, it simply is. In *The Ham,* Manet takes up the challenge of Goya and responds with contemporary fact. Gauguin's painting, in turn, picks up the challenge of Manet and responds with his own interpretation of fact. In Gauguin's still life, the colors and brushstrokes in the ham are further developed by his treatment of the wall behind it. Gauguin's richly varied palette of golden yellows, pinks, oranges, and gray blues are given definition by the white arc of fat, echoed in the white rim of the plate and amplified by the oval sweep of the table. These elements bring to the composition decorative rhythms that speak to Gauguin's unique mastery of volume and flat surface. The table, suspended before us on its spindly curvilinear supports, is nonetheless locked into place by the strong vertical elements behind it.

Had he still been living in 1910, Gauguin, who had enormous admiration for Manet, would have been pleased to be so well represented (with thirty-four works) in the great exhibition organized by Roger Fry and held in London at the Grafton Galleries, *Manet and the Post-Impressionists*.[57] Like Manet, Gauguin was a *pasticheur* who saw no obstacles to borrowing from whatever source he needed for his art. In 1891, after Manet's *Olympia* had been accepted by the Musée du Luxembourg, Gauguin went there and made a copy of it.[58] And isn't it ultimately to Manet that we must look for a precedent to Gauguin's inclusion of a Japanese print in his *Still Life with Colocynths* (plate 74) or of a still life by Cézanne in *Portrait of Marie Derrien*, or his inclusion of Puvis de Chavannes's *Hope* in his own *Still Life with Hope* of 1901? In his painting *The Woman with Mangoes*, Gauguin drew directly on both Manet's *Olympia* and Lucas Cranach's *Le Repos de Diane*.[59] It was left to Gauguin to expand the frame of reference to other exotic cultures farther afield. His work is rich in allusions, both hidden and overt, to artists past and present.

This synthetic approach to picture making was antithetical to the Impressionists. In the first galleries of the London exhibition, eight works by Manet were interspersed with fourteen by Cézanne. In the additional galleries were works not only by artists of Gauguin's generation, like van Gogh, Georges Seurat, Henri Edmond Cross, and Paul Signac, but also by younger painters who would emerge as leaders in the twentieth century, including, among others, Picasso and Matisse.[60] The introduction in the booklet accompanying the exhibition reads, "The pictures collected together in the present Exhibition

are the work of a group of artists who cannot be defined by any single term. The term 'Synthesists,' which has been applied to them by learned criticism, does indeed express a quality underlying their diversity; and indeed it is the principal business of this introduction to expand the meaning of that word, which sounds too like the hiss of an angry gander to be a happy appellation. . . . In no school does individual temperament count for more. In fact it is the boast of those who believe in this school, that its methods enable the individuality of the artist to find completer self-expression in his work than is possible to those who have committed themselves to representing objects more literally. This indeed is the first source of their quarrel with the Impressionists: the Post-Impressionists consider the Impressionists too naturalistic." And further on: "The Post-Impressionists on the other hand were not concerned with recording impressions of colour or light. They were interested in the discoveries of the Impressionists only so far as these discoveries helped them to express emotions which the objects themselves evoked. . . . They said in effect to the Impressionists: 'You have explored nature in every direction, and all honour to you; but your methods and principles have hindered artists from exploring and expressing that emotional significance which lies in things, and is the most important subject matter of art.' "[61]

Many of Manet's still lifes, whether "pure" or incorporated into large compositions, have a personal or specific resonance that goes beyond the object depicted. In his last works, Manet often approached still life with specific individuals in mind. In these late paintings we see a pure expression of his desire to share and communicate his own joy in visual experience. In painting a plum for Isabelle Monnier, Manet addresses this plum uniquely and directly to her, writing,

A Isabelle,
Cette mirabelle.
Et la plus belle,
C'est Isabelle.[62]

This witty sentiment is surpassed in poignancy by his last flower still lifes, expressed in brilliant and fluent touches of paint with a clarity and directness of response to the subject. They convey his own keen sense of the fragility and brevity of life. At the same time, they express his desire to communicate to his friends his continuing joy in life's immediate pleasures. Each bouquet is unique. Manet honors the singularity of these particular flowers in this moment of time. The fugitive life of flowers found no more eloquent expression than in these last paintings by Manet.

Manet's break with tradition was offset by his profound respect for great artists of previous generations. His ability to perceive and incorporate aspects of their art into his own and to draw upon the rich resources of his time presents us with a figure who, Janus-faced, found himself at a social and cultural turning point and who opened the door not only to the Impressionists but to the Post-Impressionists and the twentieth century. His painting is about painting. Its sense of drama is conveyed by the principal tools at the artist's disposal—color, light, and brushstroke. Manet's late works confirm his unending joy in visual experience and the communication of that joy as a primary stimulus for his art. For all the complexity of his "conversations" with the art of the past and of his own time, it is his powers of observation and his distillation of visual experience into ravishing brushstrokes of color that surpass the objects perceived to have an eternal life of their own.

Both the Impressionists and the Post-Impressionists claimed Manet as a source of inspiration and leadership. The evolution of their art might be compared to the development of analytical cubism and the synthetic cubism that followed, the one analyzing nature and optical experience, the other creating a new synthesis that couldn't have occurred without the movement that preceded it. Although Manet did not fully explore all the ideas he initiated, we might look for his legacy not only in the art of Matisse, through Gauguin, or Picasso, through Cézanne, but also in the Surrealists' understanding of the curiously potent encounter of objects and the poetic associations they can evoke. Perhaps more than anything, Manet sought and offered in painting a new equivalent to poetry in his unique marriage of art and nature.[63]

George T. M. Shackelford

Impressionism is generally characterized as a movement that set its goals and its aesthetics in opposition to tradition and history—rejecting the past in order to forge a new modern style, richly expressive of its own time and place. The popularly held view of Impressionism as an art of sunlight and motion—an optical art that captured fleeting effects in the out-of-doors—would seem to make its engagement with still life paradoxical, for how could the Impressionist painter maintain a real interest in *nature morte,* in an art of stasis?

The still lifes assembled in this exhibition make it clear that the Impressionists were deeply and inventively engaged with the indoor art of still life, that their very real innovations were not always made at the expense of tradition; in fact, many of the artists in the exhibition saw their works as part of a long chain of history going back to the old masters or even to the Renaissance. If they rejected anything, it was formulaic complacency: their frequent use of the art of the past was never slavishly imitative; on the contrary, their paintings rang changes on their sources that show a deeper understanding and appreciation of their precursors' achievements. It is perhaps significant that—with the possible exception of Henri Fantin-Latour, who based his career upon the success of his still-life paintings—no other artist in this exhibition became a specialist in the genre; instead, these painters are primarily known for their genre paintings, portraiture, and landscape. But in still life, perhaps as in portraiture and scenes from modern life, and much more than in landscape, the Impressionists' accomplishments are part of an organic continuum stretching back to the seventeenth century, when still life emerged as an independent form, and reaching forward into our own time.

While still life has always been favored by collectors, it has always been accorded a lowly role in the established hierarchy of genres—whether that hierarchy was imposed by the academy or the avant-garde. Writing in the seventeenth century, the academician André Félibien argued that "he who makes perfect landscapes is above another who only does fruits, flowers, or shells. He who paints living creatures is more worthy than those who only represent lifeless, motionless things, and as the figure of man is the most perfect work of God on earth, it is likewise certain that he who imitates God in painting the human figure is the most excellent of all."[1] Félibien's judgment on still life held sway through the eighteenth century and into the nineteenth, although, as we shall see, major still-life figures emerged and were admired—without being accorded the status that the academy bestowed on painters who practiced *la grande manière.* The assumption was, and has been, that still life was a matter of the slavish imitation of a found "reality" (a criticism also applied to photography since its incursion into the realm of art after 1840). The still-life painter, in other words, did not need to exercise invention in the way that a painter of histories did, in composing from his imagination a scene drawn from the Bible, from literature, or from myth, nor was he even called upon to reorganize and refine the landscape in painting.

By the middle decades of the nineteenth century, however, in the generation before the emergence of Impressionism, still life was gaining in popularity among critics and the public alike at the Salons and at private art galleries in Paris. In part, the rise of still life after 1840 and especially after 1850 can be linked to the rise in interest in realism—not just the grandiloquent realism of a revolutionary like Courbet, but also the quieter genre subjects of an artist like Jean-François Millet. But interest in still life is also inextricably tied to the revival of interest in the art of the past, not only in the exuberance of the rococo—evidenced everywhere in late romantic painting, sculpture, and design—but also in more humble strains of French art, reaching back to the seventeenth century, to the Le Nain brothers. The most important figure to reappear in the imagination of collectors and critics, and then to reach a broader art-loving public, was the great painter of still life and genre, Jean-Siméon Chardin (1699–1779).

Chardin was celebrated in his own lifetime. He was received as a member of the Académie Royale de Peinture et Sculpture before he reached the age of thirty (and as a still-life painter, at that). As historians have often noted, his paintings were praised by the critics, chief among them the great Denis Diderot, whose audience was precisely the circle of wealthy or noble connoisseurs who vied with each other to obtain Chardin's works for their collections. But after his death in 1779—and particularly in the early nineteenth century, which saw the ascendancy of neoclassical history painting at the Academy, to the suppression of all other modes of expression—Chardin's name was all but forgotten. Little by little, however, beginning in the 1840s, Chardin's reputation began to be polished. Articles appeared on him in specialist journals; the Louvre acquired more of his paintings, adding to the reception pieces

already in its care; a critical catalogue of his works was attempted; collectors began once again to search out his paintings—and his heirs—and to amass significant groups of still lifes and genre subjects by the master. Finally (and most importantly, for our story), in the early 1860s two important events took place. First of all, the critic Philippe Burty organized, at the Galerie Martinet—where Manet would later show his still lifes—an exhibition of French eighteenth-century paintings and drawings, which included at first twenty-two and then a further nineteen paintings by Chardin, all drawn from the collections of Parisian *amateurs*.[2]

That exhibition took place in 1860, when most of the painters who would become the Impressionists were in the first years of their professional careers. The second event took place three years later, when the naturalist novelists and sometime art critics Edmond and Jules de Goncourt published in the *Gazette des beaux-arts* and then in an independent volume their painstaking study of Chardin's life and work. The culmination of two decades of gradual rediscovery of the artist—by writers and painters alike—the Goncourts' study established Chardin, once and for all, as France's greatest master of still-life painting.[3]

The Goncourts described Chardin's genius in terms that made it clear—as Diderot had recognized a century before—that Chardin was an artist of genius, not a humble imitator to attract the scorn of Félibien. In their view, he was a painter marked by two great gifts:

Awareness and science—these sum up the methods, the secret and the talent of Chardin. His admirable technique is rooted in the most profound theoretical insights gained in long and solitary meditation. His gift of painting stemmed from his gift of seeing. . . . This extraordinary visual awareness enabled Chardin to discern at first glance whether a painting lacked harmony and, if so, how the discordant elements could be brought together. . . . He had no use for convention and prescribed arrangements. . . . Like Nature, herself, he dared use the most contradictory colors. . . . [His paintings possessed] a sonorous, noble harmony which flows only from the hand of the masters.[4]

"It is Chardin that we admire in the glass that he paints," wrote Théophile Thoré in agreement, giving Chardin, and not his models, credit for his paintings' genius.[5]

Among the artists who were coming into prominence during the 1860s—not only Manet, but his young friends Fantin-Latour, Monet, and Renoir, as well as Pissarro and Cézanne—Chardin was thus recognized as the great touchstone for contemporary still life. Imitators of Chardin, for example François Bonvin, were to be seen regularly at the

Salons, where their proliferation was noted by the critics. Jules Castagnary, writing at the moment of the notorious Salon des refusés of 1863, spoke of the "poor fabricators of still lifes, who have been so violently disbarred just when they least expected it. . . . [T]hey are multiplying at an alarming rate. The rats in the Paris sewers are less numer-

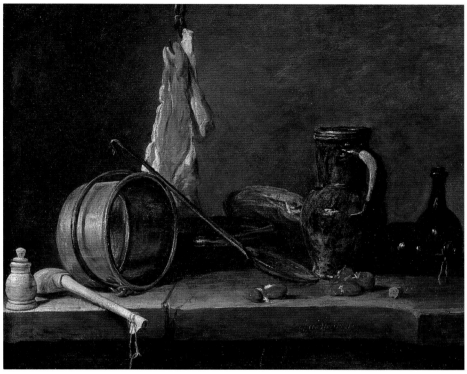

FIGURE 11

FIGURE 11
JEAN-SIMÉON CHARDIN
THE MEAT-DAY MEAL. 1731
OIL ON COPPER,
13 X 16⅛ IN.
(33 X 41 CM)
MUSÉE DU LOUVRE, PARIS

ous and less menacing. If the academic order ever crumbles, it will be because the still-life painters, down below, have gnawed away, one by one, at its foundations."[6] Interestingly enough, the young artists who cared little for the academic order turned to still life, one by one, in the years immediately following this same Salon—as is clear in this exhibition, where a spectacular group of canvases from the middle 1860s are assembled, by artists such as Manet, Fantin-Latour, Degas, Monet, Renoir, Bazille, Sisley, Cézanne, and Pissarro.

For many of these painters, Chardin's example was particularly compelling. His *Meat-Day Meal* of 1731 (fig. 11) had once belonged to the critic Théophile Thoré, the champion of the realists, and had been acquired, with its pendant, *The Fast-Day Meal,* by the Louvre in 1852.[7] Mentioned in many of the mid-nineteenth-century sources on the artist, *The Meat-Day Meal* depicts implements commonly found in the kitchen, including a round box for pepper or spices, an overturned wooden spoon projecting off the stone ledge, a copper pot lined in tin, upon the rim of

FIGURE 12

FIGURE 12
FRANÇOIS BONVIN
*STILL LIFE WITH PIECE OF
MEAT.* 1858
OIL ON CANVAS,
28¾ X 36¼ IN.
(73.7 X 92.9 CM)
MUSEUM OF FINE ARTS,
HOUSTON; MUSEUM
PURCHASE

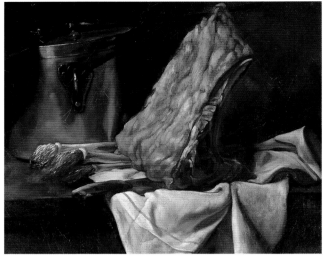

FIGURE 13
JEAN-SIMÉON CHARDIN
*BASKET OF PEACHES WITH
WALNUTS, KNIFE, AND
GLASS OF WINE.* 1768
OIL ON CANVAS,
12⅞ X 15⅝ IN.
(32.5 X 39.5 CM)
MUSÉE DU LOUVRE, PARIS

which an iron-handled skimmer is balanced, a pottery dish and a jug, and two glass bottles, together with foodstuffs— a hanging piece of meat, a loaf of bread, and a few kidneys, glistening chestnut-brown, above Chardin's signature. Although small in scale, the painting has a carefully worked surface, and the objects it depicts take on a grandness of scale that belies the delicacy of their execution. *The Meat-Day Meal* exemplifies the kind of composition that inspired imitative artists such as Bonvin, whose fine *Still Life with Piece of Meat* (fig. 12) of 1858 is one of his many variations on a Chardin theme.[8] But Chardin's painting could also have served as a model for Cézanne or Pissarro, whose kitchen still lifes of the later 1860s (plates 6, 7), in their somber tonalities and careful arrangements of light-struck volumes, seem to depend not only on Manet, but also on the great master of the eighteenth century.

Chardin's later still lifes also had their admirers. His *Basket of Peaches with Walnuts, Knife, and Glass of Wine* (1768) (fig. 13), was one of the last still-life paintings he executed—and among the last he ever exhibited. In contrast to *The Meat-Day Meal*, which is approximately the same size, the *Basket of Peaches* concentrates on a few objects depicted under a magically tender light, which makes the subjects loom much larger within the picture space—taking on "a life of their own," in the words of the Goncourts. After Chardin's death, the painting passed to one of his relations, from whose estate the collector Laurent Laperlier purchased it—with Bonvin acting as his agent.[9] Laperlier lent it to the 1860 exhibition of French art at the Galerie Martinet, and it seems to have struck a number of painters at that time, particularly Manet and Fantin-Latour (plates 15, 18, 20). But an older artist, such as Jean-François Millet, could also take inspiration from Chardin. One of Millet's very few still lifes, the *Pears* of 1862–66 (fig. 15),

seems to be an attempt to rival Chardin's luminous treatment of the skins of peaches, pears, apples, or grapes, and to give to inanimate objects depicted on an intimate scale the monumentality generally granted only to the human figure.[10]

For the Impressionists, then, Chardin offered two important lessons. First of all, he set the standard among still-life painters as history's greatest manipulator of objects—an artist who was able to assemble his kitchen implements with the same skill that Raphael brought to the arrangement of human figures, making his compositions seem harmonious without ever appearing forced or contrived. Second, he was a master of light and, above all, of how light could be rendered through a novel, even scientific, approach to color. As the Goncourts explained, "Instead of blending [his colors] he interrelated them, grouped them, corrected and caressed them in a systematic interplay of

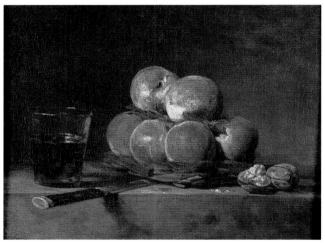

FIGURE 13

reflections which, while preserving the frank character of each color, unified the picture and seem to imbue every object with the light and hue of its surroundings."[11]

But Chardin was by no means the only model from the past whose works were accessible to artists of the Impressionist generation. The state collections included works by the eighteenth-century French painters François Desportes (1661–1743), and Jean-Baptiste Oudry (1666–1755), specialists in game pieces, the kind of composition that Sisley and Bazille followed when painting their own *Herons* in 1867 (plates 13 and 14); and there were works by Chardin's followers Henri-Horace Roland de la Porte (1724–1793) and Anne Vallayer-Coster (1744–1818). Among the Dutch and Flemish paintings at the Louvre were the famous monumental *The Dessert* by Jan Davidsz. de Heem (1606–1683/84) (fig. 14), animal paintings by Frans Snyders

(1579–1657) and Jan Fyt (1611–1661), a breakfast piece by Willem Claesz. Heda (1594–1680), flower paintings by Jan van Huysum (1682–1749) and Abraham Mignon (1637–1679), and of course, the *Slaughtered Ox*, 1638, by Rembrandt (1606–1669).

More significant as a source of inspiration may have been the work of Eugène Delacroix (1798–1863), the great colorist of the romantic movement, like Chardin a "painter's painter" almost universally admired by the members of the Impressionist circle. Delacroix completed only a handful of still lifes over the course of his long career, but the group of flower pieces that he exhibited at the Salon of 1849, including the ravishing *A Basket of Flowers Overturned in a Park* (fig. 16), must have been keenly appreciated by the artists who came to still life in the 1860s. First among them may have been Gustave Courbet, whose earliest success came at the same Salon, where he exhibited his *After Dinner at Ornans* (1849, Musée des Beaux-Arts, Lille), which depicted a group of countrymen seated around a table at an inn; the still life of an abandoned dinner, in tones of gray and brown, occupied the center of the linen-covered tabletop. How sober Courbet's solemn canvas must have seemed to visitors to the Salon, compared to Delacroix's jubilant evocation of floral luxury, and how Courbet must have despised this product of romantic excess! When the Delacroix *Basket of Flowers* was shown again, in the gallery devoted to the artist at the Paris world's fair of 1855, perhaps the realist looked on it differently. Delacroix's flower pictures must have been in Courbet's mind in the summer of 1862, when he painted the equally sumptuous bouquet in this exhibition (plate 1), and above all when he composed his *Woman with Flowers* (plate 3), with its extravagant display of blossoms in a garden setting.[12]

Delacroix's technique—above all the transparency of his oil glazes—was imitated by Degas in his *Woman Seated Beside a Vase of Flowers* (plate 2), painted in 1865, the year after the great *A Basket of Flowers Overturned in a Park* was exhibited in public once more, when Delacroix's atelier was sold in Paris in February 1864, following his death in August 1863. Might Renoir, or his friends Monet and Bazille (who used to spy together on Delacroix at work in the garden of his studio on the Place Furstemberg) have seen the older painter's flower pieces in 1864, and been inspired by them to undertake their own magnificent floral compositions, on a similar scale? Monet and Renoir produced their "hothouse" studies of flowers in the same year the *Basket of Flowers* was exhibited once again, and Bazille took up similar themes in 1867 and 1868 (plates 9, 10, 11, 21).[13] And although Renoir's *Mixed Flowers in an Earthen-*

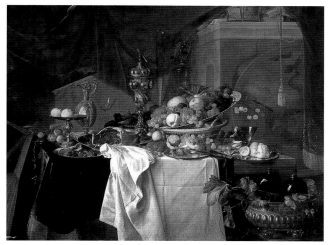

FIGURE 14

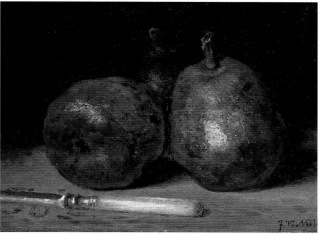

FIGURE 15

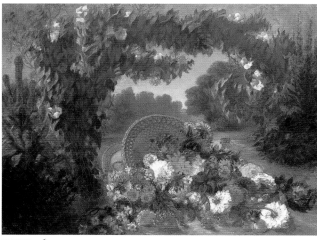

FIGURE 16

ware Pot of about 1869 (plate 22) shows an arrangement of blossoms on a tabletop, their glowing petals seem to reflect something of the incandescence of Delacroix's outdoor flower studies of twenty years earlier. (Could Renoir's bouquet, exhibited at the first Impressionist exhibition in 1874, have inspired one of the critics to praise the exhibition as a "fireworks display of enraged colors"?)[14]

For the Impressionists in the formative decade of the 1860s, it made sense to learn how to paint still life through the assimilation of traditional examples. The works of Delacroix offered lessons in color that the Impressionists studied intently. And Chardin might represent, in terms of composition, the "approach to still life taught in art schools," mentioned by Zola in his famous description of

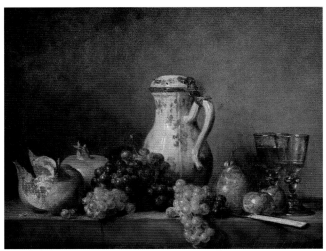

FIGURE 17

Manet's methods of figural composition, when he said that Manet "groups the figures before him a bit haphazardly, and then he is concerned only to fix them on the canvas just as he sees them, with the lively contrasts they produce by their juxtaposition."[15] The young Impressionists knew, of course, that such figure paintings as *The Luncheon* (fig. 1) were hardly the result of some haphazard grouping of figures—any more than Manet's battle-cry pictures, the *Déjeuner sur l'herbe* of 1863 and *Olympia* of 1865 (both Musée d'Orsay, Paris), which were in fact modern recastings of compositions from the Renaissance. On the contrary, like Chardin's paintings of kitchen tables or of baskets of fruit, Manet's compositions—in figure or in still life—were carefully arranged, artfully staged. If their facture led the uninitiated to believe that they were effortlessly, even carelessly painted by a man who, as Zola argued, "knows how to paint and that is all," then the deception was perfect. But as the younger painters' own aesthetic concerns began to coalesce—as they began to dis-

tance themselves from Manet, for example, in the years around 1870—a shift began to occur in their attitudes to the art of the past.

That shift can be discerned in two pairs of paintings from 1872 presented in this exhibition. The first two, by Pissarro, are the *Still Life with Apples and Pitcher* and the *Still Life: Apples and Pears in a Round Basket*, both thought to have been painted in the late summer or autumn of 1872, when orchard fruits were in season, and before the paintings were sold to the dealer Paul Durand-Ruel in November (plates 29, 30). In the first of these still lifes, Pissarro creates a composition very much in the Chardin mode: a few objects—among them a ceramic pitcher, standing tall above all the other elements—are placed side by side on a horizontal surface, brought close to the viewer. The painting recalls such Chardin prototypes as *Grapes and Pomegranates* of 1763—which in spite of its title is dominated by a Chantilly porcelain ewer—bequeathed to the Louvre in 1869 by Dr. Louis La Caze (fig. 17). That painting built upon a compositional idea that Chardin had explored much earlier in his *Bowl of Plums, a Peach, and Water Pitcher* in The Phillips Collection (fig. 18), which cannot have been known to Pissarro. Pissarro's still life is, in other words, a work in the tradition of "composed" still lifes, in which a beautiful image is the result of the skillful juxtaposition of unlike objects, harmoniously arranged and then skillfully rendered by the hand of the artist.

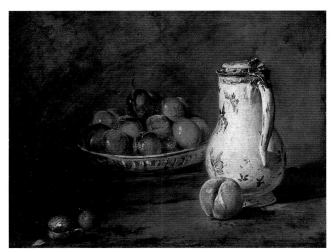

FIGURE 18

Pissarro's brilliant still life, *Apples and Pears in a Round Basket*, on the other hand, attempts to sidestep composition. It is hardly necessary to say that this, too, is a contrivance—for the still life is necessarily the result of a series of choices made by the painter. But here Pissarro makes every attempt to avoid the "picturesque." For instance, a

painter like Chardin or one of his imitators in the nine-teenth century would have turned the basket (or a copper pot, or a pitcher, or a casserole) so that its handle formed a graceful arc, foreshortening the element so as to give the painting a comfortable illusion of depth, or to confirm the painter's ability to render volume. Pissarro, on the contrary, gives only meager indications of volume, allowing the handle of the basket to curl only slightly, and instead empha-sizes the silhouette of the basket as a whole, which he makes into a great unstable circle inscribed on the inter-section of the vertical stripes of the wallpaper and the hori-zon afforded by the linen-covered tabletop. It is as if the painter were not allowed to alter his subject, and like the slavish copyist of Félibien's treatise, was only fit to copy what he saw before him. The result, in this work, is that the viewer is transfixed by the motif.

Let us turn now to two paintings made at almost the same moment, at Argenteuil, where Monet had taken up residence in late 1871. The first of them, *Still Life with Melon* (plate 25), has rightly been characterized as an evo-cation of Fantin-Latour's still-life manner as represented in such works as the *Flowers and Fruit on a Table* (plate 19). This means that it is a retelling of a translation of an orig-inal idea from Chardin; the Chardin "text" is almost cer-tainly *The Cut Melon* in the Louvre—an oval painting containing an elegant piece of porcelain, a sliced melon with orange flesh, and a plate of peaches.[16] (Bequeathed by La Caze in 1869, the Louvre canvas is now thought not to be by Chardin himself, but a version of a painting in a pri-vate collection.) By contrast, there is no prototype for Monet's *The Tea Set*, the other still life of 1872 (plate 24). While the teapot and cups have been placed upon the lac-quer tray, and then set down on the tablecloth, we can hardly imagine that the artist had anything to do with their arrangement: harmony is willfully abandoned, to suggest the momentary experience of the objects, untem-pered by taste, by knowledge, or by history.

What Pissarro and Monet were doing in these two remarkable still lifes—remarkable for their daring, when juxtaposed with their equally beautiful, if more conven-tional "pendants"—was closely akin to what they were seeking in landscape painting at the same moment. As Joel Isaacson has argued, the painters were intent upon finding a way to make art in which all their accumulated knowl-edge of *other* art played no part. Thus Monet had written to Bazille in 1868 that "directly in nature and alone one does better. . . . [W]hat I am painting here has at least the merit of not resembling anyone," anticipating the advice that Corot would give in 1872, urging painters to "interpret nature naïvely and according to your own feeling, detach-

ing yourself from what you know of the old masters and your contemporaries." As Isaacson hastens to point out, "The dream of innocence was both a rhetorical strategy and an index of serious commitment to develop a painting that would somehow break free from the constraints of entren-ched theory and practice. . . . A recognition of the unat-tainability of the goal does not, however, destroy the idea of forgetting."[17]

How did the desire to escape convention—to detach themselves from the example of the old masters, above all—find expression in the work of the Impressionists? In Pissarro's landscape paintings, Isaacson argues, it was in the attempt to avoid a time-honored compositional formula that would recognize what the artist had been taught were the "true" spatial relationships between elements of a land-scape subject, thereby forcing each part of the painting to have its own integrity as a visual component. In several of Pissarro's landscapes, notably in views of landscape seen through trees, this strategy resulted in images that defied conventional spatial recession and the anticipated domi-nance of foreground over background elements—not unlike the effect that he achieved in *Still Life: Apples and Pears in a Round Basket*, where a crescent of wallpaper "trapped" within the circle of the basket seems to join in its plane, rather than remaining fixed on the wall behind.

But few of the Impressionists attempted, in their still lifes, to achieve this kind of "innocence of the eye" (as John Ruskin had phrased it). Instead, they sought out ap-proaches to their subjects that would give the *appearance* of such innocence, chiefly by choosing arrangements of objects that did not seem to be arranged. Thus Fantin-Latour, a few months after Monet's *Tea Set* was finished, embarked on his "attempt to realize the natural," in the *Still Life: Corner of a Table* (plate 35). He later affirmed that in order "to make a painting representing things as they are found in nature" he was forced to "put a great deal of thought into the arrangement, but with the idea of mak-ing it look like a natural arrangement of random objects. This is an idea that I have been mulling over a great deal: giving the appearance of a total lack of artistry."[18]

Fantin-Latour's honesty about the complications of attempting "the appearance of a total lack of artistry" shows him to be philosophically closer to Degas than to Monet at this point. Degas was always insistent that no matter how much it was based on careful study of nature, the work of art was always a fabrication of the artist's imag-ination. Many years later, Degas said to his friend Georges Jeanniot that "It's all very well to copy what one sees. But it's much better to draw what one can only see in memory." Degas described the process as "a transformation during

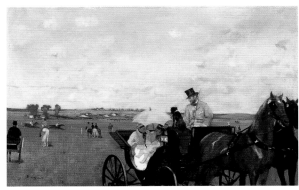

FIGURE 19
EDGAR DEGAS
*AT THE RACES IN THE
COUNTRYSIDE.* CA. 1869
OIL ON CANVAS,
14⅜ X 22 IN.
(36.5 X 55.9 CM)
MUSEUM OF FINE ARTS,
BOSTON, 1931 PURCHASE
FUND

FIGURE 20
EDGAR DEGAS
*IN A CAFÉ (THE ABSINTHE
DRINKER).* 1876
OIL ON CANVAS,
36¼ X 26¾ IN.
(92 X 68 CM)
MUSÉE D'ORSAY, PARIS

which the imagination collaborates with the memory. . . . There," he argued, "your recollections and your fantasies are liberated from the tyranny which nature imposes."[19]

Appropriately enough, the statement was made at the moment when Degas was making his own "fantasy" landscapes in monotype; but his provocative statement disguises the fact that time and again he made paintings and pastels that were accepted by the audience of his day as true records of an immediate and unusually perceptive view of nature—unfettered, as it were, by the tyranny imposed by memory. His *At the Races in the Countryside* of about 1869, for example, which was presented at the first Impressionist exhibition, has often been praised for the degree to which it appears to present a "slice of life" (fig. 19). This perception is, of course, the result of the artist's choice of a spatial framework in which signifcant portions of the motif are literally cropped by the position of the viewer/artist, ingeniously suggesting the peculiarities of human vision. This device became almost a cliché in

Degas's scenes of the racetrack, the ballet, cafés and cafés-concert, and found its way into his pastels and paintings of laundresses and milliners as well (plate 60). His colleague Mary Cassatt employed the same scheme of juxtaposing the near and the far around 1879 in her *Tea* (plate 53). Like Degas's *In a Café (The Absinthe Drinker)* of a few years earlier (fig. 20), *Tea* places the fictive viewer in an immediate, if imprecise, relationship with the principal figures in the painting, who are pushed to the middle ground of the composition—observed by the viewer/artist, but not subject to his or her control. (We are reminded of Monet's *Tea Set*, which refused to be arranged by the taste of the painter.)

In a series of remarkable interiors, beginning about 1876, the painter Gustave Caillebotte, who exhibited with

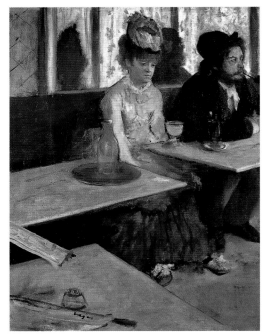

the Impressionists at the insistence of Degas, began to experiment with radical foreshortening and with the designation of a social role for the viewer through the agency of the artist's vantage point. Of course, the aim of Degas, Cassatt, and Caillebotte was to attain that sense of truth that Duranty urged on them in his review of the second Impressionist exhibition in 1876, his famous article "The New Painting," in which he argued that "in real life views of things and people are manifested in a thousand unexpected ways."[20] In figure painting, Duranty praised Degas's methods without naming him; to sum up the parallel efforts of the landscape painters, he quoted an unexpected source, giving in French the famous remark of John Constable: "When I sit down to make a sketch from nature, the first thing I try to do is, to forget that I have ever seen a picture."[21]

It is perhaps no overstatement of fact to say that Caillebotte was able to forget that he had ever seen a picture when he undertook a series of remarkable still lifes, among the most original in the history of the genre, and among the most striking works in the history of Impressionism. The effect of these paintings—the most unusual of which is probably the Boston *Fruit Displayed on a Stand* (plate 58)—is to deny the artist any role in the organization of the motif, "giving the appearance of a total lack of artistry" (in Fantin-Latour's words) through the peculiarity of the point of view assumed by the painter. (It is picking that vantage point, of course, that constitutes the artist's intervention.) A critic of the Impressionist exhibition of 1882, where the painting of a fruit stand was first shown, marveled that another picture by Caillebotte seemed "balanced in color, and almost balanced in form. . . . Happily," he noted in jest, "the *Street Seen from Above* and the inverted perspective of his boxes of grapes reassures me that his convictions are still firmly held."[22] Firmly held convictions, yes—resulting in paintings that seem unstable, fleeting, momentary, disjointed, and therefore apparently *authentic.* Degas's milliners, or his views of dancers backstage, share Caillebotte's aesthetic; and with Caillebotte close at hand, Monet too made a foray into this territory, producing one of his

own most radical still lifes, *The "Galettes"* of 1882 (plate 57).

This desire to make still lifes or other forms of painting that would appear to be drawn from specifically modern experience, in the words of Stéphane Mallarmé "oblivious of all previous cunning," was one of the great contributions of mainstream Impressionism to the still-life tradition, but the impulse was relatively short lived.[23] The majority of still-life paintings by the Impressionists from the later 1870s and the 1880s are not unlike still lifes of the past in their basic organizational principles. When Monet re-turned to still-life painting in earnest in advance of the Impressionist exhibition of 1882, he presented a group of large-scale bouquets of dazzlingly colored blossoms—Jerusalem artichokes, chrysanthemums, gladioli, and sunflowers—along with a painting of pheasants. In the weeks following the exhibition, Durand-Ruel persuaded Monet to execute a series of panels to be mounted on doors in his drawing room, where walls set within white and gold *boiseries* were hung with dark velvet draperies, on top of which the dealer's collection of Impressionist paintings was displayed. The Durand-Ruel doors were a challenging commission that might have provoked a modern renewal of still life's decorative role. But Monet's creative solution to the compositional problem depended on Japanese prototypes more than on European sources, and was overwhelmed by the apartment's elaborate decoration; the paintings were ultimately dispersed.

A few years later, van Gogh's 1887 still lifes of books reflected his dual awareness of Japanese prints and of the still life compositions of Jan Davidsz. de Heem, particularly one that was on loan at the Mauritshuis, The Hague, during his period of residence there in 1882–83.[24] Cézanne, ironically enough, since he thought that van Gogh painted "like a madman," seems to have shared van Gogh's interest in the master of seventeenth-century Dutch still life. Cézanne, who often stated his intention of remaking the art of the Louvre "from nature," must have been aware of de Heem's painting at the Louvre, called *The Dessert* (fig. 14). The lessons that such spatially complicated Dutch tabletop still lifes offered would have reinforced Cézanne's own notions of composition when he undertook the most

precariously balanced of his tabletop still lifes in the late 1880s and 1890s (see plates 73, 83).

The story of Cé-zanne's great triumph is told elsewhere in this volume. But it is worth noting here, in conclusion, that he, more than any other Impressionist painter of still life, forges the link between the movement's accomplishments in still-life painting and the traditions of still life in

FIGURE 21

the twentieth century. Virtually every vanguard painter of the first quarter of the century just past felt obliged to grapple with Cézanne's example, whether in still life, figure, or landscape. But again and again, Cézanne's distinctive mastery of objects, his ability to charge the physical article with a spiritual dimension, has continued to intrigue and to inspire painters who followed him. First the cubists—Picasso, Braque, Gris, and Léger—and then the fauves—notably Matisse—followed by such diverse artists as Miró, Morandi, and Beckmann were moved to imitate and to reinvent Cézanne's still lifes in their own work, which in turn has had its effect on generations that followed. At the close of this exhibition, Cézanne's skulls speak to us across the art of the twentieth century, poetic emblems of vanity—still life, still living.

FIGURE 21
MAX BECKMANN
STILL LIFE WITH THREE SKULLS. 1945
OIL ON CANVAS,
21 ¾ X 35 ¼ IN.
(55.2 X 89.5 CM)
MUSEUM OF FINE ARTS,
BOSTON, GIFT OF MRS.
CULVER ORSWELL

Jeannene M. Przyblyski

FIGURE 22
EDOUARD MANET
_STILL LIFE WITH MELON AND
PEACHES_. CA. 1864
OIL ON CANVAS,
27⅛ X 36¼ IN.
(68.3 X 91 CM)
NATIONAL GALLERY OF ART,
WASHINGTON, D.C. GIFT OF
EUGENE AND AGNES E.
MEYER

Emile Zola famously defined Edouard Manet's modernism in terms of still life and, in turn, still life's modernity in terms of Manet:

His approach to figure painting is like the approach to still life taught in art schools; I mean that he groups the figures before him a bit haphazardly, and then he is concerned only to fix them on the canvas just as he sees them, with the lively contrasts they produce by their juxtaposition. Ask nothing of him other than a literally accurate translation. He would not know how to sing or philosophize. He knows how to paint and that is all.[1]

Written in 1867, these words suggest one foundational narrative for the "heroism" of modern painting. Inaugurated by the denial of "philosophy," by the advent of painting as such, and by a positive embrace of the inconsequential subject matter that had long doomed still life to the bottom of the academic hierarchy, figure painting is reduced to a process of objective visual transcription—a matter only of colored marks and touches seen and painted—and still life becomes the standard by which such visual objectivity and reductive sensationalism is to be measured. This mode of painting produced the coolly confrontational colorism and deadpan social dynamics of Manet's scandalous _Déjeuner sur l'herbe_ and _Olympia_ (both 1863, Musée d'Orsay, Paris). It also pro-

FIGURE 23
RANDON
CARICATURE OF MANET
STILL LIFE, IN _LE JOURNAL
AMUSANT_ (29 JUNE 1867)
LIBRARY, GETTY RESEARCH
INSTITUTE, LOS ANGELES

duced the lavish (and almost universally admired) still lifes of the 1860s—the _Still Life with Melon and Peaches_ (fig. 22), for example, with its magnificent cascade of white damask and austere contrast between the bitter brown of the liqueur bottle and the acid green of the melon, or the _Still Life with Fish_ (fig. 55), in which a tangle of sea creatures seems to spill, like entrails, from the white

FIGURE 23

expanse of a carp's underbelly, playing on our recognition that such illusionistic viscera is, after all, "only" paint. The view of Manet's painting as dominated by a sensibility best suited to still life became commonplace quickly enough. A caricature appearing in the _Journal amusant_ the same year reduced the whole world of Manet's painting to a melon and a bottle, larger than life and somehow more lively too—it is almost as if the master and mistress of the house had been transformed, like Cinderella's pumpkin in reverse (fig. 23).

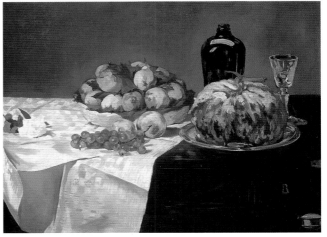

FIGURE 22

But if Manet was celebrated for approaching all painting _as if_ it were still life, other painters, most conspicuously Manet's friend and colleague Henri Fantin-Latour, have not been treated so kindly in the annals of modernism. Fantin-Latour would seem to be the other side of the modern painting/still life coin—the artist who seemed all too confined by the genre. A caricature from the 1866 Salon dubbed Fantin-Latour's submission the "Timid Still Life," its sparse bunch of flowers, single lady apple, and wilting knife barely able to hold their own on the stark expanse of the tabletop (fig. 24). It was not the first time Fantin-Latour would have heard this word applied to his work. In 1863, for example, the otherwise sympathetic critic Jules-Antoine Castagnary grumbled that he wished "this young man, who is as talented as the next person, could throw off whatever timidity it is that enchains him and holds him back."[2] Perhaps "timidity" accounts for the careful alignment of objects in _The Betrothal Still Life_ of 1869 (plate 23), for example, the wineglass and dish of strawberries arranged around the fulcrum of a towering bouquet like a pair of scales, the jewel tones of the strawberries balanced by the wine's deeper red, the white of the compote dish at left visually anchored by a camellia blossom laid on the table at right. The desire to refute such a characterization might also stand behind the baroque complexity of _Flowers and Fruit on a Table_ from the same decade, with its almost overpowering array of colors and forms (plate 19). Certainly the dilemma of appearing nei-

ther too modest nor too overreaching must have sometimes struck Fantin-Latour himself as unresolvable. After the critical lambasting of his *Le Toast* (destroyed) in 1865, the artist wrote to his good friend Edwin Edwards that he had decided to confine himself to "carefully painted heads and still lifes—with these I am much more sure of myself."[3] A similarly disheartened abdication would seem to be in evidence when Fantin-Latour's ambitious group portrait of Parisian poets (fig. 50), poorly received at the 1872 Salon, was depopulated, leaving only a simple still life (plate 35) to be exhibited in 1873.

This was one problem of still life as modern painting, especially as the linkage was being forged in the 1860s. In defiance of the academic tradition of history painting, it was asked to stand as the genre of intransigence and avant-garde aspirations—in no small part due to the example of Manet and Fantin-Latour. But it also continued to figure as the genre of limitations—the province of artists who had not enjoyed the extensive training in figure drawing provided by the Académie des Beaux-Arts and of artists who had to work for a living, supporting themselves with small sales rather than holding out for large state commissions. Moreover, not only Fantin-Latour but also Manet "retreated" to still life in the aftermath of the infamous Salon des refusés of 1863, an exhibition of works rejected from that year's official Salon to which they as well as many of their colleagues had been consigned to face the mockery of crowds and critics alike. Manet's equally disastrous reception at the Salon of 1865 yielded another sustained engagement with still life in 1866–67.

Such shared experiences have led scholars to speak of a "generation of 1863," for whom the Salon des refusés was a defining moment—both an enduring sore point and a badge of honor.[4] The artistic profile of that generation was codified, among other places, in a novella by Louis-Edmond Duranty, an art critic who sympathetically championed many of the "advanced" painters of his day. *Le peintre Louis Martin* takes as its hero a young artist of the Second Empire, thirsting for a new way of painting and possessed of all the nervous passion and skepticism of young men his age. In company with Manet, Fantin-Latour, and James Whistler, Louis Martin made his public debut among the "refused." But unlike Manet, his work failed to create a stir, meeting instead with the even greater disappointment of

La timide nature morte
—Un bouquet de fleurs sur une nappe bien blanche, une pomme d'api et un couteau à manche d'ivoire.

FIGURE 24

critical indifference. Defiantly, Martin seized his brush and roughed out a small painting of a little gray pot with some blue flowers, a lamp, and a few books, declaring to himself that it was finer and more alive than all of the *machines* that had figured so prominently on the Salon's walls.[5] A consoling gesture and a personal attack on the academy, Martin's act of painterly self-affirmation also echoes Zola's view of still life as a matter, mostly, of colored forms and painted touches.

But still life's formalism alone did not sum up the challenge it posed to the academic tradition. Martin revolutionized still life, Duranty goes on to explain:

In place of those accumulations of objects, with no other reason for being together save that of the so-called picturesque and decorative taste of the painter, he has gathered together the genuine fragments of an interior—significant, expressive of a kind of life in which things ultimately retain the place and the physiognomy that the habits and tastes of those who live in that interior fix to them.[6]

FIGURE 24
ANONYMOUS
"LA TIMIDE NATURE MORTE,"
LA VIE PARISIENNE (5 MAY 1866), 248
LIBRARY, GETTY RESEARCH INSTITUTE, LOS ANGELES

Here then is the second paradox facing the emergence of still life as a distinctively modern category of practice in the 1860s. Weighted with ambition and yet resolutely minor, still life was said to be nothing but color and form; yet color and form were to be endowed with a mysterious eloquence that conveyed the nature of the individual through the painting of everyday things, as if such objects had yielded their secrets to the inquiring eye of a detective. Such eloquence was not merely anecdotal or "literary," a function of iconography and inventorying. It might be more accurately described, to use Duranty's word, as "physiognomic," a product of physical impressions and traces—a cumulative effect of the deep, domestic familiarity born of the habits of daily use worn into the surfaces of commonplace objects and imprinted from their surfaces to the surface of the painting. Still-life painting was thus conceptualized as simultaneously optical and tactile, objectively neutral and yet subjectively charged, purely formalist and yet almost evidentiary in its ability to "produce" the inhabitant of its domestic setting—this was a lot to ask of paintings primarily of flowers and fruit. The remainder of this essay will grapple with understanding the context for the multiple demands made upon still-life painting by the generation of 1863 and its followers. In doing so, we will

be led, inevitably, to savor the elegance, economy, and sheer authority of Manet's still-life compositions. But I would also propose that we come to see Fantin-Latour as an equally revealing figure in mediating between the realist legacy of the 1850s and the set of intentions and practices that would become the full flowering of Impressionist still life.

On the one hand, realist still life was to a great degree constituted through a reconsideration of the work of Chardin as the preeminent French master of the genre. Largely forgotten during the period when Jacques Louis David and his followers ruled French painting, Chardin had come in for a considerable revival in the 1840s and 1850s.[7] To the painters and critics of the realist circle, Chardin stood for a more direct relationship between painting and everyday life, and a newly revitalized French art, far removed from the moribund academic taste for scenes from ancient history and mythology. The critic Théophile Thoré argued as much when he asked, "What makes a master? An original sensibility toward nature and, at the same time, a particular mode of execution. When a painter has these two qualities, even if he only applies them to very inferior objects, he is master of his art and in his art."[8] An eye able to detect visual potential in even the most mundane things and an identifiably particular painterly "touch"—unfortunately, for many of Chardin's nineteenth-century followers, this lapsed all too quickly into a repertory of stock objects and surface effects that, by the 1860s, had become thoroughly routinized as "Chardinesque."[9]

In 1859 Fantin-Latour reportedly copied a still life by Chardin, and he could have seen many examples of Chardin's work at an important exhibition held at the Galerie Martinet the following year.[10] Several small paintings spanning the 1860s, including *Plate of Peaches* from 1862, *White Cup and Saucer* from 1864, and *Peaches* from 1869 (plates 15, 16, 20) seem the direct results of this exposure. These deceptively simple works allow us to see how seriously Fantin-Latour engaged not merely with Chardinesque iconography, but with Chardin's mode of composition, most particularly the relationship this mode seemed to propose between the still life set up as a way of handling objects and the still-life painting as a way of handling paint. Composition, for Chardin, was an act that preceded, yet also penetrated, the painting process. "Select a spot," the critic Denis Diderot was fond of directing his readers when describing a Chardin still life, "arrange the objects on it just as I describe them, and you can be sure you'll have seen the paintings of Chardin."[11] Borrowing from Diderot's chain of imperatives, it doesn't take much

to imagine Fantin-Latour sitting quietly before his solitary white cup, and then gently laying a spoon on the saucer, just so. Now imagine him picking up a brush and beginning to build the white cup out of touches of paint applied with similar patience. Then take your place at the table, and see Fantin-Latour's painted cup as the evidence of a deeply human process of seeing and shaping that gives way to a kind of visual handoff from artist to viewer. Such an approach to still life tends to merge the domestic and artistic uses of these otherwise unremarkable objects in ways that also made sense to Manet. In addition to the more obvious (and grand) turn on Chardin's great *Ray* (1725–26, Musée du Louvre, Paris) represented by the large-format *Still Life with Fish* in 1864, or the direct quotation from Chardin in some later game pieces, other works by Manet like the simple *Basket of Fruit* from ca. 1864 (plate 18), with its mother-of-pearl–handled knife laid carefully parallel to a tidy pile of plums and peaches, seem to see Chardin in the same way.

The generation of 1863's interest in Chardin was tempered by the example of Gustave Courbet as well, who loomed large as the preeminent painter of embodied reality—no matter that still life had preoccupied him only briefly in 1862–63 (plate 1) and then not again until his imprisonment in the aftermath of the revolutionary Commune of 1871.[12] Not only Fantin-Latour and Manet, but younger artists like Claude Monet, Auguste Renoir, and Frédéric Bazille responded to Courbet's flower pieces (plates 9, 10, 11). Marvelous examples of his sensual investment in the natural world, Courbet's blooms seem charged with an almost sentient energy—they chafe at the confines of bowl or vase and seem ready to burst from the surface of the canvas. The later "prison" paintings were so unmistakably urgent in their insistence that blemished fruit or a fish struggling for air stand in for the mortified flesh of the artist himself that one wag, referring to a painting of apples under a tree that was summarily rejected from the 1872 Salon on political grounds, joked that the apparently "unripe" condition of these "fruits of reflection" was due to the six-month prison sentence Courbet served for his involvement in the insurrection (fig. 25). Along with the compositional gambit of bringing his motifs forward on the picture plane, the main means for signifying the corporeal authority of Courbet's realism, and, by extension, the prolongation of the artist into the objects he pictured, was the thickly worked paint that Courbet reputedly troweled on with a palette knife, "materializing everything it touches."[13] Such an embodied application of paint is evident in Courbet's *Hollyhocks in a Copper Bowl* of 1872 (plate 26), in which the massive blossoms seem made of a sub-

stance infinitely more physically powerful and enduring than mere floral matter. In his *Still Life: Fruit* of 1871–72 (plate 28), a similar facture seems to turn a lace curtain into a granite cliff and gives apples and pears a weight more comparable to stones. While neither Fantin-Latour's nor Manet's painting would appear so consistently heavy or invested with the body's life, surely Courbet's influence is detectable, among other places, in the thickening of painted matter to almost icing-like swirls in Manet's *Basket of Fruit*.

Yet by the 1860s the view in advanced artistic circles of Chardin's eighteenth-century materialism and Courbet's corporeal realism was being complicated by a new privileging of purely optical sensation that had as much to do with how the experience of vision was to be subjectivized as with representing the visual mechanics of objects being seen. "It is a moment," Jonathan Crary has observed, "when the visible escapes from the timeless order of the camera obscura and becomes lodged in another apparatus, within the unstable physiology and temporality of the human body."[14]

Impressionism was to be all about investing this "unstable physiology and temporality" in a representational regime based upon optical sensation alone. As early as 1874, the Impressionists had already been dubbed by one (predictably hostile) critic, "the school of the eyes."[15] But a decade earlier Manet, and even more so Fantin-Latour, might be seen as attempting to mediate between these two ways of representing the "reality" of the perceptual world, the one born of the weight and sensations of sentience carried within the body, the other a product of the eye's affinity for outward appearances and surfaces. Painting an explicitly modern still life thus meant registering the ways in which the corporeal could be represented as giving way to the optical, or perhaps better, in which vision was in the process of overwhelming other orders of sensory perception and knowledge.[16]

Compounding these potentially contradictory "modern" aesthetic imperatives was the sense that the circumspect vision of comfortable domestic order and propriety thought to be contained within Chardin's painting was equally under fire. Paris itself was modernizing, and that process of modernization, masterminded by Napoleon's Prefect of the Seine, Baron von Haussmann, was registered

FIGURE 25

not only in the ways Parisians negotiated its glittering new boulevards and wide-open public spaces, but in how they lived their private lives as well. As early as 1860, the brothers and literary collaborators Edmond and Jules de Goncourt (who, not coincidentally, led the mid-century rococo revival that had included the "rediscovery" of Chardin) complained that the traditional life of the interior seemed to be "passing away," along with Paris as they knew it.[17] Instead, people lived (almost literally) out in the streets, in the cafés, places of public entertainment, arcades, and department stores that were springing up in a newly externalized Paris that seemed more suited to the perceptual affinity for fleeting sensation and kaleidoscopic spectacle ascribed to the idle stroller, or *flâneur* as he was popularly called, while leaving the *homme de l'intérieur* disgruntled and alienated. If the poet Charles Baudelaire famously likened the *flâneur* to "a mirror as vast as the crowd itself; or a kaleidoscope gifted with consciousness," the Goncourts took a dimmer view.[18] "It is idiotic to arrive in an age under construction," they concluded glumly, "the soul has discomforts as a result, like a man who lives in a newly built house."

The Goncourts's lament makes clear that the crisis provoked by the modernization of Paris was as much a crisis of interior life as of a public world that seemed increasingly to dissolve into fragmentary illusions and counterfeit appearances. Manet's still lifes, however, betray no similar sense of conflict. Or to put it another way: a painting like the glistening *The Salmon* of ca. 1864 (plate 4), with its limpid surface sheen and silvery, satiny juxtapositions of salmon skin and damask, seems to successfully resolve the corporeal/optical dilemma described earlier by reaching past the examples of Chardin and Courbet to the ability to render material texture and shine exemplified by seventeenth-century Dutch painting, with its own interest in optics and the physiology of sight.[19] But Manet at his most Dutch is also Manet at his most bourgeois, the artist whose confident ability to master the spectacle of modern Paris extended to a mastery of his home as a space of elegant leisure, where a gentleman could enjoy a peaceable after-dinner discussion of aesthetics with his good friend Stéphane Mallarmé, or proffer a floral tribute to a beautiful and equally well-bred woman like Berthe Morisot (plate 31). Moreover, such a view of private life was an equally vital element in the rehabilitation of

Manet's public reputation. Zola argued as much in the same 1867 essay in which he defined Manet's style in terms of still life. Attempting to counter the conviction widely held among the general public that any man who could conceive of such disturbing paintings as the *Olympia* had to be a drunkard or worse, a sociopath, Zola "discreetly raise[d] the veil of intimate life," insisting that Manet, as a "man of the world" also lived happily married, in a well-run home, where he found "peace and affection, and the little pleasures of existence."[20]

Even more than Manet, Fantin-Latour appears as the quintessential man of the interior, whose most notable works were to be still lifes set predominantly in the dining or drawing room, and genre paintings of women absorbed in reading or embroidering. To look at the *Still Life* (fig. 26) he sent to the Salon of 1866, for example, is to find him as equally committed as the fictional Louis Martin to materially rendering the objects of daily life and the physiognomic impressions they might retain (indeed, the well-thumbed blue book and its coloristic relation to Fantin-Latour's characteristic gray background suggest that perhaps Duranty had this work in mind when describing Martin's). An orange anchors a red lacquer tray to the tabletop—it appears almost planetary in its spherical wholeness, creating a kind of gravitational field within which everything else seems to revolve. The orange is flanked by an empty white cup waiting to be filled and another orange that has been peeled and split into segments, the peel still cupping the orange flesh like a glove that "remembers" the shape of the hand that had been inside it. But if still life's ability to embody the modernity of contemporary experience had something to do with these effects of containing and retaining the impressions adhering to the surfaces of things, then it also had to explicitly register the relation of those "physiognomic" impressions to sight. For Fantin-Latour, the opticality of modern still life had as much to do with representing the space between things as the textures and sheen of the objects themselves. Optics was a matter of the light and air that appeared to circulate through the painting, and yet light and air are largely registered in Fantin-Latour's still-life paintings by the deliberate compositional relation of one thing to another: the white cup nestled within its saucer, and the saucer within the greater ellipse

of the red tray; or the angle of the table against the background wall, the basket of fruit against the table, the lacquer tray to the book—space opened out and measured like the hinged segments of a carpenter's pocket rule. Later, Fantin-Latour felt it necessary to defend his apparently scattered yet carefully calculated displays. He wrote, "I put a great deal of thought into the arrangement of random objects. This is an idea that I have been mulling over a great deal: giving the appearance of a total lack of artistry."[21]

But this was easier said than done. The problem of the "timid still life," as the 1866 caricature of Fantin-Latour's work suggested, *was* a problem of empty space as much as modest objects. Edmond About, one of the few critics in attendance at that year's Salon to pay any attention at all to Fantin-Latour's still life, complained that the composition was "literally murdered" by its background, and though finely painted, was "too big for its contents."[22] As these contemporary responses make clear, seeing Fantin-Latour as mediating between a realism of physiognomic impressions and a realism of optical sensation is also to see him at his most awkward, arbitrary, or labored; or, to put it another way, it is to see him making a representational problem of the process of composing the domestic interior at the very moment when it needed most to appear natural, artless, and unlabored—as a conceit of both bourgeois domestic leisure (increasingly fraught by the pressures of private life, to evoke the Goncourts again, "turned back to become public") and advanced painting's desire to claim a new relationship to the everyday. Unlike Manet, whose fantasy of the detached observational powers of *flânerie* found its counterpart in his pose of the leisured gentleman at home, Fantin-Latour seemed to work at his vision of domesticity—and the traces of his efforts showed.

In one way, it is certainly true that Manet's example would seem most immediately useful to the Impressionists, whose "school of the eyes" was founded in the image of the new bourgeois economy of spectacular leisure. The wholly "visual poetics" of Manet's late floral paintings—with their delicate, light-edged blooms and the limpid transparency of their water-filled crystal vases (plates 63, 64, 65)—stand comfortably next to the sparkling brilliance and optical sensationalism of Claude Monet's later flowers (plate 61).[23] For those, like Gustave Caillebotte,

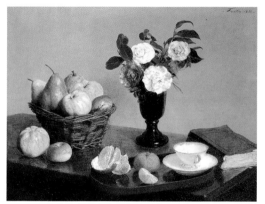

FIGURE 26

FIGURE 26
HENRI FANTIN-LATOUR
STILL LIFE. 1866
OIL ON CANVAS,
24 3/8 X 29 1/2 IN.
(62 X 74.8 CM)
NATIONAL GALLERY OF ART,
WASHINGTON, D.C., CHESTER
DALE COLLECTION

who sought to render the *flâneur*'s account of Paris's central food markets in Zola's *Belly of Paris* as still lifes of butcher windows and produce stands, the flatness exemplified by Manet's still-life paintings was readily adapted as the very sign of commercial availability (plates 58, 59).[24] Not until Cézanne would the spatial dynamics of still life again become so insistently the measure of its modernity. But Cézanne also decisively relocated still life from the home to the studio (notice the stack of painted

FIGURE 27

canvases in the corner of the *The Kitchen Table* (plate 73), for example, or the presence of the same workmanlike table no matter how "drawing room" or "kitchen-like" the composition) (plate 88)—as if the only way to move such investigations forward was to give up still life's attachment to the domestic conventions that had revitalized the genre in the hands of Chardin and the Chardin revivalists.

All of this is not surprising. When we look back to the 1860s, we are used to seeing Manet's "success" and Fantin-Latour's "failure." But it was nonetheless Fantin-Latour who provided us with an enduring image of the ambivalence of Manet's success. Fantin-Latour's 1867 portrait of Manet (fig. 27) is a grandly affectionate image of the then-controversial artist, and was meant to be a sympathetic claim of affinity. Moreover, it is a portrait whose keen observation derives much of its compositional force from Fantin-Latour's own still-life conventions: the subject placed at a slight angle to the picture plane, carving a space for itself against a gray background; the small, patient touches of color that build up the density and presence of the figure; the interest in themes of containment—hat conforming snugly to head, glove pulled smooth over the hand, hand wrapped tightly around the cane, breeches closely fitted to the shape of the thigh.

In his portrait of Manet, Fantin-Latour may have given us the quintessential portrait of the *flâneur*—a dispassionate observer whose bourgeois "uniform" of top hat, black coat, and gloves is worn like a cloak of invisibility. But he also unflinchingly (not timidly) reminds us that such authority entailed its own limitations. Embedded in Fantin-Latour's spongy gray background like a specimen is an image of a man who, in order to appear modern, must also appear completely enclosed and contained, who must wear his clothes form-fitted, like armor or a shell, like a snail carries its home upon its back. The portrait captures the *flâneur*'s confident *tenue* but also offers a partial vision of

the "un-housed" body's poignant vulnerability: in the fraying of Manet's beard into nothingness, and in the strange accumulation of blue and yellow touches of paint "clothing" Manet's ungloved hand—which end by making this hand appear not so much ungloved but flayed. Fantin-Latour presents us with the curious duality of a man of the world and a man immobilized, an all-seeing man who has submitted himself to being seen. Mapping the constraints of bourgeois propriety onto Manet at his most elegant and worldly, by painting the *flâneur* as equally an *homme de l'intérieur,* in other words, Fantin-Latour ends by turning a dominant conceit of Manet's painting back upon himself—painting Manet *as if* he were a still life.

In the end, it is not a matter of arguing that Fantin-Latour is a greater painter than he is often given credit for being. Although he was as heroic as anyone, his heroism is more tinged with poignancy. Seeing Fantin-Latour and Manet together in the context of the "generation of 1863" gives us a special purchase on one of the central paradoxes of the modern artistic "personality" or "temperament" (to use a nineteenth-century word) as it was to be articulated in relation to still life and modern experience in the 1860s. It hardly needs saying that giving an image to "home"—the counterweight to the increasing spectacularization, perceptual dislocation, and experiential uncertainty of modern life—was not to be only women's work (although the many women artists in the nineteenth century who made a living painting still life are to a great degree still awaiting their reinscription into the genre's history). But if the deeply dependent relationship of avant-gardism to domestic life too often falls out of both historical and theoretical accounts of modernism otherwise dominated by the masculine figure of the *flâneur,* then Fantin-Latour's portrait of Manet reminds us that the *flâneur*'s fantasy of idling in the streets, granted the social dispensation to see without being seen, could only succeed insofar as it was recognizably implicated in the domestic economy of the middle-class household—upon which the *flâneur* depended for his social legitimacy and his ability to pass without notice. As Walter Benjamin so acutely reminded us, the *flâneur* without a place to call home would be nothing but a vagabond—a very different sort of "street person" from Manet indeed.[25]

FIGURE 27

HENRI FANTIN-LATOUR

EDOUARD MANET. 1867

OIL ON CANVAS,

46¼ X 35½ IN.

(117.5. X 90 CM)

ART INSTITUTE OF CHICAGO,

STICKNEY FUND

CÉZANNE'S DIFFERENCE

John McCoubrey

FIGURE 28
PAUL CÉZANNE
*THE ARTIST'S FATHER
READING* L'EVÉNEMENT
1866. OIL ON CANVAS,
78⅛ X 47 IN.
(198.5 X 119.3 CM)
NATIONAL GALLERY OF ART,
WASHINGTON, D.C.
COLLECTION OF MRS. AND
MRS. PAUL MELLON

Reviewing Ambroise Vollard's 1895 exhibition, which first brought Cézanne's art before the public, the critic Thadée Natanson proclaimed Cézanne "a master of still life." He wrote, "Cézanne's apples belong to him. They are his just as much as an object belongs to its creator."[1] Despite doubts about his own talent and distrustful of praise, Cézanne, if he read the article, would have been gratified. Still life was as important to him as any other painting, and the critic was right—his apples were like no others. Roughly a fifth of his total output was still lifes. From 1877, once he had mastered Impressionist color, his work in that unsung genre reveals a thoughtful development that produced paintings that rival any in early modernism.[2] In still life, he found the colors that are the lifeblood of his art. His still lifes also reveal his patience in overcoming, in what was considered the easiest kind of painting, obstacles to his most tenaciously held goals in art.

The large number of Cézanne's still lifes—172—and their development are not the only signs of their importance. They are also present in the most memorable statements he made late in his life: "Drawing and color are not separate at all; insofar as you paint you draw. When the color harmonizes, the more exact the drawing becomes. When the color achieves richness, the form attains its plenitude." Where but in still life could he find the saturated reds, yellows, oranges, and greens to assert this primacy of color? His often quoted statement—"Everything in nature is modeled on the sphere, the cone, and the cylinder. One must learn to paint from these simple forms; it will then be possible to do whatever one wishes"—may also have been based on his still-life painting, where the volumes of round fruit, bowls, jars, and jugs set the governing rhythms of his compositions.[3]

A few of his still lifes have important histories in themselves. In *The Artist's Father Reading "L'Evénement"* (fig. 28), he included a depiction of a small still life, *Sugar Bowl, Pears, and Blue Cup* (fig. 29) painted with a palette knife in his most brutal manner to defy the standards of the official art establishment. The still life is shown hanging on the

FIGURE 29

FIGURE 29
PAUL CÉZANNE
*SUGAR BOWL, PEARS, AND
BLUE CUP.* 1865–66
OIL ON CANVAS,
11⅞ X 16⅛ IN.
(30 X 41 CM)
MUSÉE D'ORSAY, PARIS

FIGURE 28

wall above his father's head; its protest matched a mischievous reference conveyed by the inclusion of the liberal newspaper his conservative father never read. It was put in his hands in homage to Cézanne's friend, Emile Zola, whose first attacks on the Salon juries and defense of Manet had been published a few months earlier by that paper.

Cézanne's newly discovered technique of closely packing multicolored bands of paint seen in *Still Life with Compotier* (plate 48) immediately attracted the attention of Edgar Degas and Camille Pissarro, who sought a less improvisational technique than their fellow Impressionists Monet, Renoir, and Sisley. In a letter to Pissarro of 1881, Gauguin asked him to get from Cézanne, by any means, his "secret" of controlling color. Gauguin eventually bought *Still Life with Compotier* (1879–80, Museum of Modern Art, New York), a painting very closely related to the one mentioned above, and used it while lecturing on Cézanne to his followers in Brittany and Paris. Cézanne's new method appears, loosely interpreted, in Gauguin's still lifes in the

exhibition. Two years after Gauguin sold his Cézanne, it was again celebrated in Maurice Denis's *Homage to Cézanne* (fig. 38) where it appears on an easel surrounded by a circle of painters, representing a variety of theorized aesthetic positions, paying their respect to the master who had none.[4]

One can perhaps understand how Gauguin, who described Cézanne as a mystic and dreamer, drew from the quiet congress of shapes and resonant color of his painting an aura of mystery and, in the leaf forms drifting from the wallpaper—as they also do in *Still Life with Compotier*—the source of the mysterious floating symbols in his Tahitian paintings. Typical of the range of responses to Cézanne is the exhaustive formal analysis of the painting Gauguin had owned in the British critic Roger Fry's influential monograph of 1927, where the opposite position—that Cézanne was at heart a classicist—is eloquently argued.[5] Given Cézanne's methodical technique and tight organization, Fry's observations on the subtlety by which common objects are interrelated—and lifted out of the ordinary—are basic to any understanding of the artist's

FIGURE 30

still lifes. Other milestones in the interpretation of Cézanne are Meyer Schapiro's psychological readings of his paintings in his 1957 monograph and in a brilliant 1968 essay arguing that his apples were an "unconscious symbolization of a repressed erotic desire."

The still lifes have been the subject of insightful writing by nonspecialists as well. In his marvelous 1907 letters Rainer Maria Rilke movingly discovers the presence of Cézanne himself in the late paintings, while the writer—and painter—D. H. Lawrence wrote in 1929 that in still life, Cézanne most successfully treated apples in their physical fulfillment as apples, without visual clichés or "the winding sheet of abstraction." The philosopher Merleau-Ponty, holding close to his own phenomenology, believed his still lifes gave the impression of an emerging perception, their difficulties those "of the first word." With favor to none of these positions, this brief essay will perhaps help viewers understand how Cézanne's paintings are different from others in the exhibition, will demonstrate what to look for in them, how they evolved, and in the process will perhaps make it easier to understand something about the

painter himself.[6]

Although one Blaise Desgoffe, hailed as "the Raphael of still life," continued to paint meticulously detailed pictures of national treasures which hung in the Salle d'Honneur in the official Salons of the sixties, realist still life was well established there and in 1863, overflowed, in part because if their sheer number, onto the walls of the Salon des refusés. The still lifes of fish, dead game, and homely table settings painted by Manet, Cézanne, and the Impressionists-to-be in this exhibition were a continuation of a realist tradition that had begun with Courbet. Cézanne's signed *Still Life with Bread and Eggs* (plate 7)—probably one of the paintings refused by the Salon jury in 1866—is close to the work of Bonvin, an established realist still-life painter.[7] In a great step forward, Cézanne turned to another source in *Still Life with Kettle (Green Pot and Pewter Kettle)* (fig. 30), which is remarkable for the Manet-like decisiveness and clarity wrested from its subdued colors. These and two other paintings rich with Manet's blacks account for his major still lifes prior to his taking up Impressionism.

Before considering his return to still life in 1877, it is important to point out profound differences that separate Cézanne from the other artists represented and the problems he alone encountered in still-life painting. The others saw the world as a unified field to be treated in their characteristic techniques. Manet, for example, rendered the lovely face of Berthe Morisot with the same bold and sure brushwork he used for a basket of plums, while Monet's brilliant recording of light and color seen in his *Still Life: Apples and Grapes* (plate 41) also appears in his figure painting. In this sense, the canard that Cézanne painted people as he did apples applies to the Impressionists as well. Cézanne was sadly aware of this distinction. In conversation with Jules Borély in 1902, he remarked on how Monet "stayed with his single vision of things. . . . A man like Monet is happy; he fulfills his beautiful destiny." Referring to himself, he added, "Unfortunate is the artist who disputes with his own talent and has written poetry in his youth."[8] One cannot help noticing the geniality of the Impressionists' pictures, with their colorful, sparkling surfaces, the brilliant areas of unmodulated color in Gauguin, or Fantin-Latour's preference for isolated

FIGURE 30
PAUL CÉZANNE
*STILL LIFE WITH KETTLE
(GREEN POT AND PEWTER
KETTLE).* 1867–69
OIL ON CANVAS,
24 ¾ X 31 ½ IN.
(63 X 80 CM)
MUSÉE D'ORSAY, PARIS

FIGURE 31

FIGURE 31

PAUL CÉZANNE

MME CÉZANNE IN A YELLOW
ARMCHAIR. 1888–90

OIL ON CANVAS,

45 ¾ X 35 IN.

(116 X 89 CM)

METROPOLITAN MUSEUM OF

ART, NEW YORK

FIGURE 32

PAUL CÉZANNE

MME CÉZANNE IN A
RED ARMCHAIR. 1877

OIL ON CANVAS,

28 ½ X 22 IN.

(72.5 X 56 CM)

MUSEUM OF FINE ARTS,

BOSTON

objects. Noticeable too, even among the Impressionists, are what prejudiced critics in the seventeenth century permitted as "digressions agréables": expensive china, books, and statuettes presented in correct perspective. Cézanne thought the information such things provided about status and taste were distracting prettiness.

What is further distinctive in Cézanne's work derives from his probing beneath the surface of the genres of landscape, figure, and still life to discover the opportunities and constraints inherent in each. He acknowledged that the human body—a system in itself that could not be disrupted—would resist submission to the higher order he sought. Nonetheless he did manage to frustrate the natural human curiosity that a painted figure attracts by means of abstraction. Although his figures are often stiff, he recognized that, for an artist, the human capacity for movement was a primary distinction. Confident that the rather rigidly posed figure of his wife in *Mme Cézanne in a Yellow Armchair* (fig. 31) would hold its own, he did not hesitate to give her what Roger Fry termed in his monograph "the accident of life" by tilting her, her chair, a chair rail, and presumably the unseen floor at a steep angle to the right. In another portrait, *Mme Cézanne in a Red Armchair* (fig. 32), empathy enabled him to express the weight of her solidly modeled torso on her right arm by indirection in the nearby downward thrust of her asymmetrical red chair. In contrast, the lower part of her body, which bears no weight, is painted in airy blue-green tones of broken colors as full of light as one of his landscapes.

Cézanne saw in the landscape a passive, varied surface, continuous and virtually infinite in extent. He could not eat it, walk around it, or even approach it. He was in it as he painted. What he sought to do was to shape this continuity with respect to its materiality. This was an ordering that served both the viewer and the demand of pictorial

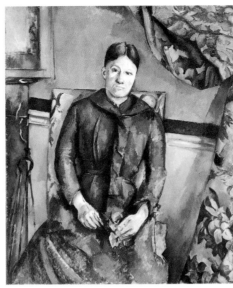

FIGURE 31

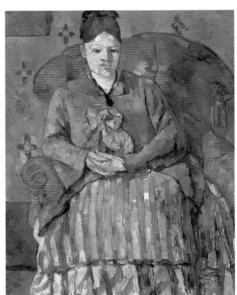

FIGURE 32

composition. The innumerable devices he used to this purpose: assorted framing devices—the unnatural clarity of his distances, collapsed middle grounds, high horizons, and structures integrated into or flattened by compressed space, most boldly contrived in *Mont Sainte-Victoire with Great Pine* (fig. 33)—testify to the intensity of this lifelong search. When seen from a distance, as was usually the case, landscape generously permitted his elisions and omissions. The landscape had no ideal form, which is the reason for its low estate just above still life. It was an accident whose true likeness could be judged only locally. Furthermore, the enormous reduction in size from what the eye sees in a natural landscape to a thirty-inch canvas compels its painters to find a visual shorthand.

After some false starts in Auvers in 1872, Cézanne put still-life aside to concentrate on the Impressionist palette in plein air painting. When he returned to it, he knew that traditional still life, with its precise imitations, precious objects, and signs of recent human activity—tipped glass, half-peeled orange, indeed anything that suggested narrative—was useless. Only the small, uncrowded still lifes of the eighteenth-century master Jean-Siméon Chardin were remembered with humility in the simple arrangements in the small paintings he began with. The claim that Chardin led Cézanne to banish human involvement can only be true of Chardin's small paintings. In Chardin's more ambitious works, objects are thematically related to dining, and, in the grandest of them, seem to have been carefully placed by a servant to await their next use. Chardin's paintings, which had been models for realist still-life painters for twenty years and available for study in the Louvre, probably led to the grainy texture in some of Cézanne's painting. More important to him was the "breadth of execution independent of the extent of the canvas and the size of objects" as described by Denis

Diderot in his article on the Salon of 1759. Chardin's touches of color, always visible, resemble Cézanne's description of seeing nature "in terms of an interpretation in patches of color according to a law of harmony and recording them," but there is an important difference.[9] When the viewer focuses on Chardin's objects, his touches of color come together to become, in Diderot's terms, "nature itself" and serve the uniqueness of the object. The broader touches in Cézanne's method avoid particulars but allow his fruit to relate to one another and to breathe.[10]

Problems addressed even in Cézanne's modest, Chardinesque beginnings were almost diametrically opposed to what was permissible in landscape and to his natural inclinations as a painter. The assertive colors and self-contained shape of his fruit tended to resist the harmonies that came so easily in the greens and earth tones of landscape. The universal fruits, familiar to all human senses but hearing, and viewed in still life close at hand, precluded the various devices he resorted to in landscape. Furthermore, these small objects and their attendant tableware presented the figure-ground problem he did not address in figure painting and could easily dispose of in landscape.

His study of still life began with a series in cheerful, highly keyed colors, whose simple arrangements reflect his humility in bringing Impressionist colors to still life. *Compotier and Plate of Biscuits* (plate 46) is the culmination of this series where the problem of relating the objects on the table to the background, and thus bringing the whole surface into play, is solved by wallpaper with a lozenge pattern ornamented at the crossings of the diagonals. In the simplest of these paintings, he left out the diagonals and placed the isolated ornaments above neatly placed apples and small containers on the table, which produced a pattern of spots. In *Compotier and Plate of Biscuits*, however, the inverted V of the diagonals in the pattern spans, on the right, the compote's width, bridges the space between it and the plate of biscuits at the center, and on the left, dictates the diagonal left border of the tablecloth. To relieve this insistent pattern and pick up the unusual sprigs of green in the compote, Cézanne surprises with the top of a green wine bottle jutting into the picture like an afterthought. The technique, however, is rather cumbersome as though worked with a heavily loaded brush; Cézanne soon corrected this problem.

The new constructive brushstroke used in *Still Life with Compotier* (plate 48), the technique so admired by Gauguin, was Cézanne's remedy. Its invention was derived from his idol Eugène Delacroix, whose colorism, embodying the legacy of Rubens and the Venetians, was a model for Cézanne in all respects. Specifically, the great romantic's use of tightly packed striations of opaque color bent to define the form in space showed Cézanne how to control his "modulations" of color.[11] He introduced two important changes: first he broke each band into small segments of different colors that create the image; the second was to put these varicolored lines down in straight diagonals independent of the form. Thus Cézanne allowed pure color to do the work of modeling. He could also control with precision areas like the unifying blue, which—substituting for the earlier wallpaper—descends from the wall into the whites of the linen. Another result of this technique was a

FIGURE 33

FIGURE 33
PAUL CÉZANNE
*MONT SAINTE-VICTOIRE
WITH GREAT PINE*. 1886–87
OIL ON CANVAS,
23½ X 28½ IN.
(59.6 X 72.3 CM)
THE PHILLIPS COLLECTION,
WASHINGTON, D.C.

nonrepresentational surface texture which held the composition together with its uniformity. Few works were as rigorously executed in this style, but it appeared occasionally throughout his career, especially in the painting of foliage, but after its invention he had no more difficulties with technique.

In *Apples and Biscuits* (fig. 34) the new technique is already more relaxed and selectively deployed than in the painting just discussed. Tightly assembled objects give way to an arrangement in beautiful color of unconfined fruit and a lavender plate cut off at the right edge. Here an applied randomness—already introduced by the earlier wine bottle and in a few lesser paintings—is apparent; it remains a characteristic of the rest of his still lifes. This randomness, particularly when isolated in such an informal setting, relates to the Impressionists' insistence on seizing a moment, familiar in the street scenes of his friends Monet and Renoir, while the cut-off plate recalls Degas's less fortunate strollers. Although not the stoppage of a continuous action like walking, it is the result of an action stopped. This effect takes some of the "stillness" out of his still lifes

FIGURE 34
PAUL CÉZANNE
APPLES AND BISCUITS
1879–80. OIL ON CANVAS,
18⅛ X 21⅜ IN.
(46 X 55 CM)
MUSÉE NATIONALE DE
L'ORANGERIE, PARIS. JEAN
WALTER AND PAUL
GUILLAUME COLLECTION

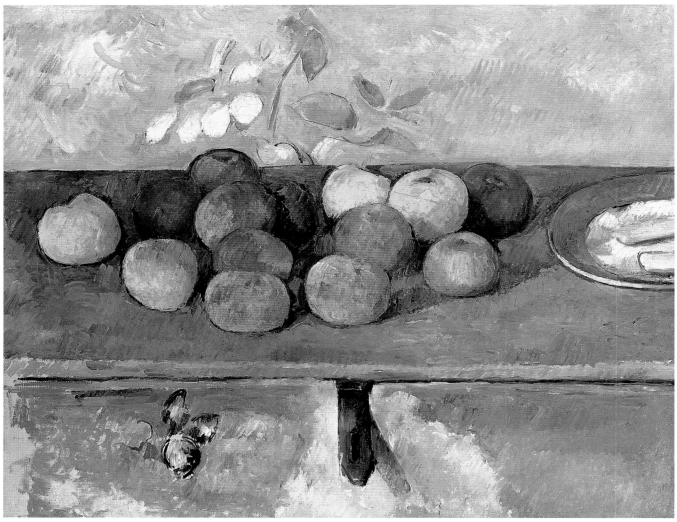

FIGURE 34

and places them in the flux of time. In the most natural of these arrangements, the painter withdraws, leading the viewer to forget that such casualness is nowhere to be found in French kitchens. This effect ends in the nineties in *Sugarpot, Pears and Tablecloth* (plate 81) where the blue rug and an intricate relationship of fruit to bowl orchestrated by the pears mark a return to artifice.

Cézanne took his first liberties with the laws of perspective with containers seen as if from two points of view, but his animus against perspective was revealed more radically in his still lifes than in his landscapes, where it caused forms to "escape." From the mid-1880s on, tabletops warp and edges appear at different levels and recede at angles at variance with the skirt below. Since Cézanne trusted the human eye to see the truth in nature, more than the inflexible conventions of geometric perspective, exaggerations based on what years of peering intently at his models allowed him, and only him, to see should first be distin-

guished from violations of perspective. In *Still Life with Open Drawer* (1877–79, Musée d'Orsay, Paris) a common soup plate with the hollow of the bowl surrounded by a surface sloping upward to the rim is viewed obliquely from above. The edge of such a plate when so viewed becomes a true ellipse only when geometrically projected onto a vertical surface. Cézanne's practiced eye saw in human perspective—which is not the same as geometric—what Merleau-Ponty termed oscillations around the ellipse. He exaggerated the flattened front to show the plate more firmly aligned with the table and drew it out at the sides to express its hollow space. What other distortions were derived from his vision or what optical illusions he exploited—like those produced by the proximity of straight or curved lines—will remain his secret.

The decisive break with perspective appears with the boldness of a first step in *Still Life with Commode* (fig. 35). In a space limited in depth by a wall with a decorative

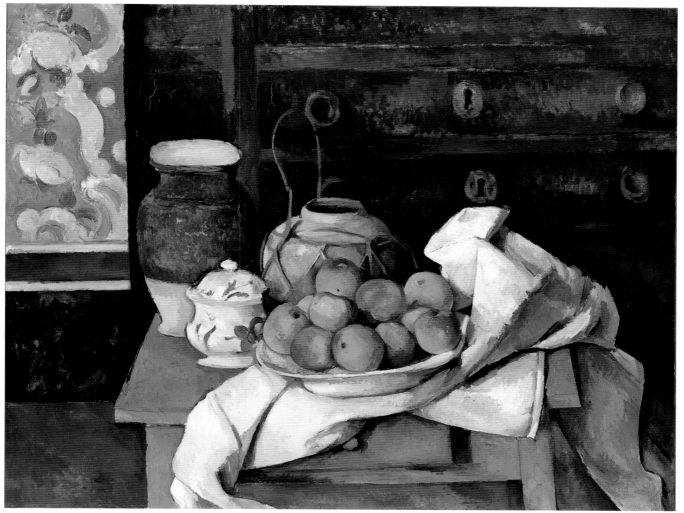

FIGURE 35

FIGURE 35
PAUL CÉZANNE
STILL LIFE WITH COMMODE
1887–88. OIL ON CANVAS,
28 ⅛ X 35 ½ IN.
(71.5 X 90 CM)
BAYERISCHE
STAATSGEMÄLDESAMMLUNGEN,
NEUE PINAKOTHEK, MUNICH

hanging and a nearer bureau front, the tabletop appears to have been broken under the napkin with its left side rising more steeply than its other half. The ascent of this surface lifts the olive jar, set well back and somewhat flattened in another breach of perspective, into a closer relation with the hanging and framed by the side of the bureau. On the right, the frozen, snowy-white napkin makes a more surface connection as it rises to touch a keyhole. Squeezing space to tighten his composition was not Cézanne's only reason for disrupting perspective. He destroyed the coherence of the container to emphasize the objects he could not change. Deprived of perspective's coordinates, objects— lifted by their color—come forward as though seen anew. There were few examples of such blatant disregard for perspective. He could distribute fruit at will, knowing that he could construct the space around them with fabrics and other disguises, while violating perspective here and there to ease the transition from facts in his supporting tables to the fiction of his arrangements.

These works offer a rich sampling of the shift in the late 1880s and early 1890s toward more crowded canvases and broader rhythms, richer and occasionally new colors, and touches of wit. Portents of this change appear in *The Kitchen Table* (plate 73), a painting that could almost be called an interior. In the foreground a normal still-life setup on a table is crowded from behind by a basket—with no visible means of support—brimming with a disorderly array of fruit, including two pears pointing in opposite directions. Cézanne favored pears in his late still lifes because their shape broke the rhythm of round forms and gave direction to the more energetic movement he sought. A table, a chair, and a chair leg intrude in the background, adding further confusion. The contents of the basket call attention by contrast to the order present in the still-life setup, and the painting that contains it, also a still life, does the same at a higher level by reconciling the duality. In *Ginger Pot with Pomegranate and Pears* (plate 80), an experimental color scheme appears in the orange-red of the

pomegranate and a towel's orange stripe seen against a pale lavender wall. *Fruit and Jug on a Table* (plate 82), is probably early in a series begun around 1890 where Cézanne's familiar ginger pot is joined by an earthen jug and a patterned blue rug. The tensions in Cézanne's risky pile up of apples and his brilliant color are striking when compared

FIGURE 36

to the complacent fruit in Courbet's *Still Life: Fruit* (plate 28).

Nature morte—dead nature, the most pejorative term for still life—becomes *nature vivante* in *Still Life with Ginger Jar and Eggplants* (plate 83) of about the same date. Familiar jars are set on a blue rug, which contributes energetic movement. Over it a white napkin breaks from the right like a wave, thrusting into the picture a plateful of apples teetering on the tip of a dark triangular shadow and on the point of capsizing. In *Still Life with Peppermint Bottle* (fig. 36) the same blue rug rises and balloons left and right, its shape and movement reinforced on each side by scrolls in its pattern. The decorative elegance of the rug's curves and the conveniently placed scrolls, which would have been difficult to create in the setup, question Cézanne's fidelity to his model. It is also a reminder that the question can never be answered with certitude for, in still-life painting, setups, so carefully pinned and propped, are dismantled as soon as the paintings are finished. The rug is topped left of the center by a white napkin like snow on a peak. In its blue folds are a peppermint bottle, a carafe, a glass, and some fruit, which enact a tense formal drama. The carafe is lopsided—an aberration that often goes unnoticed. To its right, pieces of some fruit are safely nestled, but two others, a lemon and an apple, are in peril. They are dramatically saved by the white napkin, which descends to put pressure on the lemon and, on another path, delicately

slides past the flatter side of the carafe and under the apple. In these paintings, the wonder is that they hold together with dignity as paintings and, despite the Matisse-like curves of the rug and drama of the fruit, require no suspension of disbelief.

Between 1893 and 1905, Cézanne painted a group of six ambitious still lifes, a coda to his career that takes still life out of the kitchen, drapes it in the trappings of the past, supplies it with more attractive tableware, and entrusts it to the security of perspective. During the decade of their production, Cézanne's health was failing and he was preoccupied by his great Bathers, enormous canvases of nudes in landscape settings, a subject treated by the great masters of the European tradition in whose lineage he hoped posterity would place him. His renewed awareness of tradition and perhaps the need of relief from sustaining the emotive power of his major undertaking may account for this seeming retreat. Unfortunately, fatigue and lack of time pressured him to leave many of this last group of still lifes unfinished. One of them, *Still Life with Apples* (plate 88) offers an idea of the others with its lack of tension and easy adjustment to its setting. Its unfinished state shows that the red, yellow, and green fruit were the first to be modeled in color to provide from the beginning a key for the colors that will follow. In this series the activity of color replaces that of forms and, as the series progressed, colors became

FIGURE 37

deeper and their harmonies richer.[12]

Apples and Oranges (fig. 37), officially dated 1899, must have been painted at the moment of transition in 1895. Dressed up like the more sedate group, it retains the restless movement and some of the tension of the earlier paintings with the blue rug, couched in an explosion of sumptuous color keyed to the warm reds and yellows of the

fruit. Its visible supports, a chair with scrolled arm and green upholstery backed by a table, can account for only part of what is seen. The movement is broad and sustained. Folds of a hanging white tablecloth lift five pieces of fruit and a flowered pitcher high on the table. Starting from the secure occupants of that high point, a downward movement to the left is carried by a whiter cloth. The pitcher, whose painted flower rhymes with the surrounding apples, starts with a slight tilt the downward movement from high in the picture. The elliptical rim of the ill-shaped compote tips further on the diagonal, and finally a plate is so canted that its pile of apples should be on the floor. All of this accelerated movement is limited to the top half of the painting, which makes room for the lift and fall. Isolated just a shade to left of dead center of the canvas, a strongly modeled apple, centered on its own axis with nothing to support it, concentrates the dynamic of the whole. The vivid yellow oranges and reds of peach and apple are active as well, as they are projected onto the hanging on the left radiating upward and mixed with touches of brown, purple, red, and green. The setting for the fruit occupies all but a corner of the canvas. Figure and ground were conceived as one, with the spaces between them as tangible as the fruit that they present like precious jewels. It is Cézanne's exaltation of still life itself.

Conditioned by cubism, nearly a century of abstraction, and a mantra of flatness, we cannot trust our way of looking at Cézanne's still lifes. We cannot be sure that the surface texture produced in his constructive method was intended to integrate the whole or an unintended consequence. Nor can we know whether Cézanne compressed space to tighten his composition or put the objects forward to be truly seen. The statements made late in life continue to guide interpreters of his art, but they are not always clear or reliably reported. Early supporters of Cézanne, including his painter friends, talked principally of his color. Zola, reviewing the third Impressionist exhibition in 1877, called him the premier colorist of the group.[13] Some of his most eloquent supporters have been the nonprofessionals who allowed the artist to appear as a person in this least expressive branch of his art. Rilke, Lawrence, and Merleau-Ponty, and, one must add Meyer Schapiro, were all, in Lawrence's phrase, unhindered by the "winding sheet of abstraction."[14]

This sketch of Cézanne's development of still-life painting makes it clear that in spite of doubts about his own talent he maintained a steely conviction to force still life to be something else. Painfully shy, socially awkward, quarrelsome, distrustful of praise, Cézanne was a solitary removed from the art world. He became a legend while in his forties. Summers, he moved from place to place in the Ile de France; in Provence his living arrangements with his wife and child were unstable, and they lived apart as often as not. He painted for no one but himself. In these circumstances, his art was desperately his life. His still lifes were related to him physically in a personal space defined by the act of making the setup, kept close at hand during the act of representing it on canvas. Emotionally, the ordinary, familiar furnishings of domesticity—some probably his own since childhood—repeatedly handled and painted, assuaged his isolation. He once said of the apples in his still lifes, "*Ils se parlent, ses gens-là,*"—"They talk to each other those folks." Perhaps he talked to them as well.

APPLES AND ABSTRACTION

Richard Shiff

It was probably Paul Gauguin's doing. By the late 1880s, he was proclaiming the genius of Paul Cézanne to anyone who would listen. Gauguin owned several Cézannes, of which his favorite was a still life of apples (fig. 38; see pages 166–69).[1] Using it, he gave impromptu lectures on the master's color and system of brushstroke, those technical details of painting that Gauguin believed would convey emotional content independent of the subject matter.[2] Indeed, Cézanne's technique seemed to have gone its own strangely expressive way. He often rendered apples with rectilinear marks that resisted the curvature of the fruit, its visual texture, and all conventional mimeticism. Gauguin's persistent efforts at explanation caused apples, Cézanne, and the technical abstractions of painting to become linked in the collective imagination, not only at the close of the nineteenth century but throughout the twentieth. A Parisian writer in 1894 was already referring to "those famous apples."[3] And while Barnett Newman struggled through the 1940s in New York, attempting to create a style of painting adequate to the trauma of those times, Cézanne's apples faced him as an oppressive presence—at least until he realized that the powerful effect of their form could be separated from the trivial subject matter. Before that realization, "they were like superapples," he recalled in 1970, or better, "cannonballs."[4]

Like his fellow New Yorker Willem de Kooning, Newman was associated with the critic Harold Rosenberg, who introduced the term "action painting" in 1952.[5] It identified a type of abstraction that for Rosenberg constituted the radical future of painting in America: gestural, immediate, and liberated from "European" composition, whether free of all vestiges of representational subject matter (Newman) (fig. 39) or betraying certain irreducible traces (de Kooning) (fig. 41). In Rosenberg's view, the alternatives to action painting were a rather shopworn, mildly abstract figurative style, derived from School of Paris artists like Pierre Bonnard (fig. 42), and a sometimes austere geo-

metric formalism modeled after Piet Mondrian (fig. 40). Many found in Cézanne's art the ultimate source for both lines of modernist practice—one retaining mimetic imagery, the other purged of it. Rosenberg aimed to show that neither mold would fit the new American painting.

For Rosenberg's generation, Cézanne need not have been mentioned by name, since a code word applied: "apples." The culturally informed public assumed that any writer referring to the power of a still life of apples probably had Cézanne in mind, and further, that the issue at hand might be abstraction, formalism, pure painting, advanced composition, even expressionism—but far less likely the iconography of fruit. When Clarence Bulliet wrote on advanced modern art for a general readership in 1927, he titled his book *Apples and Madonnas*, regarding his two references as sufficiently obvious. He opened with a provocation: "An apple by Paul Cézanne is of more consequence artistically than the head of a Madonna by Raphael." The justification followed immediately: "It is the emotional power of the artist that counts, not the subject matter."[6] Bulliet was reiterating the common view that still life hardly registered as a subject, serving merely as a form to bear expression.[7] To the contrary, the conventional religiosity of the Madonna theme (fig. 45) precluded any original artistic content. From this perspective, early commentators who implied that Cézanne depicted his wife as if she were an apple (no Madonna) were not necessarily complaining (see *Mme Cézanne in a Red Armchair*, fig. 32).[8] They were suggesting that, for better or worse, the diminishment and even the insignificance of subject matter was correlative to modernity in art.

The situation inspired Rosenberg to insist that the classic stand-in for modernity's lost human subject had itself by mid-century become superfluous. Hence, the ban on apples: "The apples weren't brushed off the table in order to make room for perfect relations of space and color. They had to go so that nothing would get in the way of the act of painting."[9] Rosenberg's "apples" are surely Cé-

FIGURE 38
MAURICE DENIS
HOMAGE TO CÉZANNE
(REDON, VUILLARD,
MELLERIO, VOLLARD, DENIS,
SERUSIER, RANSON,
ROUSSEL, BONNARD, AND
MADAME DENIS). 1900
OIL ON CANVAS,
70⅞ X 94 ½ IN.
(180 X 240 CM)
MUSÉE D'ORSAY, PARIS

FIGURE 38

FIGURE 39

thetic theory, Cézanne wrote to him: "The literary type [the intellectual] expresses himself with abstractions, whereas the painter makes his sensations [and] perceptions concrete."[11] Cézanne's statement was consistent with a common nineteenth-century use of the word "abstraction" to connote debilitating intellectual excess, the opposite of empirical, material grounding. In his *Salon of 1846*, Charles Baudelaire referred to the philosophical notion of absolute beauty as a vacant "abstraction" removed from any sense of passionate art.[12] Today we still identify a distracted, mentally confused person by his "abstract" look. So the fact that certain critics around 1905 judged Cézanne's art dangerously abstract suggests at least two possibilities:

FIGURE 40

zanne's, and the critic had two reasons for arguing that the new American abstraction, or "action painting," must finally be rid of them. First, Cézanne's art was representational and could only be considered abstract in some compromised sense, as with School of Paris artists. Second, history had already shown that Cézanne's approach led to formalism of a Mondrian kind, and the new American painting rejected this type of abstraction as inhibiting, formulaic, too "European." When Rosenberg referred to removing the apples for reasons other than "perfect[ing] relations of space and color," he meant that something more rewarding should come of escaping subject matter entirely. The new, "no apples" style would represent dramatic gesture and the existential act.[10]

Whether or not Gauguin was ultimately the responsible party, critics were associating Cézanne with abstraction as early as the 1880s, two decades before "pure" abstraction (art lacking all trace of mimeticism) developed as a clear option for modernist practice. In 1952, Rosenberg would find the Cézanne problem an unavoidable modernist inheritance. How, more specifically, had this situation come about?

In Cézanne's own language, the word "abstraction" had unpleasant, or at least inartistic, overtones. Late in his life, irked by his acolyte Emile Bernard's concern with aes-

FIGURE 41

first, his style of painting may have seemed to reflect conceptualization taken to an extreme; second, for whatever reason, his repeated admonitions to Bernard and others were having little effect.

Could Cézanne's artistic motivation have been more intellectual than emotional, his aesthetic pleasure more mental than sensual? Did he plan things out, constructing an "abstract" pictorial logic with its own rules and contradictions? A substantial twentieth-century tradition of interpretation takes this position. I prefer to think that Cézanne's fundamental concern was immediate visual sensation, which, with an intense physicality, he converted into tactile sensations of the brush. This seems especially evident in densely painted landscapes dominated by his consistent, repetitive marking (fig. 43). Indeed, to represent sensation and the pictorial "motif" (as opposed to social, political, religious, mythological, literary, and philosophical themes) became itself a cultural thematic of primary importance to Cézanne and his generation.[13] Simple sensation could be the societal aim as well as the cultural "meaning" of art.

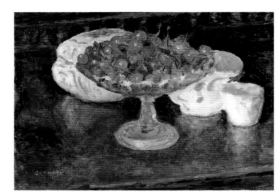

FIGURE 42

FIGURE 43

Yet Cézanne produced some oddly complicated pictures, which do resemble conceptual puzzles; and many of them happen to be still lifes. His *Pichet de grès* (fig. 46) and *Still Life with Plaster Cupid* (fig. 44), both painted around 1894, present a particularly compelling case by exhibiting thoroughly analogous structures, while neither is a study for the other. This indicates that Cézanne deliberately constructed the same set of pictorial relationships twice, a kind of intellectual exercise. The two studio scenes generate elaborate visual and conceptual puns (or contradictions) that ambiguously link foreground to background. At the left side of both images, Cézanne extended a patterned cloth from the foreground table into the adjacent background, where it becomes something *already* rendered, that is, part of a depicted painting that rests against the studio wall. In a similar manner, the jug in *Pichet de grès* and the statuette in *Still Life with Plaster Cupid* appear to converge with or be framed by the stretched canvases behind them, as if to suggest that they exist pictorially as both foreground and background elements. They become three-dimensional and two-dimensional at once, sitting on tables while simultaneously filling canvases. Numerous other contradictions could be mentioned, all of which appear analogously in the two paintings, evidence that Cézanne conceived these works as if they were playing the same intellectual game, each move being part of an encompassing mental "abstraction."[14]

Examples of this kind suggest that Cézanne experienced abstraction in the nineteenth-century sense, that at times he was capable of letting conceptualization precede sensation. On the whole, however, this is not why Cézanne's art was called abstract. For his contemporaries at least, the cause lay elsewhere, in paintings that manifested directness and simplicity. Although richly nuanced, such pictures were often modest—*Fruit and Jug on a Table* (plate 82)—or extreme in the bluntness of their presentation—*The Three Skulls* (plate 90). Cézanne's early critics thought his art had become "abstract" as a consequence of his having immersed himself in the process and sensation of making a painting. They implied that Cézanne gradually became distracted by the intensity of his own act of painting to the point that he ignored complex cultural and social values; this in itself produced the abstract look of his work. To early viewers, many of his paintings seemed to contain little more than their repetitive marks, those famous "little sensations" that Gauguin once threatened to "steal" from his idol.[15] Perhaps viewers today see clearly enough the apples, the table, and so forth. But a century ago, the

crude abruptness of Cézanne's brushstroke kept the eye fixated, especially when areas devoid of significant pictorial incident, often in backgrounds, appeared as heavily marked as the central objects (plates 48, 49, 82).[16]

It was the autonomy of the marks themselves—always seeming a bit too big in relation to what they were representing—that made Cézanne's apples abstract. As a picture progressed, the individual marks seemed to increase, not decrease, in prominence. In 1904, having visited Cézanne's studio, Bernard put it this way: "The more he works, the more his work removes itself from the external view [and] the more he abstracts the picture."[17] When painter and theorist Maurice Denis attempted a final assessment of Cézanne's importance in 1907, he referred to his colleague Paul Sérusier's variant of the same idea: "[Cézanne] is a pure painter. . . . Of an ordinary painter's apple, you say, 'I could take a bite out of it.' Of Cézanne's apple, you say, 'It's beautiful.' You don't dare peel it, you want to copy it. There's the essence of Cézanne's spiritualism. . . . [His] apple addresses the soul by way of the eyes. . . . The remarkable thing is the absence of subject matter [which] disappears [leaving] only a *motif*."[18] Sérusier was suggesting that ordinary painters create illusions of real things on canvas; if the apple looks good enough to eat, the painting is a success. Cézanne's "apple" has a different reality, created through its beauty of form and color, structured without any regulative conception of a subject.[19] The "motif" (Cézanne's word as well as Sérusier's) is not the product of abstract categories of thought but of abstracted material means.[20]

When remarks such as these were being made, "abstraction" had not yet settled into its dominant twentieth-century definition of pure form. Nor had images called "abstract" abandoned representational reference, as they would begin to do not long after Cézanne's passing. Yet Cézanne's technique struck viewers with compelling force, while his subject matter seemed either banal (still lifes of apples, prosaic landscapes, deadpan portraits), or puzzling (*Still Life with Plaster Cupid*), or mystifying (elaborate scenes of bathers). Because early commentators such as Denis, Bernard, Sérusier, and Gauguin (whose opinions affected the others) perceived a gulf between technique and subject in Cézanne, they linked the autonomy of his form to a process of abstraction more aggressively than they would otherwise have done.[21] This turn in interpretation entailed precisely the kind of irony to which antiformalist critics like Rosenberg and antiformalist painters like de Kooning or Newman were sensitive fifty years later—the fact that "abstract" form, however visual, was a conceptual entity suited to endless philosophizing by academic minds.[22] The often verbose theorizing of Bernard and other young artists whom Cézanne encountered was always a source of irritation: "No more theories!" he protested.[23] To reconcile abstraction, itself an "abstract" notion, with the very physical nature of Cézanne's painting, most of those immediately familiar with the artist's opinions and the character of his work claimed that *his* abstraction developed from the senses, not the intellect. It was more intuitive harmony than a science of color, more spontaneous rhythm than a deliberated geometry.[24]

A context outside the world of painting bears on why such interpretive turns occurred, and it guides Cézanne's historical fortune. In 1905 Denis observed that artists of his generation were being dehumanized by the leveling effects of modern urban life—mechanization, commodification, standardization, social regulation—all leading to impoverishment of intellectual and spiritual experience. He claimed that the remedy could be found in what, for a brief moment, he was willing to call "an abstract ideal . . . the expression of inner [mental] life or a simple decoration for the pleasure of the eyes."[25] Under the circumstances, Denis argued, the representational arts should strive to mask out dull environmental realities and "evolv[e] toward abstraction."[26] However much this kind of "abstraction" might appeal to the intellect or the imagination, it was crucial for it to retain a distinct material component located in a purified form and a straightforward procedure. This was what Denis meant by speaking of "simple decoration"— form from which viewers could take simple pleasure. Cézanne was exemplary because his pictorial marks appeared independent of any thematic or theoretical motivation; they were so very physical, representing a *material*, not a conceptual, abstraction of the painting process.

Denis nevertheless soon decided that "abstraction" and "form" were being pushed so far that neither sensible reason nor human feeling but only misguided theorization could justify these practices. After Cézanne died in 1906, Denis decided to salvage the painter's reputation from such associations, insisting that he had never "compromised" his pictorial synthesis "with any abstraction," his art having remained rooted in nature.[27] If this rescued Cézanne from the intellectual excesses of abstraction, it did nothing to excuse his progeny. Because intellectualized, abstracted styles seemed to derive from Cézanne's example—including, in Denis's estimation, both Henri Matisse's fauvism and Pablo Picasso's cubism—the critic was struck by a historical irony of his own: Cézanne had been "a slave to nature and to the model [yet] ended up having authorized every audacious abstraction" that was to come in the work of others.[28] While Cézanne's mark maintained its physical links to immediate sensation and emotion, the marks of most of

FIGURE 44
PAUL CÉZANNE
STILL LIFE WITH PLASTER
CUPID. CA. 1894
OIL ON CANVAS,
27 ½ X 22 ½ IN.
(70 X 57 CM)
COURTAULD INSTITUTE
OF ART, LONDON

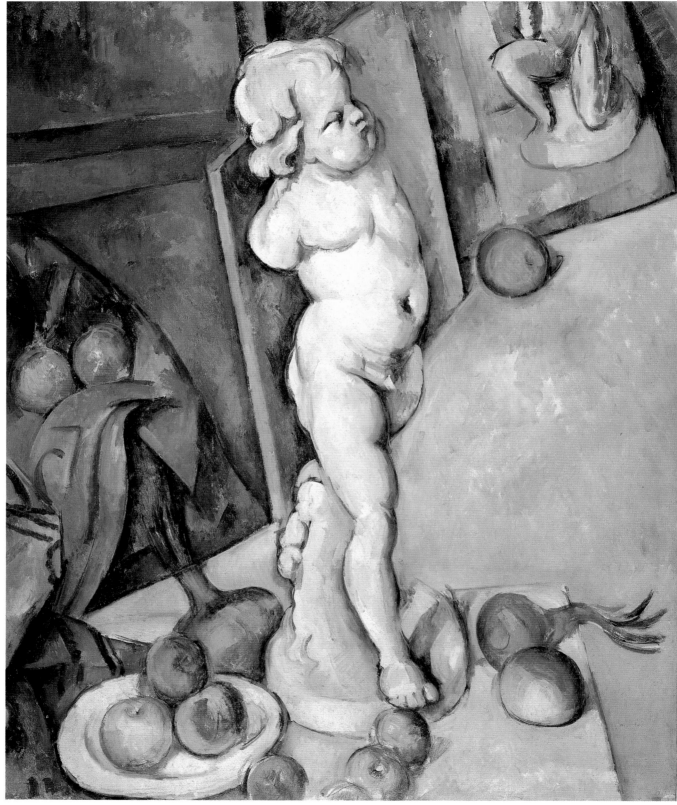

FIGURE 44

his followers were preconceived, conceptual inventions—"abstractions."

Like Denis, the critic Charles Morice, who had collaborated with Gauguin on the book *Noa Noa*, linked the emerging problem of abstraction to social and cultural modernity. For him, there were two "abstractions" visible at the beginning of the twentieth century: the abstract marks of the neo-Impressionist followers of Georges Seurat, derived (Morice believed) from a mistaken faith in science, and Cézanne's abstract marks, more a product of withdrawal and isolation.[29] The cultural impact was the same—loss of humanistic content. After Cézanne's death, Morice, who quite admired his work, summarized the situation: "We hardly dare say that Cézanne lived; no, he painted. . . . [His is] painting estranged from the course of life, painting with the [sole] aim of painting. . . . [His art constitutes] a tacit protest, a reaction {to society}. . . . He put everything in question."[30] How does a painting—of a mere apple, perhaps—"put everything in question"?

Along with many others, Morice believed that scientism and technocratic efficiency were deadening all spiritual life. One could either join the new scientist society or withdraw into pure sensory experience. The fact that Cézanne disapproved of electric street lighting—it spoiled the twilight—is symptomatic of his actual position.[31] According to Morice, Cézanne resisted his new society, purging his life of all "moral values," for which he substituted "color values;" here the critic's clever turn of phrase was worthy of the artist's own mordant wit.[32] Moral values became color values. Ethics was becoming art. Morice did not mean that Cézanne abandoned all political, religious, or philosophical belief; rather, that theoretical and ideological concerns could no longer guide his practice. It was left to the technique of painting, not the worldly subject matter it represented, to become the means, as the critic said, of a "tacit protest." Acknowledging Cézanne's impenetrability, Morice added: "Was [his action] fully conscious? I don't know."[33]

This was the essential mystery of Cézanne, who not only resisted society but resisted revealing his motivations. His art guided others toward abstraction of every type, an effect he never acknowledged and seems never to have desired. Morice's central observation—Cézanne substituted painting for living—was not only astute but prognostic. It leaves us wondering whether Cézanne committed a series of existential acts, gesturing with paint in response to the conditions of his life, as Rosenberg urged American artists to do a half century later: "to paint . . . just to paint."[34]

FIGURE 45

FIGURE 45
RAPHAEL
MADONNA OF THE GOLDFINCH. CA. 1505
OIL ON CANVAS,
42 ⅛ X 30 ⅜ IN.
(107 X 77 CM)
UFFIZI, FLORENCE

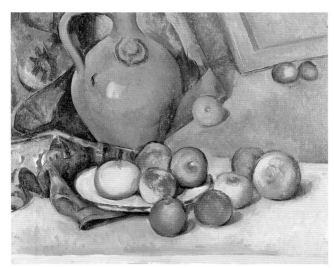

FIGURE 46

FIGURE 46
PAUL CÉZANNE
PICHET DE GRÈS. CA. 1894
OIL ON CANVAS,
15 X 18 ⅛ IN.
(38 X 46 CM)
BEYELER FOUNDATION,
RIEHEN

Gustave Courbet, like his rival Edouard Manet, exerted a profound influence on the group of young artists who were to become known in the 1870s as the Impressionists. Although he never associated closely with the young men and women who would steer "the new painting" through the years after his death in 1877, Courbet's paintings of the 1860s and early 1870s often paralleled theirs stylistically and thematically. Nowhere is this more clearly seen than in a group of still lifes that he painted during the summer of 1862.

In the late spring of 1862, Courbet journeyed to the Saintonge, a region near the Atlantic coast in the department of Charente-Maritime. He went there at the invitation of a wealthy young collector and author, Etienne Baudry, to whom he had been introduced by the naturalist critic Jules Castagnary, and whose estates were there near the town of Saintes. The envisioned stay of two weeks at Baudry's extended to several months, followed by periods of residence in neighboring towns until the spring of 1863. During this time Courbet painted an astonishing range of compositions, including a group of ambitious floral still lifes. Exhibited as *Fleurs* in a show organized in January 1863, the large vertical bouquet is one of Courbet's most frankly sensual and luxurious creations. Rising from a rounded bowl, the mass of summer blossoms is painted with a lightness of touch and a delicacy of feeling that was unexpected, as one critic noted, from the painter of wrestlers and country funerals.[1]

Bouquet of Flowers in a Vase found its home in the collection of a local banker, but the painter retained the most impressive of the recent still lifes he put on display at the 1863 show and elsewhere. Almost twice as large as the bouquet still life, the image of a young woman arranging branches and blossoms on a trellis evokes the great seventeenth- and eighteenth-century traditions of decorative painting in which female figures are juxtaposed with luxuriant displays of floral abundance. As critics have noted, however, Courbet placed greater emphasis on the flowers than on the woman who tends them. Although the painting was shown with the title *Young Girl Arranging Flowers* at Courbet's 1867 one-man retrospective, it might have been more accurately called *Flowers Being Arranged by a Young Girl*.[2] (The checklist of the 1867 exhibition also added the annotation *Saintes 1863* to the painting's title, although the canvas was certainly complete by the end of 1862, since it was first shown in January of the following year.)

Because it juxtaposes a mass of beautiful flowers with a female figure, Edgar Degas's *Woman Seated beside a Vase of Flowers* has often been compared to Courbet's picture. Details of the composition—the pair of gloves tossed on the table at left, beside a half-empty pitcher of water—suggest that the woman at right may have assembled this informal bouquet from a mass of summer blossoms she gathered herself, presumably from the flowerbeds that Degas shows us in a patch of sunlit garden just visible (perhaps in a mirror reflection) at the upper right-hand corner of the canvas. But as Henri Loyrette has noted, the still life functions here as an attribute to modify the sitter rather than the other way around.[3] *A Woman Seated beside a Vase of Flowers* is, in fact, one of Degas's earliest and most successful experiments in what might be called "disjunctive" portraiture, in which the artist captures the sitter in what he called a "familiar and typical attitude," with the ironic and calculated result that the sitter no longer seems to be the primary subject of the painting.

GTMS

GUSTAVE COURBET, 1819–1877

Bouquet of Flowers in a Vase, 1862, Oil on canvas, 39½ x 28¾ in. (100.5 x 73 cm), The J. Paul Getty Museum, Los Angeles

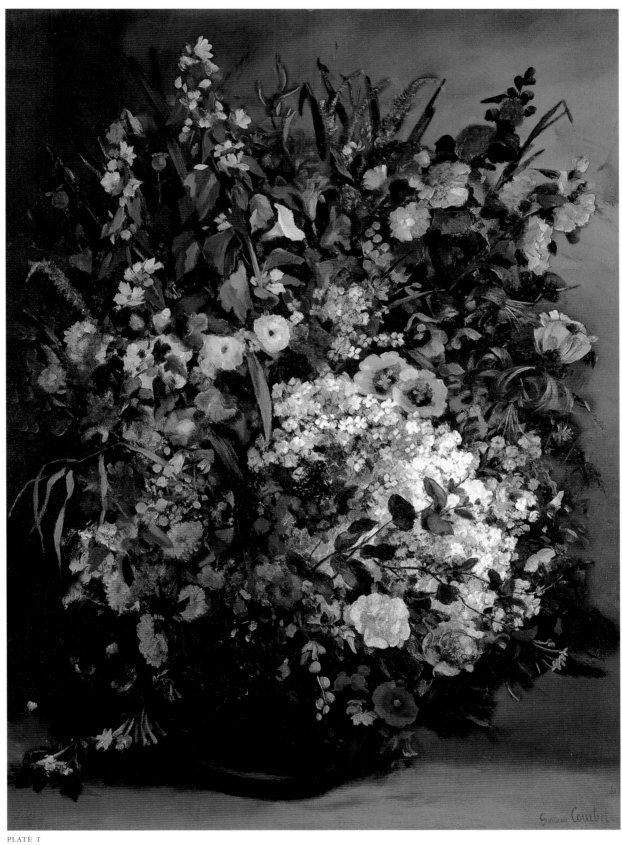

PLATE I

EDGAR DEGAS, 1834–1917

A Woman Seated Beside a Vase of Flowers (Mme Paul Valpinçon?), 1865 Oil on canvas, 29 x 36½ in. (73.7 x 92.7 cm),

The Metropolitan Museum of Art, New York, H. O. Havemeyer Collection

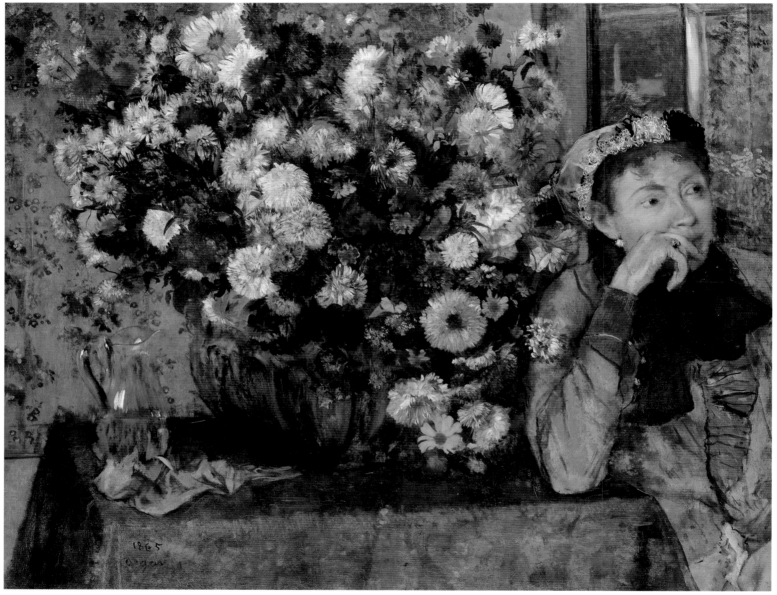

PLATE 2

GUSTAVE COURBET, 1819–1877

Woman with Flowers (The Trellis), 1862, Oil on canvas, 43¼ x 53¼ in. (109.8 x 135.2 cm),

The Toledo Museum of Art, Purchased with funds from the Libbey Endowment, Gift of Edward Drummond Libbey

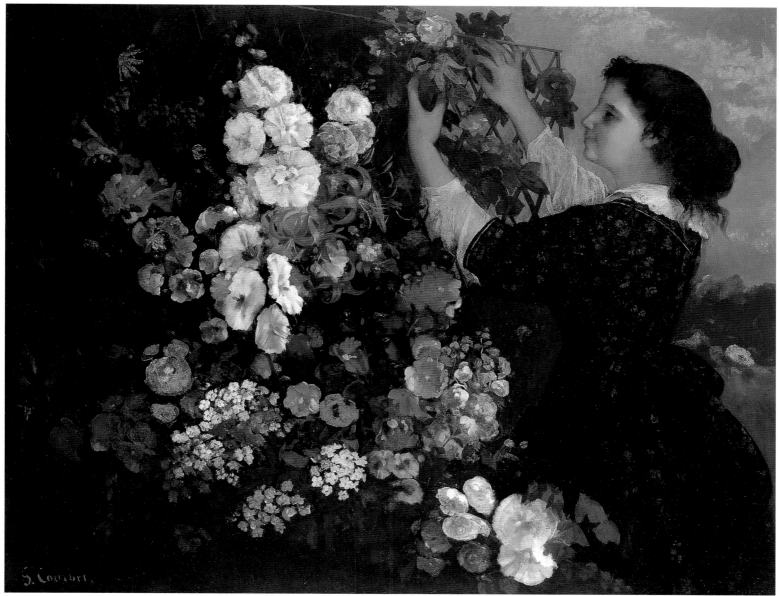

PLATE 3

The painter Edouard Manet, who steadfastly refused to exhibit with his friends the Impressionists, was nonetheless recognized by critics of the mid-1870s as in some ways their mentor, often even their unofficial leader. "He has assumed the leadership of the movement," wrote the critic Edmond Duranty in 1876, "and time and time again has given the public, with a candor and courage akin to genius, works that are the most innovative, the most flawed, most rife with excellence; works full of breadth and intensity, a voice distinct from all others; works in which the most powerful expression is bound to clash with the uncertainties of an almost entirely new approach that lacks, as yet, its full means of embodiment and realization."[4]

The critics of Manet's day admired his pure still lifes, as they did the still-life details in even the most controversial of his figure paintings. "As long as M. Manet paints lemons and oranges, as long as he brushes still lifes, one can still grant him extenuating circumstances," wrote the critic Albert Wolff in 1870. As Emile Zola had noted earlier, "The most declared enemies of Edouard Manet's talent affirm that he paints inanimate objects well."[5]

He was also gifted at choosing the objects he wanted to paint. In *Still Life with Fish* (fig. 55) and *The Salmon*, Manet depicted the before and after of the art of cuisine. In the former, Manet showed an array of seafood laid out on a cloth beside a copper pot, clearly in preparation for a meal. In *The Salmon*, the presentation of the food is complete. The silver-skinned salmon with its pale pink flesh is centered on a buffet, with accompaniments appropriate to the serving of the meal, including a saltcellar, a glass and a flagon of wine, and finally a pair of yellow lemons, one nestled in a blue-and-white bowl, the other lying half-peeled against the white tablecloth.

The qualities that Duranty saw in the 1870s as the distinguishing characteristics of Manet's art were already fully formed in the painter's 1860s still lifes, such as *Still Life with Fish* and *The Salmon*. These works are innovative and yet—at least in terms of public expectation in Manet's day—flawed. Though they are full of breadth and intensity, possessed of a distinct voice that can still be heard even generations later, it is clear, too, that their "powerful expression" rises from the conflicts of what Duranty called "an almost entirely new approach." We take our greatest pleasure not in Manet's truth to nature but in the novelty of his approach to subject matter and, above all, in his way of transcribing the subject in paint. In *The Salmon,* for instance, the heavy drape of a folded linen tablecloth and the tenuously balanced knife and fork at the edge of the buffet hint at the kinds of illusionistic effects commonly practiced by such still-life painters of the realist generation as François Bonvin, a practitioner who made such details almost a cliché in his compositions (see fig. 12).[6] But here, in the subtly juxtaposed strokes of black, the palest blue, grays, and bright white in the snowy tablecloth, and in the silvery skin of the fish, Manet's brilliant brushwork undermines the three-dimensional illusion, insisting on the oily physicality of the paint surface.

GTMS

EDOUARD MANET, 1832–1883

The Salmon, ca. 1864, Oil on canvas, 28⅛ x 35⅜ in. (71.4 x 89.9 cm),

Courtesy Shelburne Museum, Shelburne, Vermont

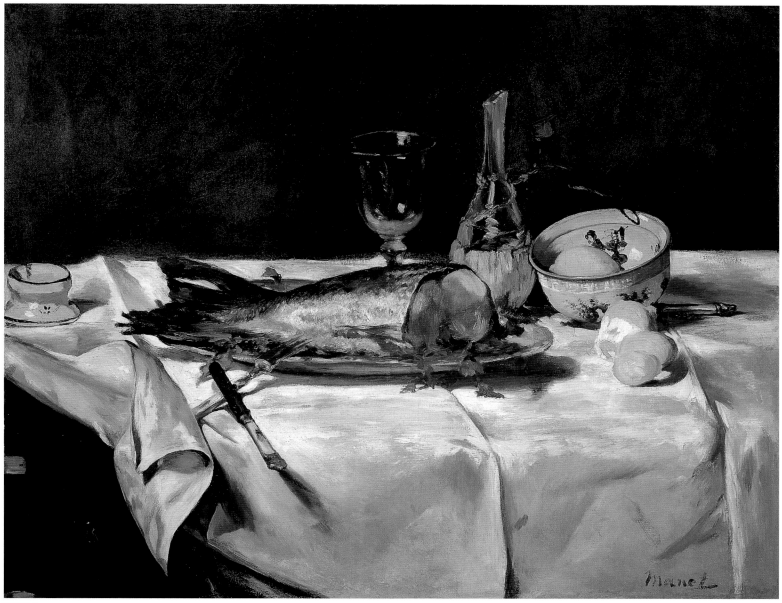

PLATE 4

The revival of interest in Jean-Siméon Chardin during the Second Empire coincided with a burgeoning interest in and market for still-life paintings. Such artists of the realist school as François Bonvin, Philippe Rousseau, and Théodule Ribot made a specialty of compositions that merged, with more or less success, the structures and subjects of Chardin's still lifes—particularly the more humble kitchen scenes—with the tonalities of other old master prototypes, particularly the somber, monochromatic paintings of Dutch and Spanish artists of the golden age.[7] Manet, in his turn, responded to this interest with his own brand of realism, producing and exhibiting such masterworks as *Still Life with Fish* (fig. 55), presented at a Parisian art gallery in 1865, and *The Salmon* (plate 4), which was shown at Manet's independent exhibition outside the international exposition of 1867.[8]

Artists of a younger generation were not immune to the popularity of still-life painting and its potential as a route toward critical recognition and acceptance at the Salon. Cézanne's *Still Life with Bread and Eggs*, conspicuously signed and dated 1865, was probably destined for the Salon of that year, but if it was submitted, it did not meet with the jury's approval. Its deliberate crudeness, verging on naïveté, might well explain why a juror of the mid-1860s would reject it. In comparison to Manet's effortless treatment of a similar grouping in *The Salmon*, Cézanne's composition seems roughly sketched, the forms somewhat arbitrary, lacking harmony and dexterity. In its awkwardness may lie its power and originality, however. Although the somber background does nothing to set off the shape of the table that supports the still-life objects, it was precisely this quality that appealed to the poet Rainer Maria Rilke, when he traveled to Prague to see this and other Cézannes in 1907. "A still life," he described it,

preoccupied with black. . . . And here, . . . black is treated as a color, not as its opposite, and is recognized again as a color among colors everywhere: in the cloth, over whose white it is spread, inside the glass, muting the white of the eggs and weighting the yellow of the onions to old gold. (Just as, without having quite seen this yellow yet, I surmised that there must have been black in it.)[9]

Of Bazille's *Still Life with Fish,* one critic at the Salon of 1866 wrote that it was "solidly painted, but the air does not circulate enough." Reacting to Bazille's use of a dense black background, he warned the artist "to avoid dark tones," though he thought the carp, lying between a pike and a basket of mussels, to be very appetizing.[10] Bazille, fearing rejection for a large genre scene, had submitted the still life in the hopes of having at least one picture accepted. If this canvas was inspired by Manet's *Still Life with Fish*, which Bazille could have seen in 1865, the artist was altogether more conservative in his application of paint, carefully depicting the gleaming red and silver reflections of the carp's scales and detailing the vines from which the basket at left is woven. The pictorial space may be lacking in air as the critic complained, but in spite of its dim background, the painting seems full of light, which falls directly onto the horizontal plane of the table or block that supports the fish and is indirectly caught in the shadowed folds of the drapery at right. In this, his first Salon picture, Bazille affirmed his skill in still life, a genre that he was to go on to explore in such masterworks as the riotous *Study of Flowers* of 1866 (plate 11), exhibited at the Salon of 1868, and the solemn *Heron* of 1867 (plate 14). In spite of his success at the Salon of 1866, however, he seemed to doubt the importance of the genre, longing to turn to painting the nude figure. Writing to his family to ask for money to hire models, he explained his ambition: "Don't condemn me to everlasting still lifes," he pleaded.[11]

FRÉDÉRIC BAZILLE, 1841–1870

STILL LIFE WITH FISH, 1866, OIL ON CANVAS, 24 ¾ x 32 ⅝ IN. (62 x 81.3 CM),

THE DETROIT INSTITUTE OF ARTS, FOUNDERS SOCIETY PURCHASE, ROBERT H. TANNAHILL FOUNDATION FUND

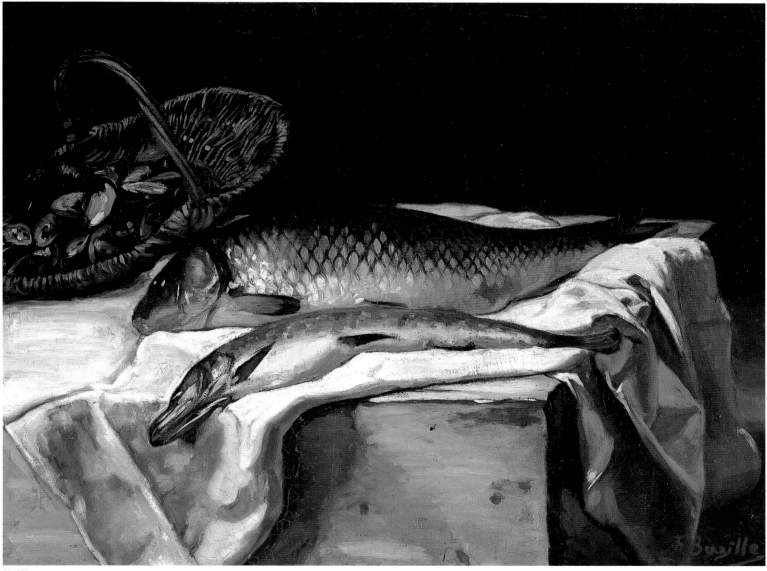

PLATE 5

CAMILLE PISSARRO, 1830–1903

Still Life, 1867, Oil on canvas, 31⅞ x 39¼ in. (81 x 99.6 cm), The Toledo Museum of Art,

Purchased with funds from the Libbey Endowment, Gift of Edward Drummond Libbey

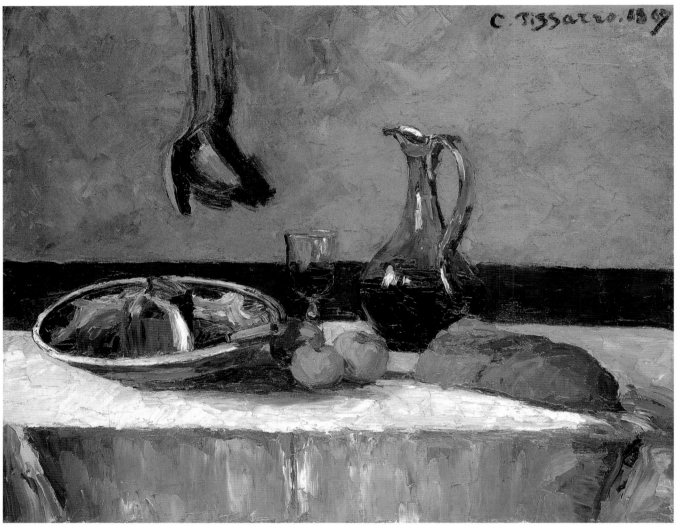

PLATE 6

Great ambitions lay behind the making of Pissarro's *Still Life* of 1867. The canvas itself is of an unusually large scale for the artist—perhaps even large enough to suggest that it was chosen with a Salon submission in mind. But here the remarkable application of the paint would be at odds with conventional practice at the Salon. Applied almost entirely in thick strokes with a palette knife, the paint creates a richly impasted surface, much thicker, in fact, than the rich effects seen in Cézanne's *Still Life with Bread and Eggs*, though Cézanne's own experiments with painting figures, landscapes, and still lifes with the palette knife may have inspired Pissarro's research in this vein. Here, the thick paint is scraped onto the canvas to delim-it four wide bands of tone that describe the ochre-colored wall with a brown dado, above the horizontal and vertical surfaces of the tablecloth. Against these bands, in thick strokes of paint, the artist sets out a kitchen still life of a pottery bowl, some apples, a loaf of bread, a glass, and a carafe of wine, accented by a spoon and a ladle hanging from the upper edge of the canvas. Through this radical simplification of technique, the ambitious problem that Pissarro posed for himself was, as one critic has noted, that of maintaining "a strange and precarious balance of scale, subject, and the insistent exposure of the means of its fabrication."[12]

GTMS

PAUL CÉZANNE, 1839–1906

Still Life with Bread and Eggs, 1865, Oil on canvas, 23¼ x 30 in. (59 x 76.2 cm),

Cincinnati Art Museum, Gift of Mary E. Johnston

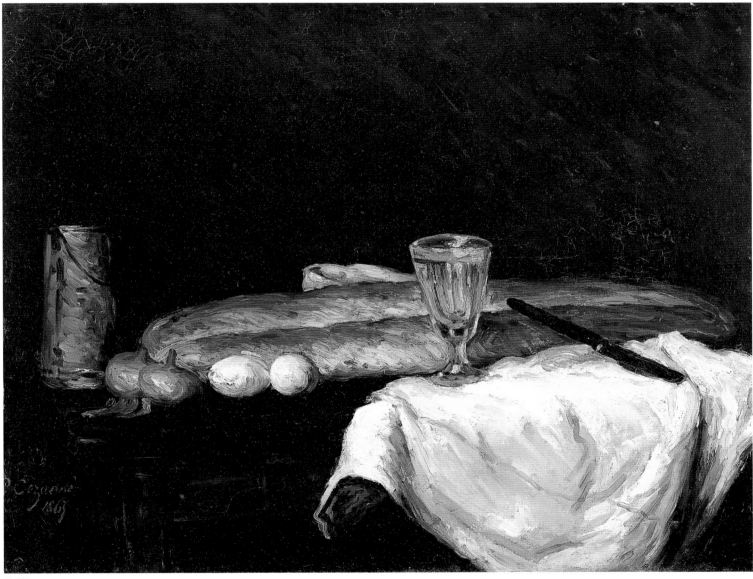

PLATE 7

Peonies were said to be Manet's favorite flower. They are the blossoms featured in a series of paintings in 1864 that signals Manet's exceptional gift as a painter of flowers and are the subject of some of his earliest and last works. Peony beds were included in the garden of the Manet family's summer house in Gennevilliers, on the Seine not far to the west of Paris. It is likely that Manet painted several of his still lifes of peonies while staying there in the early summer of 1864.[13] In *Branch of White Peonies with Pruning Shears,* the white petals of this most sumptuous of flowers are brought forward by the contrasting somber background and by the green stem that recedes diagonally, giving movement to an otherwise static composition. The small canvas is enlivened by the loose immediacy of Manet's brushstroke, and its reduced palette, dramatic contrast, and bold diagonal composition evoke not only his *Dead Toreador* (ca. 1864, National Gallery of Art, Washington, D.C.), but also his admiration at this time for Velázquez and Spanish painting in general. While *Dead Toreador* was cut down from a larger composition, *Peonies with Pruning Shears* implies a larger subject, in this case Manet's paintings of peonies in a vase of 1864 (Musée d'Orsay, Paris, and Metropolitan Museum of Art, New York).[14] In these works, a single stem lies casually on the table by a vase filled with blossoms, a concept employed by Velázquez, among others, but noteworthy at this moment in time for its naturalism.[15] Here the artist's introduction of the shears tells of a human presence in nature and in this regard seems to anticipate the paintings of Monet and Renoir of the same year. This painting,

given by Manet to his good friend, Jules Champfleury, a realist critic, novelist, and champion of Courbet, was one of the first of many such gifts the artist made of his work.[16]

Close to Manet in the deliberate informality, freedom of brushstroke, and sheer pleasure of its beautiful subject is *Spring Flowers* by his somewhat younger colleague Monet. Monet's only known early still life of flowers, this painting of imposing dimensions was executed by the artist at the age of twenty. The painting shows Monet's debt to Courbet, who had recently completed a series of flower still lifes while staying in the country house of his friend Etienne Baudry in the Saintonge region.[17] Courbet's *Bouquet of Flowers in a Vase* (plate 1), an exuberant ode to the abundance and variety of nature in the tradition of Jan Breughel the Elder, is translated by Monet into a strikingly informal composition of flowers still waiting to be arranged.[18] Monet fills the field with a rich and colorful array of lilacs, peonies, tulips, and hydrangeas. His painting's dark red ground may reflect advice he received from Courbet to begin with a somber base to set off the brilliant white, pink, and blue tonalities of the blossoms.[19] "My painting of flowers is finally framed, varnished, and shown and made much better. It's decidedly the best thing I've done so far," Monet wrote from Honfleur to his friend Bazille.[20] Monet stayed from May to November 1864 at the Saint Siméon Farm near Honfleur and worked intensively during this period, mostly on landscapes.[21] "I have so much work to do on my outdoor landscapes that I don't dare do flowers," he wrote to

EDOUARD MANET, 1832–1883

Branch of White Peonies with Pruning Shears, 1864, Oil on canvas, 12⅛ x 18¼ in. (31 x 46.5 cm),

Musée d'Orsay, Paris, Bequest of Count Isaac de Camondo

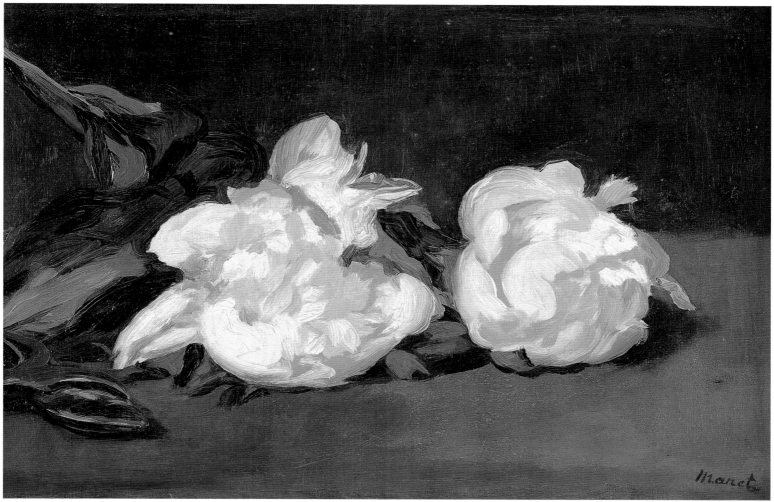

PLATE 8

Bazille, and yet he admitted his attraction to the subject and recommended that Bazille take it up too.[22]

About the same time, Monet's young friend and contemporary Renoir attempted a similar flower subject of slightly larger dimensions. Sharing Monet's realism and admiration for Courbet, Renoir created a work that appears at once refined and informal. Striking in its asymmetrical composition, the painting offers an arrangement of shapes artfully calculated to contrast the strong horizontal of the boxed seedlings with the elegantly attenuated form of the arum lily. Against a scumbled dark green background that suggests a wall (comparable to still lifes by Chardin and Eugène Boudin), Renoir juxtaposes a brilliant profusion of feathery white lilacs, hyacinths and cineraria, a tulip, and the striking profile of a single lily. This unconventional tiered composition evokes the fresh new growth of early spring in a setting that more readily suggests a potting shed or greenhouse than a florist's display. Renoir must have been pleased with this conception, because he created a second, slightly larger version (Oskar Reinhart Collection 'Am Römerholz', Winterthur), in which he took a view one step forward to the right, resulting in the lily's more centered and prominent role.[23] This second work bears not only a signature but also a date of 1864, which allows us to assign this year to both paintings.

Two years later, Bazille, a fellow plein air painter and close friend of Monet and Renoir since their first meeting in Charles Gleyre's studio in the early 1860s, determined to paint a composition stylistically and conceptually similar to those of his friends.[24] Equal to theirs in botanical accuracy, Bazille's painting is more restrained and deliberate in execution. Tidier than Monet's profusion, Bazille's conception reveals a studied control of his subject—one that suggests a marketplace like Les Halles, although the painting is believed to have been painted at the Bazille family estate at Méric.[25] The bouquet of flowers provides a brilliant contrast to the white paper in which it is wrapped and animates the foreground of this colorful composition. It is reminiscent of the flowers in Manet's notorious *Olympia* (1863, Musée d'Orsay, Paris), as every such bouquet would be thereafter.

All three paintings date from a period when Monet, Renoir, and Bazille had become close friends in their shared struggle to establish themselves as artists. Striving to exhibit their work at the Salon, a bastion of conservative taste, they nonetheless revealed their incipient revolt in the freshness of their approach to the humble and traditional subject of still life. In spite of the scale and apparent ambition of all three works, Monet's painting was shown to disadvantage in Rouen soon after its completion[26] and Renoir, who had recently succeeded in showing at the Salon for the first time, is not known to have shown either version of *Spring Flowers* in his lifetime.[27] Only Bazille was successful in showing his ambitious flower still life at the Salon of 1868. Nonetheless, neither Monet's nor Bazille's painting found buyers and remained in the extended families of the artists and their descendants until well into the twentieth century. Renoir's painting entered the collection of the artist Max Liebermann about 1900, long after it was painted.

EER

CLAUDE MONET, 1840–1926

Spring Flowers, 1864, Oil on canvas, 45 x 34⅝ in. (114.5 x 88 cm), The Cleveland Museum of Art, Gift of the Hanna Fund

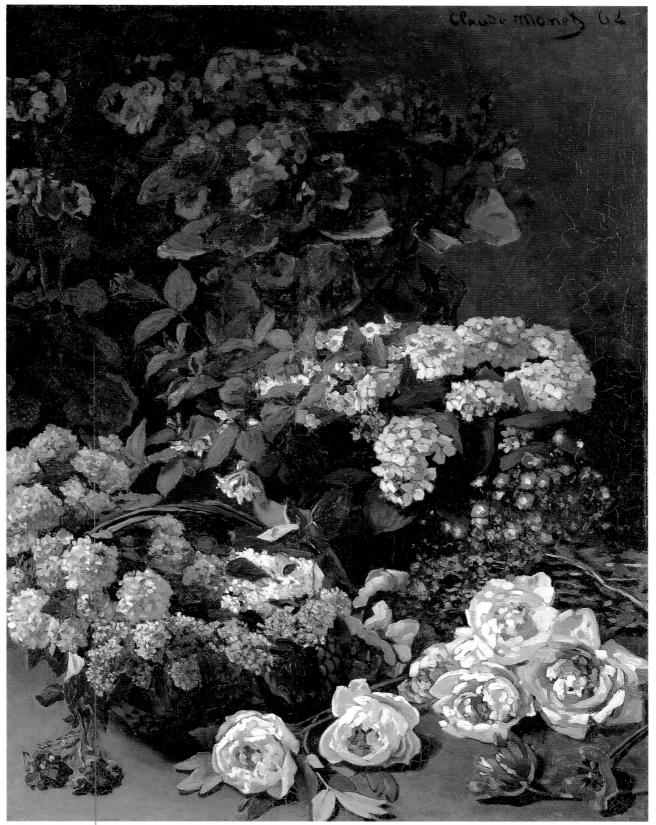

PLATE 9

AUGUSTE RENOIR, 1841–1919

Spring Flowers, 1864, Oil on canvas, 51⅛ x 38⅝ in. (130 x 98.4 cm),

Hamburger Kunsthalle, Eigentum der Stiftung zur Förderung der Hamburgischen Kunstsammlungen

PLATE 10

64 IMPRESSIONIST STILL LIFE

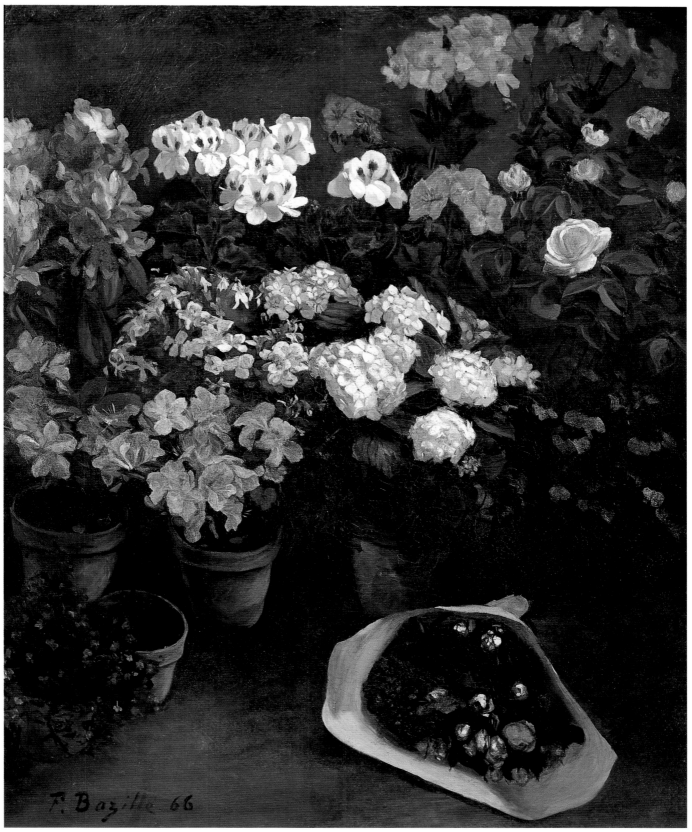

PLATE 11

During the summer and fall of 1865, Courbet painted on the Normandy coast. One of the most unusual works that issued from this visit is *The Girl with Seagulls, Trouville*, which Courbet later described as "an impression of the seashore at Trouville, [with] the daughter of a man who hunts beside the sea."[28] The painting shows a young girl with flowing blond hair who seems to be walking away from us toward the right of the picture space. As she turns her head back to offer a quizzical gaze, we can see that her cheek is flushed. And by facing us, she draws our attention to something that she does not look at herself—the center of the composition, where three seagulls hang from a pole cast over her shoulder, the gray and white feathers of their tangled wings brushing against her golden strands of hair.

The living and the dead are frequently depicted in Courbet's paintings: the corpses of stags or foxes are displayed beside lively hounds in his famous paintings *The Quarry* (1856, Museum of Fine Arts, Boston) and *After the Hunt* (ca. 1859, Metropolitan Museum of Art, New York), and a host of women prepare a body for burial in *Dressing the Dead Girl* (mid-1850s, Smith College Museum of Art, Northampton, Massachusetts).[29] But nowhere in his oeuvre is the contrast more marked than in this juxtaposition of a vibrant young woman and her burden of *nature morte*. Taken from their usual context, the gulls are, in fact, a still life, a hunt trophy in the tradition of seventeenth-century Dutch painting or of such eighteenth-century French masters as François Desportes or Jean-Baptiste Oudry. As in *Woman with Flowers (The Trellis)* (plate 3), the young woman is present to comment on the meaning of the "stilled life" she carries: the warmth of her complexion emphasizes the birds' lifeless pallor, and her golden hair

brilliantly sets off their colorless feathers. With her basket for gathering shellfish at her side, she illuminates the circumstances of the gulls' death.

It has rightly been remarked that Courbet painted this work around the time that he was closest to James McNeill Whistler, the expatriate American painter.[30] Courbet referred to Whistler as "an Englishman who is my student," but the younger artist's *Symphony in White, No. 1: The White Girl* (1862, National Gallery of Art, Washington, D.C.), showing his mistress Joanna Hiffernan dressed in white and standing on a bearskin rug before a white curtain, is a kind of physical and psychological prototype for *The Girl with Seagulls*.[31] (Whistler's model was, in fact, with him in Trouville at the same time and was painted by Courbet as she gazed into a mirror, running her fingers through her long, copper-colored hair.) While Courbet had often painted works in which grays and whites played an important part, the sensitive treatment of the seagulls here might well reflect his renewed awareness of Whistler's mastery of monochrome effects, which the younger artist was to display in paintings with such titles as *Grey and Silver: Chelsea Wharf* (1864–68, National Gallery of Art, Washington, D.C.) or *Arrangement in Grey and Black: Portrait of the Painter's Mother* (1871, Musée d'Orsay, Paris).[32]

Late in 1867, after *The Girl with Seagulls* had been exhibited for the first time in Courbet's "Pavilion of Realism" at the international exposition, the young painters Sisley and Bazille arranged a still-life motif of dead birds and set about painting it side by side, Sisley standing to the left, and Bazille to the right. (Between them stood Renoir, who shared the studio with Bazille and who portrayed Bazille at work) (fig. 47). The studio wall and a

The Girl with Seagulls, Trouville, 1865, Oil on canvas, 31⅞ x 25⅝ in. (81 x 65 cm), Private collection, New York

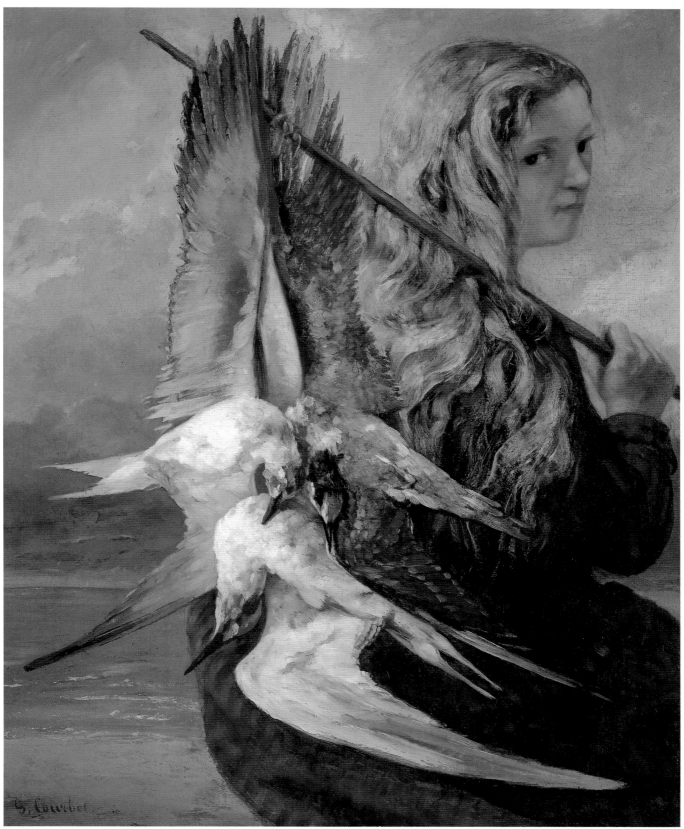

PLATE 12

ALFRED SISLEY, 1839–1899

THE HERON, 1867, OIL ON CANVAS, 31⅛ x 38⅛ IN. (79 x 97 CM), MUSÉE FABRE, MONTPELLIER, ON DEPOSIT FROM THE MUSÉE D'ORSAY, PARIS

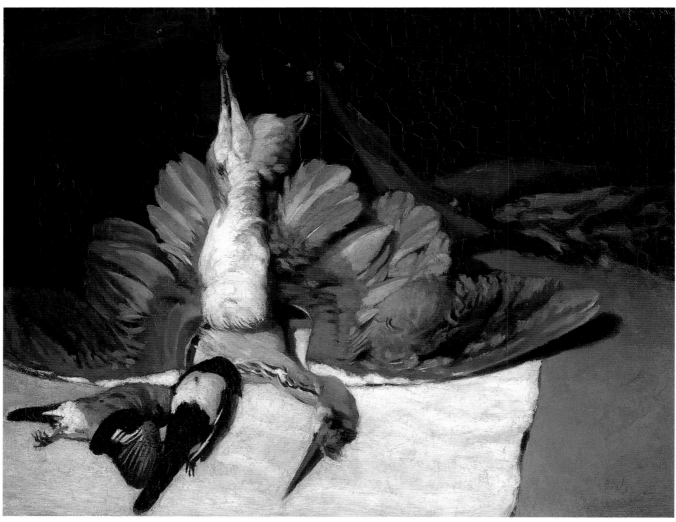

PLATE 13

table formed the background and support for the trophy of a heron hanging from its feet, its wings spread wide. The equipment of the hunter—presumably belonging to Bazille, whose father was an avid duck hunter—was to the right of the table. The artists placed several smaller birds—a black-and-white magpie and two jays with bright blue patches on their wings—with the heron on a white cloth. These patches of blue and the hint of blue in the wings of the heron were virtually the only notes of color in this otherwise monochrome arrangement.[33]

The artists chose canvases of nearly identical dimensions. From Bazille's vantage point, the shape of the still-life grouping was more dense and triangular, and he chose to paint a vertical composition in which the heron's wings just touch the edges of the pictorial space. Sisley, on the other hand, oriented his canvas horizontally to emphasize the dramatic spread of the bird's right wing, which stretches insensibly toward an empty space at the right margin of the composition—made emptier still by Sisley's decision to eliminate one of the jays that lay at the edge of the white cloth. The artists painted broadly and swiftly, in emulation of Manet's technique. While the feathered richness of the heron's wings in Bazille's version brings to mind the magnificent wings of the attendants in one of Manet's rare religious pictures, *The Dead Christ with Angels* (1864, Metropolitan Museum of Art, New York), the tragic simplicity of Sisley's muted bird seems closer to the silent dignity of Manet's *Dead Toreador* (ca. 1864, National Gallery of Art, Washington, D.C.).[34]

GTMS

FRÉDÉRIC BAZILLE, 1841–1870

The Heron, 1867, Oil on canvas, 39⅜ x 27⅛ in. (97.5 x 78 cm), Musée Fabre, Montpellier

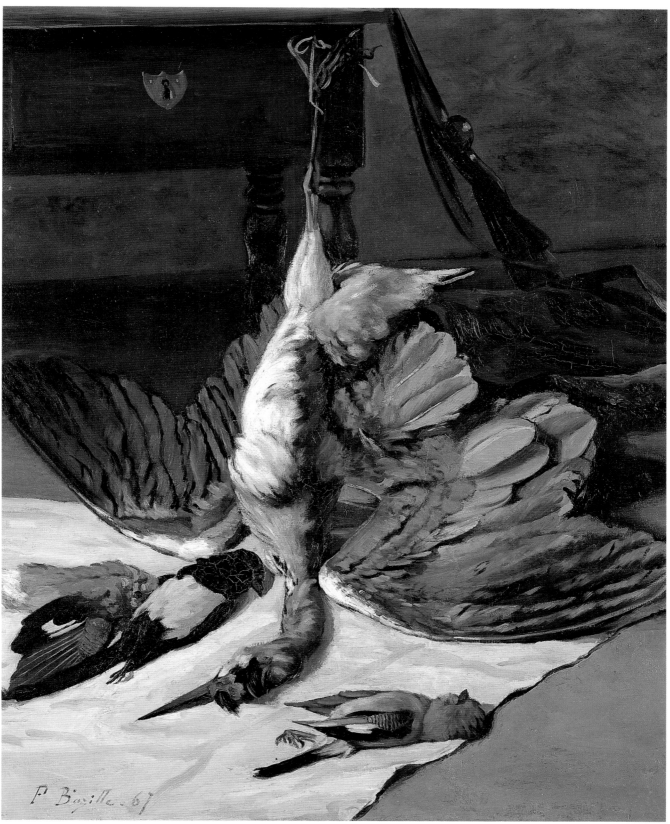

PLATE 14

Both of these striking paintings, small enough to hold in your hand, play to Fantin-Latour's strength as a still-life painter. The plate of three peaches and the single cup and saucer are each seen in isolation and thereby given a significance not normally bestowed on an object of simple daily use. Fantin-Latour focuses our attention at once on the object at hand as well as on the art of the painter through color, form, light, and composition.

As a realist painter, Fantin-Latour trained in the Louvre, where he spent many hours. His vision and technique reflect a profound respect for tradition. The subtleties of tone, quality of light, dark background, and isolation of individual still-life elements in his work are reminiscent of Spanish seventeenth-century still life, and his leaning toward simple subjects evokes the paintings of Chardin, whose revival was most acutely felt in the 1860s.[35] In both of these works, Fantin-Latour employed traditional devices for adding interest or suggesting depth, yet he conceived the knife in the one work and the spoon in the other as part of reality rather than as an artfully or artificially poised device to reference tradition or lead the eye into depth. Nonetheless, they contribute greatly to the aesthetic of the whole. The black handle of the knife accentuates and enriches the whiteness of the plate on which the peaches rest. Each peach, imperfect in its contour, has a degree of individuality, more marked here than in Fantin-Latour's later work. The peaches do not appear to constitute an arrangement (like his later pyramid of peaches) so much as a true detail taken from life. In *White Cup and Saucer*, the artist draws our attention to the delicate balance achieved between the handles of the cup and the spoon. Typical for Fantin-Latour, both works have a simple, distinctly neutral background. Warm, dark grays set off the delicate tonalities of the peaches. The light is subtly and convincingly rendered.

Fantin-Latour is thought to have painted his first still life in England in 1861 while visiting Ruth and Edwin Edwards, (fig. 49), whom he met that year. Edwin Edwards, a lawyer and amateur artist, became an agent of Fantin-Latour's work in England as well as a close friend. On a number of occasions, Fantin-Latour went to stay with the Edwardses in Sunbury, near London, where he would spend a month or more quietly painting. Both of these works are characteristic of the artist's early still lifes, although he focused primarily on flower subjects, especially roses, which were most in demand in the English market. *White Cup and Saucer*, probably painted in 1864, just two years after *Plate of Peaches,* could have been a gift to Ruth Edwards, its first owner, to thank her for his extended stay from July to October of that year.[36] The painting's quiet restraint, combined with a concentration of form and an impression of simple truth, delights the eye today as much as it did during the artist's lifetime.

EER

HENRI FANTIN-LATOUR, 1836–1904

PLATE OF PEACHES, 1862, OIL ON CANVAS, 7⅛ X 12⅜ IN. (18.1 X 32 CM), MUSEUM OF FINE ARTS, BOSTON, M. THERESA B. HOPKINS FUND

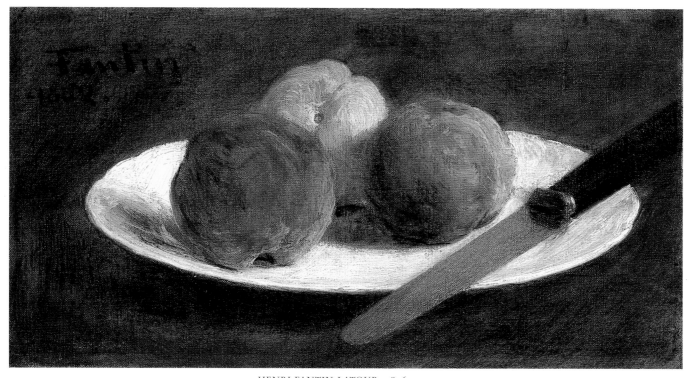

HENRI FANTIN-LATOUR, 1836–1904

WHITE CUP AND SAUCER, 1864, OIL ON CANVAS, 7⅜ X 11 IN. (19 X 28 CM), THE FITZWILLIAM MUSEUM, CAMBRIDGE, ENGLAND

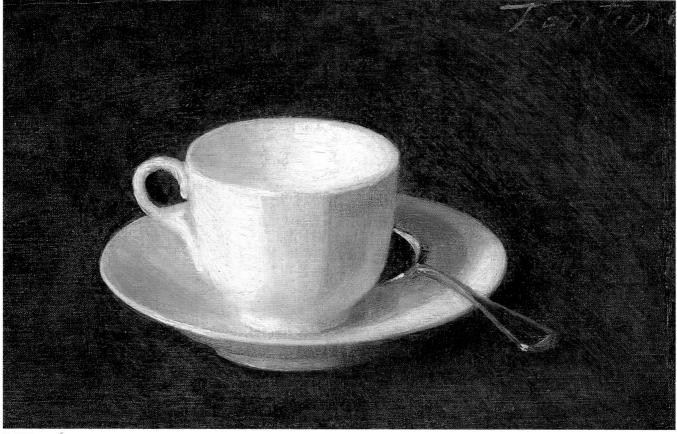

PLATES 15, 16

Startling in its modernity yet reminiscent of Chardin, *Jar of Peaches* holds a unique place in Monet's work. It stands in contrast to his slightly earlier still lifes, several of which derive from the traditional category of *trophées de chasse*, or paintings of dead game. These early paintings from 1862 to 1863 reveal the artist's burgeoning talent for realistic visual description, which includes the richly varied tonalities and sleek textures of birds' plumage. The paintings also indicate Monet's early reliance on tradition for a still-life subject. Having achieved no success in 1864 with his *Spring Flowers* (plate 9), Monet shifted his focus to an entirely different realm in *Jar of Peaches*.

Broadly speaking, Monet's *Jar of Peaches* may be derived from the tradition of kitchen still life, but it is striking in its departure from tradition and in its focus on reflection and transparency. In this modest-size painting, Monet isolates against a featureless background a group of five peaches beside a jar filled with peaches, compressed but suspended in the transparent cylinder that contains them. The jar fills the space to the top edge of the canvas, giving it a monumental presence. Because of the composition's high vantage point, the smooth marble surface on which the objects rest is an essential part of the work. The greenish-gray tonalities of the background are a foil to the peaches, defined in short strokes of delicate golden and pinkish hues. The subject engages the viewer in imagining the process of turning the fresh fruit into a preserved but succulent treat to be enjoyed later. We observe how effectively Monet captures the difference between the velvety skins of the peaches that rest on the marble and the smooth, peeled flesh of the fruit, now more uniform in hue, inside the jar. A few delicate, minimal strokes of white suggest the light reflected on the jar itself. A delightful realist touch is the suggestion of cloves floating inside the jar, conveyed by short strokes of black paint, and a stick of cinnamon, rendered in a few strokes of russet. Most striking is the sense of movement in the freely brushed description of veining in the marble tabletop. Like Monet's handling of paint in landscapes of this period, his naturally free brushstroke in *Jar of Peaches* conveys his intuitive response to optical experience.

Monet's still lifes, a relatively small percentage of his oeuvre, often reflect his contemporaneous work in landscape painting. In 1866, Monet engaged in an intense exploration of reflections in water, an endeavor that culminated in his painting *Port of Honfleur* (destroyed) at the end of that year.[37] Already deeply absorbed in his bold explorations of outdoor light, Monet had won acclaim at the 1865 Salon with *Mouth of the Seine at Honfleur* (1865, Norton Simon Museum, Pasadena) and *Pointe de la Hève at Low Tide* (1865, Kimbell Art Museum, Fort Worth).[38] In *Jar of Peaches* he brought his interest in reflection to the peaches mirrored in the marble surface—a domestic subject on an intimate scale. Yet the work seems related to the kind of ordinary subjects from modern life that Monet was also exploring on a grand scale that year, especially in his *Luncheon on the Grass* (1866, Musée d'Orsay, Paris).

Monet's search for new ideas for still-life painting may have been significantly boosted by the rediscovery in the 1860s of the work of Chardin. Indeed, Monet might even have been thinking of specific works by Chardin, such as the famed *Jar of Olives* (1760, Musée du Louvre, Paris). That work recalls a description by Denis Diderot in which he extols Chardin's mastery by saying, "These olives are really separated from the eye by the water in which they float."[39] In *Jar of Peaches*, Monet's essay in optical veracity is pared down to its essence. EER

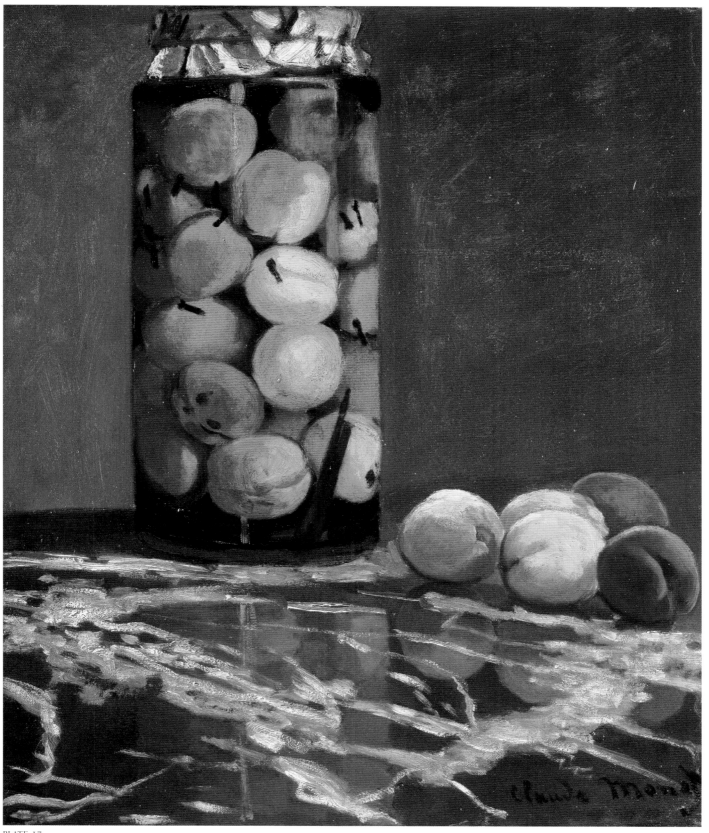

PLATE 17

Edouard Manet and Henri Fantin-Latour are said to have met as early as 1857 at the Louvre, where both artists had come to study Venetian paintings.[40] Their friendship is acknowledged in their paintings: Manet's *Music in the Tuileries* (1862, National Gallery, London) includes an abbreviated portrait of Fantin-Latour beside an even sketchier portrait of their friend the poet Charles Baudelaire; and in Fantin-Latour's *Homage to Eugène Delacroix* (1864, Musée d'Orsay, Paris), painted in the weeks before the opening of the Salon of 1864, Manet stands beside the seated Baudelaire among a group of writers and artists admiring a framed portrait of Delacroix, who had died the previous year. Although Manet's and Fantin-Latour's artistic tastes and sources of inspiration were often the same, the facture of their paintings could hardly have been more different. When Manet painted a peony, each petal of the blossom was indicated in one or two deft strokes of a fully loaded brush. Fantin-Latour, by contrast, painted his delicately shaded bouquets of asters or roses with painstaking care, gently coloring the petals of his blossoms with repeated layers of thin oil glazes.

In Manet's *Basket of Fruit*, painted about 1864, the artist turned to a subject that had attracted Chardin a century before—a basket of fruit on a simple surface, accompanied by a single table knife at lower left. Manet may well have known Chardin's *Basket of Peaches with Walnuts, Knife, and Glass of Wine* (fig. 13) from its exhibition at the Galerie Martinet in 1860; his own first exhibition of still-life paintings took place there two years later.[41] Like Chardin, Manet gives few details as to the location of his subject, but the glimmer of a reflection beneath the green fig on the right suggests the top of a polished wood table. The elegant fruit knife, in silver gilt with a handle of ivory or mother-of-pearl, implies the table of a well-to-do family. Manet needed only a few strokes of the brush to define each piece of the fruit that nestles among the dark green leaves in the basket: wet touches of tawny pink and yellow

describe the skin of two peaches at left and right, while green apples or plums mingle with two dark plums rendered in shades of deep purple, blue-gray, and white. As in his *Branch of White Peonies with Pruning Shears* (plate 8) of the same date, here Manet shows the full force of his bravura manner, giving the impression of reckless brilliance.

In contrast to the unity and simplicity of Manet's *Basket of Fruit*, Fantin-Latour's *Flowers and Fruit on a Table*, one of the artist's most ambitious early compositions, shows objects of disparate shapes, sizes, and types in a complex spatial arrangement. Space, in fact, plays a key role in the artist's conception. By placing the octagonal table slightly askew from the picture plane and by setting the tabletop back from the lower margin of the composition, Fantin-Latour indicates that the surface exists as part of a larger volume, which he is reluctant to divulge to the viewer (see, in contrast, his *Still Life: Corner of a Table* (plate 35) and *Still Life with Torso and Flowers* (plate 33), where the motif is presented as part of a decor). Still, Fantin-Latour beckons the viewer to share the pictorial space, not only through the age-old device of the projecting knife blade at lower left, but also, in a subtler way, through a succession of juxtapositions of light and shadow.

These juxtapositions reveal Fantin-Latour's acute powers of observation and his interest in a kind of veristic detail that Manet never sought to record. In the plate of peaches in the foreground, for example, Fantin-Latour reveals a hidden piece of fruit, which reflects a glimmer of light through the shadows of the fruits piled in front and above it. Where the uppermost pear in the fruit bowl touches the underside of an upturned apple, a tiny patch of light is picked out in the rounded shadow. The tangled stems of the double chrysanthemums at left are dim and dark against the glowing blossoms but stand out as fragile lines against the deep gray-green background. Finally, beneath the knife, where the oval hilt of the blade lifts the

EDOUARD MANET, 1832–1883

Basket of Fruit, ca. 1864, Oil on canvas, 14¹³⁄₁₆ x 17½ in. (37.7 x 44.4 cm),

Museum of Fine Arts, Boston, Bequest of John T. Spaulding

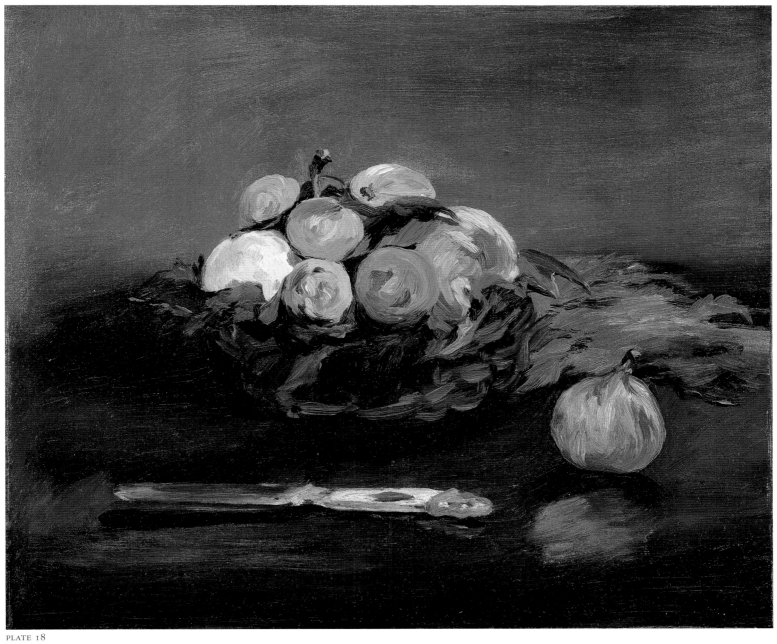

PLATE 18

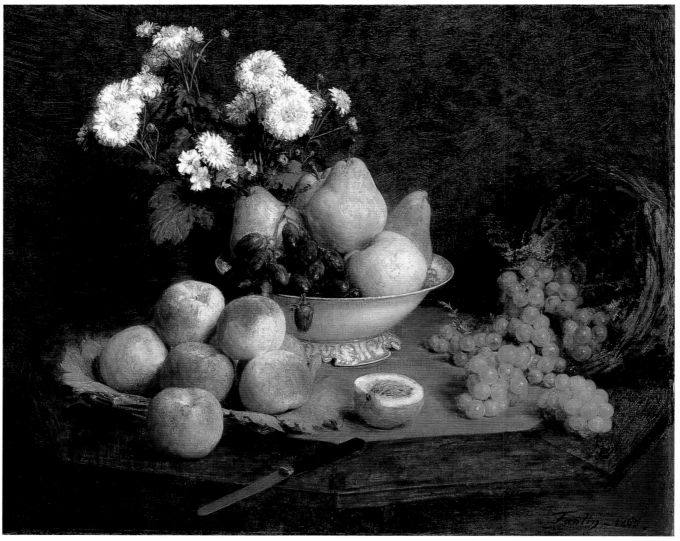

PLATE 19

ebony handle off the tabletop, Fantin-Latour shows a faint gleam of light in its shadow, ingeniously heightening the trompe-l'oeil effect.

The painter invites the viewer to touch the fruits that he so lovingly depicts, not so much to lift them from the fictive space as to caress the carefully modulated textures of his paint, which seem to carry with them some of the textures of the objects represented. Fantin-Latour constructs the skins of the peaches, in particular, with multiple layers of delicately textured paint and finally touches them with thin washes of color that give the effect of a velvety luminosity. These effects might be attributed to

Fantin-Latour's admiration for the studied textures of still lifes by Chardin—whose *Basket of Peaches* he might easily have seen in 1860. He might also have read the published description of the painting in 1863 by Edmond de Goncourt, who pointed out that the peaches "seem to detach themselves from the canvas and take on a life of their own, through I know not what marvelous optical interaction in the space between the painting and the spectator."[42] Two years after the Louvre acquired Chardin's canvas, Fantin-Latour painted his most direct homage to the composition, the 1869 *Peaches*.

GTMS

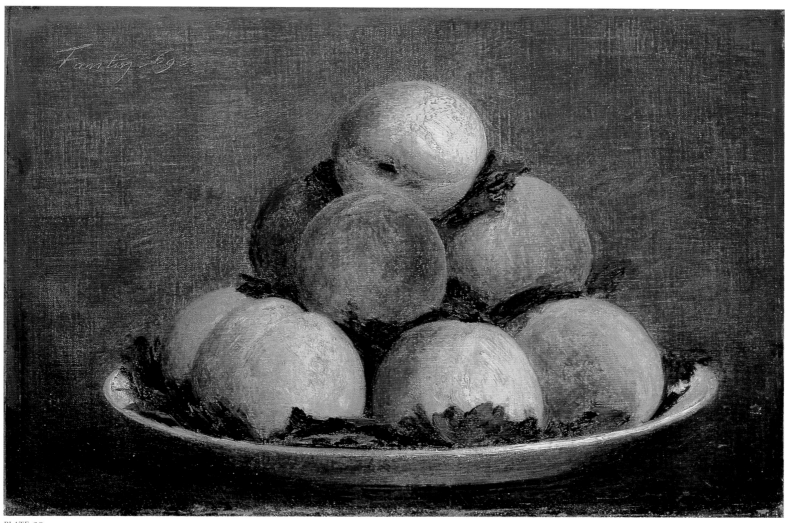

PLATE 20

FANTIN-LATOUR *The Betrothal Still Life,* 1869

In 1864 Monet and Renoir had broken with tradition to paint still lifes of flowers freed from the constraints of the vase, instead showing them growing in pots or flats or strewn on the floor of what might be a greenhouse or florist's shop (plates 9, 10). Bazille, in turn, painted an arrangement of potted flowering plants and a paper-wrapped bouquet in 1866, which he presented at the Salon two years later (plate 11). But conventional bouquets of flowers arranged in vases were more likely to be commercially successful than the radical arrangements that these young friends had painted in a spirit of experimentation. It may be that Bazille was looking to satisfy a taste for decorative floral still life when in 1868 he composed *Flowers,* an imposing, ambitious essay in the genre.

Flowers depicts a colorful mixed bouquet of summer blooms arranged in a large faïence urn, placed on a marble-topped console table that stands against a gray wall above a dado accented by a thin line of gilt. The painting relates closely to the elaborate floral still lifes that Delacroix exhibited at the Salon of 1849, many of which Bazille had seen at the exhibition of the romantic painter's studio sale in 1864. Both Delacroix and Bazille drew on the traditions of grand manner still life of the seventeenth and eighteenth centuries, as practiced by such painters as Joseph Blin de Fontenay, whose reception pieces such as *Golden Vase, Flowers and Bust of Louis XIV* (1687, Musée du Louvre, Paris) for the Académie Royale de Peinture et de Sculpture showed similar arrangements of flowers placed on console tables in architectural settings.

But even though he adopted a conventional compositional format, Bazille pushed convention to its limits, exaggerating, with an almost ironic playfulness, the spectacle of Second Empire interior decoration and its predilection for floral abundance. The outlandish bouquet in the enormous vase spills out at right through the dripping woolly flowers of an amaranth, landing on the marble tabletop where a foamy pile of dahlias and bamboo foliage wells up; roses and zinnias cascade, in turn, onto the floral-patterned upholstered stool beneath the console. Flowers and plant forms—oxalis at left, Cape honeysuckle at right—invade the composition from every side, filling the potentially neutral areas of the canvas with complicated leaf patterns.[43] Even if *Flowers* was conceived as a more

traditional and urbane alternative to the earthy realism of his 1866 *Study of Flowers,* Bazille achieved the same modern result: he posed a challenge, even in a traditional format, to the established principles of decorative still life, creating a contemporary picture in an historical mode.

In the following year, Bazille's friends Renoir and Monet, neighbors in the town of Bougival on the Seine, worked side by side on paintings of a bouquet of mixed late-summer flowers. It is not hard to imagine that they had Bazille's *Flowers* in mind when they concocted their simpler arrangement of blossoms—dahlias, again, together with asters and sunflowers—arranged in a blue-and-gray stoneware pot, the country cousin of Bazille's faïence urn. The artists placed the bouquet on the gray marble top of a table or buffet, on the border of a linen cloth, and surrounded it with fruit. While Monet pushed the bouquet to the rear and left of his composition (ca. 1869, J. Paul Getty Museum, Los Angeles) and gave the foreground over to a basket of pears and a display of apples and grapes, Renoir made the bouquet the central focus of his *Mixed Flowers in an Earthenware Pot,* a virtuoso display of his newfound technical independence. The petals of the flowers are brilliantly rendered in wet strokes of a small brush, each stroke a surely placed mark of the painter's hand. While the overall effect of the surface is focused and controlled, at close range the fluidity of Renoir's blended colors becomes apparent. The effects of light and dark are skillfully controlled, contrasting the deep blacks of the background with the luminous whites of the asters at the center of the composition. In the light reflected from the toplit asters, the orange and red dahlias glow like hot coals.

Fantin-Latour spent much of his career painting floral bouquets, but rarely did he achieve such perfect equilibrium as in *The Betrothal Still Life,* painted in the same year. The work takes its title from the occasion of the artist's engagement to Victoria Dubourg, whom he had met—probably through his friendship with Manet—in 1866.[44] In contrast to the grandeur and display of Bazille's *Flowers,* Fantin-Latour's tiny still life is quiet and modest: it shows a simple bouquet of spring flowers that might have been gathered in a garden and placed haphazardly into a porcelain vase of Chinese design. In spite of its offhand elegance, the bouquet manages to offer a series of color comple-

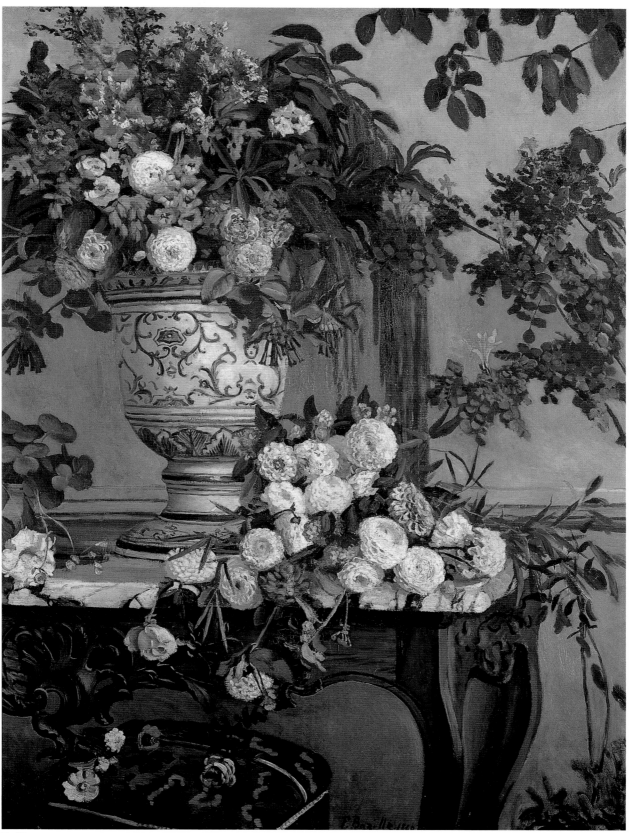

PLATE 21

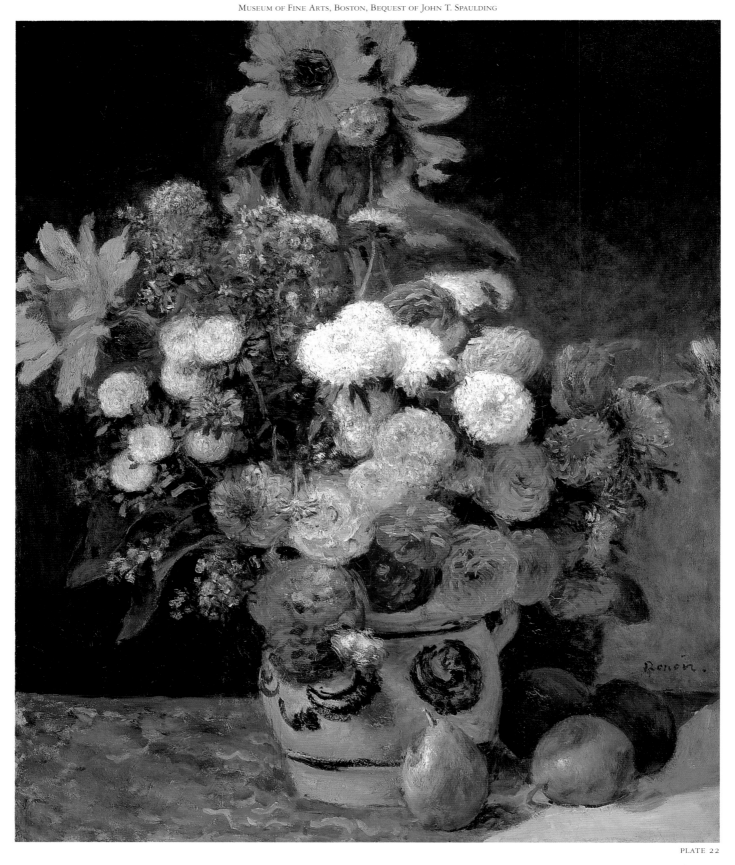

PLATE 22

HENRI FANTIN-LATOUR, 1836–1904

The Betrothal Still Life, 1869, Oil on canvas, 12⅝ x 11½ in. (32 x 29 cm), Musée de Grenoble

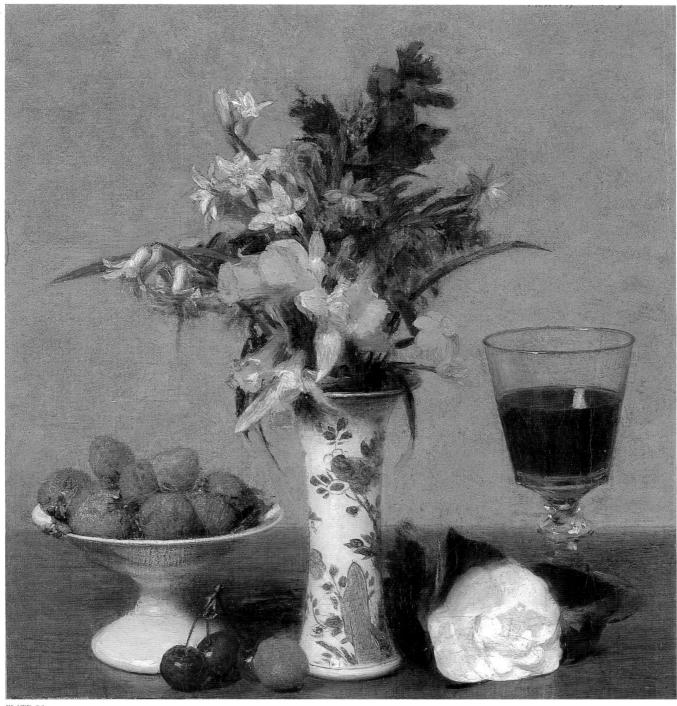

PLATE 23

ments—the red of a wallflower against the green of the leaves, the yellow jonquils and daffodils against the pale purple hyacinths. The deep red note sounded by the wallflower is echoed in the glass of wine, at right, and the cherries, at left, set against a footed dish of strawberries. Because of its pale background, the painting seems suffused with light. To give the work a final radiant touch, Fantin-Latour placed by the glass a single white camellia, as if in offering to Mlle Dubourg, who would not become Mme Fantin-Latour until 1876. GTMS

Monet's *Still Life with Melon* and *The Tea Set*, two masterpieces of 1872, have been aptly described by Anne Distel as "ideal pendants."[45] They were painted in the first year of the painter's residence in Argenteuil, the town in the environs of Paris where he and his wife, Camille Doncieux, had settled in December 1871 on their return from exile in England and Holland during the Franco-Prussian War. The majority of Monet's paintings from that year focused on the landscape in and around the town, particularly views of the river Seine and its banks, bridges, and sailboats. Like the numerous studies Monet made of the garden around his rented house, these views were painted almost entirely outdoors under varying conditions of weather and light, reflecting Monet's continuing commitment to pure plein air practice. The still lifes, on the other hand, were naturally painted in the home, where other effects of light could be explored. While many authors have cited Monet's need for indoor motifs that could be pursued during times of inclement weather as an explanation for his turn to still-life painting, John House rightly points out that his decisions may have been just as strongly influenced by market forces. The still lifes shown here were purchased by Durand-Ruel in September and November 1872 for four hundred francs each, a higher price than Monet's landscapes would have fetched at the time. Throughout the decade, Monet's still lifes found ready buyers when his landscape paintings were difficult to place.[46]

Whatever the motives behind their creation, these paintings are among Monet's most subtly worked and carefully finished pictures of the early 1870s. They were evidently of great importance to the painter. The earlier of them might be *Still Life with Melon*, which Monet sold to Durand-Ruel at the end of September. In a composition similar to those favored by his friend Fantin-Latour since the mid-1860s, Monet arranged fruits in ceramic dishes on a white cloth, but in a startling move he added the great roundel of an upturned blue-and-white Chinese or Japanese plate.[47] This plate, in harmony with the pale blue wall, a footed blue-and-white faïence dish and saucer, and the blue-gray shadows in the folded cloth, establishes the cool foil for the warm yellows, oranges, and reds of the peaches' fuzzy skins and the skillfully shaded flesh of the melon. Daylight, entering the painting from the left, throws an exaggerated shadow onto the wall behind the plate and onto the tabletop to the right of each dish of fruit; these deep shadows contribute to the painting's masterful sense of weight, volume, and space.

The Tea Set, by contrast, has relatively few deep shadows, and its elements are bathed in an even, allover light that unifies the pictorial plane. The composition is deceptively simple in appearance. Against a wall shaded in zones of blue-gray and brown, a table surface is laid with a checked damask cloth. A plant with leaves the color and texture of silver-green velvet sits at the upper left, and in the right center, a startlingly red Japanese lacquer tea tray

CLAUDE MONET, 1840–1926

The Tea Set, 1872, Oil on canvas, 20⅞ x 28⁹⁄₁₆ in. (53 x 72.5 cm), Private collection

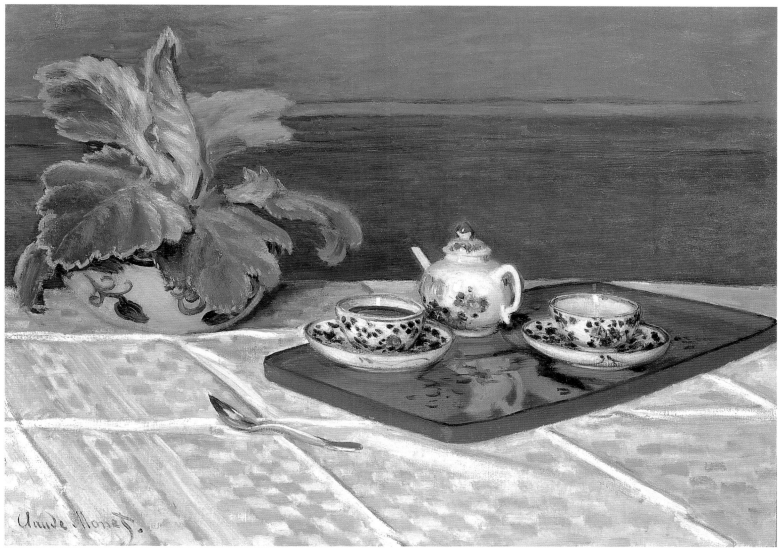

PLATE 24

holds a blue-and-white china pot and two cups and saucers, one filled with tea or coffee.[48] A single silver teaspoon is placed carelessly beside the tray, across one of the crisp folds of the gleaming white cloth. The depiction of the tray and its contents is the most masterfully subtle component of the composition. The tray itself rests at a slight angle to the composition and becomes through foreshortening a kind of lozenge shape at odds with the geometric order of the checked and folded damask cloth. The tray's inner surface reflects, alternately in light and shadow, the porcelain pot and saucers, their reflections interrupted by and mingling with the tray's own painted decoration of a blossoming cherry tree, rendered in black lacquer.

The pictures are ideal as pendants not so much because they match each other, though they share identical dimensions and a similar spatial scale, as well as the use of a white cloth as a horizontal surface and blue-and-white ceramics as a strong coloristic element. But their differences are more striking than their similarities. There is, above all, a marked contrast in mood between the two paintings. The balanced, almost classical orchestration of circular or spherical forms in *Still Life with Melon* is in some sense a variation on a theme established by Fantin-Latour in such works as *Flowers and Fruit on a Table* (plate 19). Its composition seems perfected, clearly the result of the painter's tasteful arrangement of his motif. *The Tea Set*, on the other hand, is conspicuously artless—guileless, in fact—as if Monet had stumbled upon an abandoned tea tray by accident and set up his canvas immediately to catch an effect that could be as fleeting as any element of climate or light. If *Still Life with Melon* was Monet's homage to Fantin-Latour's precedent, *The Tea Set* predates its most conspicuous complement in Fantin-Latour's oeuvre, *Still Life: Corner of a Table* (plate 35), which was not begun until the spring of 1873 and was only just finished in time for the Salon. Whether Fantin-Latour might have seen *The Tea Set* in his friend's studio is not known, but it is significant that Durand-Ruel had begun to show considerable support for Fantin-Latour in 1872 and that in late November, exactly two weeks after he had acquired Monet's painting, the dealer purchased eleven still lifes from Fantin-Latour. Perhaps seeing *The Tea Set* at Durand-Ruel's gallery might have suggested to Fantin-Latour a way toward achieving the goal that he posed to himself in his 1873 still life, which was, like Monet's, "an attempt to realise the natural."[49]

GTMS

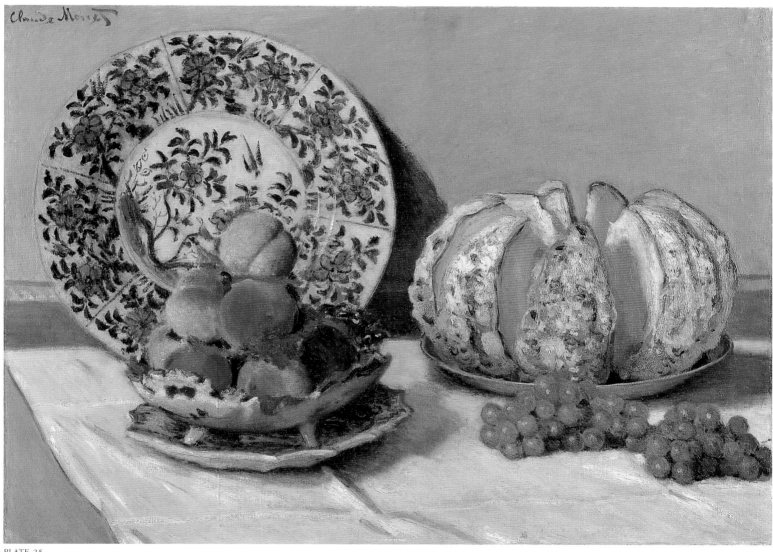

PLATE 25

On 28 May 1871, after five weeks of bloody combat between the Communards and government troops, the Paris Commune was defeated. Although he maintained that his role as president of the Artists' Committee to Safeguard the National Museums was that of a "peacemaker,"[50] Courbet was charged with having provoked the destruction of the Vendôme Column, a symbol of imperialism hated by political radicals. He was arrested on 7 June 1871 and sentenced to a six-month term at Sainte-Pélagie prison in Paris.[51] One year after he had declared himself "the foremost man in France" with more commissions than he could handle, Courbet was reduced to an existence of relative obscurity.[52]

Sainte-Pélagie had traditionally been a haven for political dissidents, touted as the Pavillon des Princes where prisoners could work in comfortable surroundings and enjoy garden walks and entertainment. Things were different during Courbet's stay, however, when ex-Communards were packed into dilapidated cells with common criminals.[53] The experience initially broke Courbet's spirit and killed his desire to paint. One month into his term at Sainte-Pélagie, after serving nearly three months in holding prisons while awaiting his trial, Courbet finally expressed the desire to resume making art.[54] He imagined painting the Paris cityscape from the roof of the prison, but this request was denied. Denied also a live model, Courbet was limited to whatever objects could be brought to him in the confined space of his cell.[55] He thus painted small canvases of fruit and flowers, extending these motifs onto the walls and door of his cell.

Hollyhocks in a Copper Bowl seems to register some of Courbet's despondency. Pale violet, crimson, and yellow hollyhocks emerge from a pall of darkness, allowing the black of the background to seep through many of their petals. Blooms traditionally associated with death in Dutch and Flemish baroque painting, the loosely painted, almost amorphous hollyhocks of Courbet's canvas are a marked departure from his precise renderings of lush garden flowers in the early 1860s.

The vibrant bouquet in *Head of a Woman with Flowers*, painted a year before *Hollyhocks*, is more in keeping with his earlier forays in flower painting. Somewhat reminiscent of the four portraits Courbet painted around 1865 of Joanna Hiffernan gazing into a mirror, the female figure in the lower left corner of *Head of a Woman with Flowers* looks closely at what appears to be a piece of paper, perhaps reading the lines upon it.[56] Are the flowers, densely thick with impasto, meant to represent the thoughts stimulated by the text in her hand? Is their palpability suggestive of the vividness of the description that she may be reading? Or does the faintly rendered head speak simply to the inaccessibility of models and Courbet's predicament of having to paint the figure from memory? The sharp contrast between the bouquet's physicality and the figure's vaporousness challenges conventional modes of perception. In subordinating what normally attracts our focus in figural compositions—the human subject—to an arrangement of flowers, the artist underscored the sometimes-precarious compositional relationship between figures and inanimate, decorative objects. This enigmatic image is quite unlike any of Courbet's other works.

The slice of sky viewed at the far right edge of *Head of a Woman with Flowers* is a device Courbet commonly used in his fruit still lifes from 1871. In *Still Life: Fruit*, a broader expanse of sky is viewed through a window behind the copious tabletop arrangement of apples and pears at the center of the composition. A poignant foil to the artist's incarcerated state, this luminous open-air vision of plenty was probably created—despite its inscription of "Ste.-Pélagie"—in 1872, after Courbet had been transferred to a nursing home in Neuilly, where he was treated for illness and left to finish out his prison term. "I have finally escaped those unspeakable prisons," Courbet wrote to Eugène Boudin on 6 January 1872. "I am painting fruit these days."[57] That same day he wrote to his father and sisters to pronounce that he was "in heaven" and had "never been so comfortable in all [his] life."[58]

The spirit of *Still Life: Fruit* is markedly different from the fruit still lifes that Courbet completed in prison, which sometimes depict bruised or cut-open fruit in dim, unadorned spaces. Situated in a comfortable

GUSTAVE COURBET, 1819–1877

HOLLYHOCKS IN A COPPER BOWL, 1872, OIL ON CANVAS, 23⅜ x 19⁵⁄₁₆ IN. (60 x 49 CM), MUSEUM OF FINE ARTS, BOSTON, BEQUEST OF JOHN T. SPAULDING

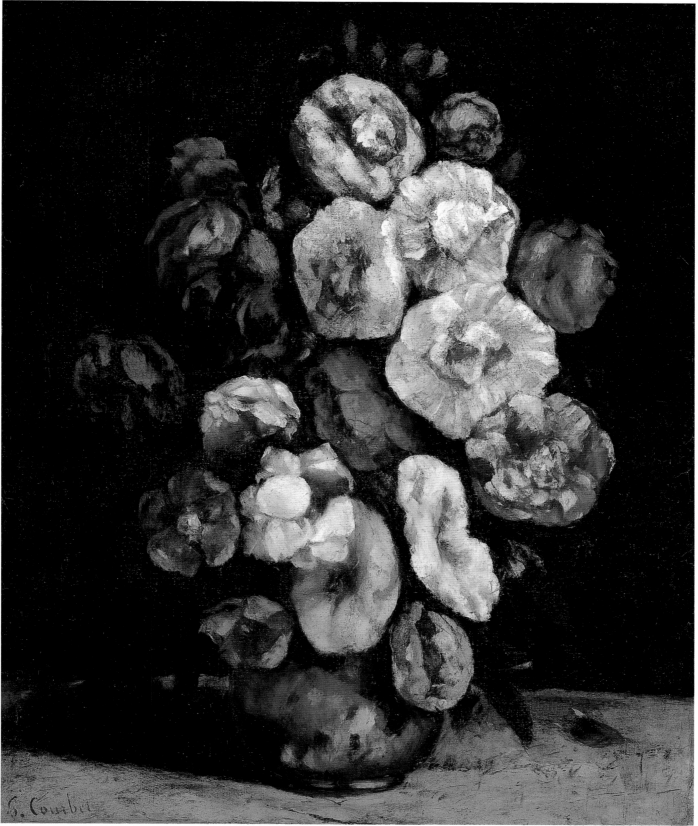

PLATE 26

GUSTAVE COURBET, 1819–1877

HEAD OF A WOMAN WITH FLOWERS, 1871, OIL ON CANVAS, 21 ¾ X 18 ¼ IN. (55.3 X 46.3 CM), PHILADELPHIA MUSEUM OF ART, LOUIS E. STERN COLLECTION

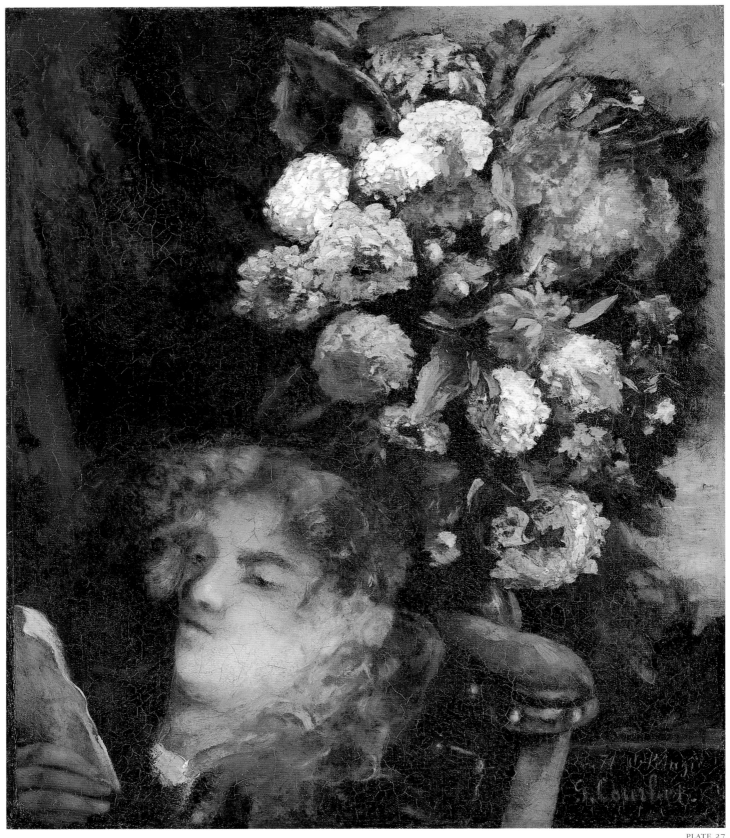

PLATE 27

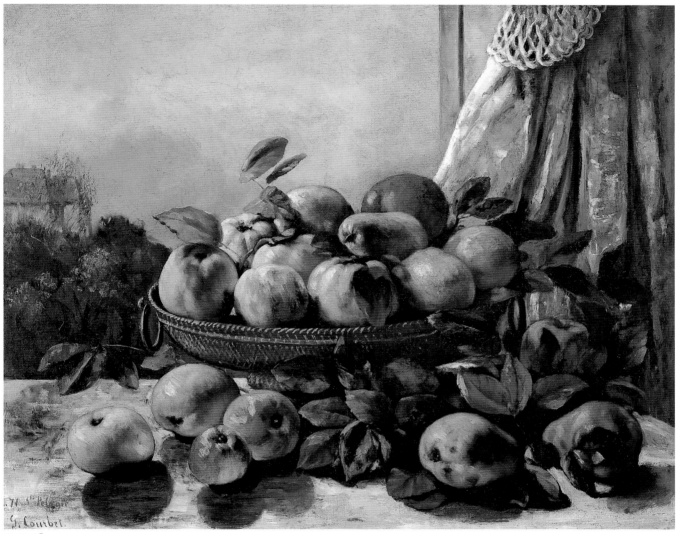

PLATE 28

interior—the pulled–back curtain on the right revealing another dwelling on the hill outside—this cluster of fruit is bathed in rosy light. Juxtaposed with the comparatively hazy landscape behind, Courbet's fruit presents a similar pictorial problem as his bouquet in *Head of a Woman with Flowers*. Invested with a material, almost corporeal weight, as Jeannene M. Przyblyski has noted, Courbet's fruit from these years seems to literally embody his physical presence.[59] Even the shadows cast by the group of four apples in the left foreground exude a heaviness.[60] By inscribing even these more joyous fruit still lifes with the name of Sainte-Pélagie, Courbet affirmed his status as a political prisoner, perhaps crediting, as well, the place that first imposed the subject on him. Upon his release, Courbet resumed his painting of landscapes and seascapes with renewed intensity. JAG

Still Life: Apples and Pears in a Round Basket and *Still Life with Apples and Pitcher* are two of Camille Pissarro's most accomplished still lifes from the early 1870s.[61] While still life was relatively rare in his oeuvre, Pissarro experimented with it in earnest throughout his life, beginning just over a decade after his arrival in France. These paintings, two of the eight still lifes he produced during the 1870s, were purchased together from the artist by the dealer Paul Durand-Ruel on 26 November 1872. Pissarro had met Durand-Ruel, who was to be an important proponent of his work throughout his career, in London in 1871, during the Franco-Prussian War.

Identical in size and interior setting, these two paintings display far more subtle tonal gradations than those found in Pissarro's earlier *Still Life* of 1867 (plate 6). With its simple, austere composition and lavish impasto rendered with a palette knife, *Still Life,* Pissarro's first work of that genre, was created the same year Gustave Courbet and Edouard Manet exhibited still lifes in their independent exhibition pavilions during the Paris World's Fair. Five years later, his work exhibited what Pissarro called a *qualité grise et fine* (refined grayness) of nuanced tones, with precise, even delicate, brushwork.[62] While more refined in tone and handling of color, these two compositions, like his 1867 *Still Life*, are deliberate in their simplicity. In their depiction of humble, quotidian objects, they convey the frugal nature of the artist's rural life, remaining true to his enterprise of representing genre scenes of rural France in a modern context.

The domestic interiors depicted in these two works center on fruit, placed in a basket and on a round plate, carefully arranged on a tabletop covered with a sharply creased cloth. This was a format explored, to varying degrees, by Manet, Monet, and Sisley throughout the Impressionist years. Another still life by Pissarro from this decade, depicting pears in a bowl placed on a tablecloth, has been discovered through X-ray examination beneath the surface of a landscape from 1877.[63]

Paying close attention to compositional issues, Pissarro contrasted the solid curvilinear forms of the apples and pears and of the vessels containing them on the horizontal tabletop with the vertical lines and organic swirls of the wallpaper. The same patterned wallpaper serves as the background for both works—and, interestingly, also for a self-portrait of 1873.[64] The two still lifes might also have been conceived as pendants, but they are composed quite differently. In *Apples and Pears in a Round Basket*, the basket, with the graceful arc of its handle, forms a circle, carefully placed between two sharply ironed creases in the tablecloth that reinforce the vertical emphasis of the wallpaper, while in *Still Life with Apples and Pitcher*, the diagonal of the knife offsets the collective vertical emphasis in the wallpaper design and the pyramid composed of the pitcher, glass, and stacked fruits.

Pissarro's compositional strategies in these two paintings, his use of a decorative background, and especially his treatment of apples—as well as his exploration of still lifes in interiors in general during this period—were to exert a strong influence on Cézanne. The younger artist joined his mentor Pissarro in Pontoise in 1872, when these pictures were created. There, they worked closely together throughout the next five years, during which time Pissarro introduced Cézanne to Impressionist techniques and to plein air painting. The remarkable clarity of form Cézanne achieved in such 1870s still lifes as *Compotier and Plate of Biscuits* (plate 46) and *Still Life with Compotier* (plate 48) was already present in Pissarro's simple still lifes of 1872.

This pair of compositions also anticipates Paul Gauguin's still lifes of the 1880s, in particular *Still Life with Apples, Pear, and a Ceramic Portrait Jug* (plate 75) and *Still Life with Colocynths* (plate 74). And like his vanguard colleagues Cézanne and later Gauguin, Pissarro in these paintings refused to paint the tablecloth in tones of pure, bright white, in opposition to traditional still-life practice. AAL

CAMILLE PISSARRO, 1830–1903

STILL LIFE: APPLES AND PEARS IN A ROUND BASKET, 1872, OIL ON CANVAS, 18 X 21 ¾ IN. (46.2 X 55.8 CM),

COLLECTION OF MR. AND MRS. WALTER SCHEUER

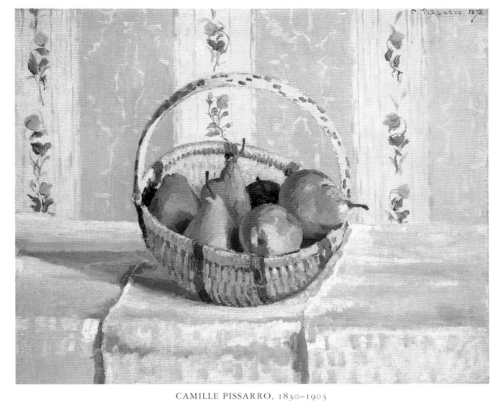

CAMILLE PISSARRO, 1830–1903

STILL LIFE WITH APPLES AND PITCHER, CA. 1872, OIL ON CANVAS, 18¼ X 22¼ IN. (46.4 X 56.5 CM),

THE METROPOLITAN MUSEUM OF ART, NEW YORK, MR. AND MRS. RICHARD J. BERNHARD, GIFT, BY EXCHANGE

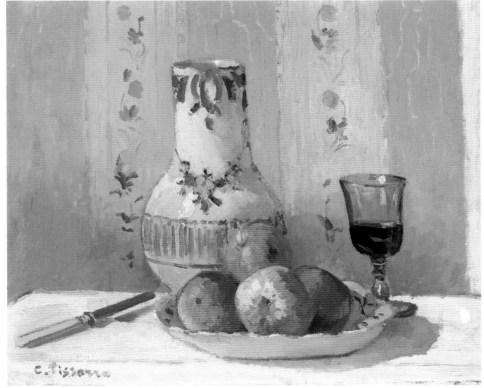

PLATES 29, 30

This painting, a gift from Manet to Berthe Morisot, instantly conveys the very special nature of their friendship. Small in size, spare in its elements, it has a power to move us that transcends its seeming simplicity of means. Had we no prior knowledge of the specific references embedded in the red lacquer fan and bouquet of violets, we would still intuit the intensely personal nature of this work.

Fantin-Latour introduced Manet to Morisot in the galleries of the Louvre in 1867.[65] Both Berthe and her sister Edma, in their mid-twenties at the time, were studying painting, although only Berthe continued to make it her life's pursuit. The Morisots, of a similar social background to the Manets, were quickly embraced in the Manet family's circle of friends and regularly invited to join their Thursday evening soirées. The following year Manet wrote to Fantin-Latour, "I quite agree with you. The mademoiselles Morisot are charming."[66] So began the period of a profound relationship between the two artists during which Manet made Morisot the subject of paintings, drawings, and etchings that offer a compelling portrait of their friendship as well as of Impressionism's most gifted woman painter.

Beginning with *The Balcony* of 1868–69 (Musée d'Orsay, Paris), for which Morisot was one of the three principal models, Manet would ask Morisot to model for him on numerous occasions and most intensively between July and September 1872, the year following the siege of Paris in the Franco-Prussian War and the ensuing bloody Commune. Manet, who was very patriotic, served as a lieutenant in the National Guard.[67] Following the war, he wrote to Morisot, expressing his relief that she and her family had been spared and his expectation that she would soon return to Paris, concluding, "Everyone is returning to Paris and the fact is it's impossible to live anywhere else."[68] In 1874 Morisot would become Manet's sister-in-law by marrying his brother Eugène.

In Manet's many paintings of Morisot, she is almost never without her fan, an accoutrement that became the subject of *Berthe Morisot with a Fan* (1872, Musée d'Orsay, Paris), in which she holds the open fan to her face, peeking through the lower portion at the artist and immediately conveying the playful and familiar relationship that existed between them. On the other hand, his most captivating portrait of her must surely be *Berthe Morisot with a Bouquet of Violets* (fig. 56), in which a little bunch of violets and her white collar are the only accents that relieve the richness of blacks in which Morisot is attired. The blacks accentuate her large eyes, which were known for their extraordinary depth and magnetism.[69]

Violets, the favorite flower of both Empress Josephine and Empress Eugénie, were fashionable among elegant ladies of the Second Empire.[70] Morisot, whose father's career as a government official was launched under Louis-Philippe, had been born into a distinguished upper-middle-class family.[71] Despite her impressive pedigree, Morisot was still unmarried at thirty and determined to pursue her career as an artist, an unusually independent and committed stance for a young woman of her background and time.

In *Bouquet of Violets*, the red fan is unmistakably identical to the red fan folded in her hands in *The Balcony*. Here it lies diagonally in an indeterminate space with a bouquet of violets and an unfolded note on white paper. Devoid of sentimentality, the work displays an extraordinary delicacy of touch in the varied blues that constitute the bunch of tiny violets, with flecks of white beautifully married to the white paper rimmed in violet facing the source of light. We have the sense of reading a private message, "A Mlle Berthe—E Manet." Manet's deftly conceived still life is both an eloquent homage and a token of deep friendship. Inscribed "To Mlle Berthe," it has perhaps no equal in intimacy and charm.

EER

BOUQUET OF VIOLETS, 1872, OIL ON CANVAS, 8⅝ X 10⅝ IN. (22 X 27 CM), PRIVATE COLLECTION, PARIS

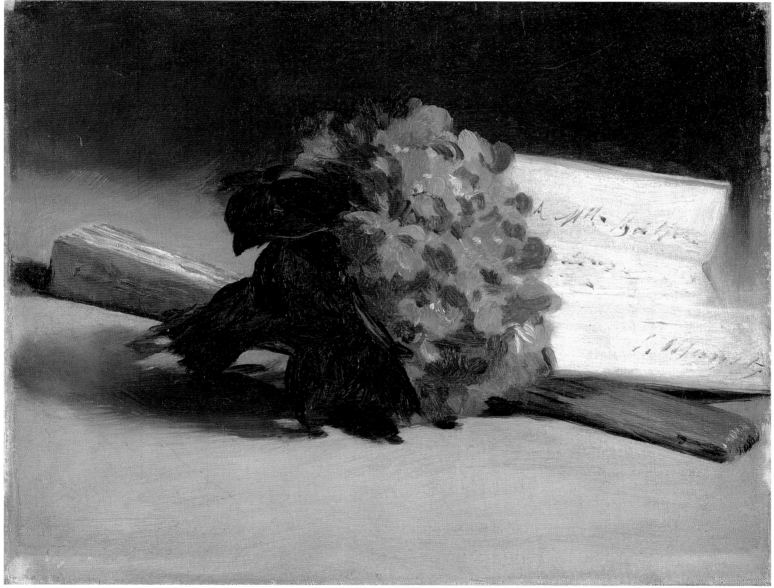

PLATE 31

Of all Eva Gonzalès's experiments with still life, the only exceptions to the standard motifs of flowers, fruits, vegetables, and tabletop displays are *White Shoes* and its metaphorical mate, *Pink Shoes* (ca. 1879–80, private collection), two small still lifes of ladies' footwear painted shortly after Gonzalès's 1879 marriage to the printmaker Henri-Charles Guérard. Shoes as still-life subject matter were not something explored by Gonzalès's teacher and mentor, Edouard Manet. They may have become intriguing to the young artist, however, after her marriage because her new husband is said to have collected shoes and is known to have used them as satirical subject matter in his prints (fig. 51).[72]

A pair of fashionable square-toed lady's slippers is featured in both *White Shoes* and *Pink Shoes*.[73] In each, the shoes are the epitome of upper-class femininity and style, with no concern for practicality or everyday wearability. They are made, it appears, of a satiny material, with feathery pompoms decorating the vamp—the part that would peek out from under a lady's skirt. *White Shoes* is more densely composed than the spare *Pink Shoes*, which features only a centrally placed pair of pink-heeled slippers seen in profile on top of a reflective surface. In *White Shoes,* the flat- or low-heeled pair of satiny lady's slippers is part of a more complex arrangement that includes a lady's brown kid glove and a pink rose, all placed on a floral-print cloth against an indeterminate dark background.

The intimately scaled *White Shoes* positions the viewer very close to the objects from a rather high viewpoint. The white slipperlike shoes and the pink rose emerge from the dark background as the primary objects that capture the viewer's initial attention through their shape and color, reaffirming Manet's enormous influence on Gonzalès and his advice to her: "Don't bother about the background. Look for the values. When you look at [a still life] . . . give the public the same impression of it as it makes on you."[74] Equally reminiscent of Manet is Gonzalès's compositional strategy, particularly her interest in rendering contrasting shapes and forms. Although they may appear to be casually askew, the shoes are carefully positioned with their toes touching, so that the right shoe is seen from the front while the left shoe is seen from the side, emphasizing the different formal shapes of each.

White Shoes, perhaps Gonzalès's most evocative and feminine still life, stimulates the viewer's imagination, prompting fantasy images of the refined and romantic woman to whom these carefully chosen objects may belong. Are these references to the elegant young artist herself or simply suggestive accessories to a lady's romantic outing with a male companion, now cast aside after the return home?

SBF

WHITE SHOES, CA. 1879–80, OIL ON CANVAS ATTACHED TO PANEL, 9¹⁄₁₆ X 12⅜ IN. (23 X 32 CM), PRIVATE COLLECTION

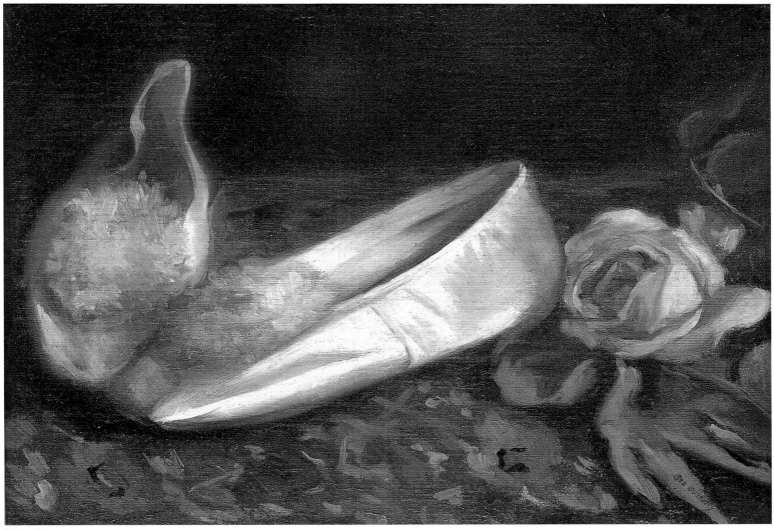

PLATE 32

These two paintings go beyond the visual delight of a straightforward still life to engage in a commentary on the subjects of the artist. Each alludes to the work of a highly esteemed contemporary—for Fantin-Latour, Whistler, and for Renoir, Manet. Here we see reflected both artists' reverence for the old masters and the lessons available to them in the Louvre, where Fantin-Latour and Renoir spent many hours. At the same time, following the vast world's fairs held in Paris in 1855 and 1867, these paintings testify to the rich mélange of new Eastern and Western sources of artistic inspiration. Each in its own way reflects the fascination with Spanish painting that reached a peak in Paris in the 1860s, the decade that also saw a growing excitement over Japanese art following Japan's opening to the West in 1854.

At the Louvre, where Fantin-Latour visited regularly to copy the old masters,[75] the artist met Manet in 1857 and Morisot and Whistler the following year. He became a close friend of Whistler and made his first of four trips to London in 1859 at Whistler's suggestion. He included Whistler, Manet, and himself in his first group portrait, *Homage to Delacroix* (1864, Musée d'Orsay, Paris). He also expressed his sense of artistic lineage in his famous homage to Manet, *A Studio in the Batignolles* of 1870 (fig. 53), which recognized Manet's role as the leader of "the new painting" and Renoir's position as one of his most fervent admirers. Like Manet, Fantin-Latour admired Spanish painting, especially the works of Velázquez. Indeed, we sense the inspiration of Spanish painting in *Still Life with Torso and Flowers*, in which the artist plays up the contrast between the cool and somber tonalities of the wall and the delicate yellow and pink primula and tea roses.

Just as Fantin-Latour included a statuette of Athena in his homage to Manet, in *Still Life with Torso and Flowers* he again refers to antiquity with a plaster cast of Aphrodite, perhaps to signal the persistent presence of the classical example for painters of his generation. In doing so, he epitomized the central emphasis of the Ecole des Beaux-Arts and of the education of his artist friends Renoir, Monet, and Bazille in the studio of Charles Gleyre, who is reputed to have said, "We must always have Antiquity in mind."[76] At the same time, Fantin-Latour alluded to the ubiquitous, contemporary influence of the Japanese aesthetic in the fan resting on the tabletop and the framed woodcut on the wall, recalling a remark by the critic Ernest Chesneau, "It's really through our painters that the taste for Japanese art took root in Paris."[77] Fantin-Latour also referred stylistically to the radical paintings of his friend Whistler, specifically *Symphony in White No. 2, The Little White Girl* (Tate Gallery, London) of 1864, the year of one of Fantin-Latour's visits to London. At this time, Whistler was enjoying considerable success both in London and Paris. While Whistler's painting is far more freely rendered than Fantin-Latour's, it too is enlivened by a flowering branch that enters the composition from the bottom, contributing a flattening decorative effect to the work as a whole—a device he frequently employed. Here Fantin-Latour adopted the motif to less dramatic effect than in the *Still Life: Corner of a Table* (plate 35) of the year before.

HENRI FANTIN-LATOUR, 1836–1904

STILL LIFE WITH TORSO AND FLOWERS, 1874, OIL ON CANVAS, 45⅝ X 35⅛ IN. (116 X 90 CM), GÖTEBORG MUSEUM OF ART, GÖTEBORG, SWEDEN

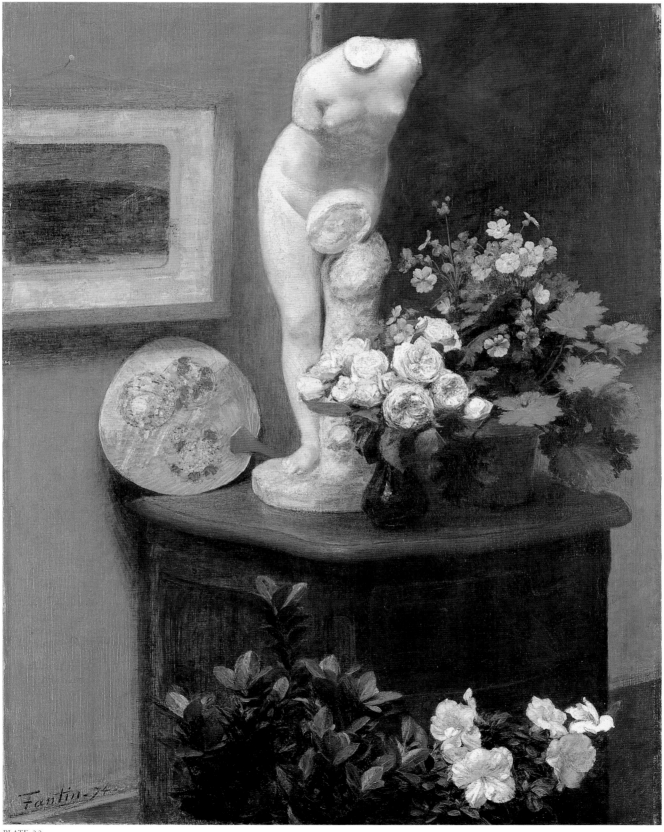

PLATE 33

Like Manet, who favored the Salon over participation in the Impressionist exhibitions, Fantin-Latour painted *Still Life with Torso and Flowers* for the Salon of 1874. In spite of some favorable response when the painting was exhibited in 1874, the work was not sold in Paris but was acquired by Edwin Edwards, Fantin-Latour's principal source of support in London. Fantin-Latour's friend Otto Scholderer, who saw the work at the Salon, considered the plaster cast in *Still Life with Torso and Flowers* to be "among all those fine and vivid things . . . a bit much."[78] It is precisely such a reference to the antique that is absent from Renoir's still life. Yet Fantin-Latour's beautifully composed, balanced composition brings together nature and art, East and West, and tradition versus realism—the central issues for the artists of Fantin-Latour's generation.

In his more emphatically personal and specific homage, *Still Life with Bouquet,* Renoir evoked Manet's admiration for Velázquez, a reference that is the most unusual element of this unique still life. By including a likeness of the etching that Manet made after a painting attributed to Velázquez in the Louvre, Renoir celebrated in this work his profound admiration for Manet.[79] Velázquez's *Little Cavaliers,* one of the few works then considered to be by the Spanish master in the Louvre, was of central importance to Manet, who copied it in watercolor, oil, and etching and exhibited his renderings on several occasions,

making plain his engagement with this work.[80] Renoir's inclusion of Manet's print seems to imply by association his own respect for the old masters in the Louvre. Nonetheless, the warm palette of his painting, while reminiscent of Delacroix, also reflects his recent experiments with the brilliant color that came to be the essence of Impressionist painting. Renoir's painting suggests a break with tradition as well as his grasp of Manet's admiration for Velázquez's truth to nature and his talent for informal composition. It is precisely this air of informality that Renoir captured in his still life, with its unlikely pairing of a paper fan and a plume of grasses in a Chinese vase, partially obscuring his loose but quite accurate rendering of Manet's print. The bouquet of red and yellow roses with lilacs wrapped in white paper instantly evokes the bouquet of Manet's notorious *Olympia* (1863, Musée d'Orsay, Paris), and the casual ensemble of disparate objects is reminiscent of the assorted attributes Manet introduced to *Portrait of Emile Zola* (fig. 8). Renoir's *Still Life with Bouquet*, replete with references to paintings and aesthetics past and present, achieves the sense of informality that eluded Fantin-Latour in the *Still Life: Corner of a Table* (plate 35). A rare still life from Renoir's early period, this work speaks to the issues of still-life painting for the nascent group soon known as the Impressionists and offers a telling tribute to Manet's leadership. EER

AUGUSTE RENOIR, 1841–1919

STILL LIFE WITH BOUQUET, 1871, OIL ON CANVAS, 28 13⁄16 X 23 3⁄16 IN. (73.3 X 58.9 CM),

THE MUSEUM OF FINE ARTS, HOUSTON, THE ROBERT LEE BLAFFER MEMORIAL COLLECTION, GIFT OF SARAH CAMPBELL BLAFFER

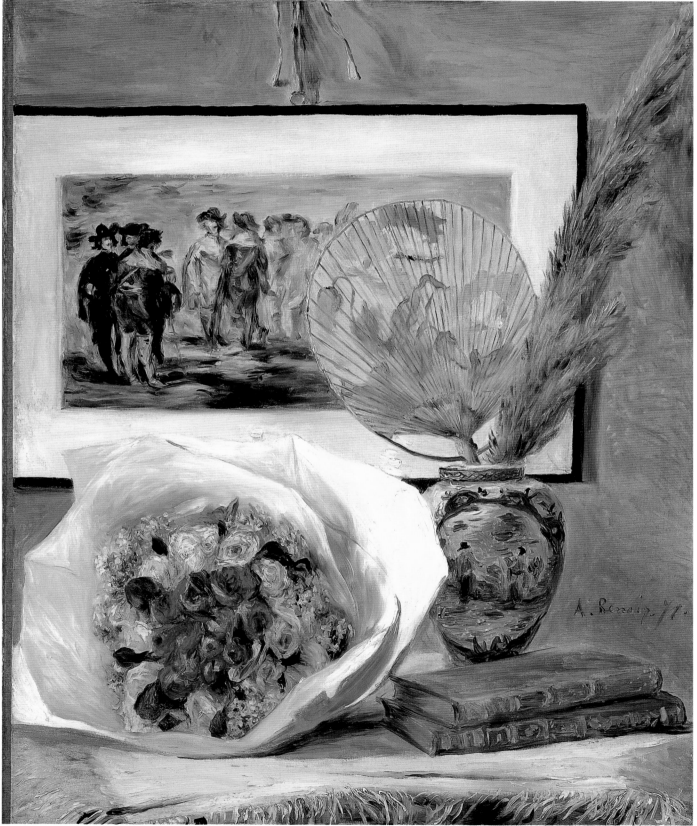

PLATE 34

"I tried to make a painting representing things as they are found in nature; I put a great deal of thought into the arrangement, but with the idea of making it look like a natural arrangement of random objects. This is an idea that I have been mulling over a great deal: giving the appearance of a total lack of artistry."[81] So Fantin-Latour described his recent painting *Still Life: Corner of a Table* to the painter Otto Scholderer in 1874. During the 1860s, he had worked steadily toward this concept of informality. This is strikingly evident in his three group portraits that date from 1864, 1870, and 1872. The third of the extant group portraits, *Corner of the Table* (fig. 50), closely precedes this painting and is clearly its source of inspiration. That he should revisit the subject to concentrate on the still life alone is revealing of Fantin-Latour's true artistic leaning as well as his hopes for critical and commercial success.

From the formal, symmetrical group portrait of 1864, *Homage to Delacroix* (Musée d'Orsay, Paris), to his homage to Manet called *A Studio in the Batignolles* (fig. 53), Fantin-Latour developed a markedly more informal approach to his subject and introduced still-life elements that play a significant role. When he set about composing the third group portrait, he worked through many compositional variations before arriving at the decidedly off-center approach that we see in *Corner of the Table.*[82] This large painting, shown at the 1872 Salon includes in its gathering of writers the poets Arthur Rimbaud and Paul Verlaine seated at the end, or corner, of the table. Here the artist explored in the postures of the figures as well as in the still-life elements themselves the look of a random, impromptu gathering. Some of the figures stand, others are seated, and the still-life elements on the table seem casually arranged. While not entirely convincing, the composition suggests Fantin-Latour's studied effort at informality. His treatment of the still life reflects his acquaintance with Chardin as well as with such paintings in the Louvre as *The Supper at Emmaus* (ca. 1535) by Titian (an artist he greatly admired), in which a half-filled glass of wine, a carafe, a piece of fruit, and bread remain scattered across the table.[83]

Fantin-Latour had originally intended to include yet another figure at the right end of *Corner of the Table,* a writer by the name of Mérat, who in the end did not wish to be present and whose place was consequently taken by the still life of flowers. The artist must have found the resulting asymmetry to his liking since he elaborated on this idea in his *Still Life: Corner of a Table,* making the flowering branch in the foreground the most striking aspect of the work. In this still life, however, he shifted his point of view so that more than half of the composition is occupied by the brilliant expanse of the white tablecloth. The idea of the white damask tablecloth as the ideal field for the display of still-life elements had been especially popular in the 1860s and was nowhere manifested to greater effect than in the work of Fantin-Latour's friend Manet.[84]

In Fantin-Latour's still life, the rhododendron prominently placed in the foreground joins the elements resting on the table, which are in turn silhouetted, friezelike, against the dark background. By contrast, the white tablecloth shows off and brings visually forward to stunning effect the pink-tinged blossoms that reach up to the golden orbs of fruit in the *compotier.* This highly naturalistic extravaganza of blossoms and foliage not only serves to relieve the potentially austere still life with a decorative naturalism that Fantin-Latour knew well, but also evokes the flattening approach to composition found in Japanese prints. Echoing the cropped introduction of flowers in the lower corner of Whistler's *Symphony in White No. 2, The Little White Girl* (1864, Tate Gallery, London), this device is reminiscent of the work of his close friend.

Most of the elements of the still life that are present here were also included on the table in the group portrait. Here, however, they are more evenly distributed, and the upturned top of the sugar basin plays a literally central role in maintaining a look of casual disarray. White highlights suggest the gleam of polished silver and reflections in the wine glass and decanters. The two partly filled decanters, glass, cup and saucer, and sugar basin constitute a somber but elegant study in the silvery tonalities for which Fantin-Latour is justly famous.

When Fantin-Latour exhibited this large and ambitious still life at the Salon of 1873, he failed to elicit the response he hoped for from the critics, one of whom complained of its lack of cohesion and equilibrium, writing, "Why does Monsieur Fantin-Latour, who is so good at painting, prove himself to be so poor at arranging what he paints? His picture . . . is composed of things that we can see only bits of. There is no feeling of line and a total ignorance of the art of grouping things together. . . . When Chardin wished to paint a bottle, a silver goblet, a pepperpot, and a bunch of cherries, at least he took care to arrange them a little."[85] EER

HENRI FANTIN-LATOUR, 1836–1904

STILL LIFE: CORNER OF A TABLE, 1873, OIL ON CANVAS, 38¼ x 49¼ IN. (97 x 125 CM),

THE ART INSTITUTE OF CHICAGO, ADA TURNBULL HERTLE FUND

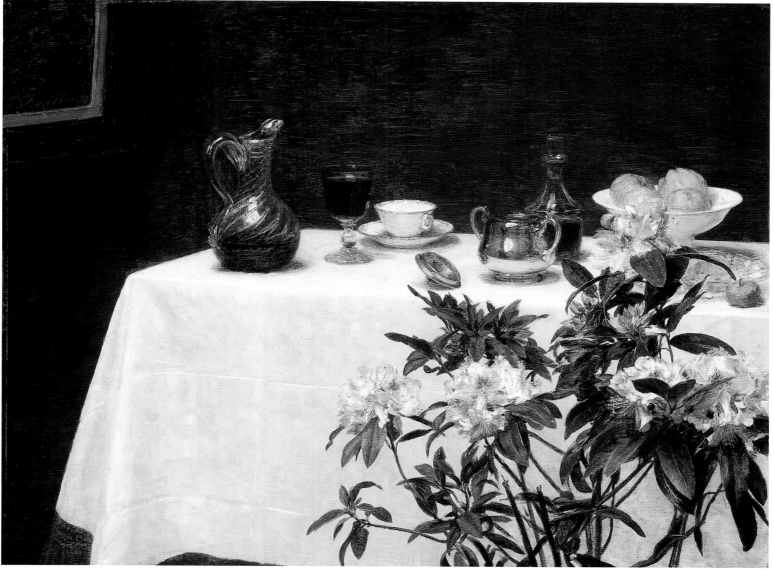

PLATE 35

Throughout the 1870s, Camille Pissarro's interest in still life centered largely on floral arrangements in interior settings. Painted about 1873, *Bouquet of Flowers* depicts one of the simple floral bouquets that were frequently arranged for the artist by his wife, Julie, a former florist, from her garden.[86] This rendering of flowers, placed casually in an unadorned vase, can be counted among Pissarro's most intimate still lifes. The rusticity of this floral arrangement, set against a relatively plain background, contrasts with the more refined and elegant bouquets depicted by Fantin-Latour and Renoir.

Further exploring this subject, Pissarro painted *Chrysanthemums in a Chinese Vase,* one of his most ornate still-life compositions, in 1873. Decorated with an intricate design of intertwined organic forms, the exotically patterned vase contains a glorious, carefully arranged bouquet of mixed chrysanthemums in tones of white, gold, and red. Adjacent, a stack of books sits atop the highly polished surface of the table. While this work is more sophisticated in its use of color and handling of paint, both paintings are vertical in format, and contain similar elements. The discreet presence of books in both pictures suggests the sophistication of worldly knowledge and might even be a reference to modernity, as explored at length by van Gogh in his studies of books, such as *Study for 'Romans Parisiens'* and *Still Life with a Plaster Statuette and Books* from 1887 (plates 70, 71).

In 1872 Cézanne joined Pissarro in Pontoise, where they would work closely together throughout the next five years. At the height of the painters' working collaboration, Cézanne's influence became most evident when Pissarro once again began to explore floral still lifes. As Joachim Pissarro has suggested, Pissarro's work of the late 1870s could have been in part a response to the three still lifes Cézanne exhibited at the third Impressionist exhibition in 1877.[87]

The influence of Cézanne is certainly revealed in Pissarro's choice of subjects in the series of floral still lifes he created during the last three decades of his life. His later work in the genre is also indebted to his protégé Paul Gauguin, perhaps by such works as *Vase of Flowers* (1896, National Gallery, London). The presence of these two painters can also be felt in the vividly patterned wallpapers and backgrounds that Pissarro employed primarily in his late still lifes of flowers. His first use of background decorative schemes composed of varied motifs and fragments of color can be seen in the fruit studies of 1872 (plates 29, 30) and in *Chrysanthemums in a Chinese Vase.* Though the background is still quite delicate in execution in *Chrysanthemums in a Chinese Vase,* Pissarro began to make it a more active force in the composition, as the printed flowers on the wallpaper repeat the colors and shapes of their living cousins in the bouquet.

In the vibrant still lifes he created toward the end of his life, Pissarro radicalized the concepts he had explored in these two floral still lifes of the 1870s,[88] prefiguring the decorative patterns and elements to be found in the early work of Henri Matisse. Pissarro painted his last still life of a bouquet of roses in 1902, a year before he died in Paris. At this time, Cézanne was composing his own ornate and prismatic *Vase of Flowers* (1903, National Gallery of Art, Washington, D.C.), reminiscent of Pissarro's *Chrysanthemums in a Chinese Vase,* created three decades before, when the artists worked side by side. AAL

CAMILLE PISSARRO, 1830–1903

BOUQUET OF FLOWERS, CA. 1873, OIL ON CANVAS, 21⅜ X 18¼ IN. (55 X 46.4 CM), HIGH MUSEUM OF ART, ATLANTA,

GIFT OF THE FORWARD ARTS FOUNDATION IN HONOR OF ITS FIRST PRESIDENT, MRS. ROBERT W. CHAMBERS

CAMILLE PISSARRO, 1830–1903

CHRYSANTHEMUMS IN A CHINESE VASE, 1873, OIL ON CANVAS, 23¾ X 19½ IN.

(61 X 50 CM), NATIONAL GALLERY OF IRELAND, DUBLIN

PLATES 36, 37

During most of the 1870s, Monet lived in Argenteuil, a small town on the Seine that was rapidly turning into a suburb just west of Paris. Having settled there with his new young wife Camille, and their son, Jean, he found an extraordinary range of subjects and opportunities for compositional innovation near their house. In addition to exploring Argenteuil itself and views of the river, he found in his house and garden many appealing subjects. The years from 1871 to 1878 were an immensely productive period in Monet's life.

In this painting, Monet's delight in his garden and the love of flowers that would suffuse his late years in Giverny are given early expression. The work shows a view from the garden of Monet's first house in Argenteuil, where he and Camille lived from 1871 to 1874. Monet painted this work, with its appearance of rapid and sure execution, the year after his *Impression, Sunrise* (1872, Musée Marmottan, Paris), the painting famous for giving the Impressionist movement its name when it was exhibited at the first Impressionist exhibition. Here, in his view of Camille at the window, Monet inverts the more established idea of a window composition in which the artist is inside looking out, reminding us of his position at his easel in the garden and of his commitment to painting in the open air.

The shutters and windows of the house are thrown open to a warm summer day. Camille, just visible through the window in her hat and coat, seems ready to step outdoors. On the wall behind her is the suggestion of a clock and a framed image of some kind. The interior light appears cool, neutral in contrast to the garden's brilliant blues, reds, pinks, and yellows. Monet's quick dabs of color translate into fuchsia, nasturtiums, roses, and geraniums. Compositionally, the flowers overwhelm Camille's minor presence, even though the work may be considered to belong to the category of still life with figures. Indeed, it is unusual in an oeuvre that focused more on figures in landscape or pure landscape itself. Here, in spite of the geometry offered by the window and shutters that center the composition frontally, nature takes over in the rampant growth of flowers and vines that frame the entire composition, running up the sides of the shutters and bringing the joy of color to what would otherwise be a drab world. In the foreground, three potted plants rest on the ground. A similar grouping of three jardinieres with small trees in them appears in *The Garden* (1872, private collection), another view of the garden of Monet's first house in Argenteuil.[89]

In some respects *Camille at the Window* echoes Monet's winter painting of about two years before, *The Red Cape* (1869–70 or 1871, Cleveland Museum of Art), a view through the window from the inside to the passing figure of Camille outside.[90] Here, too, the effects of nature and outdoor light bring color into the work. Camille, a frequent model for Monet, gave birth to their second son, Michel, in 1878 before her tragic early death the following year in Vétheuil. Like *The Red Cape*, this painting remained with the artist throughout his life and in his family until well into the twentieth century.

EER

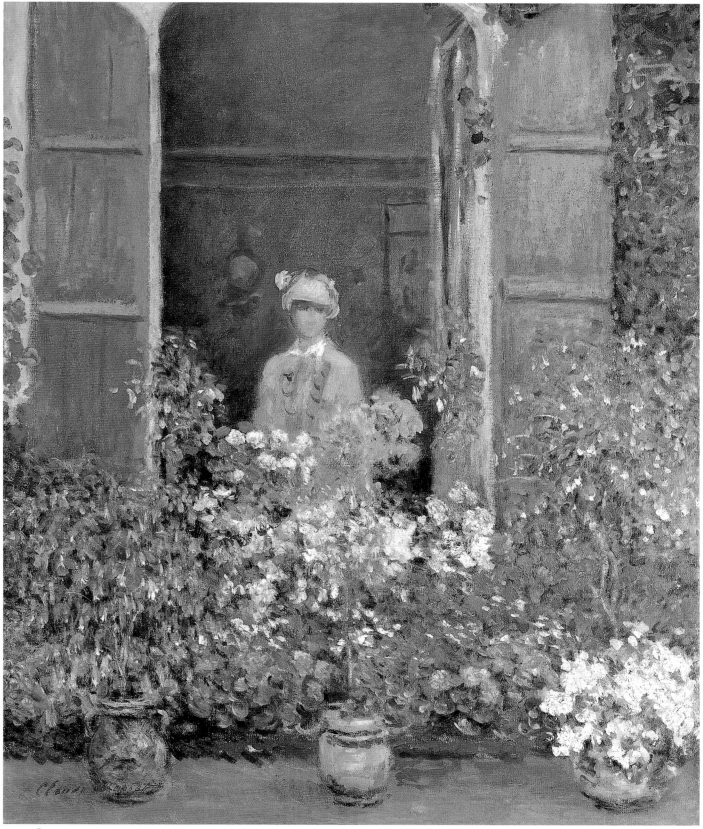

PLATE 38

During the 1870s, the most illustrious decade of his production, Sisley produced two of the finest and most complex still lifes of the nine that are recorded in his oeuvre.[91] Painted in 1876, *Grapes and Walnuts on a Table* and *Still Life: Apples and Grapes* are very closely related in composition and subject matter. It is almost certain that Sisley made use of the same table and room in both works. The Boston canvas is one of forty-five paintings that were acquired from Sisley in 1881 by Paul Durand-Ruel, who had featured works by the artist in an 1872 exhibition at his London gallery. Durand-Ruel specifically acquired this picture for his private collection, in which it remained throughout the dealer's lifetime.

Sisley's handling of paint in these two works suggests a stylistic affinity with the approach to still-life subjects employed by his fellow Impressionists, particularly Monet and Pissarro, with whom the critic Joris-Karl Huysmans compared him in 1883: "Sisley, along with Pissarro and Monet . . . was one of the first to go directly to nature, to dare heed her, and to try to remain faithful to the sensations he feels before her."[92]

The goal of remaining faithful to the sensations encountered in the presence of the subject matter was one of the central tenets of Monet's process in the 1870s and 1880s. His *Still Life: Apples and Grapes* was painted in 1880, four years after Sisley created his related compositions. One of four similar still lifes of apples and grapes that Monet painted at this time, it is strikingly similar to Sisley's pair of still lifes in subject matter, composition, and treatment of light.

Throughout the 1870s and 1880s, as the pictorial category of still life continued to increase in popularity along with its market value, Monet actively promoted his image as a painter of still lifes. He painted eight still lifes in 1880 and five studies of fruit between 1879 and 1880.[93] *Still Life: Apples and Grapes* may be one of the eighteen works that he included in his first one-artist exhibition at the gallery *La Vie moderne*, which opened on 6 June 1880.[94] Despite his evident inspiration and ability, Sisley, however, did not follow his close friend Monet's lead in pursuing still life. Nevertheless, Monet's work in still life certainly influenced Sisley's own experiments in the genre. The two painters had collaborated closely during several periods after meeting in 1862 at the atelier of the Swiss painter Charles Gleyre. They had worked alongside one another during the late 1860s and again in 1872, when they painted landscapes at Argenteuil, capturing the fugitive effects of light and atmosphere.

In all three paintings, the grid pattern of the tablecloth's ridged folds establishes a firm geometric design and ordered composition. Sisley's placement of the knife and nutcracker on the same axis as the sharp horizontal crease of the tablecloth reinforces this structure in the Boston picture. In his *Still Life: Apples and Grapes*, however, this same grid is offset by the contrasting curvilinear volumes of the basket—the arc of its handle and the fruit it contains—which in turn echo the curve of the table and accentuate the soft folds of the curtain in the background. In addition to their affinities with Monet's 1880 still life, Sisley's two carefully arranged compositions also recall Monet's resplendent *Flowers and Fruit* of 1869 (J. Paul Getty Museum, Los Angeles), which was shown at the fourth Impressionist exhibition in 1879. Though Monet's 1869 still life explodes with abundance, he also employed

ALFRED SISLEY, 1839–1899

Still Life: Apples and Grapes, 1876, Oil on canvas, 18⅛ x 24 1/16 in. (46 x 61.2 cm),

Sterling and Francine Clark Art Institute, Williamstown, Massachusetts

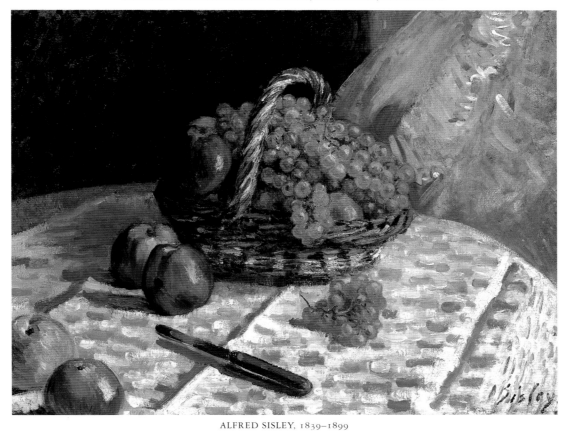

ALFRED SISLEY, 1839–1899

Grapes and Walnuts on a Table, 1876, Oil on canvas, 15 x 21¾ in. (38 x 55.4 cm),

Museum of Fine Arts, Boston, Bequest of John T. Spaulding

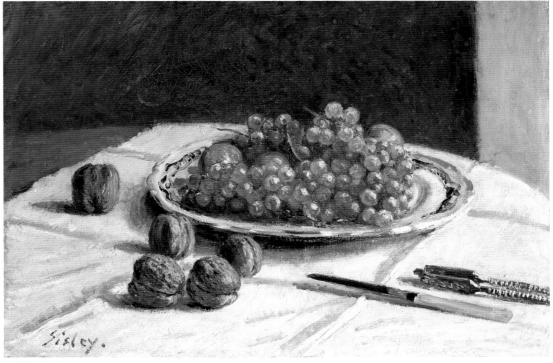

PLATES 39, 40

a grid composed of intersecting diagonal, horizontal, and vertical lines to create balance and order.

The three paintings by Sisley and Monet share not only the same high viewpoint and compositional elements, but also a similar masterful treatment of light. Sisley's description of the textures of his objects through light, such as the shimmering skin of the grapes, the gnarled shells of the walnuts, and the reflective surfaces of the knife and nutcracker, is of paramount importance to the picture's effect. While the dark palette and deep maroon tonality in Sisley's two paintings are reminiscent of Manet's tabletop still lifes of the 1860s, his saturation of the still life with light is not. The light flickers over Sisley's luxuriant displays of fruit and nuts, creating a luminescent, highly dynamic surface.

While Sisley's and Monet's arrangements of fruit are indeed plentiful, they nevertheless belong to a more modest, domestic bourgeois world than to the elegant interiors of Courbet and Manet. Carefully arranging his subjects on a white linen cloth, Manet strove to paint tables set with a cloth "white as a bed of newly fallen snow,"[95] a goal characteristic of the 1860s preoccupation with pure,

bright white. Sisley and Monet, on the other hand, explored the reflective qualities of the folds of their crumpled white tablecloths, which absorb the myriad colors of the fruit displayed upon them. As Henri Loyrette has eloquently noted, with the advent of such works that reflect "like a mirror all the colors of the objects they bore, fragmented by the juxtaposed brushstrokes of Impressionism, tablecloths and napkins would never again show this bright implacable white."[96]

Indeed, it is above all the play of light that animates the surface of these three canvases. In 1893, Sisley remarked in a rare statement, recalling Huysmans's words of a decade earlier,

The animation of the canvas is one of the hardest problems of painting. To give life to the work of art is certainly one of the most necessary tasks of the true artist. Everything must serve in this end: form, color, surface. The artist's impression is the life-giving factor. . . . And though the artist must remain master of his craft, the surface, at times raised to the highest pitch of liveliness, should transmit to the beholder the sensation which possessed the artist.[97] AAL

CLAUDE MONET, 1840–1926

Still Life: Apples and Grapes, 1880, Oil on canvas, 25⅝ x 32⅛ in. (65.1 x 81.6 cm),

The Art Institute of Chicago, Bequest of Mr. and Mrs. Martin A. Ryerson

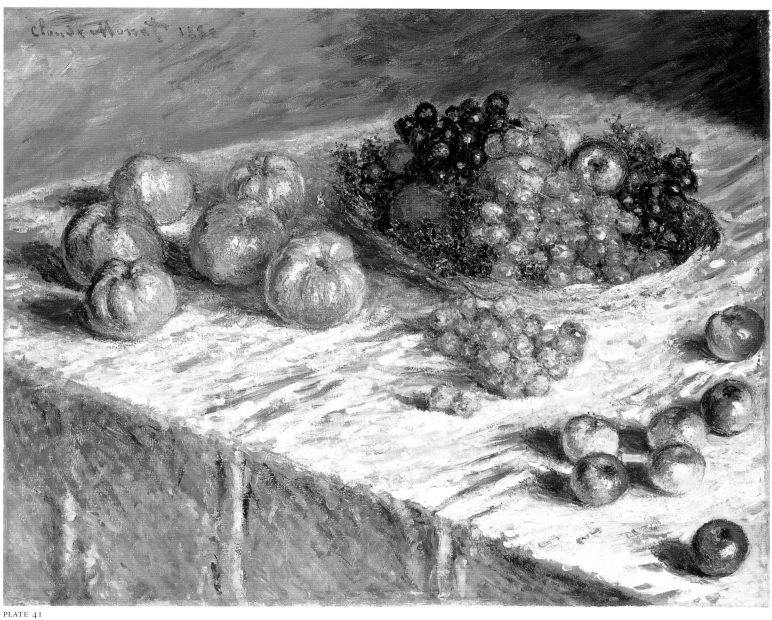

PLATE 41

As an upper-middle-class woman, Berthe Morisot, the only female founding member of the rebel Impressionists, did not paint the boulevards, but rather the life that was her immediate experience, filled with family and friends at home or on holiday. The objects and furniture featured in Morisot's still lifes were part of her day-to-day existence. *Dahlias* and *Tureen and Apple* are two exquisite still lifes probably completed in two different apartments during the early years of Morisot's marriage to Eugène Manet.[98] By 1885, when *The Cage* was painted, the couple and their seven-year-old daughter, Julie, had moved to a house on the rue de Villejust, where Morisot used the high-ceilinged drawing room, which faced directly south, as her studio.[99]

Although the scale of Morisot's work is nearly always small since her studio was a multiple-use space in her home, the boldness of her brushwork and the virtuosity of her color command the viewer's attention. Morisot was an ardent champion of the principle that all form should be expressed with touches of color rather than with line.[100] Considered by her colleagues to be a masterful colorist with accomplished brushwork, Morisot was especially noted for her tonal harmonies in white, silver, blue, and pink tones.

In each of her still lifes, Morisot focused on a few select objects from her household observed close-up. Though her rare experiments with the genre in the 1870s often remained within the bounds of conventional still-life composition, much like those of Fantin-Latour, *Dahlias* and *Tureen and Apple* demonstrate a fresh and bold painting style. Unblended color was rapidly and directly applied, thickly in some areas and quite thinly in others, drawing attention to the surface of the canvas and the painter's process.

Dahlias, one of her earliest still lifes, is built upon the division of the picture space into three horizontal bands. The commode, with a lady's fan set casually on top on the left, becomes a harmony of browns in the bottom third of the canvas, while the profusion of yellows, pinks, reds, purples, and greens that describe the cut flowers is clustered in the upper third of the painting. The dahlias that

give the painting its title spill over the lip of the footed vase and direct the eye to the brilliant white center of the work—the decorated china vase set against a luminous screen of grays, the dark opalescent gray on the left becoming a veil of thinly painted soft grays and whites on the right.

In *Tureen and Apple,* Morisot set the chest at an angle to the picture plane so that the gilded carving at the top of the commode's leg becomes the vertical anchor for the bottom right of the painting. The blue-and-white china soup tureen and the tall, lidded crystal decanter on the marble tabletop reflect the elegance of her comfortably wealthy household. Morisot contrasted the rounded solidity of the blue-and-white china tureen against the vertical transparency of the crystal vessel, which reaches to the very upper edge of the canvas. Although the composition is very much within the still-life tradition, Morisot made her own subtle adjustments to subvert the viewer's expectation. The knife, whose handle is traditionally at the table's edge, inviting the viewer to grasp it, is placed here with the blade facing the viewer, while the apple, glowing like a green beacon subsumed in a pearly fog of grays and whites, becomes the true object of the viewer's attention.

Less conventional as still-life subject matter, the birdcage appears for the first time in Morisot's work in 1885, reappearing in several figurative works a few years later. In *The Cage,* the angle of view is higher than in the earlier works, with the objects now seen extremely close-up. Morisot isolated the birdcage in the center of the canvas, contrasting its open form against a short, round, flower-filled china vase seen both through the cage and to its right. The skeletal birdcage, with its two peach-colored parakeets neatly tucked together like flower blossoms, is set within a luminous field of grays, browns, yellow ochres, greens, and reds. Morisot confidently structured the illusion of space in this painting through color and directional brushstrokes, eliminating entirely the table or commode that she described in the earlier works.

By 1874, the year of the Impressionists' first group exhibition, Morisot was beginning to experiment with works that did not have a standard degree of finish around

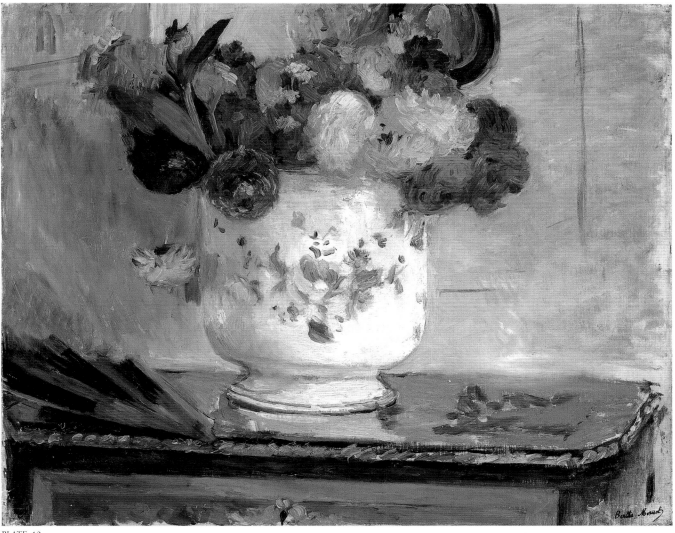

PLATE 42

the edges or in all parts of the background. Although considered less fully developed by conventional standards, Morisot valued and even exhibited these highly evocative paintings, drawing the following remarks from the critic Paul Mantz at the second Impressionist exhibition in 1876: "She will never finish a painting, a pastel, a watercolor; she produces prefaces for books that she will never write, but when she plays with a range of light tones, she finds grays of an extreme finesse and pinks of the most delicate pallor."[101]

Regardless of the subject, Morisot's distinctive style confirms the values she prized most highly in her work. Indeed, each of her still lifes is bathed with her distinctive play of light, and each lays claim to her signature calligraphic brushwork, which suggests not only spontaneity, but also an unfinished look, as if she were drawing with color.

SBF

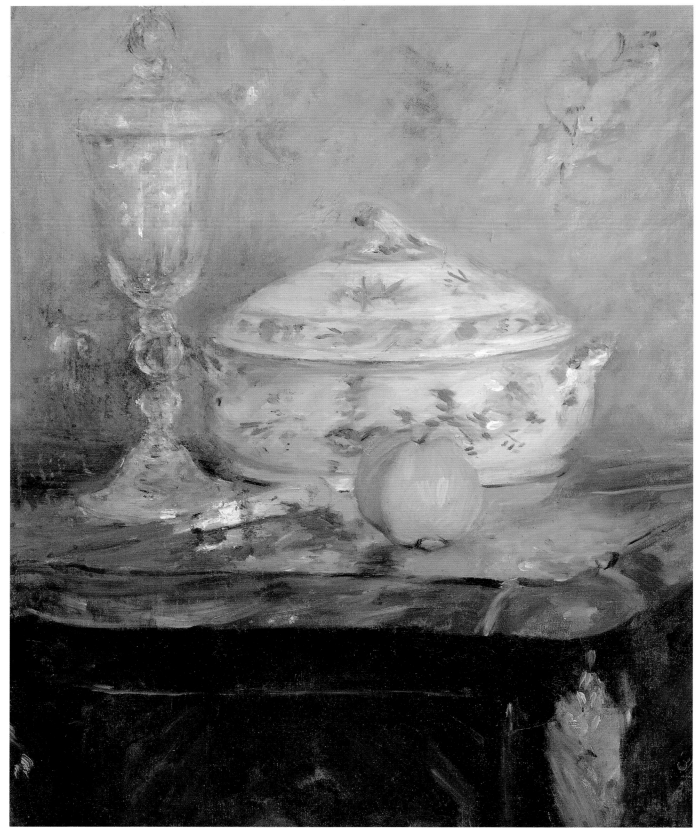

PLATE 43

PLATE 44

Although Edouard Manet completed far fewer still lifes in the 1870s than he had in the previous decade, he returned to the genre with renewed interest in the last years of his life. His still lifes of the 1880s reveal his ongoing fascination with fruit and flowers, but on two occasions he turned to a remarkable subject from the kitchen garden—asparagus.[102]

Two 1880 paintings of asparagus, inextricably linked to one another by their history, constitute Manet's entire still-life exploration of vegetables. Their first owner, Charles Ephrussi, was a collector, patron, and financier well known in Impressionist circles.[103] A man of great wealth and refinement in Manet's social orbit, Ephrussi had agreed to pay eight hundred francs for *A Bunch of Asparagus,* but upon receipt of the work he was so pleased that he instead gave the artist one thousand francs. Manet, flattered by the overpayment, painted a very small picture (6½ by 8½ in.) of a single stalk of white asparagus on a marble table (*Asparagus,* 1880, Musée d'Orsay, Paris) and sent it to Ephrussi with the witty note, "Your bunch was one short."[104]

Looking closely at *A Bunch of Asparagus,* one can imagine why Ephrussi was so pleased. A glorious bunch of uncooked, firm white asparagus, bundled as it must have come from the market, lies on top of a bed of greens strewn across a white surface. Centrally placed, the bundle of asparagus is set against a dark background, against which it seems to loom unnaturally large, filling the space of the canvas and commanding our attention.

Manet's deft handling of paint is vividly in evidence everywhere. His loose brushwork is so alive in his treatment of the bed of greens as to anticipate the abstract expressionism of the mid-twentieth century. Although the asparagus may be white, it is far from colorless. The large stalks are a mass of yellow and white, green and rose, while the tender tips explode in a crescendo of dabs filled with purples and blues, greens and yellows. This is truly the asparagus described so vividly by Marcel Proust in *Swann's Way*—a delicacy possessed of a "rainbow-loveliness that was not of this world."[105]

Gigantic and engorged, lying on its side like a body stretched out on a messy coverlet, Manet's *Bunch of Asparagus* is treated differently than similar subjects by his contemporary Philippe Rousseau, a professional still-life painter who was much more naturalistic in his rendering of this early spring delicacy. In *Still Life with Asparagus* (1880, private collection, Cleveland), Rousseau depicts a dramatically illuminated vertical bunch of supple white asparagus that spills onto the platter next to it. By contrast, Manet allows his firm, uncooked white asparagus to dominate the composition by its unnaturally monumental scale and by the harsh allover lighting that eliminates nearly all shadows.

A Bunch of Asparagus is another of Manet's artistic enigmas. White asparagus is relatively rare in the artistic lexicon.[106] To a Parisian of the late nineteenth century, however, such asparagus would have been recognized as the variety cultivated in Argenteuil, a village on the Seine outside of Paris. A Parisian would have also recognized this asparagus as a delicacy fit for the table of a wealthy person, one accustomed to cooking in the grand style.[107] This cooking style required equally grand serving dishes, including an astonishing variety of asparagus-shaped soup tureens, vessels that had become relatively common in cultivated upper-class and aristocratic households since the eighteenth century.[108] As it happens, *A Bunch of Asparagus* is fully as large as any soup tureen. Could Manet, who adored witticisms and puns, have created his monumental *Bunch of Asparagus,* the ultimate homage to an early spring Parisian delicacy, as a humorous nod to his contemporaries' grand table services? It is fun to contemplate. SBF

PLATE 45

During the late 1870s the color, energy, and experimentation in Cézanne's work resulted in his highly individual use of Impressionist technique. His brushstroke and almost aggressive manipulation of form reflected the passion and intensity of his temperament.[110] In *Compotier and Plate of Biscuits*, Cézanne achieved an ordered composition that is nonetheless full of movement. The fruit dish on a stand provided a way to elevate a part of his still life, creating a dynamic interplay of elements across the surface. Cézanne further avoided a static composition by artfully manipulating the tablecloth to make rich folds, like the drapery in old master paintings he so admired. The folds themselves, at the center of the composition, suggest movement that builds toward the *compotier*, which is filled with a colorful combination of red and yellow apples and greenery. Equally compelling in terms of form is the tower of biscuits on the left, which appears by its weight to hold the tablecloth in place. Cézanne must have felt the need to counterbalance the dark green leaves in the *compotier* (in themselves an unusual aspect of this painting) with the green bottle in the left foreground. The bottle serves to remind us that the objects he endowed with such scale and monumentality are in reality not very big. In this painting, they appear to rest on the same chest that is included in so many later works (see plates 48, 49). Cézanne carried this chest with him on trips north from Provence; indeed, the wallpaper shown behind it in this painting has been identified with the apartment he occupied in Paris in 1877 at 67, rue de l'Ouest.[111] The wallpaper's diagonally embossed motif carries the eye upward and lends movement throughout the composition, unifying its various elements.

At the end of the 1870s and beginning of the 1880s, Cézanne dedicated tremendous energy to his exploration of still life. Some of these works seem to develop out of the compositional strategies initiated in *Compotier and Plate of Biscuits*; others reveal a desire to focus on fewer objects. In the process, he made many smaller works, such as *Pears and Knife*.

Two pears and a pot of preserves share the field of this small painting with a knife placed at a gentle diagonal in the foreground. Obliquely opposing the diagonal of the knife is a passage of canvas where the unpainted ground is visible, allowing our eye to imagine a planar shift, perhaps an edge that Cézanne declined to describe further. The placement of the pears seems deliberately designed to allow the artist to study the contour and difference of each piece of fruit rather than to explore overlapping forms, as he so often did even in his smallest still-life paintings of this time. The composition is therefore unusual, made even more so by the introduction of the jam jar, a choice of object that relates to only one other painting by Cézanne, a similarly small work from circa 1880–81.[112]

From 1877 to 1879 Cézanne painted approximately fifteen small studies of fruit. These spare, modest canvases, which functioned as visual exercises for Cézanne, hark back to some of Chardin's paintings like *Pears, Walnuts and a Glass of Wine* (n.d., Musée du Louvre, Paris).[113] Cézanne's studies feature pieces of fruit (apples or pears and occasionally grapes) in simple arrangements of two or three or as many as eight or nine on a table, in a bowl, or on a plate.[114] In each, the disposition of forms across the canvas is different, posing a subtly differentiated range of problems for the artist to master.

EER

PAUL CÉZANNE, 1839–1906

Compotier and Plate of Biscuits, CA. 1877, OIL ON CANVAS, 20⅞ x 24¾ IN. (53 X 63 CM), PRIVATE COLLECTION, JAPAN

PAUL CÉZANNE, 1839–1906

Pears and Knife, 1877–78, OIL ON CANVAS, 8⅛ x 12¼ IN. (20.5 X 31 CM),

ASHLEY ASSOCIATES

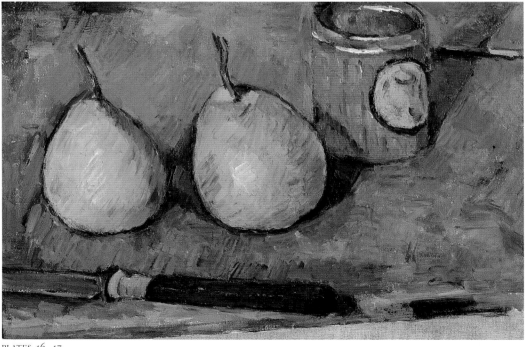

PLATES 46, 47

Between about 1879 and 1881 Cézanne produced a series of eleven still-life paintings from a motif arranged on a chest in front of a bluish leaf-patterned wallpaper. These works culminate a decade of extraordinary development and change in his work and may be seen to mark a critical turning point for Cézanne—the transition from Impressionism to the mature style of his later years.[115] During the 1870s Cézanne had become a close friend of Camille Pissarro, with whom he explored Impressionist technique and plein air painting, an experience that eventually led to the development of his own method of short, parallel brushstrokes as a means of recording his visual perception of color and light.[116] In this series of paintings from about 1879 to 1881, Cézanne was with great deliberation laying the foundation of his future work, rearranging the same few elements to explore variations on a theme.

It has generally been assumed that Cézanne painted all of his still lifes that show the bluish wallpaper with its sprays of leaves and the wooden chest (identifiable by the latch in the immediate foreground of the composition) in the north, where he traveled quite often during this period, bringing his wooden chest with him.[117] Scholars continue to debate, however, where precisely they were painted.[118] They may have been painted in the house in Melun where Cézanne spent eight months in 1879 or in the apartment at 32, rue de l'Ouest in Paris, where Cézanne stayed from the spring of 1880 to the spring of the following year. The most convincing evidence for the latter may be the fact that he is presumed to have been in Paris when he painted a portrait of the son of his friend and neighbor, *Portrait of Louis Guillaume* (ca. 1880, National Gallery of Art, Washington, D.C.), which shows the same patterned wallpaper behind the figure.[119]

All of the compositions with the chest and bluish paper are composed primarily in two nearly equal horizontal registers, that of the top of the chest and that of the wall behind, establishing a pictorial field in which depth is only conveyed by the elements of the still life themselves. *Still Life with Compotier*, with its richly folded napkin that cascades over the edge of the chest, is unique in this series in combining two round dishes—a fruit dish on a stand (*compotier*) and a plate—of apples. The arrangement of the dishes at opposite sides of the composition, like a pair of scales, affords it an unusual kind of equilibrium, with one group of apples in the upper register and the other in the lower register. In its elaborately constructed path across the surface of the chest, the folded napkin stops short of crossing the carefully calibrated horizontal that divides the upper and lower portions of the composition. At the same time it counters the diagonal created by the relationship of the two dishes and leads the eye toward the leaf motifs in the wallpaper, with which it shares tonalities.

Cézanne reworked certain passages of the painting, giving particular attention to contours. The flat planes he employed as the framework for his composition are offset by the sense of weight and physical presence of the objects on the chest. His cropping of the fruit dish on the left reinforces our reading of the elements across the surface.

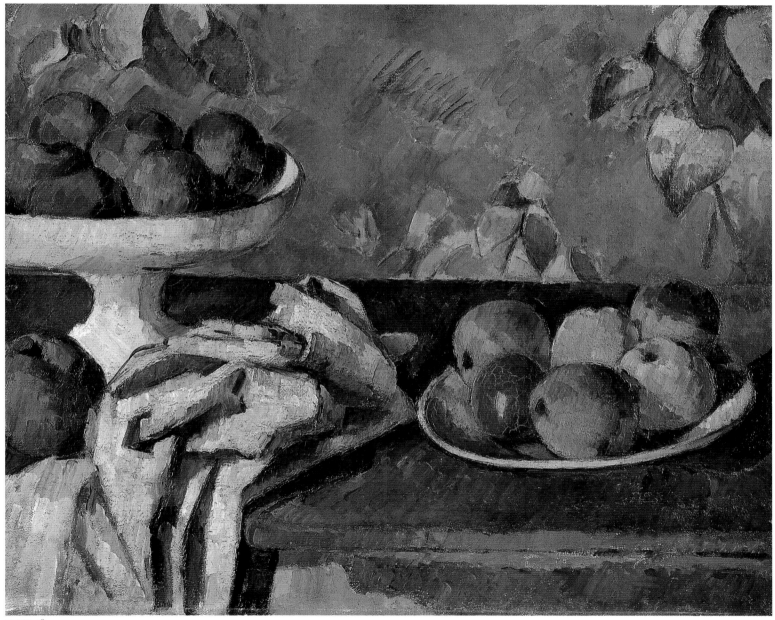

PLATE 48

Cézanne miraculously allows the eye to travel across the surface of the painting in his richly nuanced tones of grays and blues while at the same time inviting a reading of the ridges and folds as sculptural forms as if they had been carved out of the painted surface itself.

In *Still Life with Milk Can and Apples*, there are no rounded forms except the apples themselves and the tubular vertical element of the milk can, which provides a somber stabilizing element to the left of the composition. In place of the highly sculptural white *compotier* as a culminating point, here the napkin itself rises to a peak. The red, golden, and green apples surround the base of the napkin, which is crumpled and folded in such a way that its upward movement in the center of the composition gives a focus and dynamism to the whole. Its diagonals and curved forms are rendered with both strength and nuance in short hatchings of shades of blue-green, gray, and white to convey a powerful form reminiscent of the profile of the Mont Sainte-Victoire.[120] Again the composition is divided almost in half horizontally, and the fruits on the right do not cross above the "horizon" of the far side of the chest.[121] In its shades of aqua blue, blue-gray, lavender, and white, the napkin shares tonalities with the leaves of the wallpaper, creating a rich dialogue in paint between flatness and sculptural illusion.

Of all the paintings in this series, *Still Life with Compotier* bears the closest resemblance to the painting of the same name (*Still Life with Compotier*, 1879–80, Museum of Modern Art, New York), that was the prized possession of Gauguin, who once said he would part with the shirt off his back before giving it up.[122] This extraordinary work that includes a glass as well as a *compotier*, napkin, and fruit was included in Gauguin's *Portrait of Marie Derrien* (1890, Art Institute of Chicago) and also is the still life celebrated in Maurice Denis's *Homage to Cézanne* (fig. 38). The description of this work by the artist and influential critic Roger Fry may be seen to apply to some considerable degree to *Still Life with Compotier* and *Still Life with Milk Can and Apples*:

Each touch is laid with deliberate frankness, as a challenge to nature, as it were, and, from time to time, he confirms the conviction which he has won by a fierce accent, an almost brutal contour, which as often as not he will overlay later on, under stress of fresh discoveries and yet again reaffirm. These successive attacks on the final position leave their traces in the substance of the pigment, which becomes of an extreme richness and density. . . . It is by such considerations . . . that we may judge of the rare perfection of this work of Cézanne's. And one must, I think, venture to proclaim boldly that it represents one of the culminating points of material quality in painting. Under the double impulsion of his analysis of coloured surfaces and of his native feeling for large structural unities Cézanne created a new pictorial beauty.[123]

EER

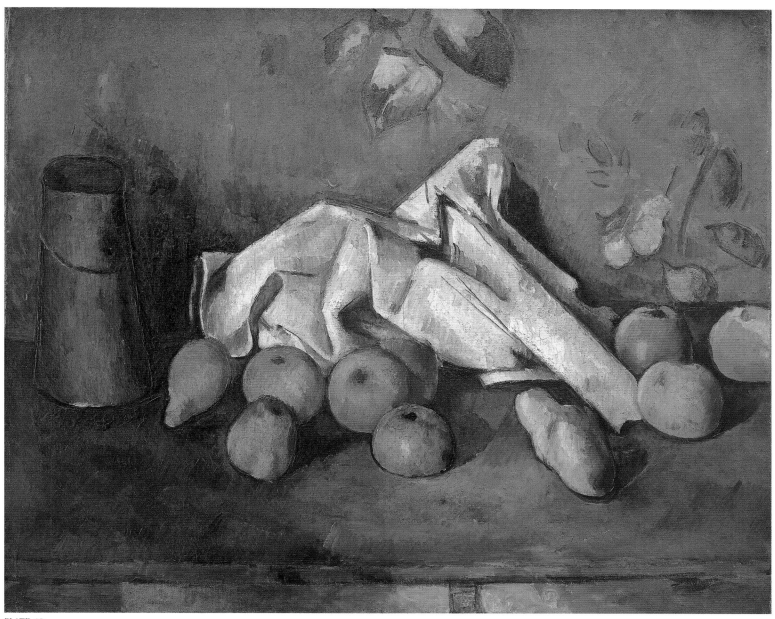

PLATE 49

enoir's *Onions*, so different in its humble subject from his expected flowers and fruits, was painted late in 1881 during the artist's stay in Naples, part of an extended trip through Italy intended to transform his figural style into something more solid and classical.[124] Although most of the paintings that originated from his Italian trip were landscapes and figure studies, Renoir wrote to his friend Charles Deudon from Naples in December 1881 announcing that he was sending to Paris one or two still lifes, at least one of which he hoped was good.[125] *Onions,* believed to be one of these two still lifes, employs Renoir's light Impressionist palette, emphasizing a limited range of pastel colors and tight but lively brushwork, particularly to define the rounded shapes of the onions and to animate the plain background with rhythmic and feathery diagonal brushstrokes.

This small still life is composed of six onions and two bulbs of garlic arranged asymmetrically in extreme close-up on a crumpled white napkin or kerchief, bordered in stripes of blue and red, and placed on a white tabletop. The two garlic globes, tiny round cousins of the onions, are part of Renoir's virtuoso handling of white on white in the tabletop and napkin. Of all the local produce that Renoir could have chosen, he settled on onions. Perhaps what attracted him to this everyday vegetable were the qualities he exploited in the painting. His onions are defined as much by their luminescent skins of pink and gold as by their bulbous bodies. Each culminates in a stem surmounted by wispy remnants of a stalk now withered to tiny ribbons that seem to ripple in the air, evidence of a life force still contained within each bulb. If, as scholars have suggested, Renoir painted *Onions* during his Italian trip as a way of escaping the complications of his more ambitious figure paintings, he nonetheless chose a vegetable that has certain affinities with the human form and its translucent skin.[126]

Renoir's artful composition—in which all of the evenly illuminated objects are inscribed within a circle set within a rectangle—is spatially understandable in an almost classical manner. Although the onions and garlic are arranged to appear as if they were casually set down on the table, they are in fact carefully placed, leaning left and right to create a circular movement of form, and encircled by the cloth's serpentine blue-and-red-striped border. Every element contributes to the composition's sense of intimacy and harmony: the softly rounded edge of the table arching from left to right in the middle of the composition echoes the rounded forms of the onions, and the garlic at bottom center acts as both a visual anchor and as the starting point for the cloth's sinuous blue-and-red border that touches its side and defines its right contour.

Renoir's deceptively simple study of onions and garlic may have been important for van Gogh. Scholars have suggested that van Gogh's *Still Life: Red Cabbage and Onions* (1887, Van Gogh Museum, Amsterdam) is related to Renoir's *Onions,* which the Dutch artist could very well have seen at Durand-Ruel's gallery in Paris in 1886.[127]

SBF

AUGUSTE RENOIR, 1841–1919

Onions, 1881, Oil on canvas, 15⅜ x 23⅞ in. (39.1 x 60.6 cm),

STERLING AND FRANCINE CLARK ART INSTITUTE, WILLIAMSTOWN, MASSACHUSETTS

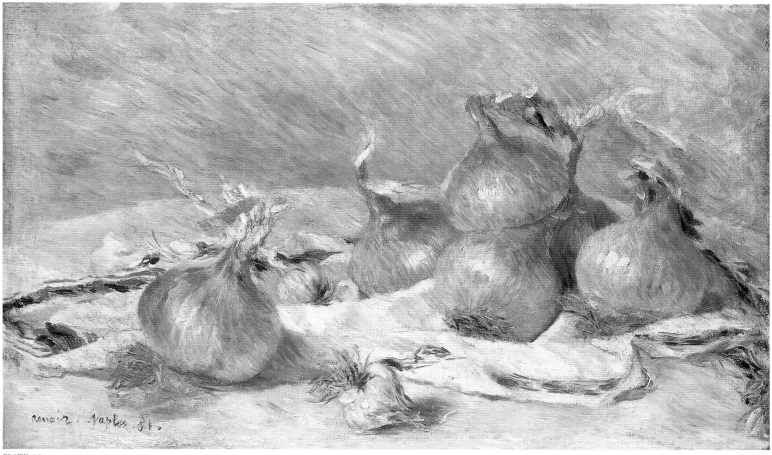

PLATE 50

Exhibiting together at the second Impressionist exhibition in 1876, Monet and Caillebotte established a close friendship that would endure until Caillebotte's death almost twenty years later. Of more modest means than his upper-class comrade, Monet relied heavily on monthly advances provided by Caillebotte during the 1870s and early 1880s. Caillebotte purchased Monet's works when he was having difficulty selling them, paid his rent at two locations, and settled an outstanding debt of Monet's that had landed him in court.[128] The two artists shared a mutual admiration that is clear in their letters.[129] Caillebotte refused to take part in the 1882 Impressionist exhibition without Monet and was asked to serve as a witness at his 1892 Giverny wedding to Alice Hoschedé.

Monet's *Pheasants and Plovers*, painted in 1879, and Caillebotte's *Game Birds and Lemons*, from four years later, illustrate the artists' shared sensibility. In both works, the fruits of the hunt lie on a white surface—a damask tablecloth in Monet's rendering, a slab of marble in Caillebotte's. Angled at opposite diagonals, each table fills the width of its respective canvas, the foreground corner cropped, just as the length of the table is cut off at the painting's opposite edge. The gray-blue background of each work, although measurably darker in Caillebotte's picture, is echoed in the plumage of the birds, which are positioned perpendicular to the long edge of the table, side by side, their heads pointed toward the viewer. Not yet dressed for cooking, the birds are pristine; in neither canvas is there evidence of the wounds that brought them to the artists' tables.

In 1879, when he painted this and two other pictures of game birds, Monet was struggling to cope with the death of his first wife, Camille. In declining financial health, the artist was left to care for his two sons and was beginning to seriously question the benefits of his association with the Impressionists. These pheasant pictures, along with a trio of paintings of fruit, were probably produced for ready sale during this uncertain time.[130] Indeed, the deliberateness of each brushstroke that defines the forms of the birds' bodies contrasts sharply with the more intuitive approach he took in his landscapes from the same period. It is as if Monet were trying to assert his place in the lineage of the eighteenth-century still-life tradition of Jean-Siméon Chardin and Jean-Baptiste Oudry, thus assuring the sale of his work. That he exhibited *Pheasants and Plovers* in 1880, at his first solo exhibition, and two years later at the seventh Impressionist exhibition suggests his desire to be associated with this genre of still life, even though he had devoted a mere six canvases to the subject of game birds before 1879 and would produce only one more in his long career.[131] All three of the pheasant paintings from 1879 were sold to prominent Paris dealers by 1880.[132]

Caillebotte would have seen Monet's painting at the 1882 Impressionist show, if not before. One year later, he painted his version of the subject.[133] While the initial conception for the work seems to derive directly from Monet's composition, Caillebotte subtly pushed the convention further. Pairing his pheasant with woodcocks instead of Monet's plovers, Caillebotte created a much less orderly arrangement. His birds are not laid out tidily, one

CLAUDE MONET, 1840–1926

Pheasants and Plovers, 1879, Oil on canvas, 26¾ x 35½ in. (67.9 x 90.2 cm),

The Minneapolis Institute of Arts, Gift of Anne Pierce Rogers in memory of John DeCoster Rogers

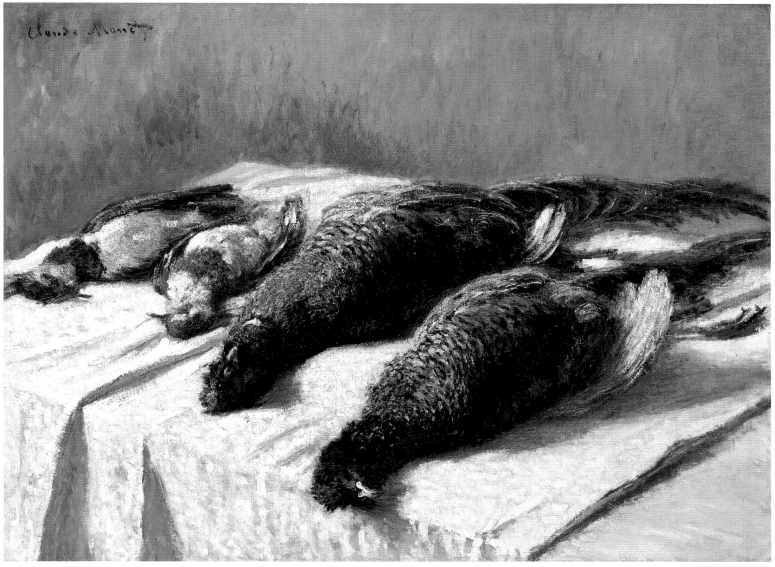

PLATE 51

by one, but overlap one another, the leftmost bird (or birds) partially cut out of the picture space. Tilting the table up toward the viewer, Caillebotte created a more puzzling compositional space. And while Caillebotte employed the same device of the white ground to set off the vibrant colors of the plumage, he described his marble surface with a feathery brushstroke that echoes the surface of the birds themselves.

Caillebotte also made the striking addition of three lemons to the scene. Highlighting the golden feathers of the pheasant, the lemons add a colorful piquancy to the composition, much as they are used in cooking to intensfy the flavor of a meal. But are these lemons that will be used in cooking the game birds, as Manet seems to suggest in his kitchen still life from 1864 (*Still Life with Fish,* fig.55)? Not yet dressed, Caillebotte's birds are far from the cooking stage. It is almost as if we were meant to feast visually on them as they are, with a sprinkle of lemon. Like Monet's composition, which presents the dead birds on a fine table linen, thereby placing the scene somewhere between the bourgeois dining room and the kitchen, Caillebotte's painting hovers in a space of ambiguity.

JAG

GUSTAVE CAILLEBOTTE, 1848–1894

GAME BIRDS AND LEMONS, 1883, OIL ON CANVAS, 20 X 32 IN. (51 X 81 CM),

MUSEUM OF FINE ARTS, SPRINGFIELD, MASSACHUSETTS, JAMES PHILIP GRAY COLLECTION

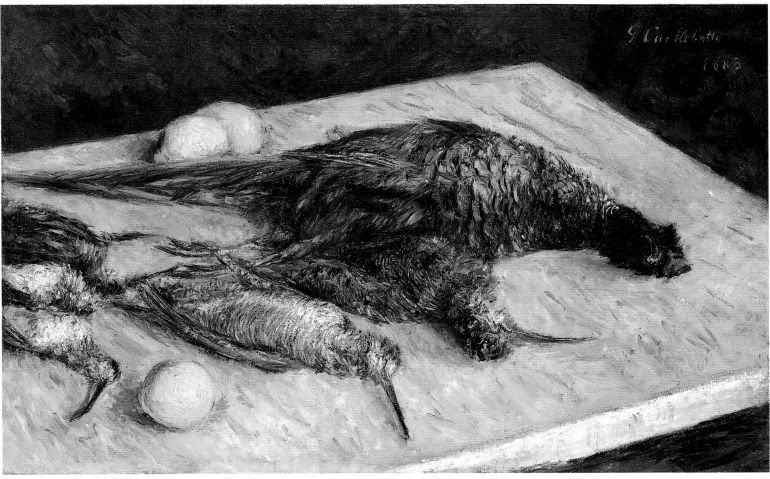

PLATE 52

ike her friend and mentor Edgar Degas, Mary Cassatt was fundamentally a figure painter; she turned to pure still life only twice in her career. Also like Degas, Cassatt was a great chronicler of modern life who often used objects—carefully chosen and deftly depicted—to embellish her chronicle, set a scene, or signify a social situation, a class, or a personality. In 1879, for example, she painted an extraordinary image of an ordinary social event, *Tea*, posing her sister, Lydia, at left, with an unidentified woman in the comfortable bourgeois interior of a Paris apartment.

Objects and surfaces define the social sphere of the women: the visitor is distinguished from the hostess by her hat and gloves. The naked hand of the hostess touches her chin, while the visitor's kid-gloved hand holds a teacup, obscuring much of her face. Cassatt recorded the elements of the decor with care. Her women sit on furniture upholstered in a cream-and-red chintz. A delicate, tasteful gray-and-rose wallpaper forms the spatially ambiguous background wall, which terminates at right with a Louis XV–style fireplace fitted for burning coal. A blue-and-rose porcelain vase, with gilt-bronze mounts, ornaments a white marble mantelpiece, surmounted by a gilded rococo-style overmantel mirror. Beside the mirror, almost invisible against the stripes of the wallpaper, hangs a tasseled bellpull used to summon a servant.

But most conspicuous of all the objects in the painting is the gleaming tea tray of highly polished silver, holding a silver teapot, a matching sugar bowl and lid, and a china teacup, which together form an arresting still life at the lower right-hand corner of the composition. The silver pieces are from a service made in Philadelphia around 1813, which belonged to Cassatt's grandmother, Mary Stevenson, for whom she was named. The service passed to the artist's parents and was brought from Penn-

sylvania to Paris in 1877, when the elder Cassatts joined their daughters there to set up housekeeping.[134]

In comparison to the background details, the tea service is painted with an almost hallucinatory precision, its reflective surfaces brilliantly rendered in tones of blue-black, gray, and vivid white, shot through with glints of pink. It seems to hover above the very foreground of the picture space, the handle of the tray threatening to break through the plane of the canvas into the viewer's world. At the Impressionist exhibition of 1880, the critic Paul Mantz paid particular attention to this detail:

Unfortunately, to complete the decor and lend veracity to the scene, accessories had to play a role, in the form of a tray on the table with all the necessary accoutrements. The artist managed—not without difficulty—to show a teapot in English metal, but *what* was to be done about the sugarbowl? Circular shapes in perspective, light reflected on curving surfaces! Impossible task! Mlle. Cassatt has made her lines dance, she has crumpled the metal, she has not known how to express her thoughts. This unfortunate sugarbowl is left floating—dream-like—in mid-air. The life of the Independents is not without its tragic hours.[135]

But the critic misunderstood Cassatt's intentions. She had a purpose in using intensified contrast and daring spatial effects to call attention to this still life of silver. To her, the silver tea set from Philadelphia represented her heritage, her decorous and dignified American ancestry. To further strengthen her point, she deliberately contrasted the sharp, cool surfaces of the silver with the warm gilded surfaces of plaster and bronze at upper right, faint echoes and distant memories of France's ancien régime. The still life affirms Cassatt's position in Paris—a stranger among the French, but one with every claim to their respect.

GTMS

PLATE 53

"This is how still lifes should be done," commented Joris-Karl Huysmans of the dining-room scene Gustave Caillebotte exhibited with the Impressionists in 1880.[136] Perhaps encouraged by the critic's praise, Caillebotte painted six more still lifes between 1880 and 1883 memorializing the opulence of late-nineteenth-century bourgeois dining. Whether fruits of the sea or of the pastry shop, Caillebotte's culinary delights are neatly arranged in spaces devoid of a human presence, waiting patiently, it seems, for the feast to begin. That Monet painted *The "Galettes"* while sharing a Paris studio with Caillebotte gives added weight to the visual correspondences between his still life and Caillebotte's paintings of set tables.

Born into affluence, Caillebotte was conversant with the details of fine dining. *Still Life: Oysters,* one of his most elaborate works in this vein, features an assortment of circular forms—two lemon halves, a bottle of wine in a round saucer, and a place setting with two goblets—which echo the curved outlines of the centerpiece of shucked oysters. Surveying the arrangement from above, one is able to see only a small portion of the chair still awaiting its occupant between the diagonal line created by the table's edge and the top of the canvas. Is the chair meant to mark our place at the table, or do we occupy a place opposite it, beyond the space of the painting? Unlike the artist's *Luncheon* (1876, private collection), which provides compositional cues inviting the viewer to assume a place at the Caillebotte family table, *Still Life: Oysters* confronts us with a setting that is difficult to read. Our slightly skewed, cropped view of the table is the glance of a passerby, perhaps that of another restaurant patron making his way to his table. We do not know who will dine on this costly meal but can be reasonably certain of that person's social station. Only a member of society's upper echelons—such as Caillebotte himself—would fit the part.[137]

Hors d'oeuvre and *Still Life with Crayfish* suggest a more inclusive—although still resolutely upper-class—dining experience. Featuring four serving dishes seen from above, the rightmost of which is partially cropped out of sight, *Hors d'oeuvre* puts the viewer in the position of a diner or perhaps a waiter scanning the sideboards at a buffet. The depiction in this long, horizontal canvas of nothing more than a series of diamond-shaped containers points to Caillebotte's underlying interest in the cadences created by the repetition of their outlines. As with Caillebotte's late flower pictures, which exhibit the artist's delight in pattern and design, in *Hors d'oeuvre* the surface of the canvas itself is at the forefront of the artistic exercise. It is as if the inclusion of a serving utensil or the suggestion of a human presence would bring the painting too far into the space of reality and out of the domain of abstraction and artistry.

The silverware and stacks of plates in *Still Life with Crayfish* indicate a buffet or banquet setting similar to that of *Hors d'oeuvre.* The dish that will be shared once the plates are distributed is "langouste à la Parisienne," which, as Douglas Druick has explained, is prepared by slicing the meat into small pieces and then inserting it back into its shell with vegetables and a garnish of truffles and aspic.[138] Laid across the length of a large silver platter, Caillebotte's crayfish appears as elaborate as its preparation. The meal is as much a feast for the eyes as it is for the palate, the white backdrop of the table linen emphasizing the shell's vibrant red and coral tones. As our eye follows the line of black circles dotting the body of the crayfish up to the background stacks of plates, the imminent destiny of the display becomes clear. It will soon be divided into many bites and bathed in the sauce of the adjacent silver boat.

Implicit in *Still Life with Crayfish* is the suggestion of studied refinement, social performance, and well-bred respectability. The elaborate, almost ostentatious display hints at the kind of person who might be engaged in polite conversation beyond the edges of the canvas—top-hatted Parisian gentlemen and bejeweled bourgeois ladies as gorgeous as the food before them. By contrast, Monet's *The "Galettes"* has a decidedly simpler feel. It partakes of pictorial strategies characteristic of Caillebotte's work but is bred of a remarkably different sentiment.

The last tabletop still life that Monet painted until 1907, *The "Galettes"* celebrates the flaky, round pastries of Paul Antoine Graff, master pâtissier and owner of the hotel-restaurant aptly named "At the Sign of the Famous Galettes."[139] After painting at various locations along the Normandy coast in 1881 and 1882, Monet was particularly taken with the setting of Graff's Pourville establish-

GUSTAVE CAILLEBOTTE, 1848–1894

Still Life: Oysters, 1881, Oil on canvas, 15 x 21¾ in. (38 x 55 cm), Private collection

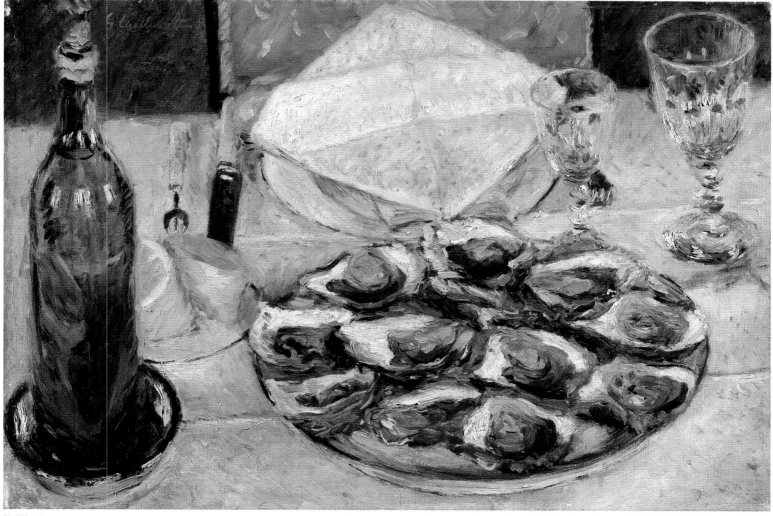

PLATE 54

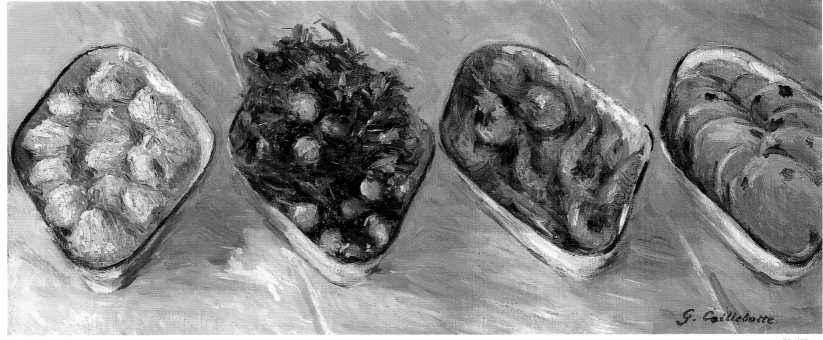

PLATE 55

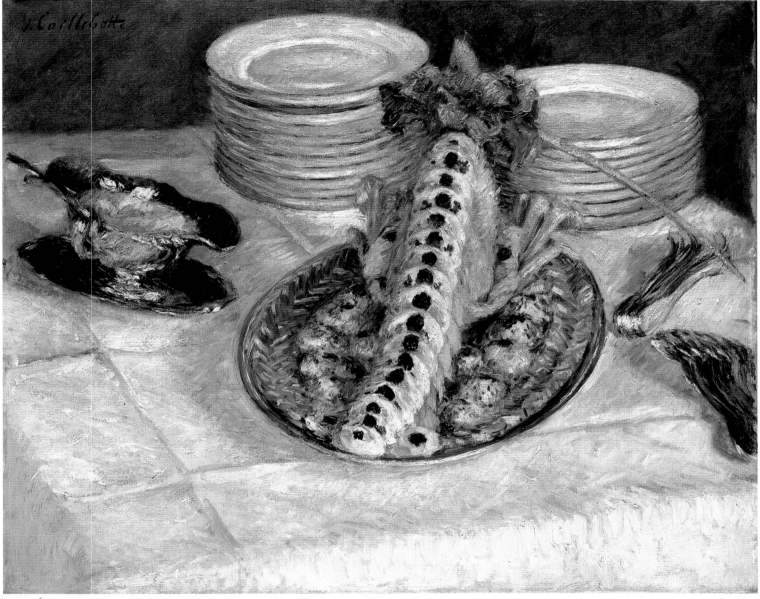

PLATE 56

ment, which provided him with an ideal vantage point from which to paint the sea. "One could not be closer to the sea than I am," he wrote to Alice Hoschedé during his first stay there in the spring of 1882. "The waves hit up against the foot of the house."[140] Monet's affection for the place extended to its proprietors, exemplified in the two portraits he painted of "Père Paul" and his wife, Eugénie Lavergne, with their dog (1882, Österreichische Galerie, Vienna, and Fogg Art Museum, Harvard University Art Museums). The "Galettes," which hung for a time at Père Paul's, was not painted until Monet's second stay in Pourville, with his children and the Hoschedé family in June 1882.

Laid out on two sizes of osier racks and flanked by a knife and a flask of cider, Père Paul's galettes appear, like Caillebotte's culinary arrangements, to await the party who will take the first bite.[141] Round forms predominate, as in Caillebotte's Still Life: Oysters, although here more economically; a simple trio of circles echoes the curved edge of the table, which cuts across the canvas's upper-left corner. The neck of the flask is cropped out of view, abstracting the bottle to a globe of amber color and heightening the unity of the forms. The black-handled knife, which sits perpendicular to the wooden slats of the table, almost seems to interrupt the curvilinear rhythm that defines the composition. The knife is essential if the cakes are to be divided and consumed, yet its handle is not positioned for the viewer's hand; subverting traditional still-life formulas, Monet put the blade, rather than the handle, within the viewer's reach. Does the knife's position reflect the artist's desire to modernize the genre, or can it be read as an impediment to the consumption and thus the dissolution of the harmonious composition he has crafted? The rustic arrangement of an unadorned table set with pastries seemingly aglow with the oven's warmth, however, is unambiguously inviting. Unlike Caillebotte's depictions of bourgeois fastidiousness, Monet pictured a simple culinary pleasure that sings of communal enjoyment and effortless conversation.

Some of Monet's other still lifes, particularly those depicting fruit strewn about the surface of a table, such as Still Life: Apples and Grapes (plate 41), share the same spirit of relaxed ease that defines The "Galettes." Monet also employed the tilted-up table in this painting of apples and grapes, although to a much lesser degree. In fact, nowhere else in Monet's oeuvre do we see such an extreme table angle as in The "Galettes," yet, as we have seen, this was a pictorial strategy commonly used by Caillebotte. Compare the structure of The "Galettes" to Caillebotte's Still Life with Crayfish. The eye moves diagonally in these cropped views of set tables tilted forward "for the viewer's delectation" from the left foreground to the upper-right corner.[142] We are left to surmise how each scene fits within a larger environment, the absence of which allows us to focus on the formal relationships between the objects depicted.

Because Monet and Caillebotte shared a Paris studio during the years these works were painted, it seems likely that the visual connections between them represent a sharing of ideas. We do not know whether they ever painted together on the ground floor of 20, rue Vintimille, but they would have most likely had the opportunity to view each other's works there.[143] Between trips to the Normandy coast, Monet could have seen Caillebotte's still lifes, which the artist did not readily sell.

Monet and Caillebotte were longstanding friends, and their admiration for each other is most evident in Caillebotte's borrowings of specific views painted by Monet in his landscapes and seascapes. In the case of The "Galettes," however, it appears that the elder artist was influenced by Caillebotte's aesthetic. Monet's painting, however, takes Caillebotte's characteristic view from above to an even greater level of spatial uncertainty, foreshadowing the work of Cézanne. Whereas Caillebotte's sumptuous dishes are angled toward us but still firmly grounded on their tables, Monet's pastries threaten to slip or spin off their serving wheels into the viewer's space. Monet, who requested the painting from Père Paul to exhibit at his one-man show at Durand-Ruel's in 1883, clearly considered it one of his best works.[144] JAG

CLAUDE MONET, 1840–1926

The "Galettes," 1882, Oil on canvas, 25⅝ x 31⅞ in. (65 x 81 cm), Private collection

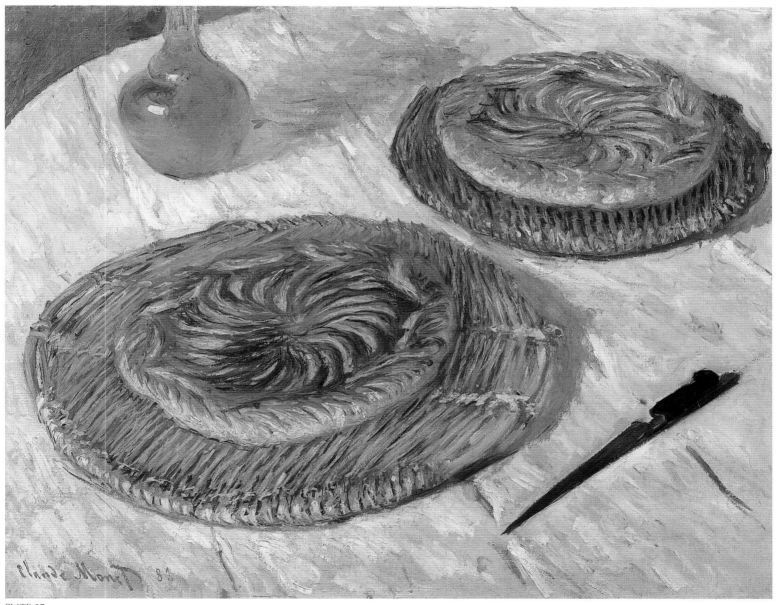

PLATE 57

At the time of the 1882 exhibition of the Impressionists, a satirical cartoon appeared in the Parisian press showing Gustave Caillebotte as a floor scraper, in reference to a canvas that he had exhibited with the Impressionists in 1876. The caption to the cartoon described Caillebotte as "one of the youngest fathers of Impressionism. Made his debut scraping floors, then as a landscapist. Revealed to Parisians the beauty of the panorama of the Place de l'Europe." The caption went on to say that Caillebotte "is giving himself over nowadays to still lifes . . . as conceived by millionaires. When he passes a shop display that pleases him, he goes in, showers it with gold—the display—and has it delivered to his studio to serve as a model."[145]

The author of the caption was right to assert Caillebotte's fascination with still life in the early 1880s, but interestingly enough, only one still life numbered among the eighteen pictures that Caillebotte presented in 1882. From his comments, however, it is clear that it was this very still life, *Fruit Displayed on a Stand*, that caught the satirist's attention. One of the most remarkable conceptions of the artist's career, the painting shows the display of a high-class greengrocer, with red, yellow, green, and blue fruits set out in carefully ordered piles against crisp white paper, surmounted by the shiny, dark green leaves of aspidistra plants—in short, still life as conceived by a millionaire consumer or his housekeeper.[146] At the exhibition the painting also came to the attention of the novelist and critic Joris-Karl Huysmans, who saw it as evidence of the artist's considerable originality:

Unlike most of his fellow artists, [Caillebotte] continually renews his subject matter, never specializing and thus avoiding the risk of a certain form of repetition, an inevitable trivialization of subject; his fruits stand out from their paper bedding with extraordinary clarity. Juice wells up beneath his pears' skin, a pale golden silk shot with ripples of green and pink; a dewy haze of moisture clings to the surface of the grapes, dulling and dampening them. And all of this is conveyed with strict truthfulness, an absolute fidelity of tone: it is still life freed of duty and routine. Gone are those fruits in common use, thick skins bloated and impenetrable, pinned to backgrounds of rubbery gray and sooty black.[147]

Indeed, *Fruit Displayed on a Stand* was a radical departure, a kind of renewal, for Caillebotte. Like *Still Life with Crayfish* (plate 56), it relies for its effect on the transcription of a particular point of view, but it goes farther in inventing a radical compositional scheme. Here the range of vision, the segment of the world chosen for depiction, is dictated by an almost accidental experience: the slight asymmetry of the picture's axis suggests that it is being perceived by a passerby. In this regard, it echoes the views of men looking down from balconies that Caillebotte showed with it at the seventh Impressionist exhibition in 1882, together with *Boulevard Seen from Above* (1880, private collection), a remarkable painting of a slice of the street seen from a high vantage point.[148] It is as if Caillebotte, in choosing a point of view, gladly surrendered control of the motif to the experience of the marketplace. Contrary to the traditional practice of still-life composition, the arrangement of the objects them-

GUSTAVE CAILLEBOTTE, 1848–1894

Fruit Displayed on a Stand, ca. 1881–82, Oil on canvas, 30⅛ x 39⅝ in. (76.5 x 100.5 cm), Museum of Fine Arts, Boston,

Fanny P. Mason Fund in Memory of Alice Thevin

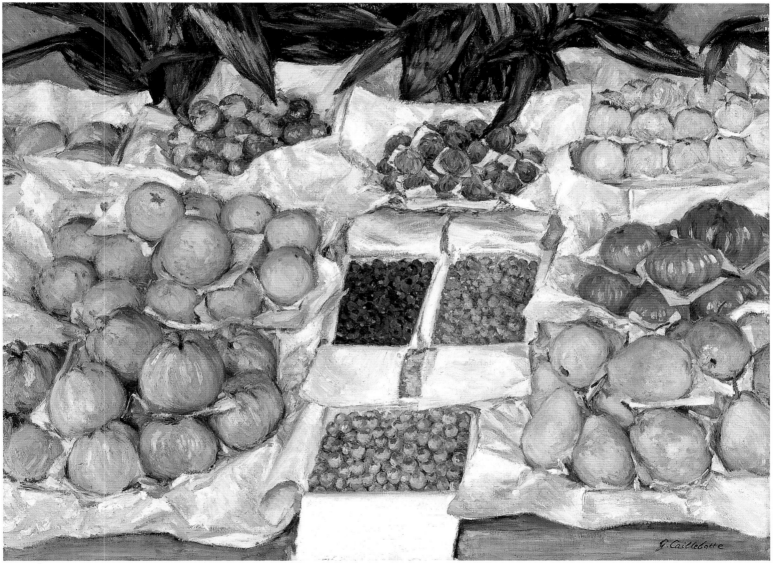

PLATE 58

selves is dictated not by the painter's aesthetic concerns but by the shopkeeper's commercial strategies. Caillebotte, to use the words of the satirist, "showers it with gold—the display—and has it delivered to his studio."

A number of similar market still lifes by Caillebotte are thought to date from the early 1880s, including several that depict the display of meat at a butcher's shop. In addition to a large canvas showing a slaughtered calf, decorated with an absurd but stylish garland of paper roses and hanging against a white curtain, Caillebotte painted a gruesomely beautiful work called *Calf's Head and Ox Tongue* (ca. 1882, Art Institute of Chicago), a delicate arrangement of crimson, pink, mauve, gray, and white.[149] Turning to the seller of poultry and game, he produced *Display of Chickens and Game Birds*, one of the most striking still lifes of his career, a masterpiece of naturalism, rivaling in paint the vivid descriptions of markets in Zola's *Ventre de Paris.* The work shows a profound appreciation for the abstract cadence set up by the shopkeeper's organization of wares. In fact, in Caillebotte's hands the display transcends the novelist's prose to rival the work of the poet or, better still, the composer: the shining metal bar with hooks for hanging game, seen against the dark background above, with the gleaming white marble slabs that support the plucked chickens below, become the bars of a macabre musical score.[150] Eight dressed chickens sound the rhythmic notes of a solemn bass line at the bottom of the composition, while above the repetition of five tiny partridges, followed by three pheasants, construct a staccato melody line, rising to a crescendo in a pair of rabbits. The final note of the composition is struck by the body of the last chicken, its feathered head resting on the stone at lower right.

GTMS

GUSTAVE CAILLEBOTTE, 1848–1894

DISPLAY OF CHICKENS AND GAME BIRDS, CA. 1882

OIL ON CANVAS, 30 X 41⅜ IN. (76 X 105 CM), PRIVATE COLLECTION

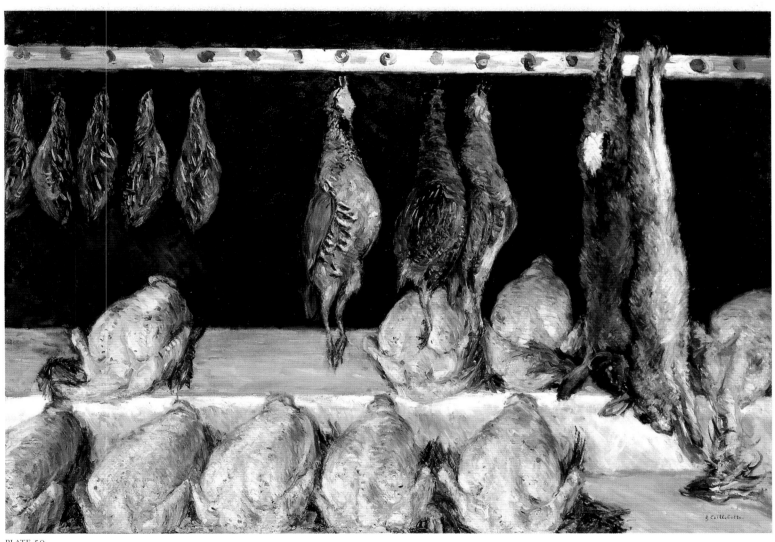

PLATE 59

From the beginning of his career, Degas revealed an interest in the color and texture of fabrics, reveling in the delicately pleated gauze that clothed his visions of antiquity as well as the crumpled kid gloves of a modern Parisian. Linked to this appreciation of fabrics was his gift for depicting objects encountered as if by accident—a bulletin board covered in a patchwork of scraps of paper or cloth, calling cards, and photographs; a banker's desk littered with ledgers and accounts; the contents of a wastepaper basket in a New Orleans cotton office; or piles of books and papers on the desk of an art critic.[151] Degas noted his intention to "include all types of everyday objects . . . in a context to express the *life* of the man or woman," and again and again, he employed his genius for seizing upon these material details to make the fiction of his painting or pastel seem immediate and real.[152] And time after time, his love for the material gave rise to miniature still lifes pushed into the corners of his scenes of modern life: an unlaced corset lies on a bedroom rug; starched shirts sit in a pile on a laundress's table; a brush, a comb, and a tangled hairpiece, together with an ointment jar and a bottle of cologne, make up the still life of a woman's toilette.[153]

In the 1870s, Degas tapped his gift for rendering the textures of fabrics in scores of paintings and pastels of ballet dancers, whose tulle skirts and satin bows—in a dazzling range of tones and hues—gave him the opportunity to explore the way fabrics appeared in daylight and gaslight. In making his most famous sculpture, the *Little Dancer, Fourteen Years Old* (1881 [original], National Gallery of Art, Washington, D.C.), he engaged the services of a dollmaker to costume his wax figurine in a miniature tutu of tulle, with a bodice of silk faille and a wig of blond hair. And closer still to the world of modern fashion, during a dinner at Berthe Morisot's in the autumn of 1891, Degas proposed to a retailer that an edition of

Zola's novel of a great department store, *Au bonheur des dames*, should be brought out in the new year and illustrated with swatches of fabric pasted into the pages of the volume.[154]

Nowhere was Degas's fascination with women's clothing more cunningly displayed than in a series of pictures of milliners that date from 1882 to about 1886—several of which include complex still lifes of hats resting on stands in the foreground. The first of these to be shown to the public, *At the Milliner's* (1882, Museo Thyssen-Bornemisza, Madrid), was presented in London in July 1882, where a critic noted that "half of the design is occupied by the milliner's table, on which lies a store of her finery. Silk and feather, satin and straw, are indicated swiftly, decisively, with the most brilliant touch." And when Degas showed other pastels of milliners at the last Impressionist exhibition in 1886, a French critic described the "fabulous hats [that] beneath their fingers, are embellished with flowers and birds, [and] become gardens or aviaries."[155]

In the 1882 pastel, two clients sit beside the still life of hats in the foreground, but in the great oil on the same theme, *The Millinery Shop*, the identity of the woman presented is less clear. She has been seen by some writers as a client and by others as a shopkeeper or perhaps even a worker, one of the "girls who earn two francs a day in constructing twenty-louis hats, in the hope that one day they may wear them themselves," as one critic wrote in discussing another pastel.[156] It seems that in the process of finishing the oil, his most ambitious canvas on the theme and one of the largest of his later works, Degas may have changed his idea about the woman's function. But whatever her identity, she remains an accessory to Degas's ravishing still life of pastel-colored hats—an exuberant celebration of the stuff of fashion and a wry comment on its place in modern life. GTMS

EDGAR DEGAS, 1834–1917

The Millinery Shop, 1882–86, Oil on canvas, 39⅛ x 43½ in. (100 x 110.7 cm),

The Art Institute of Chicago, Mr. and Mrs. Lewis Larned Coburn Memorial Collection

PLATE 60

By the late 1870s Claude Monet realized that his still lifes were commanding higher prices than his landscapes.[157] Having completed only two paintings of cut flowers in the 1860s, he took up the genre with renewed intensity between 1878 and 1883, when he painted twenty-one flower still lifes, among them, *Vase of Flowers*.[158] The profusion of such work during these financially difficult years reflects Monet's awareness of the marketplace and the taste of the buying public for large-scale, opulent flower pieces. By working on still lifes in the studio when the weather was too inhospitable to be outdoors, Monet could be productive every day.[159]

Unlike his 1860s flower paintings, which show different kinds of flowers in a single composition, Monet's floral still lifes a decade later are luxuriant displays of a single type of flower. *Vase of Flowers* features mallows, a flower native to most of Europe, where it grows wild in damp meadows, by the sides of ditches, and on the banks of tidal rivers; mallows—*mauves* in French—are closely related to cultivated varieties, such as the "Rose of Sharon."[160] Atop tall, upright stems with roundish leaves, the two- to three-inch mallow blossoms are frequently blush colored, though in Monet's vision the pink petals fade to white, the mass of greenery and blooms suggested only by rapid dabs of pigment. No absolute definition is given to either the forms of the leaves or the flowers themselves.

All of Monet's flower still lifes from 1878 to 1883 are variations on the standard format of a more-or-less centralized vase of flowers on a tabletop or shelf, and many of Monet's flower still lifes of this period emphasize a glossy wooden tabletop or a vividly patterned table covering. In all of these late flower still lifes, Monet replaces the conventional dark background with a field of colored brushwork that illuminates the picture from within. In *Vase of Flowers*, however, Monet challenges his own convention by his use of unusually bold brushwork and vibrant colors, his slightly off-center placement of the vase, and his preference for an exceptionally close-up and high point of view. Viewed from above, both the tabletop and the vase of mallows tilt slightly to the left, another rather disconcerting feature. *Vase of Flowers* depicts a table surface described by a flurry of rapidly applied horizontal dabs of whites, blues, and oranges. As a result, the table's edge is imprecisely defined and seems to merge into the pastel-yellows and greens of the background. Indeed, it was Monet's manner of combining both the decorative and the expressive in his monumental flower still lifes that van Gogh admired in 1888.[161]

Interestingly, *Vase of Flowers*, one of the many large-scale flower compositions that Monet favored after 1879, was not sold at the time of its execution, but after 1920, late in the artist's life.[162] Monet's letters to his dealer Durand-Ruel in September 1882 imply that he was having trouble completing some of his large flower paintings. Recent scholarship has suggested that *Vase of Flowers* may not have been quite so appealing to the 1880s buyer because of its stylistic qualities—its vigorous application of paint, its rough surface, and the lack of definition of any form, whether the table, the flowers, or the greenery.[163] Today, however, it is these very qualities that we so much admire. SBF

CLAUDE MONET, 1840–1926

VASE OF FLOWERS, CA. 1881–82, OIL ON CANVAS, 39½ X 32¼ IN. (100.4 X 81.9 CM), COURTAULD GALLERY, LONDON, SAMUEL COURTAULD COLLECTION

PLATE 61

In the last two years of his life Edouard Manet, terminally ill and rapidly losing his mobility, painted twenty floral still lifes.[164] Each of these flower paintings was small enough for Manet to work on while seated.[165] These last floral still lifes—he died in April 1883—depict assorted bouquets that were being delivered to the artist by his friends. Roses, lilacs, pansies, tulips, pinks (dianthus), carnations, and clematis are Manet's subjects, along with the peonies that had attracted him in the 1860s.[166]

All but two of the last flower paintings are vertical in format, with the flowers always centered and placed in a glass vase. *Two Roses on a Tablecloth* is one of the two that vary from this general format, and it is also one of the smallest.[167] Its original owner, Eugène Pertuiset, a renowned hunter and arms collector, was perhaps Manet's most important patron in the last three years of his life, buying fourteen paintings, among them several of his late flower pieces.[168] The two roses in this work lie side by side on a table; there is no vase, as if they were left over from a bouquet that is unseen or were waiting to be placed in one. Perhaps, instead, they were gifts given or received and then casually set aside.

Limited to tones of creamy yellow, peach, pale rose, white, and green, Manet's palette is more restricted in *Two Roses on a Tablecloth* than in most of his other late flower paintings.[169] In counterpoint to the composition in *Branch of White Peonies with Pruning Shears* of 1864 (plate 8), the yellow rose and its softly pink mate do not fill the central picture space and are confined to the light-colored bottom half of the composition. The blossoms are diagonally separated and off center, pointing toward the left; their green leaves and stems fill most of the table space with abstract patterns. Manet's rich brushwork and limited palette directly capture the essence of the roses.

With the above exception, Manet placed his fresh bouquets in any one of seven glass vases, some of which appear many times in his late flower paintings and range from the vertical elegance of a champagne glass to the bottom-heavy, gourd-shaped carafe depicted in *Moss Roses in a Vase*. Here, the small, tight blooms of the moss roses are clustered into a dome that crowns the wide neck of the glass vessel and reaches to the upper edge of the canvas. The greenery that encircles the flowers reveals thin color washes in some areas, bare canvas in others, accented by the occasional dash of yellow, while the vibrant lusciousness of the pink roses plays against the dark blue-gray background. The carafe's bulbous body provides an opportunity to explore distortions, reflections, and refracted colors through the prism of glass and water, beginning with the reflected glow from the tabletop that lifts the bottom of the carafe away from the background. Although Manet made the entire composition appear casual and haphazard, he carefully constructed it so that even his signature in the lower right balances against the rose lying on the table at the left. This single rose, appearing in three other late floral paintings, was Manet's artistic signature. Evident in many of his still lifes dating back to the 1860s, such as *Still Life with Melon and Peaches* (fig. 22) as well as in the portrait of Eva Gonzalès (fig. 52), the motif of the isolated flower is also directly related to the two single blossoms depicted in *Two Roses on a Tablecloth*.[170]

At least three different bouquets appear in the same small stub-footed glass seen in the National Gallery's

EDOUARD MANET, 1832–1883

Two Roses on a Tablecloth, 1882–83, Oil on canvas, 7⅜ x 9½ in. (19.3 x 24.2 cm),

The Museum of Modern Art, New York, the William S. Paley Collection

PLATE 62

Flowers in a Crystal Vase. In this charming work, Manet has grouped together roses, pansies, and dianthus in a compact swirling mass of pink and white, accented with dabs of purple, red, and green. No doubt Manet considered the relatively small blossoms of pansies and dianthus, supported on somewhat flexible stems, to be suited to the proportions of the glass vessel in which they would be displayed. In this little painting, unlike many of the others, Manet has made almost no effort to describe the tabletop as distinct from the background. Tightly contained, this lovely bouquet floats in a haze of whites, grays, blues, and lavenders that swirl around the base of the vase and then dissolve into a vaporous soft veil.

The Musée d'Orsay's *Flowers in a Crystal Vase* is the only one of Manet's last flower paintings signed by Manet with a dedication—"to my friend Dr. Evans."[171] Dr. T. W. Evans, a very successful American dentist who spent his career in Paris and moved in the highest social circles, attending such patients as the emperor Napoleon III, is known to have met Manet through Méry Laurent, a close friend of the artist, who had her maid deliver flowers to the ailing Manet every day.[172] Five floral still lifes use this same heavy-bottomed crystal vase decorated with a pattern of small etched flowers. Composed of lilacs and roses, two spring flowers Manet is known to have loved, the sim-

ple bouquet in its vertical vase is surrounded by a darkness that is unbroken except for the apparent reflections of the etched flowers on the tabletop.[173] The pervasive darkness in this work is unlike his other late flower paintings, yet *Flowers in a Crystal Vase* still delights the eye with reflections. The translucent whiteness emanating from within the vase culminates in the froth of the white lilacs, which crown the bouquet and reach nearly to the upper edge of the canvas.

Manet's compositions in each of these last floral works are spare and simple, yet they were carefully constructed to achieve a perfect balance in their architecture of flowers, vase, and color harmonies. Painted quickly, perhaps in a matter of one or two sessions, these still lifes capture the painter's view of the flowers' freshness and vibrancy.[174] Although the subject matter may appear restrictive, Manet's vision is exquisitely honed by his technique and bravura brushwork to present bouquets in all manner of lushness and light as well as seemingly limitless explorations of reflection, transparency, translucency, and distortion in the water-filled glass vessels. In each instance the intensity of the artist's focus is magical—a pure reflection of Manet's famous remark that "a painter can say all he wants to with fruit or flowers or even clouds."[175]

SBF

EDOUARD MANET, 1832–1883

Moss Roses in a Vase, 1882, Oil on canvas, 22 x 13½ in. (55.9 x 34.3 cm),

STERLING AND FRANCINE CLARK ART INSTITUTE, WILLIAMSTOWN, MASSACHUSETTS

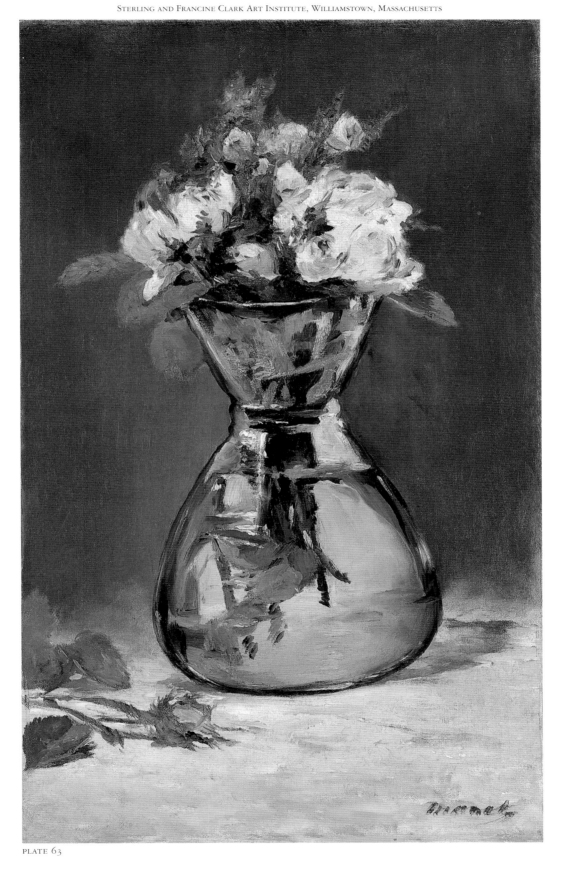

PLATE 63

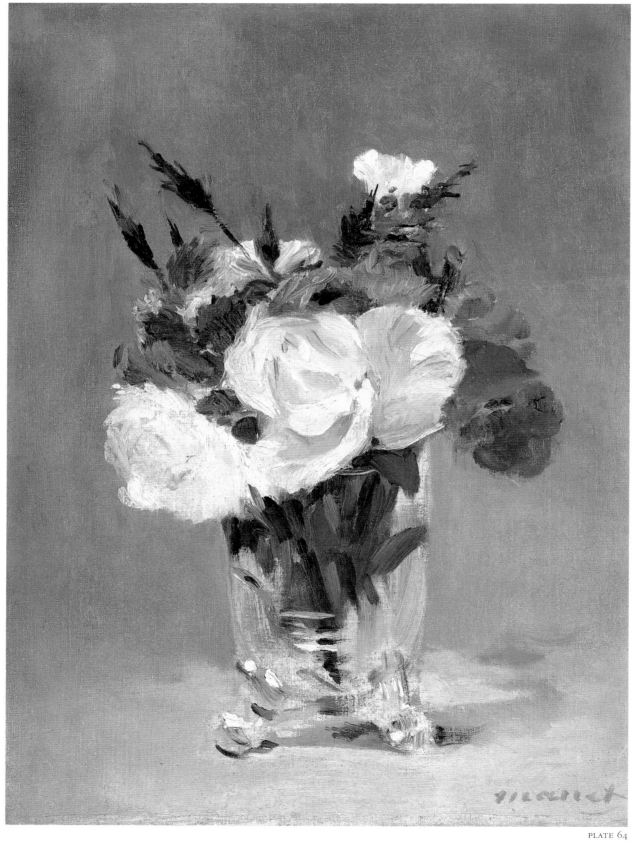

PLATE 64

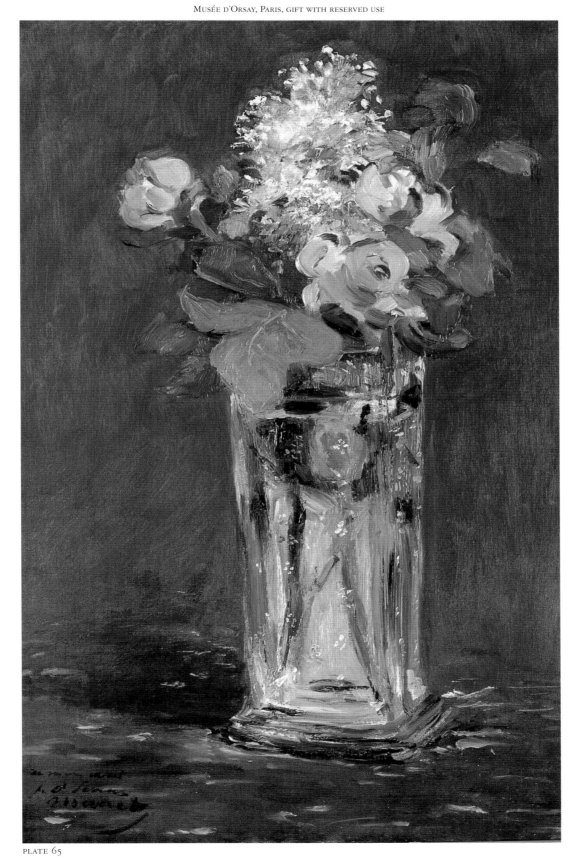

PLATE 65

GAUGUIN *Sleeping Child,* 1884

L
ike their Impressionist colleague Mary Cassatt, both Berthe Morisot and Paul Gauguin created innovative genre scenes with children during the 1880s. Two compositions painted in 1884, Morisot's *On the Veranda* and Gauguin's *Sleeping Child,* display an intriguing conflation of the pictorial categories of still life and figure study, combining genres in a manner similar to that of Edgar Degas and Claude Monet (plates 2, 38, 60). These interesting hybrids explore the interior lives of children, albeit in different ways—one decidedly Impressionist in handling and the other symbolist in nature. Despite their formal differences, Morisot's concept and her treatment of paint invite a comparison with Gauguin's intense exploration of the same theme, for the innovations of both artists exemplified in these two paintings had a significant impact upon the development of modern art.

Of a monumental scale seldom found in her work, *On the Veranda* was the painting that Morisot chose to exhibit more frequently than any other during her lifetime.[176] The painter depicts her daughter, Julie, then nearly six years old, sitting in the dining room of the family home in Bougival in the summer of 1884, quietly contemplating the petals of a large white flower.[177] The table at which she sits, in a room flooded with sunshine, contains the elements of a traditional floral still life, including a glass pitcher with spiral fluting upon which the light plays. Julie is set against the backdrop of a suburban landscape, Morisot's incorporation of a third pictorial category, seen through the balcony windows. The young sitter is completely absorbed in her play and private thoughts and exudes a state of peaceful reverie, conveyed by a dynamic surface composed of fragmented brushstrokes.

Gauguin depicts a nocturnal scene portraying a slumbering child, probably one of his own, although the child's identity has been the subject of an unresolved debate.[178] Gauguin's tabletop still life is composed largely of an imposing eighteenth-century Norwegian tankard, which is strikingly out of proportion with the reclining head of the young child. Gauguin, like Morisot, also strove to exhibit his work, sending it to Oslo for a group exhibition soon after its completion. This fantastical painting, along with four other still lifes of 1884, was painted in Rouen, where the artist had moved his family a year prior due to the lower cost of living.[179] Among the first of many works in which Gauguin incorporates a stylized, decorative background, *Sleeping Child* is an example of the artist's keen interest in modern decorative art. This canvas prefigures his more overtly symbolist works, in which the background is employed symbolically to depict the inner realm of a foreground figure.[180] (The Japanese-inspired wallpaper in the background of this painting can also be found in another still life with the same dimensions of 1884.)[181] *Sleeping Child* is no doubt a reprise of Gauguin's 1881 painting of the same subject, *Sleeping Boy (The Little Dreamer)* (Ordrupgaard Collection, Copenhagen), another genre scene for which his only daughter, Aline, then four years old, served as the model. Charles F. Stuckey has observed in this earlier work a "prefiguration of his symbolist preoccupation with 'correspondences' and dreams,"[182] a preoccupation that is likewise evident in *Sleeping Child.*

BERTHE MORISOT, 1841–1905

On the Veranda, 1884, Oil on canvas, 31⅞ x 39⅜ in. (81 x 100 cm),

Collection John C. Whitehead, New York

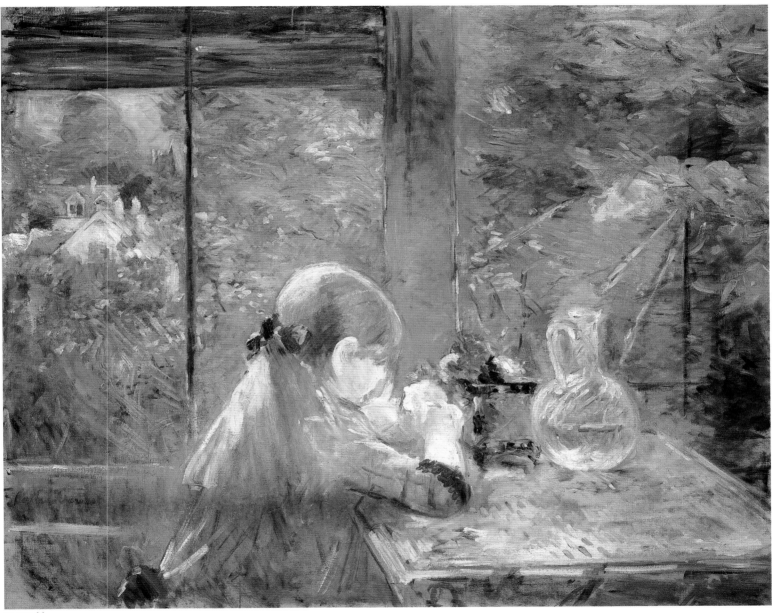

PLATE 66

Despite marked differences of gender and social position, both artists were clearly intrigued by the challenges posed by the unpredictability of children as models. For Gauguin, whose early works featuring children may have also been a sort of dialogue with Cassatt, it was surely expedient to use family members as models, as Morisot and Cassatt so often did for obvious reasons. Yet as Stuckey observes, Gauguin's "paintings are far from conventional domestic portraits of cheerful innocence,"[183] as so often seems the case in Morisot's work. Gauguin's early pictures explore the mysterious inner realms and dreams of children. Like the visions later represented in his Brittany pictures, this work's evocation of dreams, symbolized by the swirling motifs of the wallpaper above the head of the little sleeper, prefigures Gauguin's later symbolic representations of the private meditations of Tahitian figures.[184]

Both Morisot's and Gauguin's children are absorbed in their own private worlds. Morisot's child, however, is occupied with the act of looking, thereby reinforcing the position of the viewer, while Gauguin's child is apparently dreaming, perhaps inspired by the still life beside him. In these tender and magical evocations of the interior life and imaginations of children, the innovations of these two very different vanguard artists represent, as Stuckey writes, "the poetry in images that bordered simultaneously on true-to-life observations and hinted at fairy tale marvels."[185]

AAL

PAUL GAUGUIN, 1848–1903

Sleeping Child, 1884, Oil on canvas, 18 x 21⅞ in. (46 x 55.5 cm), Private collection

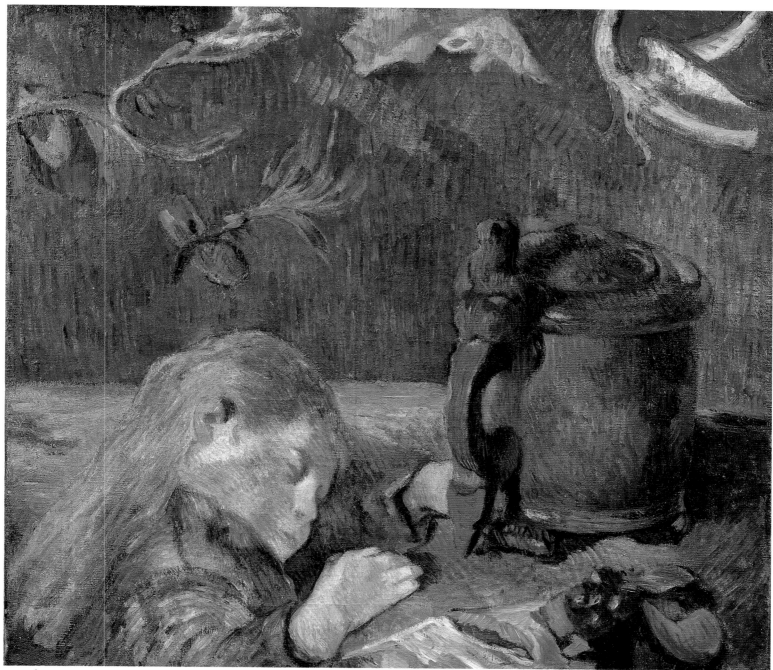

PLATE 67

Among van Gogh's earliest paintings are still lifes of humble objects—beakers, cups, bottles, tobacco jars—against dark brown backgrounds, painted as exercises in mastering the effects of light and shadow. In the autumn of 1885, however, he began to paint a group of remarkable studies of birds' nests, which he had collected in the countryside around Nuenen, a village in the province of Brabant in the south of the Netherlands, where he lived with his parents. Vincent wrote to his brother, Theo, in early October that he was "busy painting still lifes of my birds' nests, four of which are finished; I think some people who are good observers of nature might like them because of the colors of the moss, the dry leaves and the grasses." Although he was fascinated by the natural history of these constructions, van Gogh wanted to distinguish the still lifes from studies made outdoors: "When one wants to paint nests from one's *collection of nests*, one cannot express strongly enough the fact that the background and the surroundings in nature are quite different, therefore I simply painted the background black."[186]

In this small canvas, the artist places a group of three nests in just such a murky, indeterminate space. The nests are painted life size, the artist's brush having moved quickly through the wet paint, placing shadows and highlights with a delicate flourish. With its crown of twigs, a craggy branch encloses the largest of the nests, which in turn cradles a handful of eggs. The black background and the monochrome palette, as well as the artist's nimble brushwork, are occasioned by the local colors and textures of the nests themselves, but they may also reflect van Gogh's admiration for the works of the old masters, who were to remain models for him throughout his career. When he told Theo about his nest still lifes, he said that he was "longing most of all for Rembrandt and Frans Hals," the giants of Dutch painting of the golden age, and he vowed his intention to "go to the museum in Amsterdam for a day." Theo—an art dealer in Paris, more aware than his brother of the Impressionists' free use of color—warned him against using too much black; van Gogh's early masterpiece, *The Potato Eaters* (1885, Van Gogh Museum, Amsterdam), had found few admirers among painters and critics in the Parisian vanguard. The painter defended his choices, citing the brilliant blacks of Rembrandt and Hals, as well as those of Velázquez and his modern disciple Edouard Manet. Still, he admitted, "Just now my palette is thawing and the barrenness of the first beginning has disappeared."[187]

Van Gogh gathered birds' nests with a naturalist's fascination for their creators. He wrote to his friend Anton van Rappard, to whom he sent some nests, that he had "quite a collection. . . . They're of thrush, blackbird, golden oriole, wren and finch." The nests became part of a virtual museum of rural life: a visitor to van Gogh's studio recalled "a cupboard with about thirty different birds' nests, all sorts of moss and plants brought along from the heath, several stuffed birds, [as well as] . . . old caps and

VINCENT VAN GOGH, 1853–1890

Three Birds' Nests, 1885, Oil on canvas, 13 x 16½ in. (33 x 42 cm),

Kröller-Müller Museum, Otterlo, The Netherlands

PLATE 68

hats, dusty bonnets, wooden shoes, etc."[188] The painter admired the nests' architecture and claimed that "wrens and golden orioles can surely be considered artists." But the nests were not only pretexts for painting: van Gogh, the son of a pastor and a former student of theology, would surely have been aware of the long association, in literature and art, of nests and eggs with themes of rebirth and resurrection. In fact, the still lifes of birds' nests precede by a matter of weeks van Gogh's most consciously emblematic still life—a study in black and yellow in which an open Bible and a burned-out candle stood as symbols of his late father, a pious churchman, juxtaposed with a copy of the kind of modern novel van Gogh so much admired, Emile Zola's *La joie de vivre*.[189]

It is not known precisely when van Gogh painted the first of his still lifes of shoes, whether in Nuenen in 1885 or in Paris, where he settled for two years in the early spring of 1886. Three canvases, similar in tonality to the still lifes of nests, catalogue various pairs of shoes that van Gogh owned—one pair of low boots with gussets at their sides and two pairs of boots with laces, one of them fitted with eyelets, the other with small boot hooks above the instep to hold the laces in place. The six boots are united in *Three Pairs of Shoes*, where they are displayed in a jumbled row against a white cloth. Another canvas, brighter in color than the rest, depicts the pair of boots with eyelets; it is dated 1887, by which time the other canvases must have been completed.[190]

The boots, by all accounts, are van Gogh's own, but they carry with them several other levels of meaning. A painter friend described seeing van Gogh "finishing a still life, which he showed me. At the flea market he'd bought an old pair of clumsy, bulky shoes—peddler's shoes—but clean and freshly shined. . . . He put them on one afternoon when it rained and went for a walk along the old city walls. Spotted with mud, they had become interesting." Gauguin, writing in 1894, described a still life of shoes: "Two enormous shoes, worn, deformed. The shoes of Vincent. The shoes that he put on—they were new then—one beautiful morning to make his way on foot from Holland into Belgium."[191] Both observers place stress on the enormity and clumsiness of the shoes, associating them, as did the philosopher Martin Heidegger, with toil. But the toil was, in great measure, the artist's own, and as the historian Meyer Schapiro suggests, they are therefore in some way emblems of the artist as laborer. They are also, finally, reflections of the artist's continuing fascination with the art of Jean-François Millet, the painter of peasants, whose "self-portrait" drawings of wooden shoes were van Gogh's inspiration. GTMS

VINCENT VAN GOGH, 1853–1890

THREE PAIRS OF SHOES, 1886–87, OIL ON CANVAS, 19⅜ X 28½ IN. (49.2 X 72.2 CM),

FOGG ART MUSEUM, HARVARD UNIVERSITY ART MUSEUMS. BEQUEST COLLECTION OF MAURICE WERTHEIM, CLASS OF 1906

PLATE 69

Books and writing were of great importance to van Gogh throughout his life. Although his early schooling was somewhat haphazard, he was adept at languages, reading and writing not only in his native Dutch, but also in English, French, and German, as well as the classical languages. Although he left home and school at sixteen, books and learning reentered his career episodically. Abandoning his early career as an art dealer, he worked as a schoolteacher in England and as a clerk in a bookshop in Dordrecht and studied theology in Amsterdam before he turned to evangelism and finally, at the age of twenty-seven, to the study and practice of art. His letters to his brother, Theo, are peppered with references to literary classics as well as to modern writers and their works, chief among them the novels of such French naturalists as Emile Zola, Edmond de Goncourt, and Guy de Maupassant.

Among van Gogh's most interesting still lifes are his paintings of books, made after his assimilation of the Impressionist style in Paris after 1886. He had already painted books in Nuenen in 1885, when he made a kind of emblematic memorial to his father, a still life (Van Gogh Museum, Amsterdam) of a Bible open on a table beside a modern novel, the preferred reading matter of father and son respectively. In the spring of 1887, van Gogh returned to the theme, and over the course of the year he began to paint images of specific modern works. He began with a small painting, *Three Novels* (Van Gogh Museum, Amsterdam), made on the lid of a tea chest, that showed three books, their titles clearly legible: Zola's

Au bonheur des dames and Goncourt's *La fille Elisa* lie beside and beneath a copy of the novel *Braves gens* by Jean Richepin. Van Gogh was careful to transcribe the subtitle of Richepin's book, *Roman parisien*, or "Parisian novel," and he adapted it to a large still life of piles of books, mostly with sunny yellow covers, that was dispatched to the exhibition of the Independants. Although none of the books bore a decipherable text, the painting's title announced that they were *Romans parisiens* (1887, private collection).

Romans parisiens is one of the paintings that he left in Paris with Theo on his departure for Arles in the spring of 1888, but it stayed in his memory. In October, he wrote to Theo about a newly finished painting of his bedroom and compared it to "the still life of the 'Romans Parisiens' with the yellow, pink and green covers, you remember it. But," he wrote in reference to the painting of the bedroom, "I think the workmanship is more virile and simple. No stippling, no hatching, nothing, only flat colors in harmony."[192] This simple, virile workmanship, ironically, was already present in the *Study for 'Romans Parisiens'*, which is painted in broad planes of color, the complementary colors of bitter red and green sounding sharp notes against the dominant tone of luminous yellow. The stylistic transformation from the dappled effects of Impressionism to van Gogh's mature, simplified style—the origins of which can be discerned in this study—was effected in a matter of months, between his arrival in Arles in the spring of 1888 and the autumn of that year, when he completed his famous portrait of Mme Ginoux,

PLATE 70

L'Arlésienne (1888–89, Metropolitan Museum of Art, New York), seated behind a stack of books, in a composition dominated by the tones of yellow, green, and orange red.

At about the same time that he was completing *Romans parisiens*, van Gogh painted *Still Life with a Plaster Statuette and Books*. Here, against a deep blue background and a curiously tilting cloth of pale yellow, two books sit awkwardly on what might be a piece of white paper—perhaps their wrapping—between a plaster statuette of a female nude and a spray of roses. One of the books, deep yellow in color, bears the title of Goncourt's novel *Germinie Lacerteux*; the other, pale blue, is Maupassant's *Bel-ami*. Although some scholars have cautioned that it would be impossible to interpret the meaning of van Gogh's choices precisely, Judy Sund has argued that the painting is a "study in contrast, both formal and conceptual."[193] Thus the tragic story of Germinie Lacerteux, a respectable woman who descends through her passion into misery, balances the witty story of Georges Duroy, the *bel-ami* of the novel's title, who rises to social prominence through wit and sexual charm. Flanking the books are the delicate, even chaste, rosebuds and the lively, robust figure of the nude statuette—contrasting elements that reinforce the picture's sense of dynamic equilibrium.

GTMS

VINCENT VAN GOGH, 1853–1890

Still Life with a Plaster Statuette and Books, 1887, Oil on canvas, 21½ x 18¼ in. (55 x 46.5 cm),

KRÖLLER-MÜLLER MUSEUM, OTTERLO, THE NETHERLANDS

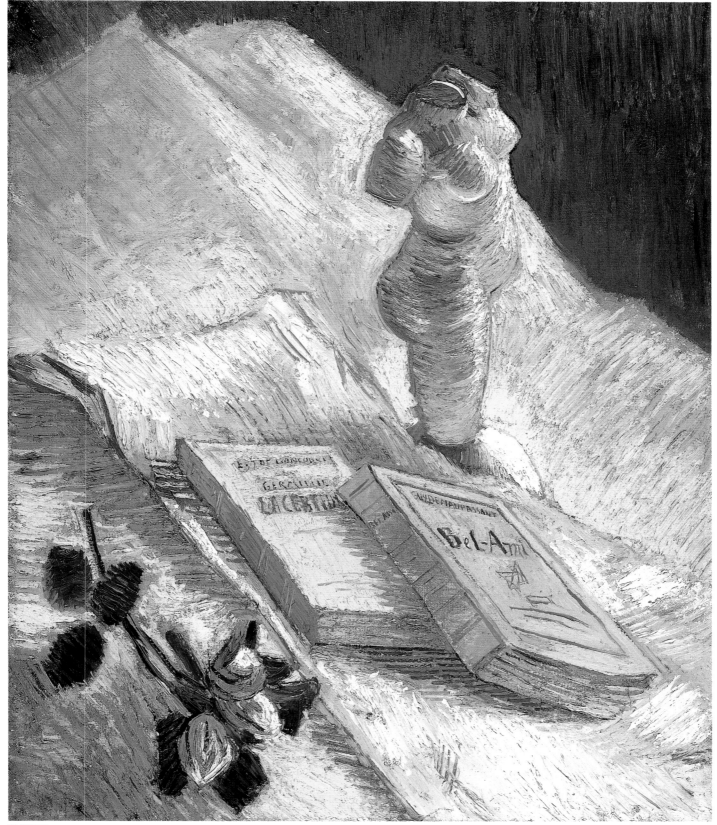

PLATE 71

VAN GOGH **161**

At the end of February 1888, van Gogh left Paris to seek an equivalent, in the south of France, to the Japan that he had imagined from his study of the woodblock prints he so actively collected. Seeking a warm and sunny landscape where he could work in harmony with nature, he arrived to find snow on the ground and bitter cold. But he was undaunted: to his brother he wrote that "the landscapes in the snow, with the summits white against a sky as luminous as the snow, were just like the winter landscapes that the Japanese have painted." Ten days later conditions had not improved greatly, but there was some hope of spring. "Down here it is freezing hard and there is still some snow left in the country. I have a study of a landscape in white with the town in the background. Then two little studies of an almond branch already in flower in spite of it."[194]

One of these studies is the *Sprig of Flowering Almond in a Glass*, which must surely number among van Gogh's most tender and evocative images. Critics see it as a painting filled with a sense of budding hope and promise, evidence of van Gogh's optimism at this crucial juncture in his career. While the parallel hatchings that define the surface of the tabletop and the ridged surface of the water glass relate this painting stylistically to such Parisian works as *Still Life with a Plaster Statuette and Books* (plate 71), there is nothing here of that painting's calculated spatial and emotional tension. Instead, the rounded glass holding a tiny branch of blossoms, each delicate petal and bud portrayed with loving care, is subtly placed against a surprisingly simple and modest background. A gray plaster wall, accented by a single stripe of red paint, occupies the upper half of the canvas and, together with the diagonally striated yellow tabletop shot through with blue shadow, becomes the simple geometric foil for the graceful spectacle of nature. In the coming weeks, van Gogh would be preoccupied with painting the orchards of Arles in bloom, turning from almond trees to peach, apricot, and pear and arranging his canvases into decorative ensembles, the roots of which we can see in the controlled harmonies of this tiny canvas.

Another version of this composition shows the glass and its branch of blossoms beside a book (1888, private collection, Japan). Van Gogh reserved that study for his younger sister, Wil, whose tastes in art and literature he sought to influence. He himself would be influenced two years later, in February 1890, by the birth of his nephew, Theo's son, named Vincent in his honor. Shortly thereafter, while he was in the hospital at Saint-Rémy, the painter returned to the subject of almond blossoms, painting a canvas of branches seen against a clear blue sky (1890, Van Gogh Museum, Amsterdam). He sent this work to his brother, Theo, and his sister-in-law, Johanna, in Paris, to decorate their bedroom. At the time of his own birthday, at the end of March, he received a letter from his brother telling him that his nephew "is particularly fascinated by the blossoming tree that hangs above our bed."[195] GTMS

VINCENT VAN GOGH, 1853–1890

Sprig of Flowering Almond in a Glass, 1888, Oil on canvas, 9½ x 7½ in. (24 x 19 cm),

Van Gogh Museum (Vincent van Gogh Foundation), Amsterdam

PLATE 72

Cézanne's *Kitchen Table* shows neither a kitchen nor a table arranged for the preparation of a meal. Instead it shows, more clearly than virtually any other still life in the artist's career, a deliberate arrangement of objects placed on a table in the studio of the painter and presented as a motif calculatedly arranged for painting. Cézanne set his arrangement in deep space. Beyond the table in the foreground, we see at left and above another table littered with objects, the planes of a folding screen, the green triangular corner of what might be a portfolio for drawings, and the rush seat and legs of a country chair, its back cut off by the top edge of the picture space, where a kind of horizon line is established by the meeting of the floor and the studio wall. To remind us that the studio is larger still, Cézanne introduced the square-cut leg of a stool that enters the pictorial space halfway down the right-hand margin of the composition. Tables, chair, and stool mark the cardinal points of the painter's world.

Though the space thus depicted is deep, it is filled to overflowing by the arrangement of objects on the table at center. These include, above all, the ginger jar wrapped in willow strands that figures in many of Cézanne's still lifes (plates 80, 83) and a large wicker basket, in which a number of pears are painted in shades of green, red, and yellow against a snowy white napkin. Both the basket and the ginger jar seem precariously balanced at the back of the shallow table, which they share with a parade of pears and apples, interspersed with a china sugar bowl and lidded pitcher on another carefully posed square of white linen.

Cézanne constructed the motif precisely, positioning the elements in a studied order to highlight resemblances between unlike objects. The bottom-heavy, bulbous green pear at the right of the tabletop echoes the shape and weight of the pot-bellied sugar bowl at left, while the yellow and red pears at left lean toward the tilting form of the jug to their right. The strapwork affixed to the ginger jar repeats the crisscross shape of the basket's latticed edges, just as the handle of the basket recalls the curve of the willow handle rising delicately above the orb of the jar. A series of ovals punctuates the center of the composition in the form of the open mouth of the jar, the lids of the sugar bowl and jug, as well as the outline of the golden apples lying between them.

Seldom did Cézanne achieve such a harmonious arrangement of color in his still lifes. Warm yellows and golden ochres unify the color scheme, moving from the wall beneath the tabletop at left to the kitchen table at center, through the highlights on the ginger jar and its willow strapping to the woven basket and its golden fruits, to the rush seat of the chair at upper center and the leg of the stool at center right. Cool mauves and gray blues sound the color complement to the warmth of these unifying tones. Whites in the napkin, tablecloth, and ceramics are painted with a range of grays and subtle pinks and serve as a foil to the most vivid colors in the composition—the dense golden yellow, red orange, and acid green of the fruits. GTMS

PAUL CÉZANNE, 1839–1906

THE KITCHEN TABLE, 1888–90, OIL ON CANVAS, 25 ⅜ X 31 ½ IN. (65 X 80 CM),

MUSÉE D'ORSAY, PARIS, BEQUEST OF AUGUSTE PELLERIN

PLATE 73

Gauguin's reliance on Cézanne's technical innovations in using repeated parallel strokes of color and multidimensional perspective is demonstrated by these three still lifes of 1889. For many years Gauguin owned a Cézanne, which he prized greatly, called *Still Life with Compotier* (1879–80, Museum of Modern Art, New York), featuring a fruit dish filled with grapes and apples, with green, red, and yellow fruits arranged on a white tablecloth or napkin.[196] Each of these still lifes by Gauguin is reminiscent of that work. In all three, the still life elements take precedence over the surface on which they rest, unlike *The Ham* (plate 77) and *Fête Gloanec* (plate 78), where the ellipse of the table is utterly integral to each painting's linear continuity. The palette common to each still life in this group resonates with recurring tones. Vivid reds and lustrous oranges are juxtaposed with rich greens, and the chalky whiteness of the underlying cloth or dish acts as a foil to a riotous festival of color. These juxtapositions of cool and warm hues and of white or neutral zones with highly colored still-life elements parallel another shared characteristic—the mix of the exotic and primitive with the refined and conventional.

Still Life with Colocynths is characterized by the synthetist style Gauguin had developed a year earlier while residing in Pont-Aven, Brittany. The artist placed his signature—*P.Go.89*—in bright red, to the right of center at the painting's upper margin. The tabletop is tilted toward the viewer, while the objects are depicted as if seen from eye level, resulting in the flat planes of color typical of his synthetist works. The lines of the painting enjoy a concordance with the sleeve of the Japanese figure's kimono that melds into the stem of a colocynth, echoed in the folds of the tablecloth and in the brushwork itself. Shown are an earthenware jug, green apples, colocynths, and perhaps onions.[197] Gauguin makes an overt nod to *japonisme*, indicated by the print of a Japanese figure on the wall to the right of the table.[198] Were the print absent from the composition, the still life would present only the simple repast of a provincial table. Its presence, however, inserts a mysterious force in the overall mood of the work, as if the figure were an Asian spirit reigning temporarily in a country kitchen in Brittany. The same unlikely presence is felt in *Still Life with Apples, Pear, and a Ceramic Portrait Jug,* where the enigmatic face of a modeled ceramic jug, though obviously inanimate, presides over the objects on the table.

In *Still Life with Peaches* an open fan creates a luminous halo of gold behind a bowl of peaches, emphasizing the aureate hues of the fruit. It is especially interesting that Gauguin chose to feature these peaches in a decorated faïence bowl, as he ordinarily preferred the simple stoneware he knew from his mother's extensive collection of Peruvian pottery.[199] He usually rejected such blatant "prettiness" in his still-life subjects. Moreover, Gauguin used very pronounced shading in his work. The shadows beneath the bowl and in the background to the right are midnight black, accented by green, which enhances their murky, inscrutable depth.

Still Life with Apples, Pear, and a Ceramic Portrait Jug shows robustly rendered fruit atop a simple wooden table. The implements could hardly be more plain. Gauguin highly valued handmade ceramics, a medium he had experimented with extensively.[200] Other elements of the painting include a landscape hanging on the white wall in the background, as well as an open doorway leading into deep shadows beyond the room.

The two still lifes from the Fogg Art Museum share a common provenance and have nearly always been exhibited as a pair. They epitomize Gauguin's chief preoccupation with the two parts of his being: *Still Life with Apples, Pear, and a Ceramic Portrait Jug* represents the Peruvian, Indian, and primitive, while *Still Life with Peaches* is all that is French, bourgeois, and civilized. Only a year before, in 1888, Gauguin had written to his wife, Mette, "You must remember I am two people rolled into one, there is the Indian in me as well as the sensitive man."[201] Together the works form a pictorial metaphor for the dichotomy of Gauguin's origins and the predilections he would struggle to resolve all his life.

MHB

PAUL GAUGUIN, 1848–1903

STILL LIFE WITH COLOCYNTHS, 1889, OIL ON CANVAS, 16 X 20½ IN. (40.6 X 52 CM),

JUDY AND MICHAEL STEINHARDT COLLECTION, NEW YORK

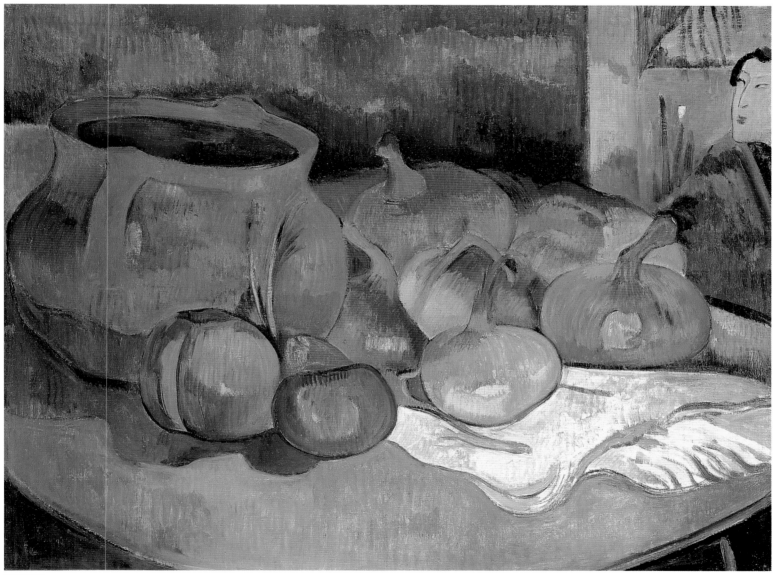

PLATE 74

PAUL GAUGUIN, 1848–1903

Still Life with Apples, Pear, and a Ceramic Portrait Jug, 1889, Oil on cradled panel, 11 ¼ x 14 ¼ in. (28.6 x 36.2 cm),

FOGG ART MUSEUM, HARVARD UNIVERSITY ART MUSEUMS, GIFT OF WALTER E. SACHS

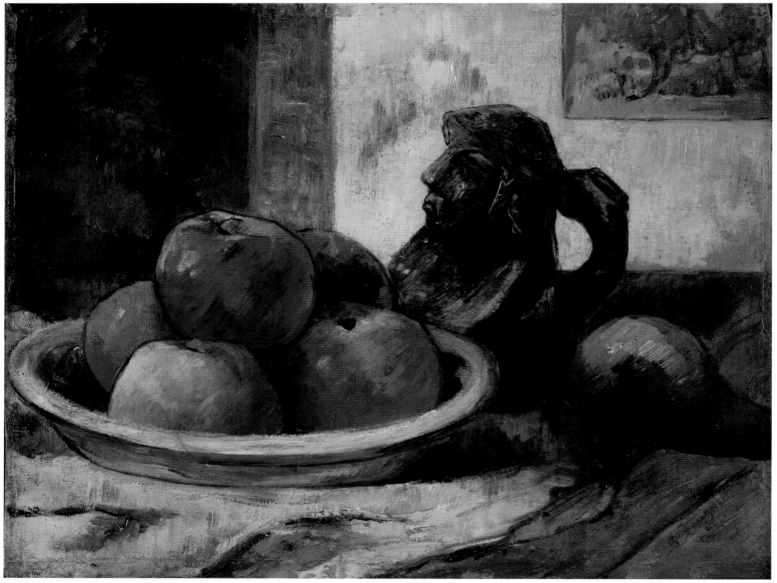

PLATE 75

PAUL GAUGUIN, 1848–1903

STILL LIFE WITH PEACHES, CA. 1889, OIL ON CRADLED PANEL, 9⅞ X 12⅜ IN. (26 X 31.8 CM),

FOGG ART MUSEUM, HARVARD UNIVERSITY ART MUSEUMS, GIFT OF WALTER E. SACHS

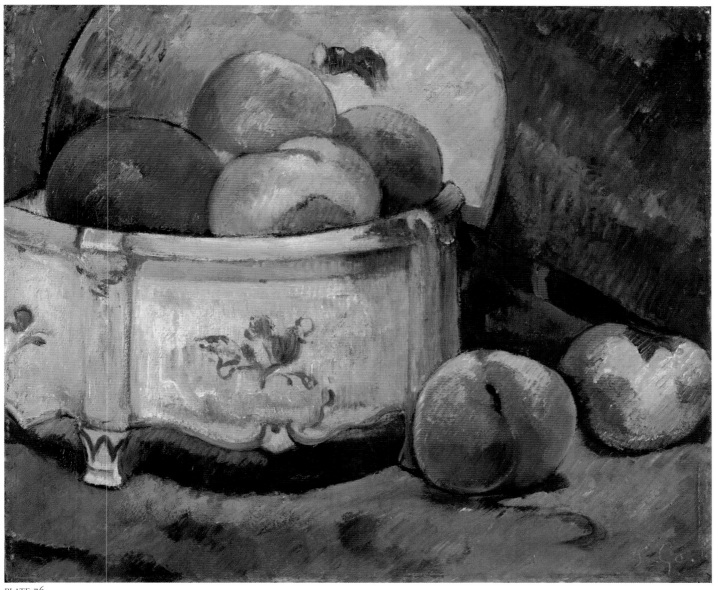

PLATE 76

In 1888 Gauguin wrote to his lifelong friend and collaborator Emile Schuffenecker, "I like Brittany, it is savage and primitive. The flat sound of my wooden clogs on the cobblestones . . . is the note I seek in my painting."[202] The wildness of the place so invigorated Gauguin that he was inspired to formulate an entirely new approach to painting he called synthetism, a "synthesis" of realism, personal subjectivity, and pure aestheticism. The style was dominated by uncompromising color combinations along with the repetition of colors to establish tonal harmonies as well as the use of flat surfaces and distorted perspectives to achieve decorative linear patterns. Gauguin was beginning to experiment with synthetism in the late 1880s and early 1890s when he painted *The Ham* and *Fête Gloanec*.

The Ham is composed of a myriad of shapes and lines, one element in the composition building upon the next. The curvilinear lines of the table legs are repeated in the succulent marbling of the ham, each curve accentuated by the delicate roundness of the onions. The sphere of the tabletop dominates the picture plane and might risk toppling toward the viewer were it not stabilized by the strong verticals of the paneling and wallpaper in the background. The mottled hues of the wallpaper are echoed in the onions scattered across the table's surface. The beads of the wallpaper hardly seem part of the wallpaper at all, but instead read like solid chain links pulled taut behind the table. The contrast between the inert flatness of the background and the physicality of the food on the tabletop imbues this painting with a palpable tension. Cross-

hatched lines of white and sage complement the festive red and orange hues of the ham, and the mottled brushwork behind the table also gives the painting a strange glowing effect, as if color and light were emanating from the ham itself. Gauguin had previously experimented with using different patterns in wallpaper in the early and mid 1880s, though never to the extent seen in *The Ham*.[203]

Gauguin's inspiration for this painting was most likely Manet's *Ham* (fig. 10), a painting of an unadorned, sumptuous ham, which he would have seen in January or February 1889 at the Paris apartment of Edgar Degas. Only from Manet could Gauguin have derived such a sense of immediacy from so simple a subject.[204] This was the one time Gauguin chose to depict meat, and it is almost certain he painted *The Ham* in the company of fellow artist and friend Meyer de Haan, whose own version of the motif is much more straightforward and realistic. Gauguin, as usual, used the subject only as a point of departure for his fertile imagination. As he frequently exhorted his circle of admirers, "It is better to paint from memory. Thus your work will be your own."[205] From the burnished metal of the bistro table to the warm yellows and piquant oranges, color harmonies pervade this intensely beautiful painting.

Fête Gloanec offers a similar vantage point to *The Ham*. Although both paintings are viewed from above and feature a tabletop cut off by the edge of the canvas, *Fête Gloanec* is more radically abstract. The sense of depth is

PAUL GAUGUIN, 1848–1903

THE HAM, 1889, OIL ON CANVAS, 19¾ X 22¾ IN. (50.2 X 57.8 CM),

THE PHILLIPS COLLECTION, WASHINGTON, D.C.

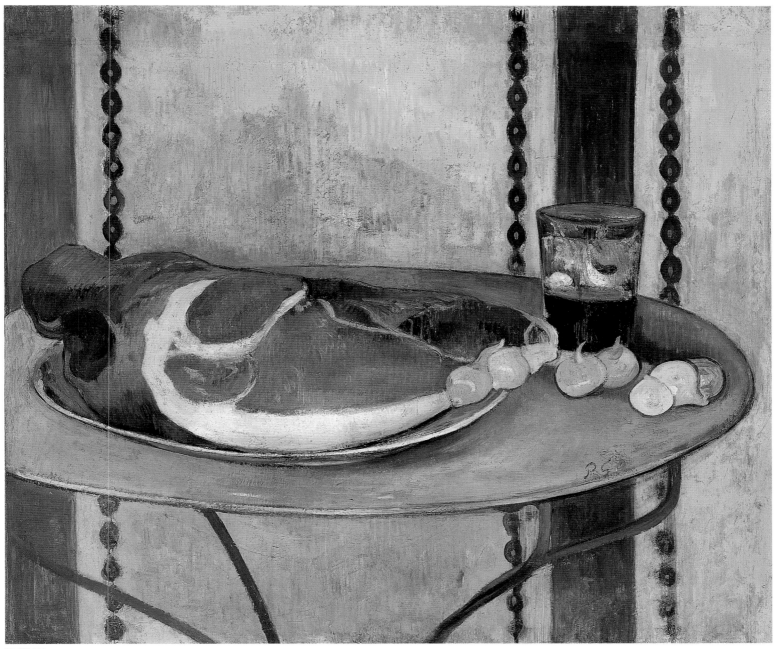

PLATE 77

deliberately distorted, resulting in a two-dimensional flatness. The picture has at least three distinct perspectives: the edge of the table is seen directly from the front; the objects on the table are depicted as if seen at eye level; and the tabletop is tilted toward the viewer as if observed from above.[206] A pronounced lack of shadowing exaggerates this flattening effect. The brilliant vermilion of the tabletop is the single element that binds the composition together. Each object is bathed in a red luminescence intensified by the presence of complementary vivid greens.

Fête Gloanec was the embodiment of the synthetism Gauguin developed while residing at the Maison Gloanec in Le Pouldu. One of the first canvases executed in the new style, it was a gift to the mistress of the house, Mme Marie-Jeanne Gloanec.[207] Featured are the trappings of Mme Gloanec's saint's day celebration—pears and other fruit, a bouquet of marigolds (with one disproportionate cornflower in the middle) wrapped in white paper, and

what is probably a Breton tart.[208] The title is rather glibly inscribed onto the table's edge. The painting also reflects the overwhelming influence of Cézanne and Degas on Gauguin's modeling with color and his placement of complementary tones side by side.

Gauguin might have had either *The Ham* or *Fête Gloanec* in mind when he wrote in 1888:

A green next to a red does not produce a reddish brown, like the mixture [of pigments], but two vibrating tones. If you put chrome yellow next to this red, you have three tones complementing each other and augmenting the intensity of the first tone: the green. Replace the yellow by a blue, you will find three different tones, though still vibrating through one another. If instead of the blue, you apply violet, the result will be a single tone, but a composite one, belonging to the reds. The combinations are unlimited.[209]

MHB

PAUL GAUGUIN, 1848–1903

FÊTE GLOANEC, 1888, OIL ON WOOD, 15 X 20⅞ IN. (38 X 53.2 CM),

MUSÉE DES BEAUX-ARTS D'ORLÉANS

PLATE 78

Vincent van Gogh left Arles on May 8, 1889 to commit himself voluntarily into the asylum of Saint Paul de Mausole on the outskirts of the town of Saint-Rémy, some fifteen miles away. There, he spent a turbulent year, sometimes unable to paint for weeks at a time due to his debilitating illness. Although he painted some of his most dazzling landscapes at Saint-Rémy—olive trees and cypresses under the noonday sun or a starry sky—he was often unable or unwilling to work in nature, preferring to remain within the grounds of the asylum. Oddly enough, when confined indoors, van Gogh did not take up still-life painting—as Monet regularly did, for example, when faced with inclement weather (see *Vase of Flowers,* plate 61). Instead, van Gogh turned to painting copies of works by Delacroix and Millet as a kind of stabilizing exercise, and at the end of the year he was able to write to his friends M. and Mme Ginoux, in Arles, "Personally I believe that the adversities one meets with in the ordinary course of life do us as much good as harm. . . . In my own case my disease has done me good—it would be ungrateful not to acknowledge it. It has made me easier in my mind, and is wholly different from what I expected and imagined."[210]

In the last weeks of his stay at Saint-Rémy, however, van Gogh turned back to still life, producing a series of dazzling flower pieces, two showing pink roses, including the National Gallery's *Roses,* and two showing blue-purple irises.[211] He described them to his brother in the second week in May:

At present all goes well, the whole horrible attack has disappeared like a thunderstorm and I am working to give a last stroke of the brush here with a calm and steady enthusiasm. I am doing a canvas of roses with a light green background and two canvases representing big bunches of violet irises, one lot against a pink background in which the effect is soft and harmonious because of the combination of greens, pinks, violets. On the other hand, the other violet bunch (ranging from carmine to pure Prussian blue) stands out against a startling citron background, with other yellow tones in the vase and the stand on which it rests, so

it is an effect of tremendously disparate complementaries, which strengthen each other by their juxtaposition.[212]

A day or two later, he wrote to say that he had "just finished another canvas of pink roses against a yellow-green background in a green vase." Although he was happy to be leaving Saint-Rémy for Auvers, north of Paris, he realized that there were still motifs to be painted in the South: "This morning when I had been to pay for my luggage," he wrote, "I saw the country again after the rain, quite fresh and full of flowers—what things I could still have done."[213]

The four flower pieces were painted on canvases of roughly equal dimensions, with similar compositions. In the two upright bouquets, one of roses and the other of irises, flowers rise with a graceful energy from Provençal vases enameled in green or yellow; in the two horizontal canvases, irises or roses unfurl toward the margins of the picture space, filling the canvas with their languid abundance. From van Gogh's letter, it is clear that he conceived the canvases differently, some "soft and harmonious," others made more vibrant because of their "tremendously disparate complementaries." Though the effect the paintings originally produced is difficult to judge, since the pink tints in three of them have faded dramatically—*Roses,* for example, once showed pink flowers against a green background, confirmation of the artist's continuing interest in the study of color complements—the brilliance of van Gogh's application of paint remains undiminished over time. From the vigorous surface of *Roses,* with thick passages of impasto in the blossoms, linked by more thinly painted, calligraphic leaves and stems, it is clear, as Vincent wrote to his sister Wil, that during "those last days at St. Rémy I still worked as in a frenzy." The "great bunches of flowers, violet irises, big bouquets of roses, [and] landscapes" that he produced in his excitement about leaving the asylum attest to his confidence in his talents as an artist and in his health, since he had been, in the doctors' estimation, "cured."[214] GTMS

VINCENT VAN GOGH, 1853–1890

ROSES, 1890, OIL ON CANVAS, 28 X 35 ½ IN. (71 X 90 CM), NATIONAL GALLERY OF ART, WASHINGTON, D.C.

GIFT OF PAMELA HARRIMAN IN MEMORY OF W. AVERELL HARRIMAN

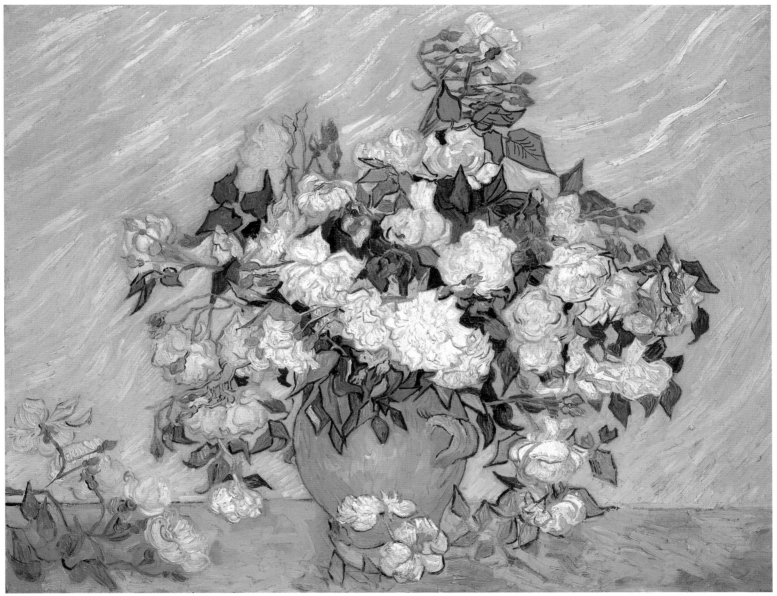

PLATE 79

Cézanne attempted to construct and solve compositional problems posed by still life until the end of his life, declaring "to see is to conceive and to conceive is to compose."[216] An entire repertoire of now-familiar objects appear repeatedly in his still lifes of the early 1890s, including the ginger jar, the green-glazed ceramic pot, the narrow-necked jug with handle, and the bottle in crisscrossed raffia. The large green-glazed pot first appeared in still-life paintings of circa 1877, whereas the narrow-necked pitcher is confined primarily to paintings from the early 1890s. Both the ginger jar and the raffia-covered bottle became central elements that the artist used time and again in a great variety of still-life compositions, especially from the late 1880s through the early 1890s.

These four paintings from the early 1890s demonstrate the range of subject, arrangement, and composition in still life that can be found in Cézanne's work from this period. The paintings vary in size from only about thirteen by sixteen inches (*Fruit and Jug on a Table*) to more than two by three feet (*Still Life with a Ginger Jar and Eggplants*). The compositions also vary in complexity: two of the works concentrate on a few objects, while the other two introduce more than one viewpoint in a complex treatment of pictorial space. In the latter two (plates 80, 83), for example, an additional table in the upper left portion of the composition can be seen as if from below.

Between *Ginger Pot with Pomegranate and Pears* and *Still Life with a Ginger Jar and Eggplants*, we can discern some shared characteristics as well as differences. Both paintings include the ginger pot, which serves as a fixed stabilizing element in the composition. In both works Cézanne employed gathered and folded fabric to tremendous effect. In *Ginger Pot with Pomegranate and Pears*, the patterned material that enters the composition from above balances the white towel that is folded and draped on the left side of the table. The uncovered portion of the table provides a strong horizontal that serves to stabilize the elements of the still life. By contrast, in *Still Life with a Ginger Jar and Eggplants*, Cézanne used two pieces of cloth, bunched and folded into elaborate arabesques, to completely obscure the table underneath and to set the ele-

ments of his still life tossing on a veritable sea of unrest. In the center of the composition, the wine bottle stands behind the ginger jar as if to reaffirm its stability in the midst of movement. Clustered closely beside them, the glazed pot and the perfect orb of a melon offer solidity and weight as well as additional convex shapes for the artist's exploration of volume.

Three eggplants dangle from a forked branch above the right side of the table, their dark overlapping shapes counterbalancing the dark bottle and answering the deep blue floral motif in the tablecloth. The other gathered cloth, which enters the composition from the right, forms an arc like a wave about to send the plate of pears, poised at a forty-five-degree angle, on a trajectory into the viewer's space. The multiple folds of the light and dark blue cloth endow the composition with an opulence that is almost baroque in its complexity of form and richness of color. Reminiscent of Jan Davidsz. de Heem's great still life in the Louvre, *The Dessert* of 1640 (fig. 14), this painting offers a contrast to the more spare *Sugarpot, Pears and Tablecloth* of the same period.

Using the same light and dark blue patterned cloth, Cézanne again chose a few predominant colors to unify the composition of *Fruit and Jug on a Table*. The work is redolent with deep blues, tranquil lavenders, and vivid greens. Speckles of the white canvas are left showing, a constant reminder of the flat canvas upon which the work is painted. An open-backed cane chair peeks out from behind a Provençal jug, which has been scaled down to emphasize the fervid yellows, oranges, and reds of the fruit. The cropped ellipse of the table emphasizes the flatness of the picture plane, while the arc itself suggests pictorial depth. A folded curtain, smooth, with the exception of one deep crease in the middle, slices through the image diagonally, functioning as a framing device for the objects on the table and further directing attention toward the modulated brushwork that dominates the painting's upper left-hand corner.

All four paintings reveal Cézanne's richly modulated color and the highly developed dialogue in his work between the two-dimensional surface and the complex relationships of volume and depth. MHB/EER

GINGER POT WITH POMEGRANATE AND PEARS, 1890–93, OIL ON CANVAS, 18¼ X 21⅞ IN. (46.4 X 55.5 CM),

THE PHILLIPS COLLECTION, WASHINGTON, D.C., GIFT OF GIFFORD PHILLIPS IN MEMORY OF HIS FATHER, JAMES LAUGHLIN PHILLIPS

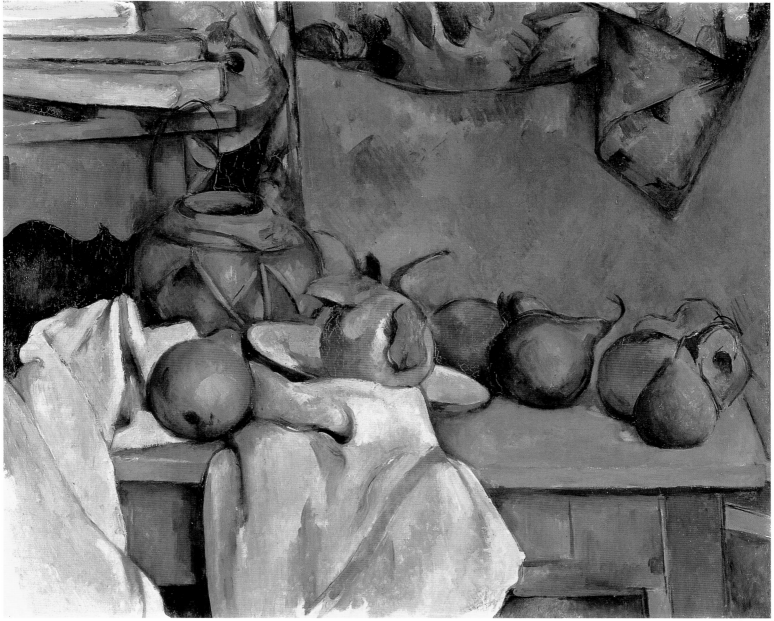

PLATE 80

PAUL CÉZANNE, 1839–1906

Sugarpot, Pears and Tablecloth, 1893–94, OIL ON CANVAS, 20⅛ X 24⅛ IN. (51 X 62 CM),

POLA ART FOUNDATION, JAPAN

PAUL CÉZANNE, 1839–1906

Fruit and Jug on a Table, 1893–94, OIL ON CANVAS, 13 X 16½ IN. (33 X 41 CM),

MUSEUM OF FINE ARTS, BOSTON, BEQUEST OF JOHN T. SPAULDING

PLATES 81, 82

PAUL CÉZANNE, 1839–1906

Still Life with a Ginger Jar and Eggplants, 1893–94, Oil on canvas, 28½ x 36¼ in. (72.4 x 91.4 cm),

The Metropolitan Museum of Art, New York, Bequest of Stephen C. Clark

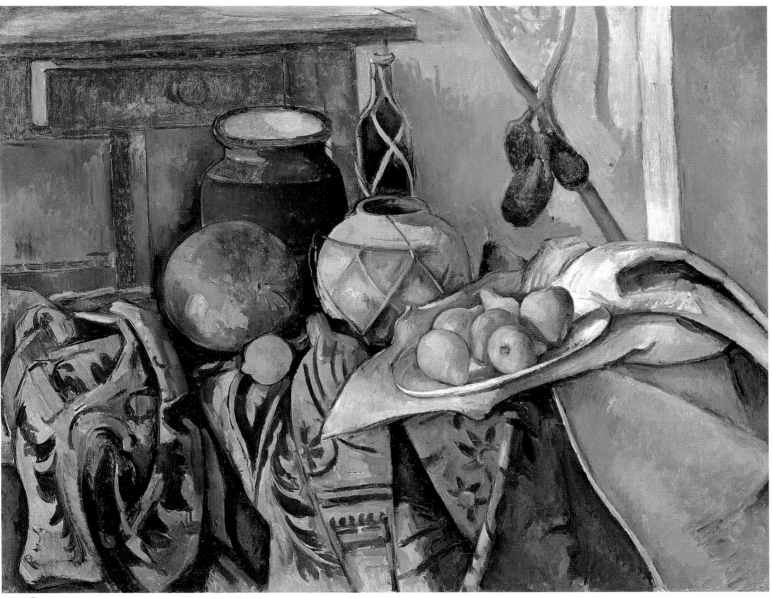

PLATE 83

GAUGUIN *Still Life with Tahitian Oranges,* 1892

Writing nearly fifty years after van Gogh's death, the painter's friend A. S. Hartrick referred to one of the still lifes of novels (see plates 70, 71) as "the first of a series of yellow pictures."[217] Surely one of the masterpieces of that series, which began in late 1887, is *Still Life: Basket of Apples,* a luminous study of ten golden apples placed on a wicker tray, which is set in turn on a horizontal surface indicated by brilliant chrome yellow hatchings, tinged with gold and ochre in the foreground. The fruits themselves are not uniformly yellow, their skins are dappled with dots of red, which are also used to show their contours, and olive and mint-green touches blended with strokes of gold suggest shadows on their irregular surfaces.

Color and its properties had been a preoccupation of van Gogh's since his days in Nuenen, but on his arrival in Paris in 1886 he began to enliven his palette by painting floral still lifes. Under the influence of his friend Paul Signac, a follower of Georges Seurat, van Gogh began to study color systematically, reading the treatise of the theorist Eugène Chevreul, building on knowledge he had gained from studying the work of the academician Charles Blanc several years before. By the autumn of the following year, his understanding of Impressionist color was complete, and he felt confident enough to begin to apply its lessons in extremely unconventional ways. Among the uses to which Chevreul had applied his study of color was the dyeing of yarns (he was the director of the Gobelins manufactory of tapestries), inspiring van Gogh to form a collection of colored yarns and experiment with different color combinations—yellow and violet, the color complements, as well as yellow and red, yellow and turquoise,

yellow and white, cool yellow and warm yellow, along with many other mixtures of hues. Van Gogh's collection of yarns, stored in a red lacquer box, is still preserved.[218] The color effects that he achieved with these mixtures of yarn are strikingly similar to those at work in *Still Life: Basket of Apples,* where disparate as well as closely related hues are juxtaposed in long, yarnlike strokes of paint. These colors appear as if woven together in the skeins of lines that describe the wicker basket and in the short, staccato strokes that indicate the yellow tabletop on which the basket sits.

The yellow hues that dominate *Still Life: Basket of Apples* permeate the paintings that van Gogh produced in the summer and autumn of 1888, after his move to Arles—depictions of the harvest, of the rising or setting sun, of a painter friend in the guise of a poet, or of a café seen at night under sulfurous lamplight.[219] His yellow paintings culminated in his series of sunflower still lifes begun in the late summer of 1888 and repeated several times in the early months of 1889. It is one of these still lifes that Gauguin, his companion at Arles in late 1888, evoked several years later in an elegiac article on van Gogh, which he published under the title "Natures mortes," perhaps best translated here as "Stilled Lives":

In my yellow room—flowers of the sun, with purple eyes, stand against a yellow ground; they bathe their feet in a yellow pot, on a yellow table. In a corner of the picture, the signature of the painter: Vincent. And the yellow sun, which flows through the yellow curtains of my room, floods this efflorescence with gold, and in the morning, when I awake in my bed, I imagine that all of this smells very good.

VINCENT VAN GOGH, 1853–1890

Still Life: Basket of Apples, 1887, Oil on canvas, 18¼ x 21¾ in. (46.5 x 55.2 cm),

The Saint Louis Art Museum, Gift of Sydney M. Shoenberg, Sr.

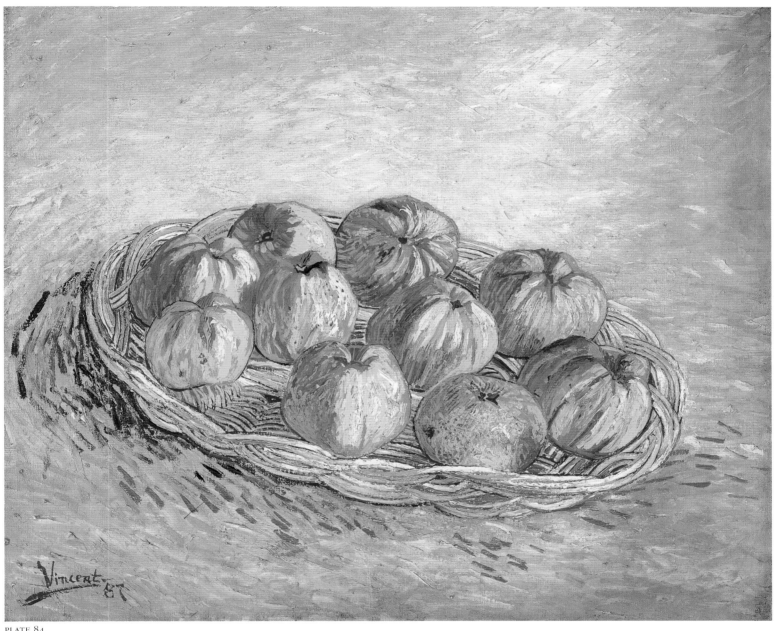

PLATE 84

Oh yes! He loved yellow, good Vincent, this painter from Holland, flashes of sunlight that warmed his soul, which lived in fear of fog. The need for warmth.[220]

Van Gogh had sought the warmth of the South in Arles, Gauguin knew. And he, in turn, a year after van Gogh's death in 1890, went to the South Seas, to Tahiti, in search of his own form of paradise. His keen interest in the appearance of Tahiti and its people and in the creation of his own Tahitian mythology led him to concentrate on landscape and figure painting during his first two-year stay there. Having painted a large number of still lifes between 1880 and 1890 (plates 74, 75, 76, 77, 78), he painted only a handful of such works in 1891 and 1892. All of the Tahitian still lifes celebrate the exotic: in two figure paintings, *The Flowers of France* (1891, State Hermitage Museum, St. Petersburg) and *The Bananas* (1891, Musée d'Orsay, Paris), Gauguin juxtaposed "portraits" of local children with displays of luxuriant flowers and fruits; and in a fantasy still life, *The Regal End* (1892, private collection), he placed the severed head of a king upon a cushion within what he called "a palace of my own invention. . . . I think it is a pretty piece of painting."[221]

More in keeping with his work of the previous years was *Still Life with Tahitian Oranges*, which bears his signature and the date 1892—inexplicably inverted—on the lower left. Like his *Fête Gloanec* (plate 78) or van Gogh's *Still Life: Basket of Apples*, Gauguin's painting is an exercise in color. On a table covered by a printed textile of coral pink and blue sits a *umete*, a wooden dish made for serving *poi*, filled with a dozen citrus fruits, some still deep green and unripe, others brilliant orange. Beside the fruit, green and red peppers play against each other at right; two dark green leaves at left enclose an arbitrary triangle of vivid red. The zone at the top of the canvas—a wall? the sky? a space that exists only in the painting?—is flooded with golden yellow light, warming the entire composition with the effect of sunshine. Was the painting, with its brilliant yellow background, a conscious reference to his lost friend? Years later, again in still life, Gauguin was to paint his own sunflowers, recollections conjured in the South Seas, of the Studio of the South that he and van Gogh shared. In *Still Life with Tahitian Oranges*, he may only have been trying to satisfy, with brilliant color, "the need for warmth."

GTMS

PAUL GAUGUIN, 1848–1903

STILL LIFE WITH TAHITIAN ORANGES, 1892, OIL ON CANVAS, 12¼ X 25⅝ IN. (31 X 65 CM), PRIVATE COLLECTION

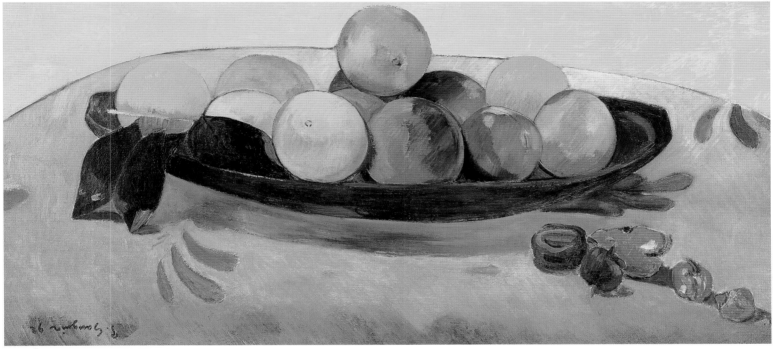

PLATE 85

At the end of the summer of 1893, Gauguin left Tahiti and returned to France, where he settled in Paris, working frantically to win recognition for the works that he had sent ahead of him or brought back with him from the South Seas. He convinced Durand-Ruel (perhaps with Degas's intervention) to hold a solo exhibition of his Tahitian compositions, and for two weeks in November 1893, the Parisian public had the first real chance to see what Gauguin had accomplished while abroad. Only eleven of the forty-one paintings were sold—two of them to Degas himself.[222]

Undaunted by the financial failure of the exhibition, Gauguin set up a salon-studio in Montmartre, decorating it with walls of chrome yellow—perhaps in memory of his friend van Gogh—and installing paintings by Cézanne and van Gogh on the walls, along with his own works. Through Ambroise Vollard, he made the acquaintance of an exotic beauty, a thirteen-year-old girl who called herself "Annah la Javanaise"—though she was from Ceylon, not Java—and she became Gauguin's mistress. In late spring, Gauguin and Annah left Paris to return to Brittany, where he had painted before his retreat to Tahiti. During a visit to Concarneau at the end of May, Gauguin was involved in a fight with a group of sailors. His leg was broken, and he was forced to remain in Brittany until it healed, settling into the inn run by Marie-Jeanne Gloanec, the recipient of his audacious still life of 1888 (plate 78).

Flowers and a Bowl of Fruit on a Table seems in every way an inversion of that earlier composition. Where *Fête Gloanec* hinted at the floor beneath the downward-pointing arc of the truncated, carmine-red tabletop, the 1894 still life presents a glimpse of the wall behind the hill-like arc of its table, covered in a cloth of white. In the earlier work, Gauguin used intense colors—the dominant red, of course, but also vivid yellow, blue, and green, along with deep black along the edge of the table. By 1894, his palette had softened, and cool, muted colors predominated: only the citrus fruits in the bowl add bright notes of orange and yellow. (The pastel effect of the Boston canvas is particularly striking because it has never been varnished.) The similarities and the particular differences between the two compositions are so conspicuous that one might almost be tempted to think Gauguin had painted the *Flowers and a Bowl of Fruit on a Table* as a pendant to *Fête Gloanec*. Although the two works are of differing dimensions, they share very similar formats—approximately 1.4 times as wide as they are high. The earlier still life was painted on wood, the later one on a fine linen canvas. Though they are clearly not pendants in the truest sense of the word, Gauguin's last Brittany still life must be understood as a response to the most daring of the still lifes he had painted there before his departure for the South Seas.

GTMS

PLATE 86

Describing Cézanne's *Still Life with Cupid*, which he saw while visiting the artist in his studio, Joachim Gasquet pinpointed some of the painting's most salient features. He thought it:

elegant, tangy, lucid—[a] work altogether French in character, decorative but pointed, half breaking away from some rich material in a muted floral pattern and draped in ample folds, a plaster Cupid, its arms broken, to its right a plate of pears, to its left a pile of plums. In the background—unexpected, bourgeois, but so richly painted, so stunningly wrought—a Prussian fireplace like the ones still used in cottages in Provence.[223]

The elegance Gasquet recognized perhaps resides in the baroque statuette, attributed in Cézanne's day to the seventeenth-century sculptor Pierre Puget.[224] Cézanne was drawn to the sculptor's ability to render motion through dynamic contours. "He is the one who makes marble move," Cézanne told Gasquet. "Before him, sculpture was rigid. . . . But he painted, created shadows."[225] Over nearly forty years, Cézanne made a series of five watercolors, eleven drawings, and five oil paintings devoted to this 17⅞-inch-high plaster cupid, which he transported with him to his various studios. Approaching the statuette from various angles, every picture is vertically oriented, with the exception of this painting from Stockholm made late in Cézanne's career.[226] Although *Still Life with Cupid* is unique among this group of pictures because of its horizontal orientation, it fits within Cézanne's dominant manner of painting still life within a horizontal space.

Fundamental to artistic training in the nineteenth century, plaster casts made after sculpture were used by artists to learn anatomy and the methods of rendering light and shade.[227] Sculpture provided an opportunity to study the nude form without having to attend to a live model; it neither required payment nor became fatigued after hours of posing. For Cézanne, who remained devoted to the human form throughout his lifetime but was uneasy in the company of female models, sculpture was an essential tool. Of Cézanne's approximately twelve hundred surviving drawings, one-fifth depict sculpture studied in the Louvre, the Musée de Sculpture Comparé at the Trocadéro,

and in the comfort of his studio.[228]

Like Cézanne, artists such as Caillebotte, Degas, Fantin-Latour, and van Gogh all depicted small sculptures in painted still-life arrangements, harking back to an eighteenth-century academic tradition.[229] From the Louvre, Cézanne would have known Chardin's *Attributes of the Arts* (1765) and Anne Vallayer-Coster's *Attributes of Painting, Sculpture, and Architecture* (1769), both of which feature a centralized statuette flanked by various tools of the artist's trade.[230]

Unlike his eighteenth-century predecessors, however, Cézanne surrounds his plaster cast with fruit instead of related artistic objects. Herein perhaps lies the "tanginess" Gasquet mentions in his account of the painting. Plump with rich red and orange tones, pears and a cluster of plums counter the icy blue coldness that defines the painting's upper and middle registers. The fireplace in the right background emits no warmth, existing simply as one piece of an environment consisting of various degrees of blue, which moves right to left along the wall to the plaster statuette, the two-toned drape, and the unreadable space behind what are probably the crosspieces of a chair back. This juxtaposition of living nature in the fruit with the cold plaster of the statuette heightens our awareness of the peculiarities of the objects Cézanne brings together in the image. The marriage in the cupid itself of life—in its dynamic body position—and death—in its frozen immobility and white-blue coloring—echoes the conflicting sensibilities of the composition as a whole.

The Stockholm *Still Life with Cupid* and another from the Courtauld of the same subject (fig. 44) are the most finished paintings of Cézanne's five oils on this subject. The Stockholm composition is less spatially complex than the Courtauld's, however, which pictures several canvases within a painting in which space is described from multiple viewpoints. Apples and onions dot the surface of the Courtauld painting instead of being separated into two orderly groups. The oblique view of the twisting cupid in this vertical composition creates a sense of tension and movement that is echoed in the diagonals breaking up the background space.

Despite the exaggerated upward tilt of the table and

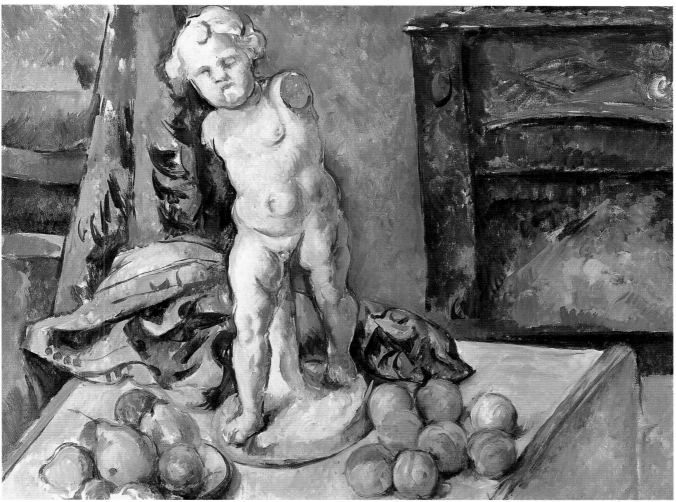

PLATE 87

the uncertain space to the left of the curtain, the Stockholm *Still Life with Cupid*, probably earlier than its sibling from the Courtauld, presents a space that is more easily understood. It is more "lucid," to use Gasquet's third adjective. The plaster cupid faces the viewer straight on, its groundedness reinforced by the stabilizing horizontals of the fireplace in the right background and the chair back to the left of the curtain. This blue drapery that Cézanne used again and again in his still lifes links foreground to background, unifying what might otherwise appear as two distinct parts. Loose, thin brushstrokes allow the white canvas to show through from the upper-left corner of the fireplace to the cupid's head, down through the drapery and the plate of pears. Presenting what John Rewald called a "perfect unity in its stages of execution,"Cézanne's *Still Life with Cupid* is thus knit together through the artist's consistent brushstroke and uniform approach to the canvas surface.[231] JAG

In November 1895, Cézanne's standing within the French art world changed dramatically. His retrospective exhibition that month at Ambroise Vollard's gallery incited new interest in his work, secured him new patrons, and established his reputation as a pioneer of new methods of art making. Cézanne emerged from what had been a largely reclusive existence to a position of public prominence. After more than thirty years of painting, he had finally come into his own.

The paintings made around 1895 exhibit a greater variety of method and technique than ever before in Cézanne's oeuvre. Consider, for example, two works that were made during roughly the same years, *Still Life with Apples* and *Still Life with Onions*. Some notable affinities can be readily discerned. Atop tilted-up tables cropped at the left and viewed at an angle, Cézanne's familiar white cloth is pinched into peaks, allowing the fruit and vegetables to nestle in its folds. Packing an ample group of objects into shallow spaces, each composition moves diagonally from the upper left corner to the bottom right. Vertical elements—the milk pitcher in *Still Life with Apples* and the bottle and wineglass in *Still Life with Onions*—act as stabilizing forces, anchoring the horizontal arrangements. Yet, despite their similarity of structure, the two paintings are distinct in spirit.

Still Life with Apples is a study in color contrasts and harmonies. The eye jumps from the rich red apples and yellow lemons spread across the tabletop to the bowl of vivid plums or figs, whose greenness is repeated in the solitary pear sitting snugly in the center of the canvas.[232]

The sky blue of the fabric covering the table's front right corner, which is echoed on the underside of the bowl and also in the folds of the white cloth, completes the circle of primary colors. Traces of blue, red, and yellow punctuate the picture surface, from the unfinished curtain with leaf design on the left (which appears in a more worked guise in so many paintings from this period) to the pattern decorating the milk pitcher on the right.[233] Golden tones with hints of amber—in the left front section of the table and the curtain just above, in the background wall, and even in the right foreground where the blue cloth drapes down off the table's edge—envelop the whole. An elaborate composition, sketchily rendered with thin multidirectional brushstrokes except in the more defined pieces of fruit, *Still Life with Apples* appears to have been built up around this central arrangement of alternating hues dotting the table's surface.

In *Still Life with Onions*, the paint is also thinly applied except around the bottle of table wine. In its subdued harmonies of olive and russet tones, however, the painting evokes a sense of somber reserve that is quite removed from the coloristic dynamism of *Still Life with Apples*. A knife handle protruding beyond the edge of a wooden table invites the viewer into what Cézanne suggests is a humble kitchen space. Unlike *Still Life with Apples*, in which objects are brought together for their formal and tonal associations, the bottle, half-full wineglass, onions, knife, and plate in *Still Life with Onions* relate to one another in a narrative of meal preparation. In this way, the work recalls some of Cézanne's earliest pictures firmly grounded

PAUL CÉZANNE, 1839–1906

Still Life with Apples, 1895–98, Oil on canvas, 27 x 36½ in. (68.5 x 92.7 cm),

The Museum of Modern Art, New York, Lillie P. Bliss Collection

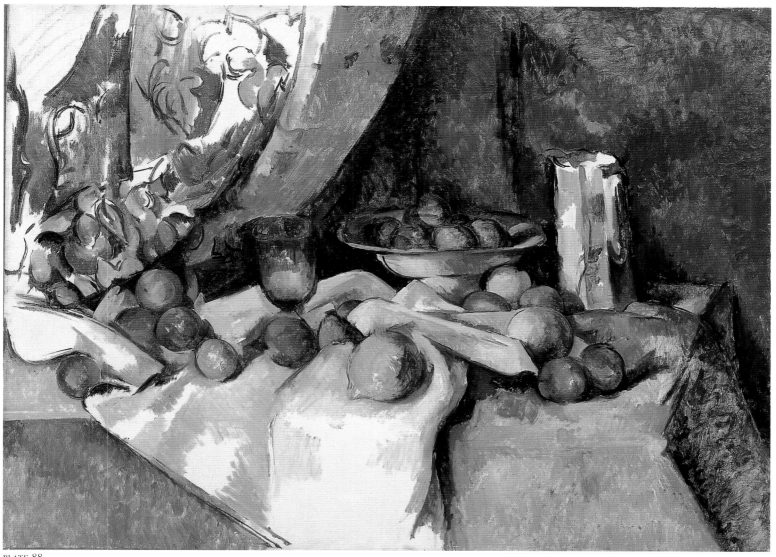

PLATE 88

in the tradition of Chardin's simple kitchen still lifes.[234]

Rather than jumping across the various elements of the canvas, the eye dwells on the left half of the composition of *Still Life with Onions*, which is heavy with objects. Again serving to isolate the round forms of the vegetables, the white cloth occupying the right half of the canvas is clumped into a heavier mound than in *Still Life with Apples*, seeming to extend far beyond the support of the table. The quickly painted wisps of green onion shoots—to the left of the bottle, just below the glass, and beneath the folds of the cloth at the right—bring the table arrangement into the space of the blank background wall, a wash of quiet green tones. Accentuating the juxtaposition between translucence and opacity, Cézanne plays the round red-brown forms of the onions off the reflected and refracted surfaces of the glass and bottle. The off-center stem of the wineglass, along with the right side of the table, which recedes back into space at an angle awkwardly incongruous to its horizontal edge, throws an otherwise staid composition slightly off-kilter. Chardinesque in many ways, the painting is thus, like *Still Life with Apples*, also very Cézanne. This pair of works demonstrates just two of the many faces of Cézanne that came into full expression in the 1890s. JAG

PAUL CÉZANNE, 1839–1906

STILL LIFE WITH ONIONS, 1896–98, OIL ON CANVAS, 26 X 32¼ IN. (66 X 82 CM),

MUSÉE D'ORSAY, PARIS, BEQUEST OF AUGUST PELLERIN

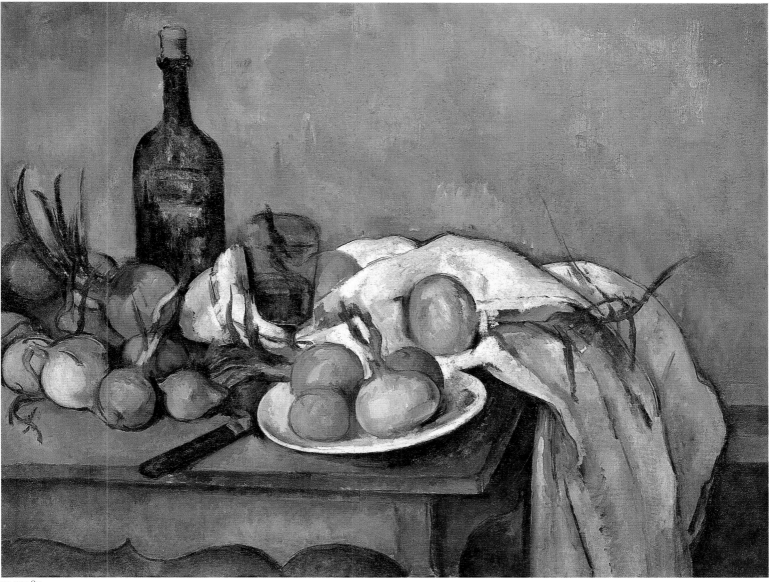

PLATE 89

From the Middle Ages, the human skull has been employed in painting as a potent symbol of death. The tradition of *vanitas* still lifes, in which a skull often serves as a moralizing reminder of the transience of life and the eternity of death, is a long one in European art. Early in his career, about 1866, Cézanne painted such a work, a thickly impasted image of a skull placed beside an open book and a candle. It was not until the late 1890s, however, that the skull would return in force to the painter's repertoire of subjects. Between about 1898 and his death in 1906, he completed six oils and four watercolors representing one or more skulls.[235]

"How beautiful a skull is to paint!" Cézanne is said to have observed. Certainly, as critics have perceived, the rounded but sculptural form of the skull served the painter well for the exploration of volume through subtle shifts in light and shadow. Visitors to Cézanne's studios—the studio he kept in the town of Aix, another at his family home nearby, the Jas de Bouffan, and his last studio above the city at the Jardin des Lauves—frequently commented on the presence of several skulls among the artist's studio paraphernalia. (In fact, the skulls depicted in the paintings shown here are probably those still kept at the last studio.)[236]

The three paintings in this exhibition present these skulls in a variety of ways. In the canvas from Detroit, exaggeratedly horizontal in format, the three forms are arranged side by side on a tabletop without touching. They are seen slightly from the right, so that the left temple of each skull is revealed. The eye sockets of each seem to "gaze" off to the left of the picture space. In *Pyramid of Skulls*, by contrast, four skulls are closely stacked in a pile. Two of these, on the bottom, and a third, behind, facing into the darkness of the background, support the fourth. Whiter than the others, this fourth skull sits almost exact-ly at the center of the composition on its upper margin. The empty eye sockets of this skull seem to focus on the viewer; its brow is deeply furrowed, and its temple is concave, as if the skull had taken on the expression of the face it no longer supports. These elements add to the disturbing impression of a sentient being within the bleached bone, dramatically modeled by the light.

In a final painting, unfinished at Cézanne's death, a single skull is once more joined with a candlestick on a shallow table set against a wall painted with delicate tones of brownish ochre, soft green, and gray blue. This time Cézanne chose to orient his canvas vertically, a relatively infrequent choice in the artist's still-life painting after 1890.[237] Although this painting recalls the artist's first still life with a skull, the stub of candle that he placed in the holder in his earlier composition is omitted here. Whether this detail has an emblematic significance is difficult to say, since the painting is unfinished—unless we read the unfinished character of the picture as a statement in itself.[238]

The reasons for Cézanne's return to the motif of the skull are almost impossible to determine, but both Theodore Reff and Françoise Cachin have linked its reappearance to the death of the artist's mother in late October 1897. "It is quite natural," Cachin writes, " . . . that pictorial meditations on death should have made their appearance precisely at the moment at which his final bulwark against annihilation—the presence of his mother—had been removed, making his own death seem that much more imminent."[239] These haunting still lifes from about 1900 mark a transition, then, in Cézanne's life. They also mark a transition in the history of art: they represent the culmination of the Impressionist still life and a point of departure for the still-life tradition in the modern era.

GTMS

PAUL CÉZANNE, 1839–1906

The Three Skulls, 1898–1900, Oil on canvas, 13⅜ x 23⅝ in. (34 x 60 cm),

The Detroit Institute of Arts, Bequest of Robert H. Tannahill

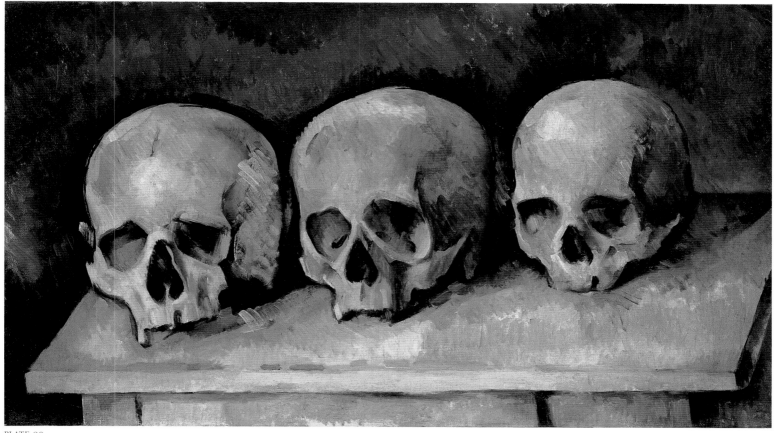

PLATE 90

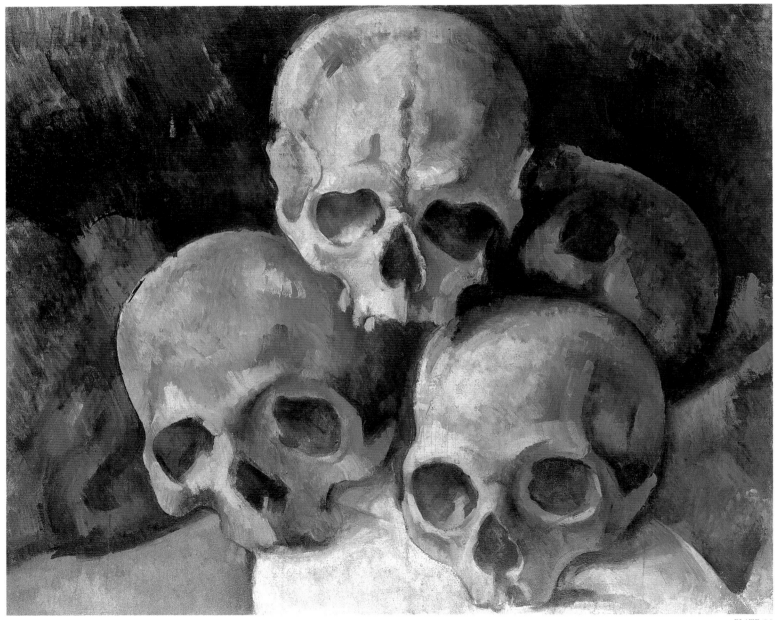

PLATE 91

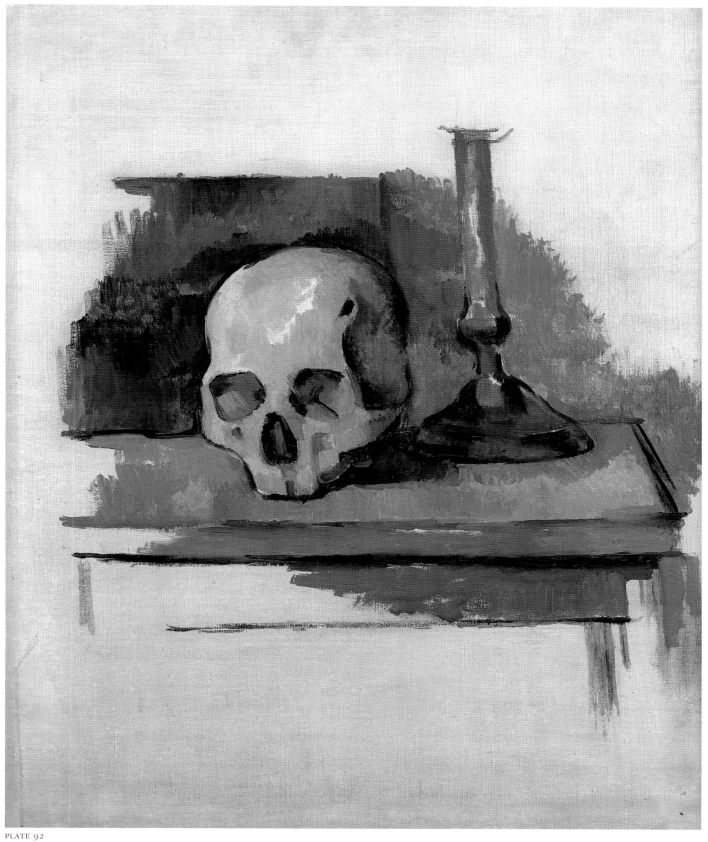

PLATE 92

CATALOGUE WITH
BIOGRAPHIES OF THE ARTISTS

BAZILLE

Frédéric Bazille, whose artistic career spans only eight years owing to his untimely death in 1870, was born into a prominent Protestant family in Montpellier on 6 December 1841. As the son of a well-to-do family, Bazille was expected to study medicine, which he pursued in Montpellier until 1862. Because of his increasing interest in an alternate career as an artist, he then convinced his family to allow him to continue his studies in Paris. Bazille enrolled simultaneously in medical school and in Charles Gleyre's studio in Paris in November 1862. After failing his medical examination in 1864, he devoted himself exclusively to painting.

At Gleyre's studio, Bazille met the future Impressionists Renoir, Sisley, and Monet. They became his devoted friends, especially Monet, with whom Bazille spent a great deal of time between 1863 and 1865. At the end of 1863, Bazille met the controversial Courbet and, through his cousins the Lejosnes and their well-attended salons, he met Fantin-Latour and Manet.

The sixty-four paintings that comprise Bazille's entire oeuvre make it clear that he focused first and foremost on landscapes and figures. Still life was of limited interest to him. Only nine still lifes are known, comprising a mere 14 percent of his total work. However, Bazille knew that with still lifes he could likely achieve acceptance in the Salons, which looked less critically on still life than on history painting, portraits, or even landscapes.

Bazille's first Salon success was the large *Still Life with Fish* from 1866 (plate 5). The other work Bazille submitted that year was not accepted. He may well have submitted the still life to the Salon in order to validate his vocational choice and to attract interest from possible patrons.[1]

Even though he did receive an income from his family, Bazille needed to achieve some financial success in the arts in order to subsidize a lifestyle that included frequent concerts, as well as the cost of maintaining a studio with live models. He could also economize by painting still lifes: dead game, flowers, and fruit were readily available and certainly cheaper than paying for live models. Because they were inexpensive to set up, still-life arrangements also were shared among the close circle of former Gleyre students, the most noted example being *The Heron* (1867) painted by both Sisley and Bazille (plates 13, 14) in the studio Bazille shared with Renoir. Nonetheless, in the early years of his artistic career, 1864–67, Bazille painted only two still lifes of dead fish and two dead birds. It is clear that he was willing to explore the genre to a degree, but it was certainly not his heart's desire. In an 1866 appeal to his mother for funds, Bazille wrote: "Do not condemn me to paint still lifes forever."[2]

Upon hearing that Bazille's family had allowed him to give up medicine, Monet wrote to the artist in August 1864 advising him to paint flowers, a subject dear to his own heart.[3] Bazille did follow Monet's advice to some extent, completing four floral still lifes between 1866 and 1870, as well as two significant works that combine the figure with flowers. The first two flower paintings, *Study of Flowers* from 1866 (plate 11) and *Flowers* from 1868 (plate 21), could not be more different from one another. The 1866 work is in the spirit of Monet's and

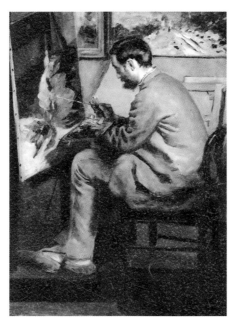

FIGURE 47
AUGUSTE RENOIR.
*PORTRAIT OF FRÉDÉRIC BAZILLE PAINTING
"THE HERON WITH WINGS UNFURLED"*. 1867.
OIL ON CANVAS, 41⅜ x 29 IN. (105 x 73.5 CM)
MUSÉE D'ORSAY, PARIS

Renoir's 1864 experiments in floral still lifes, while the larger 1868 painting is much more academic and traditional. Bazille successfully submitted the earlier, less conventional of the two to the Salon of 1868. Two other small paintings of flowers date from 1870, one of which may have been intended for his sister-in-law Suzanne.

In addition, Bazille combined the figure with elaborate floral displays in two versions of *Young Woman with Peonies* (1870, Musée Fabre, Montpellier, and National Gallery of Art, Washington, D.C.) completed in the months just before he left to fight in the Franco-Prussian War in July 1870. He was killed four months later, near Orléans. SBF

PLATE 5
Still Life with Fish
Poissons. 1866
Oil on canvas, 24¾ x 32⅝ in. (62.0 x 81.3 cm)
Signed bottom right: *F. Bazille*
The Detroit Institute of Arts, Founders Society Purchase, Robert H. Tannahill Foundation Fund

PROVENANCE
Montpellier, Collection André Bazille, 1952; Mme Rachou-Bazille, France; Detroit Institute of Arts, Founders Society Purchase, Robert H. Tannahill Foundation Fund, 1988 (1988.9).

EXHIBITIONS
Salon of 1866, Paris, Palais de l'Industrie, 1 May–15 June 1866, no. 97; *Rétrospective Bazille*, Paris, Salon d'Automne, 15 October–15 November 1910, no. 6; *Rétrospective Bazille*, Montpellier, Exposition interna-

tionale, May–June 1927, no. 6; *Centenaire de Bazille*, Montpellier, Musée Fabre, May–June 1941, no. 16; *Frédéric Bazille*, Paris, Galerie Wildenstein, June–July 1950, no. 23; *Frédéric Bazille*, Montpellier, Musée Fabre, 13–31 October 1959, no. 13; *Frédéric Bazille*, Montpellier, Musée Fabre, 11 July–4 October 1992, Brooklyn, Brooklyn Museum, 13 November 1992–31 January 1993, Memphis, Dixon Gallery and Gardens, 14 February–25 April 1993, no. 12.

PLATE 11
Study of Flowers
Etude de fleurs or Pots de fleurs. 1866
Oil on canvas, 38¼ x 34⅜ in. (97 x 88 cm)
Signed and dated in lower left corner: *F. Bazille 66*
Greentree Foundation, New York

PROVENANCE
Gift from the artist to his mother's first cousins Commandant and Mme Hippolyte Lejosne, Paris, by 1868; by descent to M. Lejosne, Pau, by 1932; Dr. F. Schoni, Zürich, until 1960; Hon. John Hay Whitney, New York, 1960; Whitney Collection, New York, 1960–82; Collection Mrs. John Hay Whitney, New York; Greentree Foundation, New York.

EXHIBITIONS
Salon of 1868, Paris, Palais de l'Industrie, 1 May–15 June 1868, no. 147 (as *Etude de fleurs*); *Frédéric Bazille*, Paris, Galerie Wildenstein, June–July 1950, no. 21; *The John Hay Whitney Collection*, London, Tate Gallery, 16 December 1960–29 January 1961, no. 2; *The John Hay Whitney Collection*, Washington, D.C., National Gallery of Art, 29 May–5 September 1983, no. 1; Paris and New York 1994–95, no. 4.

PLATE 14
The Heron
Héron aux ailes déployées. 1867
Oil on canvas, 39⅜ x 27⅛ in. (97.5 x 78 cm)
Signed and dated lower left: *F. Bazille 67*
Musée Fabre, Montpellier

PROVENANCE
Gaston and Camille Vialars Bazille, Montpellier, from late December 1868; given by Mme Gaston Bazille to the Musée Fabre in 1898 (898.5.2).

EXHIBITIONS
Rétrospective Bazille, Montpellier, Exposition internationale, May–June 1927, no. 9; *Chefs-d'oeuvre du musée de Montpellier*, Paris, Orangerie, 1939, no. 4; *Meisterwerke des Museums in Montpellier*, Berne, Kunsthalle, 1939, no. 3; *Centenaire de Bazille*, Montpellier, Musée Fabre, May–June 1941, no. 24; *Frédéric Bazille*, Paris, Galerie Wildenstein, June–July 1950, no. 38; *Vier euwen stilleven in Frankrijk*, Rotterdam, Musée Boymans, 1954, no. 96; *Frédéric Bazille*, Montpellier, Musée Fabre, 13–31 October 1959, no. 25; *Hommage à Frédéric Bazille*, Montpellier, 1970–71; *Naissance de l'Impressionisme*, Bordeaux, Galerie des Beaux-Arts, 3 May–1 September 1974, no. 85; *Frédéric Bazille and Early Impressionism*, Chicago, Art Institute, 4 March–30 April 1978, no. 24; *Trophées de chasse*, Bordeaux, Musée des Beaux-Arts, 1991–92, no. 46; Montpellier 1991–92, no. 17; *Frédéric Bazille*, Montpellier, Musée Fabre, 11 July–4 October 1992, Brooklyn, Brooklyn Museum, 13 November 1992–31 January 1993,

Memphis, Dixon Gallery and Gardens, 14 February–25 April 1993, no. 14; Paris and New York 1994–95, no. 8.

PLATE 21
Flowers
Fleurs or Vase de fleurs sur une console. 1868
Oil on canvas, 51⅛ x 37⅜ in. (130 x 95 cm)
Signed and dated in the middle of the bottom: *F. Bazille, 1868.*
Musée de Grenoble
Boston only

PROVENANCE
Painted for the artist's cousin Pauline des Hours, Montpellier; by descent to Emile Teulon; given by M. Emile Teulon to the Musée des Beaux-Arts de Grenoble in 1940; Musée de Peinture et de Sculpture, Grenoble (Inv. No. 2911).

EXHIBITIONS
Rétrospective Bazille, Paris, Salon d'Automne, 15 October–15 November 1910, no. 11; *Rétrospective Bazille*, Montpellier, Exposition internationale, May–June 1927, no. 14; *Frédéric Bazille*, Paris, Association des Etudiants protestants, 1935, no. 16; Grenoble, Musée-bibliothèque; Zürich, Kunsthaus, 1946, no. 61; *Frédéric Bazille*, Paris, Galerie Wildenstein, June–July 1950, no. 37; *Frédéric Bazille*, Montpellier, Musée Fabre, 13–31 October 1959, no. 24; *Frédéric Bazille and Early Impressionism*, Chicago, Art Institute, 4 March–30 April 1978, no. 33; *Peintres de fleurs en France du XVIIe au XIXe siècle*, Paris, Petit-Palais, 1979, no. 58; *Fleurs: de Fantin-Latour à Marquet, France 1865–1925*, Saint-Tropez, Musée de l'Annonciade, 26 June–27 September 1982, no. 4; *Frédéric Bazille*, Montpellier, Musée Fabre, 11 July–4 October 1992, Brooklyn, Brooklyn Museum, 13 November 1992–31 January 1993, Memphis, Dixon Gallery and Gardens, 14 February–25 April 1993, no. 22.

CAILLEBOTTE
Gustave Caillebotte was born to an upper-middle-class Parisian family in 1848. He earned a law degree, served in the Seine Garde Mobile during the Franco-Prussian War of 1870–71, and then began his artistic training with Léon Bonnat. Shortly after being admitted to the Ecole des Beaux-Arts in 1873, Caillebotte turned from the academic art establishment to pursue the more innovative painting methods espoused by the Impressionists. Degas asked him to exhibit with the group in 1874, but he opted not to submit any works until the second Impressionist exhibition, in 1876, when Renoir asked him to join. Caillebotte would become a regular participant in the Impressionist shows and one of the most ardent defenders of the group's ideals. He organized the exhibition of 1877, was at the fore of the planning of several others, and tried to restore unity among the Impressionist artists when many of them had become resigned to the idea of going their separate ways.[4]

Still life makes up approximately 10 percent of Caillebotte's oeuvre. The earliest examples date from the years immediately preceding his first exhibition with the Impressionists. Alternating between a realist aesthetic and whimsical scenes in which objects detached from any discernible setting appear to float in midair, the still lifes from 1872–73 attest to the artist's range.[5] Although primarily a figure painter, Caillebotte may have pursued still life in these early years because the genre provided him greater freedom to investigate compositional design, an interest that is patent in works such as *Floor-Scrapers* from 1875 (Musée d'Orsay, Paris) and *Paris Street; Rainy Day* from 1877 (Art Institute of Chicago). While he

chose not to exhibit any of these still lifes—some of which are most certainly studies—in the 1870s, *Luncheon* (1876, private collection)—a painting of his mother and brother dining at a table decorated with a lavish display of glassware—was shown at the Impressionist exhibition of 1876.[6]

Caillebotte explored still life in earnest beginning in the early 1880s when he moved to Petit-Gennevilliers, away from Paris and the theme of life along the city's vast new boulevards. He produced no less than thirty-seven paintings of fruit, flowers, game, and bourgeois table settings in the 1880s, the bulk of them painted between 1882 and 1883. Just as his street and window scenes appear as if they are constructed through a series of interlocking geometric forms, the still lifes from these years emphasize the structural organization of the arrangement. Some of the most striking spatial innovations can be seen in *Cakes* (1881, private collection) and *Hors d'oeuvre* (plate 55), both of which take a bird's-eye, cropped view of the tabletop display.

In addition to pictures of culinary opulence featuring oysters and crayfish among other haut bourgeois delights, Caillebotte painted marketplace subjects such as fruit stands and a butcher's wares. Far removed from the bourgeois still-life scenes that most of the Impressionists were painting, these pictures of ox tongues and sides of beef are perhaps truer to the French designation for the genre, *nature morte* (literally, dead nature).[7] He exhibited only two works from this broad range of still-life pictures at the Impressionist shows: a painting of fruit and crystal decanters and glasses appeared in the exhibition of 1880, and *Fruit Displayed on a Stand* (plate 58) was warmly received by the critic and novelist Joris-Karl Huysmans at the exhibition of 1882.[8] Whether he considered still life a minor aspect of his art or simply did not feel the need to cater to patrons' taste for pictures of flowers and fruit—his wealth removed him from such concerns—Caillebotte chose to be represented primarily by portraits, landscapes, and figure studies. Still life plays a similarly minor role in the collection that Caillebotte bequeathed to the French State. There were only two still lifes in his impressive collection of sixty-eight of his friends' pictures—Cézanne's *Flowers in a Rococo Vase* (ca. 1876, National Gallery of Art, Washington, D.C.) and Monet's *Red Chrysanthemums* (1880, private collection).[9]

At Petit-Gennevilliers, Caillebotte focused on yachting pictures, landscapes, and views of his garden until his premature death in 1894. The sunflowers, asters, and roses he cultivated in his greenhouse and on the grounds of the garden inspired several compositions, just as Monet's gardens at Giverny were a favorite subject of the elder artist in his later years.[10] Monet and Renoir in fact visited Petit-Gennevilliers to paint with Caillebotte in the late 1880s. Whether plucked and put into vases, captured out-of-doors in their natural setting, or transformed into panoramic designs for the door panels of his dining room, Caillebotte's flowers exude a sense of the enthusiasm with which he must have also tended to his garden. The artist's lifelong interest in compositional and decorative strategies comes to fruition in these late paintings, which are some of the most intoxicating paeans to natural beauty produced in this period. JAG

PLATE 56
Still Life with Crayfish
Nature morte au plat de langouste. 1880–82
Oil on canvas, 22⅞ x 28⅜ in. (58 x 72 cm)
Signed upper left: *G. Caillebotte*
Private collection

PROVENANCE
Lorenceau, Paris, 1952; Parke-Bernet, New York, 15 April 1959, no. 50; Marco J. Heidner, London; Christie's, London, 30 June 1967, no. 17; Richard L. Feigen, New York; Mr. and Mrs. Billy Wilder, Los Angeles, 1972; private collection.

EXHIBITIONS
Exposition des XX, Brussels, Musées Royaux des Beaux-Arts, 1888, no. 8; *Les antiquaires*, Paris, Foire de Paris, 1957; Paris, Chicago, Los Angeles 1994–95, no. 92.

PLATE 54
Still Life: Oysters
Nature morte aux huîtres. 1881
Oil on canvas, 15 x 21¾ in. (38 x 55 cm)
Signed upper left: *G. Caillebotte*
Private collection

PROVENANCE
Martial Caillebotte; Ambroise Vollard, Paris, ca. 1900; Sotheby's, London, 2 April 1981, no. 310; private collection.

EXHIBITIONS
Paris 1894, no. 68; Paris 1951, no. 166; *Le Pain et le vin*, Paris, Galerie Charpentier, 1954, no. 25; Paris, Chicago, Los Angeles 1994–95, no. 91.

PLATE 58
Fruit Displayed on a Stand
Fruits à l'étalage. CA. 1881–82
Oil on canvas, 30⅛ x 39⅝ in. (76.5 x 100.5 cm)
Signed (by Martial Caillebotte) bottom right: *G. Caillebotte*
Museum of Fine Arts, Boston, Fanny P. Mason Fund in Memory of Alice Thevin.

PROVENANCE
Given by the artist to Albert Courtier, Meaux, 1881; by descent to Mme Brunet, Paris; private collection, Paris; Palais d'Orsay, Paris, Ader Picard Tajan sale, 22 March 1979, no. 71; acquired by the Museum of Fine Arts, Boston, 1979, Fanny P. Mason Fund in Memory of Alice Thevin (1979.196).

EXHIBITIONS
Exposition des artistes indépendants, Paris, 251 rue St.-Honoré, March 1882, no. 4; Paris 1894, no. 91; *Gustave Caillebotte: A Retrospective Exhibition*, Houston, Museum of Fine Arts, 22 October 1976–2 January 1977, Brooklyn, Brooklyn Museum, 12 February–24 April 1977, no. 59; Boston 1992; Chiba, Nara, Yokohama, and Boston 1994–95, no. 38 (Japan) and no. 43 (Boston); Paris, Chicago, Los Angeles, 1994–95 no. 93 (Chicago only).

PLATE 55
Hors d'oeuvre
Nature morte hors-d'oeuvre. CA. 1881–82
Oil on canvas, 9⅞ x 21¾ in. (25 x 55 cm)
Stamped bottom right: *Gustave Caillebotte*
Private collection

PROVENANCE
Martial Caillebotte, 1894; Hôtel Drouot, Paris, room 11, 4 December 1950; Hirschl and Adler, New York, 1958; private collection.

EXHIBITIONS
Paris 1894, no. 110; Paris 1951, no. 165; *Pleasures of Summer*, East Hampton, Guild Hall Museum, 1958, no. 11.

PLATE 59
Display of Chickens and Game Birds
Poulets et gibier à l'étalage. CA. 1882
Oil on canvas, 30 x 41⅜ in. (76 x 105 cm)
Stamped lower right: *G. Caillebotte*
Private collection

PROVENANCE

Family of the artist; private collection, U.S.; private collection, Spain; private collection.

EXHIBITIONS

Paris 1894, no 87; Paris 1951, no. 48; *Gustave Caillebotte: A Retrospective Exhibition*, Houston, Museum of Fine Arts, 22 October 1976–2 January 1977, Brooklyn, Brooklyn Museum, 12 February–24 April 1977, no. 60; Paris, Chicago, Los Angeles 1994–95, no. 94.

PLATE 52

Game Birds and Lemons
Faisans et bécasses sur une table de marbre.
1883
Oil on canvas, 20 x 32 in. (51 x 81 cm)
Signed and dated upper right: *G. Caillebotte 1883*
Museum of Fine Arts, Springfield, Massachusetts, James Philip Gray Collection

PROVENANCE

Given by the artist to Paul Hugot, Paris, 1894; James Philip Gray, 1952; acquired by the Museum of Fine Arts, Springfield, James Philip Gray Fund, 1953.

EXHIBITIONS

Paris 1894, no. 57; Paris 1951, no. 204; *French and American Impressionism*, South Hadley, Dwight Art Memorial, 1956, no. 5; *Gustave Caillebotte: A Retrospective Exhibition*, Houston, Museum of Fine Arts, 22 October 1976–2 January 1977, Brooklyn, Brooklyn Museum, 12 February–24 April 1977, no. 61.

CASSATT

Mary Stevenson Cassatt was born on 22 May 1844 in Allegheny City (now part of Pittsburgh), Pennsylvania.[11] The daughter of a prominent banker, Cassatt studied at the Pennsylvania Academy of Fine Arts in Philadelphia from 1861 until 1865. In December 1865, she arrived in Paris where she continued her artistic training with the academicians Charles Chaplin (1825–1891) and Jean-Léon Gérôme (1824–1904). Cassatt exhibited at the official Paris Salon in 1868, 1870, 1872, and annually through 1876. The outbreak of the Franco-Prussian War prompted her to return to Philadelphia in July 1870, but she returned to Europe in early December 1871, commencing her studies in Italy, Spain, Belgium, and Holland. In 1873 Cassatt moved to Paris, where she remained for the rest of her career.

Primarily a painter of figures and portraits, Cassatt is best known for her treatment of the theme of mother and child. Throughout the 1870s and 1880s, she specialized in scenes of modern life, depicting upper-middle-class women in domestic settings and public places in fin-de-siècle Paris, often using her family and friends as models. At the invitation of Degas, with whom she developed a lifelong friendship and working relationship,[12] Cassatt participated in the fourth Impressionist exhibition in 1879. As the only American artist to exhibit with the group, she went on to play an instrumental role in organizing the fifth, sixth, and eighth Impressionist exhibitions in 1880, 1881, and 1886.[13]

Cassatt's work in still life is exceedingly rare. Of the 614 oils and pastels that she produced, only two are still lifes, comprising less than one-half of 1 percent of her painted oeuvre. The striking composition *Lilacs in a Window* (ca. 1880, private collection) and the less finished *Still Life of Tulips* (ca. 1889, private collection) are both studies of floral arrangements.[14] In addition, many of Cassatt's figural compositions contain elements of still life, often including detailed renderings of the trappings of upper-middle-class domestic life, such as tea services and fans.

Exhibited at the fifth Impressionist exhibition of 1880, Cassatt's important canvas *Tea* (plate 53)[15] includes a still life. An elaborate rendering of an antique silver tea service in the foreground is large in scale and given unusual prominence in the composition. Two related paintings in the Metropolitan Museum of Art, New York, *The Cup of Tea* (ca. 1880) and *Lady at the Tea Table* (1883), likewise contain still lifes, namely a floral arrangement and a tea service respectively.

By 1910, Cassatt's artistic production was curtailed by cataracts in both of her eyes. However, she continued to play an important role in advising on the purchases of important American collectors, such as Louisine and H. O. Havemeyer. On 14 June 1926 Cassatt died at the Château de Beaufresne, which she had acquired in 1893, in Mesnil-Théribus, France. AAL

PLATE 53

Tea
Le thé. 1879–80
Oil on canvas, 25½ x 36½ in. (64.7 x 92.7 cm)
Signed lower left: *Mary Cassatt*
Museum of Fine Arts, Boston, M. Theresa B. Hopkins Fund
Boston only

PROVENANCE

Henri Rouart, Paris, ca. 1880–1912; Galerie Manzi-Joyant, Paris, from Henri Rouart sale, 9 December 1912, no. 91; Dikran G. Kelekian, Paris and New York, 1912; American Art Association, New York, Dikran Kelekian sale, 30–31 January 1922; Museum of Fine Arts, Boston, 1942 (42.178).

EXHIBITIONS

Cinquième exposition d'artistes indépendants, Paris, 10, rue des Pyramides, 1–30 April 1880, no. 21; *Exposition de tableaux, pastels et gravures de Mary Cassatt*, Paris, Galerie Durand-Ruel, 27 November–16 December 1893, no. 5 (as *Five o'clock*); *Exposition of Paintings, Pastels and Etchings by Miss Mary Cassatt*, New York, Durand-Ruel Gallery, 16–30 April 1895, no. 8 (as *La tasse de thé*); *Tableaux et pastels par Mary Cassatt*, Paris, Galerie Durand-Ruel, 3–28 November 1908, no. 7; *France Forever*, Boston, Institute of Modern Art, 1913; *Impressionism*, London, Royal Academy, 1914 (loan extended to 1918); *Mary Cassatt*, Baltimore Museum of Art, 28 November 1941–11 January 1942, no. 6; Wellesley (Mass.), Wellesley College Art Museum, 1947; *The Work of Mary Cassatt*, New York, Wildenstein & Co., 29 October–6 December 1947, no. 4; *Masters of Impressionism*, Milwaukee Art Institute, 8 October–15 November 1948, no. 4; Columbus (Ohio) Gallery of Fine Arts, 1948; *Sargent, Whistler and Mary Cassatt*, Chicago, Art Institute, traveling exhibition, 11 January–25 February 1954, no. 9; *Exhibition of Works by John Singer Sargent and Mary Cassatt*, Palm Beach, Florida, Society of the Four Arts, 7 March–5 April, 1959, no. 40; *Change of Sky*, New York, American Academy of Arts and Letters, 4 March–3 April 1960, no. 14; *Manet, Degas, Berthe Morisot and Mary Cassatt*, Baltimore Museum of Art, 17 April–3 June 1962, no. 102; New York, M. Knoedler & Co., 1–28 February 1966, no. 8; *Mary Cassatt, 1844–1926*, Washington, D.C., National Gallery of Art, 27 September–8 November 1970, no. 19; Boston, 1973, no. 96; *The Painter's America: Rural and Urban Life, 1810–1910*, New York, Whitney Museum of American Art, 20 September–10 November 1974, Houston, Museum of Fine Arts, 5 December 1974–19 January 1975, Oakland Museum, 10 February–30 March 1975, no. 21; *Mary Cassatt at Home*, Boston, Museum of Fine Arts, 5 August–24 September, 1978, no. 9; *American Impressionism*, Seattle, University of Washington, Henry Art Gallery, 3 January–24 February 1980, Los Angeles, Frederick S. Wight Art Gallery at the University of California at Los Angeles, 9 March–4 May 1980, Boston, Institute of Contemporary Art, 1 July–31 August 1980, no. 12; Boston 1992; Philadelphia, Pennsylvania Academy of the Fine Arts, 10 January–14 April, 1996; *Mary Cassatt: Modern Woman*, Chicago, Art Institute, 10 October 1998–10 January 1999, Boston, Museum of Fine Arts, 14 February–9 May 1999, Washington, D.C., National Gallery of Art, 6 June–6 September 1999, no. 27.

CÉZANNE

In a 1951 article on Paul Cézanne, art critic Clement Greenberg aptly commented that the artist "changed the course of art out of the very effort to return it by new paths to its old ways."[16] It is indeed one of the paradoxes of art history that the painter who presaged cubism was actually trying to, in his words, "make impressionism something solid and durable like the old masters."[17] Born in Aix-en-Provence in 1839, Cézanne moved to Paris after abandoning his law studies in 1861. At the Académie Suisse he met Pissarro, who had a decisive influence on his forays into Impressionism. Despite Cézanne's interest in the avant-garde art of the day, however, he steeped himself in tradition, copying the old masterworks in the Louvre with the ultimate goal of gaining entry into the Salon. He faced a number of setbacks: he failed the entrance exam for the Ecole des Beaux-Arts in 1862 and exhibited only one picture at the Salon in his over forty-year career.[18]

Cézanne's debt to tradition is palpable in his twelve earliest still lifes, created in the 1860s. Humble objects emerge from dimly lit backgrounds in the manner of Chardin and the realist painters who perpetuated the eighteenth-century master's "kitchen still life" paradigm. Under Cézanne's palette knife, however, the bread loaves and pitchers that were rendered almost spiritual by Chardin's feathery touch become palpably dense.[19] Cézanne's early still lifes seem in their pronounced physicality to convey his desire to make his mark on the Paris art scene.

As one of the exhibitors at the first Impressionist show in 1874, Cézanne did make his mark; his works received the harshest criticism of all the art included. Experimenting with Impressionist techniques and painting out-of-doors in northern France with Pissarro in the 1870s, Cézanne would later remove himself from the Impressionist camp after the third group exhibition, where critics again denounced his work.[20]

It was in the 1870s that apples surfaced as a favorite subject of Cézanne's painting, which had now come to be defined by a patchwork of short, overlapping brushstrokes. Whether focusing in on a few of them scattered atop a table or fitting them like jigsaw pieces into a more complex arrangement, Cézanne invested apples with an aura of significance that would lead Meyer Schapiro in 1968 to make connections between their formal properties and the artist's psychological state.[21] Out of ninety-seven still lifes produced in the 1870s and early 1880s, more than twenty depict flowers, a less frequent subject in later years.[22] That paintings of fruit would outnumber studies of flowers in the artist's oeuvre is not surprising given Cézanne's working method; it was so labor intensive that flowers often wilted before he had successfully captured them in paint.[23] Fruit was more durable. "They like to have their portrait made," Cézanne once said of fruit to Joachim Gasquet during a studio visit. "They are there as if to ask your forgiveness for discoloring."[24]

In spite of Cézanne's diverse body of work, which

includes biblical and mythological scenes, land-scapes, bathers, and portraits, by the 1880s his name had become synonymous with still life among French avant-garde artists. "Let's do a Cézanne!" Gauguin reportedly exclaimed to Sérusier when he was inspired to address the subject.[25] Dividing his time primarily between Paris and Aix-en-Provence, Cézanne began to fill his still lifes—nearly 20 percent of his oeuvre—to the brim with objects, building up their forms through a structural, even architectural, knitting together of brushstrokes. In nearly one hundred still lifes made from the mid-1880s until his death in 1906, the artist's main objective was to explore compositional problems. He reused the same motifs—pitchers and sugar-bowls, fruit, and, especially at the end of his life, skulls—from picture to picture, slightly altering their placement or changing the viewpoint. Incongruous objects often inhabit the same space, their disorderly arrangement contrasting sharply with the artist's meticulously ordered painting style. This disparity has the effect of making us aware of the picture surface itself; Cézanne effectively peeled away the centuries-old illusion of the canvas's three-dimensionality.

Cézanne's forward-looking aesthetic finally received public acclaim at his one-man show at Ambroise Vollard's Paris gallery in 1895. "My enthusiasm is nothing compared with Renoir's," Pissarro wrote upon seeing the exhibition. "Even Degas succumbed to the charm of this refined savage. Monet, all of us—were we wrong?"[26] Having spent years pursuing his pictorial research privately, Cézanne was accepted as one of the leading artists of the day. He exhibited widely from the mid-1890s until his death in 1906, and is still today regarded as "the most copious source of what we know as modern art."[27] JAG

PLATE 7
Still Life with Bread and Eggs
Le pain et les oeufs. 1865
Oil on canvas, 23¼ x 30 in. (59 x 76.2 cm)
Signed and dated at lower left: *P. Cézanne 1865*
Cincinnati Art Museum, Gift of Mary E. Johnston

PROVENANCE
Ambroise Vollard, Paris, and Bernheim-Jeune, Paris; Ambroise Vollard, Paris; Paul Cassirer, Berlin, 1909; Walter Lewinstein, Shöneberg, 1909; Paul Cassirer, Berlin, 1915; Hugo Cassirer, Berlin; Lotte Cassirer-Fürstenberg, Berlin, 1920 (lent to the Gemeentemuseum in The Hague for several years and then to the Museo de Bellas Artes in Buenos Aires during World War II); Justin K. Thannhauser, 1945; Cincinnati Art Museum, 1955.

EXHIBITIONS
Tableaux modernes, Prague, Pavillon Manes, October–November 1907; *XII. Jahrgang. . . . III. Austellung*, Berlin, Galerie Paul Cassirer, 27 November–10 December 1909, no. 19; *Cézannes Werke in deutschem Privatbesitz*, Berlin, Galerie Paul Cassirer, November–December 1921, no. 4; *Impressionisten*, Berlin, Galerie Paul Cassirer, September–October 1925, no. 1; *La pintura francesa de David a nuestros días*, Buenos Aires, Museo Nacional de Bellas Artes, 1939, no. 5; *Still Life Painting Since 1470*, Milwaukee Art Institute and Cincinnati Art Museum, September–October 1956, no. 9; *Loan Exhibition Cézanne*, New York, Wildenstein Galleries, 5 November–5 December 1959, no. 2; *La peinture française—collections américaines*, Bordeaux, Musée de Bordeaux, 13 May–15 September 1966, no. 53; *Cézanne: An Exhibition in Honor of the Fiftieth Anniversary of The Phillips Collection*, Washington, D.C., The Phillips Collection, 27 February–28 March 1971, Chicago, Art Institute, 17 April–16 May 1971, Boston, Museum of Fine Arts, 1 June–3 July 1971, no. 1; *Cézanne: The Early Years, 1859–1872*, London, Royal Academy of Arts, 22 April–21 August 1988, Paris, Musée d'Orsay, 15 September–31 December 1988, Washington, D.C., National Gallery of Art, 29 January–30 April 1989, no. 7; Paris and New York 1994–95, no. 22; Paris, London, Philadelphia 1995–96, no. 3.

PLATE 46
Compotier and Plate of Biscuits
Compotier et assiette de biscuits. CA. 1877
Oil on canvas, 20⅞ x 24¾ in. (53 x 63 cm)
Private collection, Japan

PROVENANCE
Victor Vignon; Ambroise Vollard, Paris; Alexandre Rosenberg, Paris; Josse and Gaston Bernheim-Jeune, Paris; Wildenstein Galleries, New York; Edwin C. Vogel, New York; Acquavella Galleries, New York, and Sam Salz, New York; George S. Livanos, St. Moritz; Acquavella Galleries, New York; Galerie Nichido, Tokyo; Private collection, Japan.

EXHIBITIONS
Renoir, Cézanne and Their Contemporaries, London, Reid & Lefevre, June 1934, no. 4; *Cézanne*, Paris, Orangerie, May–October 1936, no. 34; *Chefs-d'oeuvre de l'art français* (World's Fair), Paris, Palais National des Arts, 1937, no. 248; *Honderd jaar Fransche kunst*, Amsterdam, Stedelijk Museum, 2 July–25 September 1938, no. 17; *Six Masters of Post-Impressionism*, New York, Wildenstein Galleries, 8 April–8 May 1948, no. 1; *Cézanne*, Chicago, Art Institute, 7 February–16 March 1952, New York, Metropolitan Museum of Art, 1 April–16 May 1952, no. 26; *Cézanne*, New York, Wildenstein Galleries, 5 November–5 December 1959, no. 14; *Summer Loan Exhibition*, New York, Metropolitan Museum of Art, 1959, no. 18; *Paintings from Private Collections*, New York, Metropolitan Museum of Art, summer 1961, no. 20; Paris, London, Philadelphia 1995–96, no. 48.

PLATE 47
Pears and Knife
Poires et couteau. 1877–78
Oil on canvas, 8⅛ x 12¼ in. (20.5 x 31 cm)
Ashley Associates

PROVENANCE
Ambroise Vollard, Paris; Cornelis Hoogendijk, Amsterdam; Paul Rosenberg, Paris; Charles Vignier, Paris; Marius de Zayas, Paris and New York; Lillie P. Bliss, New York, before 1926; Museum of Modern Art, New York (Lillie P. Bliss Bequest); Parke-Bernet, New York, 11 May 1944, no. 77; Mr. and Mrs. Jacques Helft, New York; Knoedler Galleries, New York; Mr. and Mrs. Charles S. Payson, New York; private collection.

EXHIBITIONS
Brooklyn, Brooklyn Academy of Arts and Sciences, summer 1926; *Memorial Exhibition: The Collection of the late Miss Lizzie [sic] P. Bliss*, New York, Museum of Modern Art, and traveling, 17 May 1931–January 1932, no. 3; *Cézanne*, Philadelphia Museum of Art, November–December 1934, no. 6; *The Lillie P. Bliss Collection*, New York, Museum of Modern Art, 1934, no. 6; New York, A. Seligman-Helft Galleries, 1947, no. 4; *XIX and XX Century French Paintings*, London, Lefevre Gallery, 1957, no. 2; *The Joan Whitney Payson Collection*, Kyoto, Municipal Museum, and Tokyo, Isetan Museum of Art, 1980, no. 36.

PLATE 48
Still Life with Compotier
Compotier, assiette et pommes. 1879–80
Oil on canvas, 17⅛ x 21½ in. (43.5 x 54 cm)
Ny Carlsberg Glyptotek, Copenhagen

PROVENANCE
Ambroise Vollard, Paris (?); Alphonse Kann, Paris (?); Wilhelm Hansen, Ordrupgaard, 1918; Ny Carlsberg Foundation, 1923; donated to the Ny Carlsberg Glyptotek, 1932.

EXHIBITIONS
Manet and the Post-Impressionists, London, Grafton Galleries, 1910–11, no. 9 (?); (*Exposition d'Art Moderne*, Hôtel de la Revue, *Les Arts*, August 1912, no. 128(?)); *Fransk Kunst*, Copenhagen, Ny Carlsberg Glyptotek, July–October 1945, no. 49; *French and Danish Paintings*, Copenhagen, Statens Museum for Kunst, 1957–58, no. 15. *Post-Impressionism: Cross-Currents in European Painting: Manet, Gauguin, Rodin . . . Chefs d'oeuvre de la Ny Carlsberg Glyptotek de Copenhague*, Paris, Musée d'Orsay, 9 October 1995–28 January 1996, no. 19; *Cézanne i blickpunkten*, Nationalmuseum Stockholm, October 1997–January 1998, no. 20; *Gloria Victis! Victors and Vanquished in French Art 1848–1910*, Copenhagen, Ny Carlsberg Glyptotek, May–October 2000.

PLATE 49
Still Life with Milk Can and Apples
Boîte à lait et pommes. 1879–80
Oil on canvas, 19¾ x 24 in. (50 x 61 cm)
The Museum of Modern Art, New York, The William S. Paley Collection

PROVENANCE
Julien Tanguy, Paris (?); Sara Hallowell, New York; Durand-Ruel, New York; Durand-Ruel, Paris; Egisto Fabbri, Florence; Durand-Ruel, Paris; Bernheim-Jeune, Paris; Oskar Schmitz, Dresden, 1904 (on temporary deposit at the Kunsthalle, Basel); Wildenstein Galleries, Paris, London, and New York; Mr. and Mrs. William S. Paley, New York, 1937; William S. Paley, New York; William S. Paley Foundation; Museum of Modern Art, New York, William S. Paley Collection.

EXHIBITIONS
[Group exhibition], Berlin, Bruno and Paul Cassirer, 1900, no. 1; *Sammlung Oskar Schmitz*, Zürich, Kunsthaus, 1932, no. 31; *Französische Malerei des XIX Jahrhunderts*, Zürich, Kunsthaus, 14 May–6 August 1933, no. 85; *La Collection Oskar Schmitz*, Paris, Wildenstein Galleries, 1936, no. 9; *The Oscar Schmitz Collection*, New York, Wildenstein Galleries, 1936, no. 9; *Paul Cézanne*, San Francisco Museum of Art, 1

September–4 October 1937, no. 13; *Cézanne—Centennial Exhibition*, New York, Marie Harriman Gallery, 7 November–2 December 1939, no. 20; *Masterpieces from Museums and Private Collections*, New York, Wildenstein, 1951, no. 49; *William S. Paley Collection*, New York, Museum of Modern Art, 2 February–7 April 1992, no. 12; *Modern Starts: People, Places, Things*, New York, Museum of Modern Art, 7 October 1999–14 March 2000.

PLATE 73
The Kitchen Table
La table de cuisine or Nature morte au panier.
1888–90
Oil on canvas, 25⅝ x 31½ in. (65 x 80 cm)
Signed at lower right in blue: *P. Cézanne*
Musée d'Orsay, Paris, Bequest of Auguste Pellerin

PROVENANCE
Paul Alexis, Paris (offered by Cézanne in 1891–92); Bernheim-Jeune, Paris; Auguste Pellerin, Paris; Musée du Louvre, Paris, 1929, Bequest of Auguste Pellerin; Musée d'Orsay, Paris (RF 2819).

EXHIBITIONS
Exposition d'art moderne, Paris, Manzi, Joyant & Cie, August 1912; *Paul Cézanne*, Basel, Kunsthalle, 30 August–12 October 1936, no. 46; *Les Impressionnistes, leurs précurseurs contemporains*, Paris, Jeu de Paume, 1947, no. 39; *Hommage à Cézanne*, Paris, Orangerie, July–October 1954, no. 57; *Cézanne dans les Musées Nationaux*, Paris, Orangerie, 19 July–14 October 1974, no. 36; *Paul Cézanne*, Madrid, Museo Español de Arte Contemporaneo, March–April 1984, no. 38; Paris, London, Philadelphia 1995–96, no. 128.

PLATE 80
Ginger Pot with Pomegranate and Pears
Pot de gingembre. 1890–93
Oil on canvas, 18¼ x 21⅞ in. (46.4 x 55.5 cm)
The Phillips Collection, Washington, D.C., Gift of Gifford Phillips in memory of his father, James Laughlin Phillips

PROVENANCE
Claude Monet, Giverny; Michel Monet, Giverny; inherited by Blanche Monet; purchased by Bernheim-Jeune, Paris, 1929; sold to L'Art Moderne (Lausanne branch of Bernheim-Jeune), 1929; purchased by Josef Stransky, New York, 1929; Wildenstein Galleries, New York, by November 1936; The Phillips Memorial Gallery, Washington, D.C., 1939, Gift of Gifford Phillips in memory of his father, James Laughlin Phillips, 1939 (Acc. no. 0284).

EXHIBITIONS
First Loan Exhibition—Cézanne, Gauguin, Seurat and van Gogh, New York, Museum of Modern Art, November 1929, no. 25; *The Stransky Collection of Modern Art*, Worcester (Mass.), 1932–33; *Cézanne*, Philadelphia Museum of Art, November–December 1934, no. 21; *Cézanne*, Paris, Orangerie, May–October 1936, no. 97; *Cézanne: An Exhibition in Honor of the Fiftieth Anniversary of The Phillips Collection*, Washington, D.C., The Phillips Collection, 27 February–28 March 1971, Chicago, Art Institute, 17 April–16 May 1971, Boston, Museum of Fine Arts, 1 June–3 July 1971, no. 20; *Master Paintings from The Phillips Collection*, San Francisco, Fine Arts Museum of San Francisco, 4 July–1 November 1981, Dallas Museum of Fine Arts, 22 November 1981–16 February 1982, Minneapolis Institute of Arts, 14 March–30 May 1982, Atlanta, High Museum of Art, 24 June–16 September 1982, Tulsa, Oklahoma Art Center, 17 October–9 January 1983, no. 8; *Impressionism and the Modern Vision: Master Paintings from The Phillips Collection*, Tokyo, Nihonbashi Takashimaya Art Galleries, 25 August–4 October 1983, Nara Prefectural Museum of Art, 9 October–13 November 1983, no. 30.

PLATE 82
Fruit and Jug on a Table
Fruits et cruchon. 1893–94
Oil on canvas, 13 x 16½ in. (33 x 41 cm)
Museum of Fine Arts, Boston, Bequest of John T. Spaulding

PROVENANCE
Ambroise Vollard, Paris; Eugène Blot, Paris; Hôtel Drouot, Paris, Blot Collection, 9–10 May 1900, no. 22; Hôtel Drouot, Paris, Blot Collection, 10 May 1906, no. 19; Paul Rosenberg, Paris; Gottlieb Friedrich Reber, Lausanne; Dr. Hans Wendland, Berlin and Paris (confiscated as enemy property); Hôtel Drouot, Paris, Liquidation Wendland, 24 February 1922, no. 211; Durand-Ruel, Paris; purchased from Durand-Ruel by John T. Spaulding, Boston, 12 May 1922; Museum of Fine Arts, Boston, 1948, bequest of John T. Spaulding (48.524).

EXHIBITIONS
Paul Cézanne, Paris, Galerie Vollard, November–December 1895; *Natures mortes et fleurs*, Paris, Galerie Blot, 1909, no. 4; *Sammlung Reber*, Berlin, Galerie Paul Cassirer, January 1913, no. 19; *Sammlung G. F. Reber*, Darmstadt, Mathildenhöhe, May–June 1913, no. 11; *Paul Cézanne*, New York, Wildenstein Galleries, January 1928, no. 4; Cambridge 1929, no. 8; Boston, Museum of Fine Arts, May 1931–October 1932 (on loan from John T. Spaulding); *Paintings, Drawings, Prints from Private Collections in New England*, Boston, Museum of Fine Arts, June–September 1939, no. 12; *The John T. Spaulding Collection*, Boston, Museum of Fine Arts, 1948, no. 9; *Eighteen Paintings from the Spaulding Collection*, Cambridge, Fogg Art Museum, 1 February–15 September 1949; *The Arts of Man*, Dallas Museum of Fine Arts, 15 November–31 December 1962; Boston 1973; Boston 1979–80, no. 42; Tokyo, Fukuoka, and Kyoto, 1983–84, no. 54; *Cézanne*, Yamanashi, Japan, Musée Kiyoharu Shirakaba, 12 May–31 July 1987, no. 12; *Connections: Brice Marden*, Boston, Museum of Fine Arts, 23 March–21 July 1991, no. 26; Boston 1992; *Monet and His Contemporaries from the Museum of Fine Arts, Boston*, Tokyo, Bunkamura Museum of Art, 17 October–17 January 1993, Hyogo Prefectural Museum of Modern Art, Kobe, 23 January–21 March 1993, no. 54; Japan and Boston 1994–95, no. 39 (Japan) and no. 45 (Boston).

PLATE 83
Still Life with a Ginger Jar and Eggplants
Nature morte aux aubergines. 1893–94
Oil on canvas, 28½ x 36¼ in. (72.4 x 91.4 cm)
The Metropolitan Museum of Art, New York, Bequest of Stephen C. Clark

PROVENANCE
Ambroise Vollard, Paris, 1899–1900; Mr. and Mrs. H. O. Havemeyer, New York, until 1907; Mrs. H. O. Havemeyer, New York, until 1929; Horace Havemeyer, New York, 1929–48; Knoedler Galleries, New York, on consignment from Havemeyer, 1948; Stephen C. Clark, New York, 1948–60; Metropolitan Museum of Art, New York, 1960, bequest of Stephen C. Clark (61.101.4).

EXHIBITIONS
Loan Exhibition of French Masterpieces of the Late XIX Century, New York, Durand-Ruel, 20 March–10 April 1928, no. 4 (as *Nature morte*); *Trends in European Painting, 1880–1930*, New York, Century Association, 2 February–31 March 1949, no. 6 (as *Still Life*); *A Collector's Taste: Selections from the Collection of Mr. and Mrs. Stephen C. Clark*, New York, Knoedler & Co., 12–30 January 1954, no. 13 (as *Nature Morte*); *Great French Paintings: An Exhibition in Memory of Chauncey McCormick*, Chicago, Art Institute, 20 January–20 February 1955, no. 4 (as *Nature morte*); *Paintings from Private Collections, 25th Anniversary Exhibition*, New York, Museum of Modern Art, 31 May–5 September 1955; *Paintings from Private Collections: Summer Loan Exhibition*, New York, Metropolitan Museum of Art, 1 July–1 September 1958, no. 18 (as *Still Life*); *Paintings from Private Collections: Summer Loan Exhibition*, New York, Metropolitan Museum of Art, 7 July–7 September 1959, no. 11 (as *Still Life*); *Paintings from Private Collections: Summer Loan Exhibition*, New York, Metropolitan Museum of Art, 6 July–4 September 1960, no. 11 (as *Still Life*); *Paintings, Drawings and Sculpture Collected by Yale Alumni*, New Haven, Yale University Art Gallery, 9 May–26 June 1960, no. 78 (as *Still Life*); *Impressionism: A Centenary Exhibition*, Paris, Grand Palais, 21 September–24 November 1974, New York, Metropolitan Museum of Art, 12 December 1974–10 February 1975 (New York only, not in catalogue); *100 Paintings from the Metropolitan Museum*, St. Petersburg, Hermitage State Museum, 22 May–27 July 1975, Moscow, Pushkin State Museum, 28 August–2 November 1975, no. 72; *Cézanne Gemälde*, Tübingen, Kunsthalle, 16 January–2 May 1993, no. 59; *Objects of Desire: The Modern Still Life*, New York, Museum of Modern Art, 25 May–26 August 1997, London, Hayward Gallery, 9 October 1997–4 January 1998.

PLATE 81
Sugarpot, Pears and Tablecloth
Sucrier, poires et tapis. 1893–94
Oil on canvas, 20⅛ x 24⅜ in. (51 x 62 cm)
POLA Art Foundation, Japan
Washington only

PROVENANCE
Ambroise Vollard, Paris; Gottlieb Friedrich Reber, Lausanne; Paul Rosenberg, Paris, 1937; Henry P. McIlhenny, Philadelphia; Christie's, New York, 15 November 1983, no. 54; private collection, New England; POLA Cosmetics Inc., Japan.

EXHIBITIONS
Sammlung Reber, Berlin, Galerie Paul Cassirer, January 1913, no. 20; *Sammlung G. F. Reber*, Darmstadt, Mathildenhöhe, May–June 1913, no. 12; *Das Stilleben*, Berlin, Galerie Matthiesen, February–March 1927, no. 88; *Austellung Frankfurter Kunstverein*, Frankfurt am Main, October–December 1927; *French Painting from David to Toulouse-Lautrec*, New York, Metropolitan Museum of Art, 6 February–28 March 1941, no. 7; *Masterpieces of Philadelphia Private Collections*, Philadelphia Museum of Art, May 1947, no. 37; *The Henry P. McIlhenny Collection*, Philadelphia Museum of Art, 1949; *The Henry P. McIlhenny Collection, Paintings, Drawings and Sculpture*, San Francisco, California Palace of the Legion of Honor, 15 June–31 July 1962, no. 2; *French Masterpieces of the 19th Century from the Henry P. McIlhenny Collection*, Allentown (Pa.) Art Museum, 1 May–18 September 1977; *Cézanne in Philadelphia Collections*, Philadelphia Museum of Art, 19 July–21 August 1983, no. 16.

PLATE 87
Still Life with Cupid
L'amour en plâtre. 1894–95
Oil on canvas, 24¾ x 31⅞ in. (63 x 81 cm)
Nationalmuseum, Stockholm

PROVENANCE
Ambroise Vollard, Paris, 1911; Klas Fahraeus, Lidingon, 1911 (November or December); National-museum, Stockholm, 1926.

EXHIBITIONS
French Art, Stockholm, Nationalmuseum, spring 1917, no. 5; Stockholm, Liljevalchs Konsthall, 1954, no. 70; *Paul Cézanne*, Zürich, Kunsthaus, 22 August–7 October 1956, no. 71; *Paul Cézanne*, The Hague, Gemeentemuseum, June–July 1956, no. 41; Paris, London, Philadelphia 1995–96, no. 161; Vienna and Zürich 2000, no. 44.

PLATE 88
Still Life with Apples
Nature morte. 1895–98
Oil on canvas, 27 x 36½ in. (68.5 x 92.7 cm)
The Museum of Modern Art, New York, Lillie P. Bliss Collection

PROVENANCE
Ambroise Vollard, Paris; Maurice Gangnat, Paris; Paul Rosenberg, Paris, ca. 1913; Durand-Ruel, Paris; Dikran K. Kelekian, Paris, ca. 1916; to Lillie P. Bliss, New York, at sale, Kelekian Collection, American Art Association, New York, 30–31 January 1922, no. 156; Museum of Modern Art, New York, Lillie P. Bliss Collection.

EXHIBITIONS
Rétrospective d'oeuvres de Cézanne, Paris, Grand Palais, Salon d'Automne, 1–22 October 1907, no. 44; *Französische Kunst des XIX. und XX. Jahrhunderts*, Zürich, Kunsthaus, 5 October–14 November 1917, no. 27; *Impressionist and Post-Impressionist Paintings*, New York, Metropolitan Museum of Art, 3 May–15 September 1921, no. 18; *Paintings by Modern French Masters Representing the Post-Impressionists and Their Predecessors*, Brooklyn, Brooklyn Museum, April 1921, no. 23; *Summer Exhibition*, Brooklyn, Brooklyn Academy of Arts and Sciences, summer 1926; *French Masterpieces of the Late XIX Century*, New York, Durand-Ruel, 1928, no. 3; *Cézanne, Gauguin, Seurat, van Gogh*, New York, Museum of Modern Art, November 1929, no. 24; *Memorial Exhibition: The Collection of the late Miss Lizzie [sic] P. Bliss*, New York, Museum of Modern Art, and traveling, 17 May–January 1932, no. 11; *Fiftieth Anniversary Exhibition*, New York, Metropolitan Museum of Art, 1932, no. 18; *A Century of Progress*, Chicago, Art Institute, 1 June–1 November 1933, no. 319; *The Lillie P. Bliss Collection*, New York, Museum of Modern Art, 1934, no. 9; *Fifth Anniversary Exhibition*, New York, Museum of Modern Art, 1934–35, no. 7; *French Paintings from the Lillie P. Bliss Collection*, Northampton, Mass., Smith College Museum of Art, 1935, no. 6; *Paintings, Drawings and Watercolors from the Lillie P. Bliss Collection*, Pittsburgh, Carnegie Institute, 1935, no. 4 (?); *Cézanne*, Paris, Orangerie, May–October 1936, no. 79; Brooklyn, Brooklyn Museum, 1936; *The Age of Impressionism*, Detroit, Institute of Arts, 3 May–2 June 1940, no. 6; *French Painting from David to Toulouse-Lautrec*, New York, Metropolitan Museum of Art, 6 February–26 March 1941, no. 10; *Paintings by Cézanne*, New York, Paul Rosenberg, 19 November–19 December 1942, no. 21; *Cézanne*, New York, Wildenstein Galleries, 27 March–26 April 1947, no. 59; *Paintings by Paul Cézanne*, Cincinnati Art Museum, 5 February–9 March 1947, no. 9; *Cézanne: An Exhibition in Honor of the Fiftieth Anniversary of The Phillips Collection*, Washington, D.C., The Phillips Collection, 27 February–28 March 1971, Chicago, Art Institute, 17 April–16 May 1971, Boston, Museum of Fine Arts, 1 June–3 July 1971, no. 26; New York, Houston, Paris 1977–78, no. 24 (New York and Houston) and

no. 18 (Paris); *Modern Starts: People, Places, Things*, New York, Museum of Modern Art, 7 October 1999–14 March 2000; Vienna and Zürich 2000, no. 48 (Zürich only).

PLATE 89
Still Life with Onions
Nature morte aux oignons. 1896–98
Oil on canvas, 26 x 32¼ in. (66 x 82 cm)
Musée d'Orsay, Paris, Bequest of Auguste Pellerin

PROVENANCE
Mme Paul Cézanne, Paris; Jos. Hessel, Paris; Auguste Pellerin, Paris; Musée du Louvre, Paris, 1929, Bequest of Auguste Pellerin; Musée d'Orsay, Paris, 1986 (RF 2817).

EXHIBITIONS
Rétrospective d'oeuvres de Cézanne, Paris, Salon d'Automne, Grand Palais, 1–22 October 1907, no. 28; *Cézanne*, Paris, Orangerie, May–October 1936, no. 98; *Paul Cézanne*, Basel, Kunsthalle, 30 August–12 October 1936, no. 47; *La peinture française au XIXe siècle*, Belgrade, Palais du Prince Paul, 1939, no. 8; *Centenaire de Paul Cézanne*, Lyon, Musée de Lyon, 1939, no. 35; *Homage to Paul Cézanne*, London, Wildenstein Galleries, July 1939, no. 37; *Les Impressionnistes, leurs précurseurs contemporains*, Paris, Jeu de Paume, 1947, no. 41; *Hommage à Cézanne*, Paris, Orangerie, July–October 1954, no. 61; *Cézanne dans les musées nationaux*, Paris, Orangerie, 19 July–14 October 1974, no. 41; New York, Houston, Paris 1977–78, no. 25 (New York and Houston) and no. 21 (Paris); Paris and New York 1994–95, no. 166 (Paris only); Vienna and Zürich 2000, no. 45.

PLATE 91
Pyramid of Skulls
Pyramide de crânes. 1898–1900
Oil on canvas, 15⅜ x 18¼ in. (39 x 46.5 cm)
Private collection

PROVENANCE
Ambroise Vollard, Paris; Estate of Ambroise Vollard; private collection.

EXHIBITIONS
Paul Cézanne, Zürich, Kunsthaus, 22 August–7 October 1956, no. 79; *Paul Cézanne*, Vienna, Belvedere, 14 April–18 June 1961, no. 38; *Exposition Cézanne: Tableaux, aquarelles, dessins*, Aix-en-Provence, Pavillon de Vendôme, 1 July–15 August 1961, no. 16; *Cézanne*, Tokyo, National Museum of Western Art, 30 March–19 May 1974, Kyoto, Municipal Museum, 1 June–17 July 1974, Fukuoka, Cultural Center, 24 July–18 August, no. 50; New York, Houston, Paris 1977–78, no. 26; *Cézanne Gemälde*, Tübingen, Kunsthalle, 16 January–2 May 1993, no. 87; Paris, London, Philadelphia 1995–96, no. 212.

PLATE 90
The Three Skulls
Trois crânes. 1898–1900
Oil on canvas, 13⅜ x 23⅜ in. (34 x 60 cm)
The Detroit Institute of Arts, Bequest of Robert H. Tannahill

PROVENANCE
Ambroise Vollard, Paris; Galerie E. Bignou, New York, 1935; Angus Whyte Gallery, Washington, D.C., 1938; Robert H. Tannahill, Grosse Pointe Farms, Michigan, 1940; Detroit Institute of Arts, 1970, bequest of Robert H. Tannahill (70.163).

EXHIBITIONS
Paul Cézanne, New York, Bignou Gallery, November–December 1936, no. 26; *Cézanne*, London, Reid & Lefevre, June 1937, no. 24; *Twentieth Century French Masters*, Washington, D.C., Whyte Gallery,

1938, no. 2; *The Age of Impressionism*, Detroit Institute of Arts, 3 May–2 June 1940, no. 8; *Two Sides of the Medal*, Detroit Institute of Arts, 1954, no. 103; *A Collector's Treasure: The Tannahill Bequest*, Detroit Institute of Arts, 1970.

PLATE 92
Skull
Crâne. 1900–1904
Oil on canvas, 24 x 19¾ in. (61 x 50 cm)
Staatsgalerie, Stuttgart

PROVENANCE
Ambroise Vollard, Paris; Estate of Ambroise Vollard; Staatsgalerie, Stuttgart.

EXHIBITIONS
Paul Cézanne, Munich, Haus der Kunst, October–November 1956, no. 61; New York, Houston, Paris 1977–78, no. 31 (Houston and New York only); Vienna and Zürich 2000, no. 57.

COURBET
Gustave Courbet was born on 10 June 1819 in Ornans, the son of a successful farmer and grandson of Jean-Antoine Oudot, a veteran of the Revolution.[28] He began his artistic training in 1833 with Père Baud at the Petit Séminaire in Ornans, moving on to the Collège Royal in Besançon four years later to study with Fajoulet, a former pupil of David. In 1839, Courbet moved to Paris ostensibly to study law but, much to his father's chagrin, continued to pursue art. Unimpressed by the traditional teaching at the Ecole des Beaux-Arts, he chose instead to study in the independent academies of Père Suisse and Père Lapin and on his own in the Louvre, making copies especially from Northern and Spanish masters.

Courbet began exhibiting at the Paris Salon in 1844, although he endured his share of rejections by the Salon jury throughout the years. Courbet's real breakthrough came at the 1851 Salon when *The Stonebreakers* (1849, destroyed), *A Burial at Ornans* (1849, Musée d'Orsay, Paris), and *The Peasants of Flagey Returning from the Fair* (1850, Musée des Beaux-Arts, Besançon) generated critical uproar. Denounced for their ugliness, these unconventional paintings of common laborers and peasants effectively secured Courbet's reputation as an anti-establishment, anti-idealist painter of the real world around him.[29] He glorified subjects that were deemed inappropriate for the monumental canvases on which he so often painted. He ignored traditional modes of representation, treating every object in his compositions with equal significance and almost brutal veracity.

Courbet's method of infusing common subject matter with weight and import would inform how he addressed the subject of still life. His first flower study was painted in 1855, the year of his retaliatory one-man exhibition at the Pavillon du Réalisme mounted to counter the Exposition Universelle's rejection of one of his most enduring works, *The Painter's Studio: A Real Allegory Determining a Phase of Seven Years of My Artistic Life* (1855, Musée d'Orsay, Paris).[30] Paintings devoted to flowers would appear only two more times in the 1850s, when the artist was focused more on figural compositions and painting the landscape around Honfleur, where he met Boudin and Monet in 1859.[31] Internationally known by this time, Courbet was also attracting an impressive number of students and followers, including the celebrated flower painter Henri Fantin-Latour.[32]

The years 1862–63 mark Courbet's most pronounced exploration of the subject of flowers. More than twenty floral pictures, two of which incorporate

female figures into the composition, were produced in this fruitful period of rest and relaxation in the Saintonge region at the country home of his friend, the art lover and amateur botanist Etienne Baudry.[33] Supremely suited to Courbet's ability to paint quickly, the exotic flora in Baudry's garden must have inspired the artist to focus on the subject. The flower studies he made in these years exude a freshness and vitality that did not go unnoticed by critics attending the 1863 exhibition of the artist's work. That Courbet could tackle the opposite poles of history painting and flower painting prompted one critic to affirm that the artist was "indeed a 'painter.'"[34]

The circumstances surrounding Courbet's next substantial foray into the genre of still life were less pleasant. A longtime supporter of the political left, Courbet's political activity culminated in the short-lived Paris Commune of 1871, during which time he served as president of the Artists' Committee to Safeguard the National Museums. His participation in the destruction of the Vendôme Column landed him in prison, and it was while serving a six-month sentence after the Commune's demise that the artist turned again to still life. His request for a model rejected, the artist was left with nothing else to draw from but the apples, pears, pomegranates, and flowers brought to him by his friends and family.[35] Courbet inscribed many of the thirty-seven still lifes that he made in 1871–72 with the name of the Sainte-Pélagie prison, although a number of the paintings were in fact made in the more comfortable accommodations of a Neuilly clinic, where, after undergoing surgery, he finished his term.[36]

In contrast to the simple and exuberant flower pictures painted during his stay in Saintonge, this series of still lifes resonates more palpably with the artist's unfortunate personal circumstances.[37] The fruit and flowers that were available to him are rendered with more specificity in these works than the human figure or the landscape, which Courbet had to paint largely from memory. The rejection of the sole painting of this series that Courbet submitted to the Salon (*Still Life with Apples*, 1871–72, Museum Mesdag, The Hague) seems to have, until recently, removed the entire group from the fertile space of critical debate.[38] Neglected by most Courbet scholars, the more than three dozen still lifes produced in this two-year period near the end of Courbet's life confirm his ability to infuse the most common of subjects with a sense of consequence. He died an exile in Switzerland on 31 December 1877, unable to pay the enormous sum demanded by the French state as restitution for the Vendôme Column. JAG

PLATE 1
Bouquet of Flowers in a Vase
Bouquet de fleurs dans un vase. 1862
Oil on canvas, 39½ x 28¾ in. (100.5 x 73 cm)
Signed and dated, lower right: '62 *Gustave Courbet*
J. Paul Getty Museum, Los Angeles

PROVENANCE
Frédéric Mestreau, Saintes, 1863; private collection, Saintes, until ca. 1968; Wildenstein & Co., New York; Florence J. Gould, El Patio (near Cannes), ca. 1973; Sotheby's, New York, Florence J. Gould Collection, 24 April 1985, no. 11; J. Paul Getty Museum, 1985 (85.PA.168).

EXHIBITIONS
Ouvrages de peinture et de sculpture exposés dans les salles de la mairie au profit des pauvres. 160 tableaux signés Corot, Courbet, Auguin, Pradelles, Saintes, Town Hall, January 1863, no. 77; *Seven Masterpieces from the Collection of Mrs. Florence Gould,* Fine Arts Museums of San Francisco, November 1974, no. 1; Brooklyn and

Minneapolis 1988–89, no. 42; Paris and New York 1994–95, no. 40.

PLATE 3
Woman with Flowers (The Trellis)
La femme aux fleurs (Le treillis). 1862
Oil on canvas, 43¼ x 53¼ in. (109.8 x 135.2 cm)
Signed lower left: *G. Courbet*
The Toledo Museum of Art, Purchased with funds from the Libbey Endowment, Gift of Edward Drummond Libbey
Boston only

PROVENANCE
Cotel, Paris, 1878 (?); Jules Paton, Paris, 1882; Hôtel Drouot, Paris, 24 April 1883, no. 23; T. J. Blakeslee, New York; American Art Galleries sale, New York, 10–11 April 1902, no. 50; Durand-Ruel, New York and Paris, 1902; Adrien Hébrard, Paris, 1906; Prince de Wagram, Paris, 1908; Durand-Ruel, Paris, 2 May 1908; Baron Cacamizy, London (?), 1908; Blanche Marchesi, London, 1909; Mrs. R. A. Workman, London, 1919–20; Paul Rosenberg, Paris, 1929; Wildenstein, New York, 1929–50; gift of Edward Drummond Libbey to Toledo Museum of Art, 1950.

EXHIBITIONS
Explication des ouvrages de peinture et de sculpture exposés dans les salles de la mairie au profit des pauvres. 160 tableaux signés Corot, Courbet, Auguin. Pradelles, Saintes, Mairie, 1863, no. 76; *Exposition des oeuvres de M. G. Courbet,* Paris, Rond-point de l'Alma, 1867, no. 108; Paris, Galerie Durand-Ruel, 1878, no. 32; *Exposition des oeuvres de Gustave Courbet,* Paris, Ecole nationale des Beaux-Arts, May 1882, no. 128; London, New Gallery, 1909 (or 1901?), no. 131; *National Loan Exhibition,* London, 1913–1914, no. 73; *Exhibition of paintings, drawings, and sculpture of the French School of the last 100 years,* London, Burlington Fine Arts Club, 1922, no. 28; Cleveland, Museum of Art, 1929; *Gustave Courbet,* Paris, Palais des Beaux-Arts, May–June 1929, no. 41; *Gustave Courbet,* Berlin, Galerie Wertheim, 28 September–26 October 1930, no. 32; *Courbet and Delacroix,* New York, Marie Harriman Gallery, 7–25 November 1933, no. 11; *A Century of Progress,* Chicago, Art Institute, 1 June–1 November 1934, no. 180; *Nineteenth-Century Masterpieces,* London, Wildenstein, 1935; *Loan Exhibition of Modern French Painting,* San Francisco Museum of Art, 18 January–24 February 1935, no. 5; *Gustave Courbet,* Berlin, Galerie Wertheim, 1935, no. 70; *Gustave Courbet,* Zürich, Kunsthaus, 15 December 1935–31 March 1936, no. 70; *Great Lakes Exhibition,* Cleveland, 1936, no. 62; *Gustave Courbet,* Paris, Paul Rosenberg, 4–29 May 1937, no. 10; *Paintings by Courbet,* Baltimore Museum of Art, 3–29 May 1938, no. 10; *Painters of Still Life,* Hartford, Wadsworth Atheneum, 25 January–15 February 1938, no. 56; *Flowers and Fruit,* Washington, D.C., Washington Gallery of Modern Art, 29 March–24 April 1938, no. 12; *Honderd jaar Fransche kunst,* Amsterdam, Stedelijk Museum, 2 July–25 September 1938, no. 72; *Masterpieces of Five Centuries,* San Francisco, Golden Gate International Exhibition, 1939, no. 144; *Gustave Courbet,* New York, Wildenstein & Co., 2 December 1948–8 January 1949, no. 19; *From David to Courbet,* Detroit Institute of Arts, 1 February–5 March 1950, no. 104; *Fiftieth Anniversary,* New York, Wildenstein Galleries, 1951, no. 36; *Masterpieces of French Painting through Five Centuries, 1400–1900,* New Orleans, Isaac Delgado Museum, 17 October 1953–10 January 1954, no. 59; *Courbet,* Venice, XXVII Biennale di Venezia, 1954, no. 21; *Courbet,* Lyon, Musée des Beaux-Arts, 1954, no. 26; *Courbet,* Paris, Petit Palais, 1955, no. 45; *Gustave Courbet,* New York,

Paul Rosenberg & Co., 16 January–11 February 1956, no. 8; Philadelphia and Boston 1959–60, no. 39; New York, Wildenstein Galleries, 1961, no. 34; *Birth of Impressionism,* New York, Wildenstein, 7 March–6 April 1963, no. 25; *Gustave Courbet, 1819–1877,* Paris, Grand Palais, 1 October 1977–2 January 1978, no. 70, London, Royal Academy of Arts, 19 January–19 March 1978, no. 67; Brooklyn and Minneapolis 1988–89, no. 41; Paris and New York 1994–95, no. 41.

PLATE 12
The Girl with Seagulls, Trouville
La Fille aux mouettes, Trouville. 1865
Oil on canvas, 31⅞ x 25⅝ in. (81 x 65 cm)
Signed lower left: *G. Courbet*
Private collection, New York
Boston only

PROVENANCE
Sold by the artist to the Société Artésienne des Amis des Arts for their annual lottery for charity, 1869; Binoche collection; Paul Rosenberg, New York; James Deely, New York; private collection, New York.

EXHIBITIONS
Exposition des oeuvres de M. G. Courbet, Paris, Rond-point de l'Alma, 1867, no. 101; *Portraits et figures de femmes,* Paris, Galerie de la Renaissance, 1–30 June 1928, no. 46; *Gustave Courbet,* Paris, Petit Palais, 1929, no. 48; *Ingres to Cézanne,* London, Reid & Lefevre, 1933, no. 10; *Great French Masters of the Nineteenth Century,* New York, Durand-Ruel Galleries, 12 February–10 March 1934, no. 8; *Gustave Courbet,* Zürich, Kunsthaus, December 1935–January 1936, no. 79; *Gustave Courbet,* Paris, Galerie Paul Rosenberg, 1937, no. 14; *Gustave Courbet,* London, Rosenberg and Helft Gallery, May–June 1938, no. 12; *La peinture française du XIXe siècle,* Belgrade, Musée du Prince Paul, 1939, no. 25; *La pintura francesa de David a nuestros dias,* Buenos Aires, 1939, no. 23; *La pintura francesa,* Rosario, 1939, Montevideo, 1940, no. 14; *The Painting of France since the French Revolution,* San Francisco, M. H. de Young Memorial Museum, December 1940–January 1941 (first showing) and November 1941–January 1942 (second showing), no. 14; *Loan Exhibition of French Painting,* San Diego, Fine Arts Gallery, March 1941, no. 8; *Masterpieces of French Art Lent by the Museums and Collectors of France,* Chicago, Art Institute, 10 April–20 May 1941, no. 23; *Loan Exhibition: The 19th Century Heritage for the Benefit of the Greenwich House,* New York, Rosenberg & Co., 7 March–1 April 1950, no. 4; *Courbet alla XXVII Biennale di Venezia,* Venice, 1954, no. 29; *Paintings by Gustave Courbet,* New York, Paul Rosenberg & Co., 16 January–11 February 1956, no. 13; Philadelphia and Boston 1959–60, no. 48; *Gustave Courbet, 1819–1877,* Paris, Grand Palais, 1 October 1977–2 January 1978, no. 70, London, Royal Academy of Arts, 19 January–19 March 1978, no. 84; Brooklyn and Minneapolis 1988–89, no. 58; Paris and New York 1994–95, no. 43.

PLATE 27
Head of a Woman with Flowers
Tête de femme et fleurs. 1871
Oil on canvas, 21¾ x 18¼ in. (55.3 x 46.3 cm)
Signed and dated lower right: 71 *Ste.-Pélagie G. Courbet*
Philadelphia Museum of Art, Louis E. Stern Collection

PROVENANCE
Hôtel Drouot, Paris, Courbet sale, Salle 9, 26 November 1877, no. 5; William Merritt Chase, New York; sold by Chase's sons to an unidentified

secondhand dealer; Jules Weitzner, New York; Louis E. Stern, New York, 1940; Philadelphia Museum of Art, Louis E. Stern Collection, 1963.

EXHIBITIONS

Courbet, New York, Marie Harriman Gallery, 1940, no. 19; *Courbet*, Chicago, Arts Club, 1941, no. 7; *Flower Paintings*, New York, Paul Drey, 1941; *Still Life and Flower Paintings*, Baltimore Museum of Art, 2 November–9 December 1945, no. 28; *Courbet*, New York, Wildenstein & Co., 1949, no. 40; *Flower Paintings by European Masters of the 19th and 20th Centuries*, Newark Museum (N.J.), 1950, no. 5; *Magic of Flowers in Painting: Loan Exhibition for the Benefit of the Lenox Hill Neighborhood Association*, New York, Wildenstein, 13 April–15 May 1954, no. 10; Philadelphia and Boston 1959–60, no. 78; *The Louis E. Stern Collection*, Brooklyn, Brooklyn Museum of Art, 1962–63, no. 25; Brooklyn and Minneapolis 1988–89, no. 84; *Gustave Courbet: en revoltör lanserar sitt verk*, Lausanne, Musée cantonal des beaux-arts, 21 November 1998–87 March 1999, Stockholm, Nationalmuseum, 26 March–30 May 1999, no. 60; *Courbet et la Commune*, Paris, Musée d'Orsay, 13 March–11 June 2000, no. 118.

PLATE 28
Still Life: Fruit
Nature morte: fruits. 1871–72
Oil on canvas, 23¼ x 28⅜ in. (59 x 72 cm)
Signed, dated, and inscribed, lower left: *71 Ste. Pélagie/G. Courbet*
Courtesy Shelburne Museum, Shelburne, Vermont

PROVENANCE

Henri Lambert, Brussels; Galerie Saint-Luc, Brussels, sale, Henri Lambert Collection, 28 April 1892, no. 8; Isidore van den Eynde; Galerie Leroy Frères, Brussels, sale, Isidore van den Eynde Collection, 13 December 1912, no. 2; Paul Rosenberg, Paris, 1912; Mrs. H. O. Havemeyer, New York, 1920; Electra Havemeyer Webb, New York, 1929; Shelburne Museum (Inv. no. 27.1.3–23).

EXHIBITIONS

Courbet and Delacroix, New York, Marie Harriman Gallery, 7–25 November 1933, no. 13; *A Century of Progress*, Chicago, Art Institute, 1 June–1 November 1933, no. 179; *Pictures Collected by Yale Alumni*, New Haven, Yale University Art Gallery, 8 May–18 June 1956, no. 61; Philadelphia and Boston 1959–60, no. 79; *Electra Havemeyer Webb Memorial Exhibition*, New York, Metropolitan Museum of Art, summer 1961; *Collection of the Electra Havemeyer Webb Fund*, New York, Knoedler Galleries, 29 March–23 April 1966, no. 6; Brooklyn and Minneapolis 1988–89, no. 80; New York, Metropolitan Museum of Art, 1993; Paris, Musée d'Orsay, 1998; *Courbet et la Commune*, Paris, Musée d'Orsay, 13 March–11 June 2000, no. 114.

PLATE 26
Hollyhocks in a Copper Bowl
Roses trémières. 1872
Oil on canvas, 23⅜ x 19⁵⁄₁₆ in. (60 x 49 cm)
Signed and dated lower left: *72 G. Courbet*
Museum of Fine Arts, Boston, Bequest of John T. Spaulding
Boston only

PROVENANCE

Reinach Collection (?); Galerie Bernheim-Jeune, Paris; Levesque Collection, Paris; Pearson Collection, Paris; sale at Paul Cassirer, Berlin, 18 October 1927, no. 15; Thannhauser Collection, Lucerne; John T. Spaulding; Museum of Fine Arts, Boston, 1948, bequest of John T. Spaulding (48.530).

EXHIBITIONS

Quatorze oeuvres de Courbet, Paris, Galerie H. Fiquet, November–December 1926, no. 3; *Fransk Malerkinst fra det 19nde aarhundrede*, Copenhagen, Dansk Kunstmuseum, 1914, no. 45; Cambridge 1929, no. 17; *Paintings, Drawings, and Prints from Private Collections in New England*, Boston, Museum of Fine Arts, 9 June–10 September 1939, no. 30; *The Collections of John Taylor Spaulding 1870–1948*, Boston, Museum of Fine Arts, 26 May–7 November 1948, no. 14; *Loan Exhibition: French Painting since 1800*, Cambridge, Fogg Art Museum, 1 February–15 September 1949; *Courbet at the XXVII Biennale di Venezia*, Venice, 1954, no. 47; *Courbet*, Musée de Lyon, 1954, no. 52; *Paintings by Gustave Courbet*, New York, Rosenberg Gallery, 16 January–11 February 1956, no. 17; Santa Barbara 1958; Philadelphia and Boston 1959–60, no. 81; *Gustave Courbet*, Bern, Kunstmuseum, 22 September–19 November 1962, no. 71; Paris and London 1977–78, no. 116; *From Neoclassicism to Impressionism: French Art from the Boston Museum of Fine Arts*, Kyoto, Kyoto Municipal Art Museum, 30 May–2 July 1989, Hokkaido, Museum of Modern Art, 15 July–20 August 1989, Yokohama, Sogo Museum of Art, 30 August–10 October 1989, no. 42; *Monet and His Contemporaries from the Museum of Fine Arts, Boston*, Tokyo, Bunkamura Museum of Art, 17 October 1992–17 January 1993, Hyogo Prefectural Museum of Modern Art, Kobe, 23 January–21 March 1993, no. 15; Japan and Boston 1994–95, no. 28 (Japan) and no. 34 (Boston); *Courbet et la Commune*, Paris, Musée d'Orsay, 13 March–11 June 2000, no. 120.

DEGAS

Hilaire Germain Edgar Degas was born on 19 July 1834 to a prominent banking family in Paris.[39] At the age of nineteen, he enrolled at the Sorbonne's Faculté de Droit, but abandoned his law studies just one year later to pursue painting in the studio of Louis Lamothe—a former pupil of Ingres—and later at the Ecole des Beaux-Arts. The influence of Ingres would resonate in Degas's work throughout his career. In contrast to other members of the Impressionist circle who captured the effects of light through a lively play of overlapping strokes of color, Degas more often focused on the primacy of line in defining the contours of his subjects.[40]

While in Italy studying the old masters in 1856–59, Degas made his first still lifes, *Corner of the Studio* (ca. 1855–60, private collection) and *Still Life with Lizard* (ca. 1858–60, private collection). Produced during his formative years, these early still lifes are best understood as part of Degas's experimentation with a wide range of themes in his effort to refine his technique. When asked later how an artist should learn his craft, Degas responded that only after mastering the techniques of copying should one attempt to render still life: "[The artist] should copy the masters and re-copy them, and after he has given every evidence of being a good copyist, he might then reasonably be allowed to do a radish, perhaps, from Nature."[41] Never again after these early forays into the genre would Degas devote an entire canvas to the subject of still life. He preferred instead to incorporate still life arrangements into figural compositions, rarely allowing the objects depicted to draw the focus away from the main subject of the work.

One remarkable exception is the 1865 *A Woman Seated beside a Vase of Flowers (Portrait of Mme Paul Valpinçon?)* (plate 2). Painted four years after the artist's return from Italy to France when he was moving in Impressionist circles, the composition grants three-quarters of its surface area to a monumental bouquet of mixed garden flowers. Degas paired

female figures with a vase of flowers in three other instances, all in the 1870s: *Woman beside a Vase* (Musée du Louvre, Paris) and *Portrait of Estelle Musson* (private collection) both from 1872, and *Portrait of Mme De Rutté* (private collection) from 1875. His earliest "woman and flowers" picture—the 1865 *Woman Seated beside a Vase of Flowers*—fetched the largest sum. After remaining in the artist's possession for over twenty years, it was sold to Theo van Gogh in 1887 for four thousand francs, the second largest amount that Degas was ever awarded for his work.[42]

Degas participated in seven of the eight Impressionist shows although his lack of interest in plein air painting and preoccupation with the figure separated him from the characteristically Impressionist concerns of many of the exhibitors. He, in fact, considered himself more of a realist than an Impressionist, and proposed that the title of the fourth Impressionist exhibition be expanded to include this designation. The too-true-to-life polychrome wax sculpture exhibited at the sixth Impressionist exhibition in 1881, *Little Dancer, Fourteen Years Old,* perhaps best reflected the artist's independent sensibility. "The terrible realism of this statuette creates a distinct unease," wrote critic and novelist Joris-Karl Huysmans. "[It is] the only truly modern attempt that I know of in sculpture."[43]

Degas would continue to "create uneasiness" in his viewers with pictures devoted to brothel scenes and female nudes in the most intimate and awkward of positions during the various stages of bathing. Although he never had to cater to the buying public or worry about finances—save for a period in the mid-1870s after his father's death left the family banking business under duress[44]—by the 1880s Degas had achieved a renown that allowed him even greater freedom. He became increasingly attracted to the subject of women working as laundresses, café-concert singers, dancers, and milliners. A small number of the milliner pictures from 1882–98 pay considerable attention to the hats themselves, which are arranged prominently in the foreground, often obscuring the figures behind. Much like the 1865 portrait of Mme Valpinçon, the group of hats in The Art Institute of Chicago's milliner painting from 1882–86 focuses the eye away from the milliner herself, who is positioned off center, behind the display.

Despite the lack of conventional still-life representations in his own work, Degas had a number of them in his personal art collection. The artist collected most zealously in the 1890s—"I buy! I buy! I can't stop myself," he wrote.[45] In addition to buying, Degas also acquired a number of paintings—such as Gauguin's small still life from 1880, *The Mandolin (On a Chair)* (private collection)—by exchanging some of his own works for those by his artist friends. At his death in September 1917, Degas's impressive collection included an important group of still lifes by Manet, Caillebotte, van Gogh, Cézanne, and Gauguin, along with some earlier flower pictures by artists of Delacroix's generation.[46] Thus, while he may have felt as an upper-echelon society artist that still life was beneath him, Degas clearly admired artists who succeeded—as he thought Chardin did—in lending common objects "elegance, grace and distinction."[47]
 JAG

PLATE 2
A Woman Seated beside a Vase of Flowers (Mme Paul Valpinçon?)
Femme accoudée près d'un vase de fleurs (Mme Paul Valpinçon?). 1865
Oil on canvas, 29 x 36½ in. (73.7 x 92.7 cm)
Signed and dated twice, lower left: *Degas 1865* (and partially illegible) *Degas 1865*

The Metropolitan Museum of Art, New York,
H. O. Havemeyer Collection
Boston only

PROVENANCE
Purchased from the artist by Theo van Gogh for
Boussod, Valadon et Cie, Paris, 22 July 1887;
deposited at Goupil, The Hague from 6 April to 9
June 1888; Jules-Emile Boivin, Paris, 28 February
1889; by descent to his widow, Mme Jules-Emile
Boivin, Paris, 1909; Durand-Ruel, Paris, 3 July
1920; transferred to Durand-Ruel, New York, 11
November 1920; Mrs. H. O. Havemeyer, New York,
28 January 1921; bequest of H. O. Havemeyer to
Metropolitan Museum of Art, 1929 (29.100.128).

EXHIBITIONS
The H. O. Havemeyer Collection, New York, Metropol-
itan Museum of Art, 10 March–2 November 1930,
no. 45; *Degas 1834–1917*, Philadelphia Museum of
Art, 7 November–7 December 1936, no. 8; *Degas*,
Paris, Orangerie, 1 March–20 May 1937, no. 6; *The
Painters of Still Life*, Hartford, Wadsworth
Athenaeum, 25 January–15 February 1938, no. 55;
Works by Edgar Degas, Cleveland Museum of Art, 5
February–9 March 1947, no. 8; *Diamond Jubilee
Exhibition: Masterpieces of Painting*, Philadelphia
Museum of Art, 4 November 1950–11 February
1951, no. 72; *Masterpieces of Fifty Centuries*, New
York, Metropolitan Museum of Art, 15 November
1970–15 February 1971, no. 375; *Impressionism: A
Centenary Exhibition*, Paris, Grand Palais, 21 Sep-
tember–24 November 1974, New York, Metropoli-
tan Museum of Art, 12 December 1974–10
February 1975, no. 10; *Degas in the Metropolitan*,
New York, Metropolitan Museum of Art, 26 Febru-
ary–4 September 1977, no. 3; *Degas*, Paris, Grand
Palais, 9 February–16 May 1988, Ottawa, National
Gallery of Canada, 16 June–28 August 1988, New
York, Metropolitan Museum of Art, 27 September
1988–8 January 1989, no. 60; *Splendid Legacy: The
Havemeyer Collection*, New York, Metropolitan
Museum of Art, 27 March–20 June 1993, no. 196;
Paris and New York 1994–95, no. 57.

PLATE 60
The Millinery Shop
Chez la modiste. 1882–86
Oil on canvas, 39⅛ x 43½ in. (100 x 110.7 cm)
The Art Institute of Chicago, Mr. and Mrs. Lewis
Larned Coburn Memorial Collection

PROVENANCE
Purchased from the artist by Durand-Ruel, Paris (as
L'atelier de la modiste, stock no. 10253) 22 February
1913; sent to Durand-Ruel, New York, 13 Novem-
ber 1917, received in New York, 1 December 1917
(stock no. 4114); Mrs. Lewis Larned Coburn,
Chicago, 1929; bequeathed to Art Institute of
Chicago in 1932; accessioned in 1933.

EXHIBITIONS
*Special Exhibition: Works in Oil and Pastel by the Impres-
sionists of Paris*, New York, American Art Associa-
tion, 10–28 April 1886, National Academy of
Design, 25 May–? 1886, no. 69 (as *Modiste*); *Exhibi-
tion of the Mrs. L. L. Coburn Collection: Modern Paint-
ings and Water Colors*, Chicago, Art Institute,
Antiquarian Society, 6 April–9 October 1932, no. 9;
*A Century of Progress: Exhibition of Paintings and Sculp-
ture*, Chicago, Art Institute, 1 June–1 November
1933, no. 286; *Edgar Degas: Paintings, Drawings,
Pastels, Sculpture*, Northampton (Mass.), Smith Col-
lege Museum of Art, 28 November–18 December
1933, no. 8; *A Century of Progress: Exhibition of Paint-
ings and Drawings*, Chicago, Art Institute, 1 June–1
November 1934, no. 202; *French Impressionists and
Post-Impressionists*, Toledo Museum of Art, Novem-

ber 1934, no. 1; *French Painting: Cézanne to the Pre-
sent*, Springfield (Mass.), Museum of Art, December
1935–January 1936, no. 1; *Degas: 1834–1917*,
Philadelphia Museum of Art, 7 November–7
December 1936, no. 40; *The Art of the Third Repub-
lic: French Painting 1870–1940*, Worcester (Mass.),
Art Museum, 22 February–16 March 1941, no. 4;
Works by Edgar Degas, Cleveland Museum of Art, 5
February–9 March 1947, no. 38; *Diamond Jubilee
Exhibition: Masterpieces of Painting*, Philadelphia,
Museum of Art, 4 November 1950–11 February
1951, no. 74; *Edgar Degas: The Reluctant Impression-
ist*, Boston, Museum of Fine Arts, 20 June–1 Sep-
tember 1974, no. 20; *Degas*, Richmond, Virginia
Museum of Fine Arts, 23 May–9 July 1978, no. 14;
Trésors impressionnistes du Musée de Chicago, Albi,
Musée de Toulouse-Lautrec, 27 June–31 August
1980, no. 8; *Degas in the Art Institute of Chicago*,
Chicago, Art Institute, 19 July–23 September 1984,
no. 63; *Degas*, Paris, Grand Palais, 9 February–16
May 1988, Ottawa, National Gallery of Canada, 16
June–28 August 1988, New York, Metropolitan
Museum of Art, 27 September 1988–8 January
1989, no. 235.

FANTIN-LATOUR
Ignace Henri Jean Théodore Fantin-Latour was born
on 14 January 1836 in Grenoble, and his family
moved to Paris when he was five so that his father,
Jean-Théodore, would have more opportunities to
pursue his career as a pastelist. Fantin-Latour's father
began teaching him drawing when he was ten, and
from 1850 to 1856 Fantin-Latour studied at the
Petite Ecole de Dessin in Paris with Lecocq de Bois-
baudran, who insisted that his students learn to draw
from memory, a technique that held lasting reso-
nance in Fantin-Latour's work.[48] Fantin-Latour
enrolled at the Ecole des Beaux-Arts in 1854, but he
was expelled after only three months when his teach-
ers could detect no progress. Fantin-Latour began
assiduously copying the old masters at the Louvre,
almost daily for the next twelve years. He met most
of his closest associates there, including the artists
Manet, Morisot, and Whistler, and the woman who
would become his wife, Victoria Dubourg.[49]

Fantin-Latour was not an Impressionist in the
true sense of the word. He showed his work regularly
at the Salon between 1861 and 1899 and exhibited
at the Salon des refusés in 1863 with *Féerie* (Montreal
Museum of Arts), but, like Manet, he refused to
exhibit with the Impressionists. He was extremely
influential to the Impressionist movement, however,
in his penchant for modern life and in his careful
study of light. Professing a "horror of movement, of
animated scenes, and the difficulty of painting in the
open air with sun and the shade," Fantin-Latour pre-
ferred the comforts of the studio, which allowed him
to arrange and rearrange his subject matter to suit
himself, much in the tradition of Chardin.[50] He was
especially adept at exploiting tonal and color rela-
tionships based on an exact ratio of values, resulting
in tightly controlled compositions, such as *Flowers
and Fruit on a Table* (plate 19).

Fantin-Latour first began painting still lifes
around 1861 after the second of four trips to Eng-
land, where he discovered a ready market for table-
top compositions and flowers. The English
bourgeoisie had developed a marked desire to deco-
rate their interiors with easel-size still lifes. Fantin-
Latour's close friend, James Abbott McNeill
Whistler, whose influence is reflected in *Still Life
with Torso and Flowers* (plate 33), introduced Fantin-
Latour to many important English collectors, ensur-
ing financial success for the rest of his life. In
particular Ruth and Edwin Edwards (fig. 49),
through whom he sold his first still lifes in the early

FIGURE 49
HENRI FANTIN-LATOUR.
PORTRAIT OF MR. AND MRS. EDWIN EDWARDS. 1875.
OIL ON CANVAS, 51⅛ x 38½ IN. (130.8 x 98.1 CM)
TATE GALLERY, LONDON

1860s, were lifelong champions of his work, along
with select members of London's Greek émigré
community, such as the wealthy Ionides family.

Following an eight-year engagement, at the
beginning of which he painted *The Betrothal Still Life*
(plate 23), Fantin-Latour finally married Victoria
Dubourg in 1876. Soon afterward the couple began
spending their summers at the Dubourgs' country
cottage at Buré in lower Normandy. There the artist
occupied himself in the garden, gathering and paint-
ing a wide array of summer blooms, characteristi-
cally working indoors. In 1878 Fantin-Latour
received a medal at the Salon and the cross of the
Legion of Honor, ensuring his enduring popularity
with the public.[51]

A prolific artist, Fantin-Latour produced nearly
2,500 works during his lifetime, over a quarter of
which were still lifes, usually of fruit and flowers, or
tabletop arrangements. The majority of these were
painted between 1870 and 1890 for the English
market. Several scholars have maintained he painted
still lifes for the sole purpose of selling them. It
seems likely that his more imaginative figurative
work was his real love, although these works did not
achieve the same critical success as his still lifes at the
Salon. His romantic, figurative paintings functioned
as a form of creative catharsis in contrast to his
detached, methodical, and studied rendering of still
lifes. By the 1890s, Fantin-Latour was weary of still
life and especially considered the painting of flowers
to be "forced labor."[52] Still, he experienced a final
burst of activity the year he died, painting seven
works of flowers and peaches just before his death on
25 August 1904, at the Dubourgs' country home in
Buré. MHB

PLATE 15
Plate of Peaches
Assiette de pêches. 1862
Oil on canvas, 7⅛ x 12⅝ in. (18.1 x 32 cm)
Signed and dated upper left: *Fantin / 1862*
Museum of Fine Arts, Boston, M. Theresa B.
Hopkins Fund

PROVENANCE

Julien Tempelaere, Paris, from the artist; private collection, Paris, 1900–60; Paul Rosenberg & Co., New York, 1960; Museum of Fine Arts, Boston, 8 June 1960, purchased with M. Theresa B. Hopkins Fund (60.792).

EXHIBITIONS

Boston 1979–80, no. 37; Japan and Boston 1994–95, no. 30 (Japan) and no. 36 (Boston).

PLATE 16
White Cup and Saucer
Tasse et soucoupe. 1864
Oil on canvas, 7⅜ x 11 in. (19 x 28 cm)
Signed and dated upper right: *Fantin 6*
(presumably the 4 in 64 has been cut off)
The Fitzwilliam Museum, Cambridge, England

PROVENANCE

Collection of Ruth Edwards; bequeathed by her to Sir (H. F.) Herbert Thompson, Bart, London, 1907; gift of Thompson to Fitzwilliam Museum, Cambridge, 1920 (no. 1016).

EXHIBITIONS

Exposition de l'oeuvre de Fantin-Latour, Paris, Ecole des Beaux-Arts, May–June 1906, no. 67; *Henri Fantin-Latour*, London, Wildenstein & Co., 10 October–21 November 1984, no. 11; *Treasures from the Fitzwilliam*, Washington, D.C., National Gallery of Art, 19 March–18 June 1989, Fort Worth, Kimbell Art Museum, 15 July–8 October 1989, New York, National Academy of Design, 5 November 1989–28 January 1990, Atlanta, High Museum of Art, 20 February–6 May 1990, Los Angeles County Museum of Art, 21 June–9 September 1990, no. 157.

PLATE 19
Flowers and Fruit on a Table
Chrysanthèmes doubles et fruits. 1865
Oil on canvas, 23½ x 28¾ in. (59.5 x 73 cm)
Signed and dated lower right: *Fantin – 1865*
Museum of Fine Arts, Boston, Bequest of John T. Spaulding

PROVENANCE

Ch. de Hèle, Brussels; Julien Tempelaere, Paris; Alex Reid, Glasgow; D. W. T. Cargill, Glasgow; Reid and Lefevre, London; Bignou Galerie, New York, by 1941; John T. Spaulding, Boston, 23 April 1941; Museum of Fine Arts, Boston, 1948, bequest of John T. Spaulding (48.450).

EXHIBITIONS

Fantin-Latour: Loan Exhibition, New York, Museum of French Art, January–February 1932, no. 25; *Fantin-Latour*, London, Reid & Lefevre Gallery, November 1934, no. 9; *French Painters of the Romantic Period*, New York, Bignou Gallery, November 1940, no. 13; *The Second Empire: Art in France under Napoleon III*, Philadelphia Museum of Art, 1 October–26 November, 1978, Detroit Institute of Arts, 15 January–18 March 1979, Paris, Grand Palais, 24 April–2 July 1979, no. VI-51; Paris, Ottawa, San Francisco 1982–83, no. 33; *The Great Boston Collectors: Paintings from the Museum of Fine Arts*, Boston, Museum of Fine Arts, 13 February–2 June 1985, no. 50; Chiba, Nara, Yokohama, and Boston 1994–95, no. 31 (Japan) and no. 37 (Boston).

PLATE 23
The Betrothal Still Life
Nature morte aux fiançailles. 1869
Oil on canvas, 12⅝ x 11½ in. (32 x 29 cm)
Signed upper right: *Fantin – 1869*
Musée de Grenoble
Boston only

PROVENANCE

Mme Fantin-Latour, Paris; given to the Musée de Peinture et de Sculpture, Grenoble by Mme Fantin-Latour, 1921.

EXHIBITIONS

Chefs-d'oeuvre du Musée de Grenoble, Paris, 1935, no. 155; *Centenaire de Henri Fantin-Latour*, Grenoble, Musée de Grenoble, August–October 1936, no. 120; Zürich, Kunsthaus, 1946; Cannes, Festival du Film, 1947, no. 20; Zürich, Kunsthaus, 1956; *Fantin-Latour, une famille de peintres au XIXe siècle*, Grenoble, Musée de Grenoble, 17 February–12 April 1977, no. 39; *Nature morte de Brueghel à Soutine*, Bordeaux, Musée et Galerie des Beaux Arts, 5 May–1 September 1978, no. 159; Paris, Ottawa, San Francisco 1982–83, no. 38; *Chefs d'oeuvre du Musée de Grenoble de David à Picasso*, Lausanne, Fondation de l'Hermitage, 16 October 1992–21 March 1993, no. 22.

PLATE 20
Peaches
Pêches. 1869
Oil on canvas, 7½ x 11 (19.1 x 27.9 cm)
Signed and dated upper left corner: *Fantin. 69*
Collection of Duncan Vance Phillips

PROVENANCE

From European collection to Kraushaar 1921; shipped to Kraushaar via Frans Buffa & Zonen Amsterdam on the Holland–America line, 28 July 1921; purchased from Kraushaar in 1922 by Marjorie Phillips; by descent to Duncan Vance Phillips; on long-term loan to The Phillips Collection.

FIGURE 50
HENRI FANTIN-LATOUR.
Corner of the Table. 1872.
OIL ON CANVAS, 63 x 88⅝ IN. (160 x 225 CM).
MUSÉE D'ORSAY, PARIS

PLATE 35
Still Life: Corner of a Table
Nature morte: coin de table. 1873
Oil on canvas, 38¼ x 49¼ in. (97 x 125 cm)
Signed and dated in the corner of picture frame: *Fantin. 73*.
The Art Institute of Chicago, Ada Turnbull Hertle Fund

PROVENANCE

Gustave Tempelaere, Paris; Ruth Edwards, London; M. Mancini, Paris, ca. 1906; E. Lernoud, Paris; Mme Vincent Daniel, Rennes, 1936; Hector Brame, Paris; Collection of César de Hauke, Paris; bequest of Ada Turnbull Hertle to Art Institute of Chicago, 1951 (51226).

EXHIBITIONS

Salon, Paris, Palais de l'Industrie, 1873, no. 557; *7th Exposition*, Society of French Artists, London, 1873,

no. 83; Manchester Royal Institute, 1874, no. 100; London, Dutch Gallery, 1902, no. 5; *Exposition de l'oeuvre de Fantin-Latour*, Paris, Ecole des Beaux-Arts, May–June 1906, no. 70; *Centenaire de Henri Fantin-Latour*, Grenoble, Musée de Grenoble, August–October 1936, no. 127; *De David à Toulouse-Lautrec, Chefs-d'oeuvre des collections américaines*, Paris, Orangerie, 1955, no. 27; *French 19th Century Paintings*, Minneapolis Institute of Art, 1 July–7 September 1969, no. 33; Paris, Ottawa, San Francisco 1982–83, no. 97.

PLATE 33
Still Life with Torso and Flowers
Fleurs et objets divers. 1874
Oil on canvas, 45⅝ x 35⅜ in. (116 x 90 cm)
Signed and dated lower left: *Fantin-74-*
Göteborg Museum of Art, Göteborg, Sweden

PROVENANCE

Edwin Edwards, London; John West Wilson (1816–89); bequest of John West Wilson to Göteborgs Konstmuseum, 1889 (GKM 247).

EXHIBITIONS

Salon, Paris, 1874, no. 702; Paris, Ottawa, San Francisco 1982–83, no. 97*bis*.

GAUGUIN

Born on 7 June 1848 in Paris, Eugène Henri Paul Gauguin spent his early years in Lima, Peru, on the country estate of his mother's uncle. Returning to France at the age of seven, first to Orléans and later to Paris, at seventeen he joined the merchant marine and traveled widely. After his mother died, he returned to France in 1867, and his guardian, Gustave Arosa, found him a position at a stockbroker office in 1871. That year, at the age of twenty-three, Gauguin began painting during his spare time. Only five years later, having received no formal training, Gauguin began exhibiting with the Impressionists following the acceptance of a work at the Salon that year. He went on to participate in the Impressionist exhibitions of 1879, 1880, 1881, 1882, and 1886.

In 1883, Gauguin left his stockbroker job in order to devote himself full-time to painting. The next year he moved his wife, Mette, and their five children to Rouen and later to Copenhagen to join Mette's family. With success evading him, Gauguin returned alone to Paris in June 1885. In the summer of 1886, he moved to Brittany, but stayed only half a year before sailing for Panama and Martinique. Two years later, Gauguin returned to Brittany, this time to the remote village of Le Pouldu. There he developed a distinctive style he called "synthetism," characterized by a vibrant intermingling of flat forms, decorative color, and spatial complexity. By 1888, Gauguin's synthetism had come to dominate much of his still life, as vividly illustrated in *Fête Gloanec* (plate 78).

Gauguin is not remembered primarily for his still lifes, although he painted them at every stage of his career and incorporated them into much of his figurative work. Around one hundred of Gauguin's paintings are of still lifes, comprising one-sixth of his painted oeuvre. While some scholars maintain that these paintings exhibit less innovative subject matter, his approach is distinguished by an intellectualism that expands the genre.

Gauguin constantly participated in a self-imposed dialogue with the still lifes of Cézanne, with whom he painted in the summer of 1881 in Pontoise. Gauguin developed his admired colleague's techniques even further in terms of modeling with color, assimilating a certain flatness and sense of color from Japanese prints.[53] This devotion

to Cézanne is seen most vividly in *Still Life with Colocynths* (plate 74) and *Still Life with Peaches* (plate 76).[54]

In the 1880s, Gauguin became increasingly attracted to inanimate objects, painting around half of all his still lifes between 1884 and 1890. He began to experiment more boldly with regard to color and contour, further developing his unique ideas on symbols and meaning. In *Sleeping Child* (plate 67) and *Te tiare farani* (1891, Pushkin Museum of Fine Arts, Moscow), there is an incongruity between his technique—in terms of proportion and color—and the subject matter itself. Often Gauguin's intention was to establish a visual disparity between the objects portrayed and the overall mood of the painting.

It is difficult to define Gauguin's general feeling toward still life. In 1899, he wrote to his lifelong friend and supporter, Georges de Monfreid, "When I am able to paint again, if I have no imagination, I shall do some studies of the flowers. . . . It is a great pleasure for me."[55] Yet Gauguin expressed a contradictory sentiment the next year in a letter to his Paris dealer, Ambroise Vollard: "You mention flower paintings. I really don't know which ones you mean, despite the small number that I have done, and that is because (as you have doubtlessly perceived) that I am not a painter who copies nature—today less than before. With me everything happens in my crazy imagination and when I tire of painting figures (my preference) I begin a still life and finish it without any model."[56] The artist seems to equate still life with the absence of inspiration, though this is certainly not the spirit his still lifes convey.

For several years toward the end of his life, Gauguin abandoned still life almost entirely, completing only five between 1893 and 1898. However, in the two years before he died, he painted eleven, most of European-style arrangements, such as *Still Life with Sunflowers on an Armchair* (1901, State Hermitage Museum, St. Petersburg), despite the fact that he was living in Tahiti and Hiva Hoa at the time. Gauguin died at the age of fifty-four, of heart-related illnesses precipitated by a morphine overdose, on 8 May 1903 in the Marquesas Islands. MHB

PLATE 67
Sleeping Child
Portrait of Clovis Gauguin. 1884
Oil on canvas, 18 x 21⅝ in. (46 x 55.5 cm)
Signed and dated at upper left, in red: *p Gauguin 84*
Private collection

PROVENANCE
Herman Thaulow, Oslo, 1884; private collection.

EXHIBITIONS
The Art of Paul Gauguin, Washington, D.C., National Gallery of Art, 1 May–31 July 1988, Chicago, Art Institute, 17 September–11 December 1988, Paris, Grand Palais, 10 January–20 April 1989, no. 13.

PLATE 78
Fête Gloanec
Fête Gloanec. 1888
Oil on wood, 15 x 20⅞ in. (38 x 53.2 cm)
Titled and signed at lower right, on edge of table: *Fête Gloanec. Madeleine B.*; dated at right, on table: *88*
Musée des Beaux-Arts d'Orléans
Washington only

PROVENANCE
Mme Gloanec; Maurice Denis; Musée des Beaux-Arts d'Orléans (inv. no. 1405).

EXHIBITIONS
Exposition rétrospective de Paul Gauguin, Paris, Galerie L. Dru, 16 April–11 May 1923, no. 10; *Gauguin*, Basel, Kunsthalle, 1928, no. 31 (or 35?); *Gauguin*, Berlin, Thannhauser, October 1928, no. 21; *Gauguin et ses amis*, Paris, *Gazette des beaux-arts*, 1934, no. 48; *L'Ecole de Pont-Aven et les Nabis*, Paris, Galerie Parvillée, 1943, no. 51; *Gauguin et ses amis*, Paris, Galerie Kléber, 1949, no. 47; *Gauguin: exposition du centenaire*, Paris, Orangerie, 1949, no. 8; *Gauguin*, Basel, Kunstmuseum, 26 November 1949–29 January 1950, no. 20; *Gauguin: exposition du centenaire*, Lausanne, Musée cantonal, 16 February–16 April 1950, no. 27; *Vuillard et les Nabis*, Paris, Musée d'Art Moderne, 1955, no. 54; *Hommage à Sérusier et aux peintres de Pont-Aven*, Quimper, Musée des Beaux-Arts, 6 July–30 September 1958, no. 46; *Chefs-d'oeuvre des collections françaises*, Paris, Musée Jacquemart-André, 1961, no. 76; *Le groupe de Pont-Aven*, Paris, Galerie Mons, 30 November–22 December 1962, no. 27; *Post-Impressionism: Cross-Currents in European Painting*, London, Royal Academy of Arts, 17 November 1979–16 May 1980; *Post-Impressionism: Cross-Currents in European and American Painting, 1880–1906*, Washington, D.C., National Gallery of Art, 25 May–1 September 1980, no. 86; *The Art of Paul Gauguin*, Washington, D.C., National Gallery of Art, 1 May–3 July 1988, Chicago, Art Institute, 17 September–11 December 1988. Paris, Grand Palais, 10 January–24 April 1989, no. 52.

PLATE 77
The Ham
Le jambon. 1889
Oil on canvas, 19¾ x 22¾ in. (50.2 x 57.8 cm)
Signed at right, on the table: *P. Go.*
The Phillips Collection, Washington, D.C.

PROVENANCE
Collection of the artist; Ambroise Vollard, Paris; Alex Reid and Lefevre, London, 1936; A. Daber, Paris, 1937; Etienne Bignou, Paris, by 1948 and until at least 1950; Maurice Cortot, Paris; Paul Rosenberg & Co., New York; The Phillips Collection purchase, 1951 (0761).

EXHIBITIONS
A Collection of Paintings by Eugène Boudin and Some Contemporaries, London, Alex Reid and Lefevre, 1936, no. 26; *The Post-Impressionists*, New York, Bignou, 1937, no. 4; *Gauguin et ses amis*, Paris, Galerie André Weil, 1–20 June 1951, no. 15; *Paul Gauguin: His Place in the Meeting of East and West*, Houston, Museum of Fine Arts, 1954, no.10; *De David à Toulouse-Lautrec: chefs-d'oeuvre des collections américaines*, Paris, Orangerie 1955, no. 29; *Loan Exhibition: Gauguin*, New York, Wildenstein, 5 April–5 May 1956, no. 15; *Gauguin: Paintings, Drawings, Prints, Sculpture*, Chicago, Art Institute, 12 February–9 March 1959, New York, Metropolitan Museum, 21 April–31 May 1959, no. 21; *Gauguin and the Decorative Style*, New York, Solomon R. Guggenheim Museum, 1966; *The Early Work of Paul Gauguin: Genesis of an Artist*, Cincinnati Art Museum, 1971, no. 25; *The Chosen Object: European and American Still Life*, Omaha, Joslyn Art Museum, 23 April–5 June 1977; *La nature morte de Brueghel à Soutine*, Bordeaux, Galerie des Beaux-Arts, 5 May–1 September 1978, no. 163; *Post-Impressionism: Cross-Currents in European and American Paintings, 1880–1906*, Washington, D.C., National Gallery of Art, 25 May–1 September 1980, no. 48; *Paris Cafés: Their Role in the Birth of Modern Art*, New York, Wildenstein, 1985; *The Art of Paul Gauguin*, Washington, D.C., National Gallery of Art, 1 May–31 July 1988, Chicago, Art Institute, 17 September–11 December 1988, Paris, Grand Palais, 10 January–20

April 1989, no. 63.

PLATE 75
Still Life with Apples, Pear, and a Ceramic Portrait Jug
Pommes, poire et céramique. 1889
Oil on cradled panel, 11¼ x 14¼ in. (28.6 x 36.2 cm)
Fogg Art Museum, Harvard University Art Museums, Gift of Walter E. Sachs

PROVENANCE
Gustave Fayet, Igny, France; purchased from estate of Gustave Fayet by Paul Rosenberg, 1925; M. M. Wildenstein, New York; Mr. & Mrs. Walter E. Sachs, New York, by 1929; gift of Walter E. Sachs to the Fogg Art Museum, 1958 (Inv. 1958.292).

EXHIBITIONS
Cambridge 1929, no. 52; *A Loan Exhibition of Paul Gauguin*, New York, Wildenstein Gallery, 3 April–4 May 1946, no. 25; *Paul Gauguin*, Houston, Museum of Fine Arts, 1 January–31 December 1954, no. 27; *Gauguin*, New York, Wildenstein Gallery, 5 April–5 May, 1956, no. 40; Chicago and New York 1959, no. 53; *The Example of Pissarro*, Cambridge (Mass.), Fogg Art Museum, 20 May–3 July 1981; *The Maurice Wertheim Collection*, Tokyo, Isetan Department Store, 1 March–10 April 1990, Yamaguchi, Prefectural Museum of Art, 14 April–13 May 1990.

PLATE 74
Still Life with Colocynths
Nature morte aux coloquintes. 1889
Oil on canvas, 16 x 20½ in. (40.6 x 52 cm)
Signed with initials and dated top center: *P Go.89*
Judy and Michael Steinhardt Collection, New York

PROVENANCE
Ambroise Vollard, Paris; Jean-Pierre Durand-Matthiesen, Geneva; M. Knoedler & Co., Inc., New York; Christie's, 12 May 1997, no. 121; Judy and Michael Steinhardt Collection, New York.

EXHIBITIONS
Paul Gauguin, London, National Gallery, 1946; *Gauguin*, Basel, Offentliche Kunstsammlung, November 1949–January 1950, no. 26; *Gauguin: Exposition du centenaire*, Lausanne, Musée cantonal des Beaux-Arts, 16 February–16 April 1950, no. 3; Chicago and New York 1959, no. 20; *Gauguin and the Pont-Aven Group*, London, Tate Gallery, 7 January–13 February 1966, no. 101.

PLATE 76
Still Life with Peaches
Nature morte aux pêches. CA. 1889
Oil on cradled panel, 9⅞ x 12⅝ in. (26 x 31.8 cm)
Signed and dated lower right: *P. Go.*
Fogg Art Museum, Harvard University Art Museums, Gift of Walter E. Sachs

PROVENANCE
Gustave Fayet, Igny, France; purchased from the estate of Gustave Fayet by Paul Rosenberg, 1925; M.M. Wildenstein, New York; Mr. & Mrs. Walter E. Sachs, New York by 1929; gift of Walter E. Sachs to the Fogg Art Museum, 1958 (Inv. 1958.291).

EXHIBITIONS
Salon d'Automne, Paris, 1 September–31 December 1906, no. 5; Cambridge 1929, no. 52; *A Loan Exhibition of Paul Gauguin*, New York, Wildenstein Gallery, 3 April–4 May 1946, no. 25; *Paul Gauguin*, Houston, Museum of Fine Arts, 1 January–31 December 1954, no. 27; *Loan Exhibition: Gauguin*, New York, Wildenstein Gallery, 5 April–5 May 1956, no. 40; Chicago and New York 1959, no. 53; *The Example of Pissarro*, Cambridge (Mass.), Fogg Art Museum, 20 May–3 July 1981; *The Maurice*

Wertheim Collection, Tokyo, Isetan Department Store, 1 March–10 April 1990, Yamaguchi, Prefectural Museum of Art, 14 April–13 May 1990.

PLATE 85
Still Life with Tahitian Oranges
Pommes et piments. 1892
Oil on canvas, 12¼ x 25⅝ in. (31 x 65 cm)
Signed and dated lower left: *P. Gauguin 92*
Private collection.

PROVENANCE
V. Goloubew, Paris; Paul Rosenberg, Paris; Georges Menier, Paris; private collection, Switzerland; private collection, Tahiti.

EXHIBITIONS
Exposition de collectionneurs, Paris, Hôtel de la curiosité et des Beaux-Arts, 1924, no. 156; *Choix d'un amateur*, Paris, Galerie Schmit, 1977, no. 36; *XIXth and XXth Century Paintings and Drawings*, London, LeFevre, 1980, no. 7; *Gauguin et ses amis*, Aoste, Centre de Saint-Bénin, 1993.

PLATE 86
Flowers and a Bowl of Fruit on a Table
Fleurs, iris bleu, oranges et citron. 1894
Oil on canvas, mounted on paperboard, 17 x 24¾ in. (42.8 x 62.9 cm)
Museum of Fine Arts, Boston, Bequest of John T. Spaulding
Boston only

PROVENANCE
Gustave Loiseau, Paris, from Gauguin in Pont-Aven, 1894; Durand-Ruel, Paris, from Loiseau, 6 October 1922; John T. Spaulding, Boston, 1922; Museum of Fine Arts, Boston, 1948, bequest of John T. Spaulding, 1948 (48.546).

EXHIBITIONS
First Loan Exhibition: Cézanne, Gauguin, Seurat, Van Gogh, New York, Museum of Modern Art, November 1929, no. 52; Cambridge 1929, no. 44; *Paul Gauguin*, New York, Wildenstein Gallery, 20 March–18 April 1936, no. 27; Baltimore, Museum of Art, 24 May–5 June 1936 (New York only); *Paul Gauguin*, Cambridge (Mass.), Fogg Art Museum, 1 May–21 May 1936, no. 25; Santa Barbara 1958, no. 38; *Fruit and Flowers*, Memphis, Brooks Memorial Art Gallery, 15–30 November 1958; *Gauguin and the Pont Aven Group*, London, Tate Gallery, 7 January–13 February 1966, Zürich, Kunsthaus, 5 March–11 April 1966, no. 50; *The Early Work of Paul Gauguin: Genesis of an Artist*, Cincinnati Art Museum, 17 March–26 April 1971; *French Paintings from the Storerooms and Some Recent Acquisitions*, Boston, Museum of Fine Arts, 2 May–27 August 1978; Boston 1992; *The Great Boston Collectors: Paintings from the Museum of Fine Arts*, Boston, Museum of Fine Arts, 13 February–2 June 1985, no. 44; Chiba, Nara, Yokohama, and Boston 1994–95, no. 44 (Boston only).

GONZALÈS
Eva Gonzalès, the oldest of two daughters, was born into a wealthy, intellectually elite family in Paris on 19 April 1849. Her father, Emmanuel Gonzalès, was a well-known writer of criticism and fiction, while her mother was an accomplished musician and singer. Their home was a meeting place for writers, critics, and painters, introducing their daughters to vanguard artistic and literary circles. The adolescent Eva was encouraged to seriously pursue her interest in the visual arts beyond the amateur level typical of young wealthy women at the time, and thus, at age sixteen (1865), she not only began formal art lessons with Charles Chaplin, a society portraitist who ran a studio for women, but also registered as a copyist at

FIGURE 51
HENRI GUÉRARD.
ASSAULT ON THE SHOE.
ETCHING AND AQUATINT WITH DRYPOINT,
COLOR À LA POUPÉE, N.D.
PRINT COLLECTION, MIRIAN AND IRA D. WALLACH
DIVISION OF ART, PRINTS AND PHOTOGRAPHS,
THE NEW YORK PUBLIC LIBRARY

the Louvre. She left Chaplin's studio in 1867. In early 1869, she met Edouard Manet through the painter Alfred Stevens and soon became Manet's model and only pupil. In 1879 Gonzalès married the printmaker Henri Guérard.

Gonzalès first exhibited at the Salon of 1870 and, like her teacher and mentor Manet, she continued to pursue professional acceptance through the Salons, never exhibiting with the Impressionists. Nonetheless, she has always been considered part of the greater Impressionist circle because of her close association with Manet, as well as her painting style, which emphasizes free brushwork. Her subject matter focused on the bourgeois environment around her, using her sister and family as models.

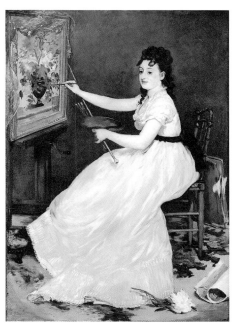

FIGURE 52
EDOUARD MANET.
PORTRAIT OF EVA GONZALÈS. 1869–1870.
OIL ON CANVAS, 55¼ X 52⅜ IN. (191 X 133 CM)
NATIONAL GALLERY, LONDON

Still life comprises nearly one-fifth of Gonzalès's known body of 124 works. In his well-known *Portrait of Eva Gonzalès* (exh. Salon 1870; National Gallery, London), Manet depicts the young upper-class woman as a flower painter seated in a fancy

white dress before her easel, evoking the stereotype of the lady amateur artist (fig. 52). It belies the fact that Gonzalès consistently sought professional recognition in the Salons as a figure painter. She exhibited only one of her still lifes at the Salon.[57]

Gonzalès took Manet's advice to emphasize tonal relationships rather than specific details. "Don't bother about the background," Manet instructed her. "Look for the values. When you look at {a still life}, when you want to render it as you see it, that's to say give the public the same impression of it as it makes on you, you don't look at it, you don't stare at it, you don't see the stripes on the wallpaper behind it. . . . Do you count the grapes? Of course not! What's so striking about them is the clear amber of their tone, and the bloom that modulates and softens the outline."[58]

Many of Gonzalès's still lifes might more accurately be considered studies than finished works. Nine depict fruit, seven are of flower arrangements, and the remaining eight treat subjects as varied as vegetables, shoes, fish, and desserts. Rendered in watercolor, as well as pastel and oil, these still lifes are generally small in scale and frequently horizontal in format, emphasizing the shapes and shadows of the objects depicted.

Gonzalès's still lifes only became known in the years after her sudden death from complications of childbirth at age thirty-four on 6 May 1883.[59] Even now they remain primarily in private hands and are rarely seen.[60] SBF

PLATE 32
White Shoes
Souliers blancs. CA. 1879–80
Oil on canvas attached to panel, 9¹⁄₁₆ x 12⅜ in. (23 x 32 cm)
Signed with studio stamp lower right, at an angle:
Eva Gonzalès
Private collection

PROVENANCE
Vente Eva Gonzalès, Paris, Hôtel Drouot, 20 February 1885, no. 1; Jean-Raymond Guérard, Paris; private collection; Galerie Hopkins-Thomas, Paris; private collection.

EXHIBITIONS
Ukiyo-e Prints and the Impressionist Painters: Meeting of the East and the West, Tokyo, Sunshine Museum, 15 December 1979–15 January 1980, Osaka Municipal Museum of Fine Arts, 22 January–10 February 1980, Fukuoka Art Museum, 15–28 February 1980; *Six femmes-peintres*, Nagoya, Prefectural Museum, Tokyo, Takashimaya Art Gallery, Osaka, Takashimaya Art Gallery, Utsunomiya, Tochigi Prefectural Museum of Fine Arts, Kumamoto, Prefectural Museum of Art, 1983, no. 43.

MANET
Edouard Manet once said, "A painter can express all that he wants with fruit or flowers."[61] Still life was always important to Manet's artistic enterprise. In his lifetime, he produced seventy-eight still lifes, comprising approximately one-fifth of his total work.

Born the eldest son of a wealthy Parisian family on 23 January 1832, Manet exhibited an early interest in drawing and began his artistic training in the studio of Thomas Couture in 1850 after twice failing the entrance exam to the Naval College.[62] He studied with Couture for six years, copying Dutch, Spanish, and old master paintings in the Louvre as well as in the museums of Belgium, Holland, Germany, Austria, and Italy. Establishing his own studio in 1857, Manet soon began submitting works to the Salon. He was rejected on his first try in 1859, but

two works were accepted in the 1861 Salon with one, *The Spanish Singer* (1860, Metropolitan Museum of Art, New York), receiving an honorable mention. Nevertheless, Manet's Salon submissions were often rejected in the 1860s, and he was frustrated with his lack of official recognition and critical success. Although he participated in the 1863 Salon des refusés, he never participated in the Impressionist exhibitions, always believing that the Salon was the only forum in which to compete. Manet's influence on the generation known as the Impressionists was considerable, however, and was memorialized in Fantin-Latour's 1870 homage to him, *A Studio in the Batignolles* (fig. 53).[63]

FIGURE 53
HENRI FANTIN-LATOUR.
A STUDIO IN THE BATIGNOLLES (OTTO SCHOELDERER,
EDOUARD MANET, AUGUSTE RENOIR, ZACHARIE
ASTRUC, EMILE ZOLA, EDMOND MAÎTRE, FRÉDÉRIC
BAZILLE, CLAUDE MONET). 1870.
OIL ON CANVAS, 80 X 107 IN. (204 X 273 CM)
MUSÉE D'ORSAY, PARIS

Manet painted still lifes throughout his career, but he focused on them with particular intensity during two periods, 1864–69 and 1880–83. His concerted interest in still life, particularly in the mid-1860s, had as much to do with its appeal to a middle-class clientele as it did with his love of painting.[64] His first still lifes date from 1862 and were probably inspired by the 1860 exhibition at Louis Martinet's gallery that featured work by Chardin.[65] In 1864–69, Manet completed six pictures of peonies, one of a dead hare, and twelve paintings of fish and fruit in lavish tabletop arrangements, often on a crisp white cloth, or in kitchen settings reminiscent of Chardin. Whereas Manet sent his major figurative works to the Salon, still life was part of his strategy for exhibiting outside that institution. All of the 1860s still lifes were intended for sale through galleries like Louis Martinet and the print dealer Alfred Cadart. Manet also included numerous still lifes in his 1867 one-person exhibition that he organized on the Avenue de l'Alma.[66]

That still life was prominent in Manet's mind in the 1860s is evident even in his figurative works, which often feature an assemblage of objects at the picture's edge or a solitary piece of fruit in the foreground of a portrait. Allowing objects to draw the viewer's attention away from the canvas's principal subject or granting them symbolic significance as clues into the artist's relationship to the sitter, as in the *Portrait of Emile Zola* (fig. 8) for example, Manet situated still life on at least an equal footing with his figures. The artist was in fact often criticized for treating his figure subjects as if they were objects in a still-life composition.[67]

In the 1870s, Manet produced far fewer still lifes, intending some as gifts for friends, such as the intimate *Bouquet of Violets* from 1872 (plate 31) dedi-

cated to Berthe Morisot, who two years later became his sister-in-law. Due to the debilitating effects of syphilis, Manet's energy and mobility were greatly reduced from 1879 on. In his last years, when he was largely confined to his home, either in Paris or on curative stays in the country, Manet painted large numbers of simple still-life arrangements. Some, like the extraordinary *A Bunch of Asparagus* (plate 45) are quite ambitious. Most of the late works, however, and almost all of those painted in the last year of his life, are small in scale and devoted to the subject of flowers.

Made Chevalier of the Legion of Honor and awarded a second-class medal at the Salon of 1881, Manet made his final submission to the 1882 Salon, *Bar at the Folies-Bergère* (1881–82, Courtauld Institute, London). Prominently displayed on the marble surface of the bar are a vase with two roses and a compote filled with oranges, testimony to the artist's enduring belief that still life was the touchstone of painting.[68] Manet died on 30 April 1883 at the age of fifty-two. SBF

FIGURE 54
MAX LIEBERMANN (1847–1935) IN HIS HOUSE IN
BERLIN-WANNSEE, 1934

PLATE 8
Branch of White Peonies with Pruning Shears
Branches de pivoines blanches et sécateur. 1864
Oil on canvas, 12⅛ x 18¼ in. (31 x 46.5 cm)
Inscribed lower right (by Suzanne Manet): *Manet*
Musée d'Orsay, Paris, Bequest of Count Isaac de Camondo

PROVENANCE
Given by Manet to Jules Champfleury, Paris, 1884; Hôtel Druout, Paris, Champfleury sale, 28–29 April 1890, no. 18; Victor Chocquet, Paris; Mme Chocquet sale, Paris, 3–4 July 1890, no. 72; Comte Isaac de Camondo, Paris; bequest of Camondo to the Musée du Louvre, 1908 (entered museum in 1911); Jeu de Paume, 1947; Musée d'Orsay, 1986 (RF 1995).

EXHIBITIONS
Paris 1884, no. 38; *Hommage à Manet*, Paris, Orangerie, January 1952; *Delacroix et les maîtres de la couleur*, Paris, atelier Delacroix, 17 May 1952, no. 21; Philadelphia 1963, no. 138; *The Taste of Paris from Poussin to Picasso*, Atlanta, High Museum of Art, 5 October–1 December 1968, no. 48; *Delacroix et les peintres de la nature*, Paris, Musée Delacroix, June–December 1975; Paris and New York 1983, no. 78; *Orsay avant Orsay*, France (Antibes, 15 June–9 September 1985, Toulouse, 19 September–11 November 1985, Lyon, 21 November–15 January 1985) no. 1; *Manet*, Copenhagen, Ordrupgaard, 15 September–26 November 1989, no. 7; *Champfleury, 1821–1889: L'art pour le peuple*, Paris, Musée d'Orsay, 1990, no. 145; Paris and Baltimore 2000–01, no. 27.

PLATE 18
Basket of Fruit
Un panier de fruits. CA. 1864
Oil on canvas, 14¹³⁄₁₆ x 17½ in. (37.7 x 44.4 cm)
Signed lower right: *Manet*
Museum of Fine Arts, Boston, Bequest of John T. Spaulding

PROVENANCE
Purchased from Manet by Mme D'Angély, Paris; Durand-Ruel, Paris, 28 May 1914; Durand-Ruel, New York, 26 January 1922; Mrs. L. L. Coburn, 20 December 1922; purchased by John Taylor Spaulding from Durand-Ruel, New York, 21 April 1924; Museum of Fine Arts, Boston, 1948, bequest of John T. Spaulding (48.576).

EXHIBITIONS
Tableaux d'Edouard Manet, Paris, Rond-point de l'Alma, 1867, no. 41; Cambridge 1929, no. 59; *Edouard Manet: A Retrospective Loan Exhibition for the Benefit of the French Hospital and the Lisa Day Nursery*, New York, Wildenstein & Co., 19 March–17 April 1937, no. 12; *Paintings, Drawings, and Prints from Private Collections in New England*, Boston, Museum of Fine Arts, 9 June–10 September 1939, no. 75; *The John Taylor Spaulding Collection, 1870–1948*, Boston, Museum of Fine Arts, 26 May–7 November 1948, no. 55; Boston 1973, no. 21; Tokyo, Fukuoka, and Kyoto 1983–84, no. 46; *Edouard Manet*, Japan (Tokyo, Isetan Museum of Art, 26 June–29 July 1986, Fukuoka Art Museum, 2–31 August 1986, Osaka Municipal Museum of Art, 9 September–12 October 1986), no. 9; *From Neo-Classicism to Impressionism: French Art from the Museum of Fine Arts, Boston*, Kyoto Municipal Museum of Art, Hokkaido Museum of Modern Art, Yokohama, Sogo Museum of Art, 1989, no. 57; Boston 1992, no. 48; *Monet and His Contemporaries from the Museum of Fine Arts, Boston*, Tokyo, Bunkamura Museum of Art, 17 October 1992–17 January 1993, Hyogo Prefectural Museum of Modern Art, Kobe, 23 January–21 March 1993, no. 48; Chiba, Nara, Yokohama, and Boston 1994–95, no. 34 (Japan) and no. 40 (Boston); Paris and Baltimore 2000–01, no. 21.

PLATE 4
The Salmon
Le saumon. CA. 1864
Oil on canvas, 28⅛ x 35⅜ in. (71.4 x 89.9 cm)
Signed lower right: *Manet*
Courtesy Shelburne Museum, Shelburne, Vermont

PROVENANCE
Sold by Manet to Durand-Ruel, Paris, through Alfred Stevens, 1872; Jean-Baptiste Faure, Paris, 16 November 1874; deposited with Durand-Ruel, Paris, 2 February 1886; purchased by Durand-Ruel, Paris, 24 August 1886; bought the same day by Durand-Ruel, New York; Mr. and Mrs. H. O. Havemeyer, New York, 1886–1907; Mrs. H. O. Havemeyer 1907–29; deposited at Durand-Ruel, New York from 22 November–15 December 1913; Electra Havemeyer Webb, 1929; bequeathed to Shelburne Museum, Electra Havemeyer Webb Fund, 1960.

EXHIBITIONS
Manet, Paris, Ecole des Beaux-Arts, April 1864 (?); *Tableaux d'Edouard Manet*, Paris, Rond-point de l'Alma, 1867, no. 36; *Society of French Artists, 5th Exhibition*, London, 1872, no. 105; Paris 1884, no. 50; *Works in Oil and Pastel by the Impressionists of Paris*, New York, National Academy of Design, 10 April–25 May 1886, no. 23; *Loan Exhibition: Paintings by Edouard Manet*, New York, Durand-Ruel, 29 November–13 December 1913, no. 8; *Loan Exhibition of French Masterpieces of the Late XIXth century,*

New York, Durand-Ruel, 20 March–10 April 1928, no. 11; *Manet: 1832–1883*, Paris, Orangerie, 16 June–9 October 1932, no. 35; *Manet et Renoir*, Philadelphia Museum of Art, 29 November 1933–1 January 1934; *A Century of Progress*, Chicago, Art Institute, 1 June–1 November 1934, no. 253; *Paintings from Private Collections*, New York, Metropolitan Museum of Art, 1960, no. 67; *Paintings, Drawings, and Sculptures Collected by Yale Alumni*, New Haven, Yale University Art Gallery, 19 May–26 June 1960, no. 50; *The Electra Havemeyer Webb Memorial Exhibition*, New York, Metropolitan Museum of Art, summer 1961, no. 15; *Collection of the Electra Havemeyer Webb Fund*, New York, Knoedler Galleries, 29 March–23 April 1966, no. 12; *Edouard Manet*, Philadelphia Museum of Art, 3 November–11 December 1966, Chicago, Art Institute, 13 January–19 February 1967, no. 101; *Impressionism: A Centenary Exhibition*, Paris, Grand Palais, 21 September–24 November 1974, New York, Metropolitan Museum of Art, 12 December 1974–10 February 1975 (New York only, not in catalogue); *Splendid Legacy: The Havemeyer Collection*, New York, Metropolitan Museum of Art, 27 March–20 June 1993, no. 350; Paris and Baltimore 2000–01, no. 19.

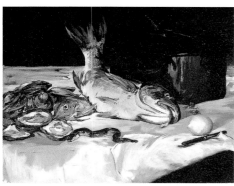

FIGURE 55
EDOUARD MANET.
STILL LIFE WITH FISH. 1864.
OIL ON CANVAS, 28⅞ x 36¼ IN. (73.3 x 92 CM)
THE ART INSTITUTE OF CHICAGO,
MR. AND MRS. LEWIS L. COBURN
MEMORIAL COLLECTION

PLATE 31
Bouquet of Violets
Le bouquet de violettes. 1872
Oil on canvas, 8⅝ x 10⅝ in. (22 x 27 cm)
Inscribed (at right, on white sheet): *A Mlle Berthe [Mo]risot/E. Manet*
Private collection, Paris

PROVENANCE
Given by Manet to Berthe Morisot; by descent to her daughter, Julie Rouart-Manet; private collection, Paris.

EXHIBITIONS
Masterpieces of French XIXth Century Paintings, London, Burlington Fine Arts Club, 1936, no. 38; *Les fleurs et les fruits depuis le romantisme*, Paris, Charpentier, 1942–43, no. 94; *Natures mortes de Géricault à nos jours*, Saint-Etienne, Musée d'Art et d'Industrie, 1955, no. 13; *Natures mortes françaises du XVIIe siècle au XXe siècle*, Paris, Daber, 9 April–6 May 1959, no. 27; *Manet*, Marseille, Musée Cantini, 16 May–31 July 1961, no. 13; Paris and New York 1983, no. 131; *Manet*, Martigny, Pierre Gianadda Foundation, 5 June–11 November 1996, no. 30; Paris and Baltimore 2000–01, no. 32.

PLATE 45
A Bunch of Asparagus
Une botte d'asperges. 1880
Oil on canvas, 17¼ x 21¼ in. (44 x 54 cm)
Signed lower left: *Manet*
Wallraf-Richartz-Museum, Cologne
Boston only

PROVENANCE
Purchasd from Edouard Manet by Charles Ephrussi, Paris, 1880; Alexandre Rosenberg (?) ca. 1900–1902; Carl Bernstein, Berlin; Paul Cassirer, Berlin; Max Leiberman, Berlin, 1907; Mr. and Mrs. Kurt Riezler (born Liebermann), New York; Mrs. Howard B. White (born Riezler), Northport, New York; purchased and loaned by the Society of Friends, the Board of Curators, and the Förderer-gesellschaft des Wallraf-Richartz-Museums, Cologne, since 1968.

EXHIBITIONS
Paris 1884, no. 96; *Centennale de l'art français*, Paris, Exposition universelle, 1889, no. 493; *Exposition centennale de l'art français*, Paris, Exposition universelle, 1900, no. 450; *Siebenten Kunstausstellung der Berliner Sezession*, Berlin, 1903; *Exposition des Impressionistes*, Galerie Paul Cassirer, Berlin, 1925, no. 30; *Internationale Kunstausstellung*, Dresden, June–September 1926, no. 123; *Manet, 1832–1889*, Paris, Orangerie, 16 June–9 October 1932, no. 75; *Honderd jaar Fransche kunst*, Amsterdam, Stedelijk Museum, 1938, no. 156; *La nature morte de l'antiquité à nos jours*, Paris, Orangerie, 1952, no. 90; *Paintings from Private Collections*, New York, Metropolitan Museum of Art, 1963, no. 30; *Edouard Manet, 1832–1883*, Philadelphia Museum of Art, 3 November–11 December 1966, Chicago, Art Institute, 13 January–19 February 1967, no. 183; *Manet*, Ordrupgaard, Copenhagen, 15 September–26 November 1989, no. 43; Paris and Baltimore 2000–01, no. 35.

PLATE 65
Flowers in a Crystal Vase
Fleurs dans un vase de cristal. CA. 1882
Oil on canvas, 21½ x 13⅞ in. (54.6 x 35.2 cm)
Signed and inscribed at bottom left: *Manet à mon ami le Dr. Evans*
Musée d'Orsay, Paris, gift with reserved use

PROVENANCE
Acquired from Manet by Dr. Thomas W. Evans, Philadelphia and Paris, ca. 1882; Thomas W. Evans Collection, University of Pennsylvania School of Dental Medicine, Philadelphia; Christie's, New York, 14 November 1990, no. 8; private collection, Paris; given under restrictions to the Musée d'Orsay, 2000.

EXHIBITIONS
Manet, Martigny, Pierre Gianadda Foundation, 5 June–11 November 1996, no. 91; Paris and Baltimore 2000–01, no. 83.

PLATE 64
Flowers in a Crystal Vase
Fleurs dans un vase de cristal. CA. 1882
Oil on canvas, 12⅞ x 9⅝ in. (32.6 x 24.3 cm)
Signed lower right: *Manet*
National Gallery of Art, Washington, D.C., Ailsa Mellon Bruce Collection

PROVENANCE
Mme Jules Féral, 1932 until at least 1938; possibly purchased by Charpentier at the Féral collection sale, 1949; Capitaine Edward H. Molyneux, Paris, 1952; Ailsa Mellon Bruce, New York, 15 August 1955; bequeathed to the National Gallery of Art, Washington, D.C., 1970.

Exhibition of French Art: 1200–1900, London, Royal Academy of Arts, 1932, no. 561; *Manet, 1832–1889*, Paris, Orangerie, 16 June–9 October 1932, no. 87a; *Het Stilleven*, Amsterdam, Kunsthandel J. Goudstikker, 1933, no. 206; *Honderd jaar Fransche kunst*, Amsterdam, Stedelijk Museum, 2 July–25 September 1938, no. 162; *Natures mortes françaises*, Paris, Galerie Charpentier, 1951, no. 105; *French Paintings from the Molyneux Collection*, Washington, D.C., National Gallery of Art, New York, Museum of Modern Art, 1952; *French Paintings of the 19th Century from the Collection of Mrs. Mellon Bruce*, San Francisco, California Palace of the Legion of Honor, 15 June–30 July 1961, no. 24; *French Paintings from the Collection of Mr. and Mrs. Paul Mellon and Mrs. Mellon Bruce*, Washington, D.C., National Gallery of Art, 17 March–1 May 1966, no. 45; *Capolavori impressionisti dei musei americani*, Naples, Museo e Gallerie Nazionali di Capodimonte, and Milan, Pinacoteca di Brera, 1986–87, no. 26; *Impressionisti della National Gallery of Art di Washington*, Venice, Ala Napoleonica e Museo Correr, and Milan, Palazzo Reale, 6 May–4 September 1989; Paris and Baltimore 2000–01, no. 82.

PLATE 63
Moss Roses in a Vase
Roses mousseuses dans un vase. 1882
Oil on canvas, 22 x 13½ in. (55.9 x 34.3 cm)
Signed lower right: *Manet*
Sterling and Francine Clark Art Institute, Williamstown, Massachusetts

PROVENANCE
Georges Bernheim, Paris; Paul Rosenberg, Paris; M. Knoedler, Paris; Robert Sterling Clark, 28 May 1923; Sterling and Francine Clark Art Institute, 1955

EXHIBITIONS
Oeuvres des grands maîtres du XIXe siècle, Paris, Galerie Paul Rosenberg, 3 May–3 June 1922, no. 54; *Peintures de l'école française du XIXe siècle*, Paris, Galerie M. Knoedler & Co., May 1924, no. 44; *Exhibit Five: French Paintings of the 19th Century*, Williamstown, Mass., Sterling and Francine Clark Art Institute, 8 May 1956, no. 111; *French Paintings of the Nineteenth Century*, Williamstown, Sterling and Francine Clark Art Institute, 1963, no. 78; *Edouard Manet*, Japan (Tokyo, Isetan Museum of Art, 26 June–29 July 1986, Fukuoka Art Museum, 2–31 August 1986, Osaka, Museum of Art, 9 September–12 October 1986); Paris and Baltimore 2000–01, no. 84.

PLATE 62
Two Roses on a Tablecloth
Deux roses. 1882–83
Oil on canvas, 7⅝ x 9½ in. (19.3 x 24.2 cm)
Signed lower right: *Manet*
The Museum of Modern Art, New York,
The William S. Paley Collection

PROVENANCE
Eugène Pertuiset, Paris; Auguste Pellerin, Paris; Gaston Bernheim de Villers, Monte Carlo; Sam Salz, New York, July 1951; Mr. and Mrs. William S. Paley, New York, 1951; bequeathed to Museum of Modern Art, 1990 (SPC 17.90).

EXHIBITIONS
Paris 1884, no. 99; *Austellung Edouard Manet, 1832–1883: Gemälde, Pastelle, Aquarelle, Zeichnungen*, Berlin, Galerie Matthiesen, 6 February–18 March 1928, no. 78; *Exposition d'oeuvres de Manet au profit des 'Amis du Luxembourg'*, Paris, Galerie Bernheim-Jeune, 14 April–4 May 1928, no. 37; *William S. Paley Collection*, New York, Museum of Modern

Art, 2 February–7 April 1992, no. 38; Paris and Baltimore 2000–2001, no. 79.

MONET

Monet, the quintessential Impressionist landscape painter, made only around sixty-four individual still lifes in the course of his long career. His nearly two thousand catalogued works testify to his lifelong commitment to investigating the genre of landscape, but still life comprises just 3 percent of his oeuvre. Nevertheless, the artist reportedly told the Duc de Trévise late in his life, "What I need most of all are flowers, always, always."[69] More than half of his still lifes depict flowers.[70]

Born in Paris 14 November 1840, Monet moved with his family about five years later to Sainte-Adresse, near Le Havre. There he made a name for himself as a caricaturist and in the mid-1850s was introduced to painting out-of-doors by Eugène Boudin. In 1859 Monet moved to Paris and enrolled at the Académie Suisse, where he may have met Pissarro. After his military service he resumed his training in Paris in autumn 1862 at the atelier of Charles Gleyre, where he developed close friendships with Bazille, Renoir, and Sisley.[71]

Although Monet became a leading proponent of large scale plein air landscape painting early on—his first two submissions to the Salon, both landscapes, gained entry to the notoriously conservative exhibition in 1865—some of his most striking works from these years are still lifes.[72] Painted in the realist vein of Bonvin and Chardin, these grand trophies of the hunt and more intimate meat cutlet tableaux are far afield from the brightly hued and swiftly painted works of the artist's mature oeuvre. A large painting of sumptuous spring flowers made in 1864 (plate 9) and probably informed by Courbet's flowerpiece from two years previous (plate 1) seems more in tune with Monet's sensibilities. Experimenting with the range of contemporary still-life styles, the artist produced thirteen more still lifes over the course of the 1860s and into the early 1870s, including three luncheon scenes featuring tabletop still-life arrangements.[73]

Although still life was never a dominant concern for Monet, his engagement with the genre reveals a great deal about his attention to the marketability of his work. Almost from the very beginning of his career, Monet's still-life paintings fetched high sums and were sought after by collectors. The early works that were not purchased within a year of their making were acquired by the more serious collectors, most notably Durand-Ruel, in the 1880s and 1890s, when Monet's reputation as a leading artist was well established. A surge of still-life activity followed the death of his first wife, Camille, in 1879; between 1879 and 1883, Monet produced four pheasant pictures, five fruit studies, and seventeen paintings of flowers, along with an unusual picture, the "Galettes" from 1882 (plate 57). Whether Monet pursued the genre in these years as a means of coping with the death of his wife or simply saw the possibility for market returns, he actively promoted his image as a painter of still lifes, exhibiting six of them at the seventh Impressionist show of 1882 and eleven at his one-man show the following year.[74]

When he moved to Giverny in 1883 with Alice Hoschedé, the woman who would become his second wife, Monet had already begun to distance himself from his Impressionist colleagues. Broadening his subject matter to views of Normandy and the Mediterranean, among other locales, Monet traveled widely and painted few still lifes in the mid- to late 1880s, save for the thirty-six decorative panels of fruit and flowers that were commissioned by Durand-Ruel for his dining room doors.[75] Akin to

the panels made a decade later by Caillebotte for the doors of his own dining room at Petit-Gennevilliers, these compositions presage the decorative impulse of Monet's late water lily canvases.[76] The two artists, fellow horticulturists, shared advice on many occasions about exotic plants and blooming flowers, and perhaps even decorative strategies. Chrysanthemums seem to have had special significance for them: Caillebotte purchased Monet's *Red Chrysanthemums* (1880, private collection) at the Impressionist exhibition of 1882 and gave Monet a painting of the chrysanthemums in his garden in 1893.[77] After Caillebotte's death the following year, Monet painted four pictures of chrysanthemums from a bird's-eye viewpoint similar to that of Caillebotte's composition. Monet exhibited the series at Georges Petit's gallery in 1898, just one year after Caillebotte's Impressionist collection was first shown to the public in its new home at the Musée du Luxembourg. Devoting more and more time to painting his gardens at Giverny once the nineteenth century gave way to the twentieth, Monet focused his still-life production almost entirely on outdoor flowers until his death in 1926.[78] — JAG

PLATE 9
Spring Flowers
Fleurs de printemps. 1864
Oil on canvas, 45 x 34⅝ in. (114.5 x 88 cm)
Signed and dated upper right: *Claude Monet 64*
The Cleveland Museum of Art, Gift of the Hanna Fund

PROVENANCE
The artist's elder brother, Léon Pascale Monet, Rouen; Wildenstein & Co., New York, until 1953; Cleveland Museum, 1953, Hanna Fund (CMA 1953.155).

EXHIBITIONS
(?)*20me Exposition municipale des beaux-arts*, Rouen, Musée de Rouen, 1 October 1864; *Claude Monet*, Saint Louis City Art Museum, 25 September–22 October 1957, Minneapolis Institute of Arts, 1 November–1 December 1957, no. 1; Philadelphia 1963; *Paintings by Monet*, Chicago, Art Institute, 15 March–11 May 1975, no. 3; *The Second Empire: Art in France under Napoleon III*, Philadelphia Museum of Art, 1 October–26 November 1978, Detroit Institute of Arts, 15 January–18 March 1979, no. VI–88, Paris, Grand Palais, 24 April–2 July 1979, no. 256; Paris and New York 1994–95, no. 115.

PLATE 17
Jar of Peaches
Bocal de pêches. 1866
Oil on canvas, 21⅞ x 18⅛ in. (55.5 x 46 cm)
Signed lower right: *Claude Monet*
Staatliche Kunstsammlungen, Gemäldegalerie Neue Meister, Dresden

PROVENANCE
Durand-Ruel, ca. 1890; Paul Cassirer, Berlin, 1900; C. L. Uhle, Dresden; Alfred Gold, Berlin; acquired in 1927 by the Gemäldegalerie, Dresden, Germany (2525 B).

EXHIBITIONS
La Haye, Cercle Artistique, 1893; *Exposition française*, Saint Petersburg, 1899, no. 242; *Claude Monet, 1840–1926*, Berlin, Thannhauser, February–March 1928, no. 2 (*Nature morte*, 1865).

PLATE 24
The Tea Set
Le service à thé. 1872
Oil on canvas, 20⅞ x 28⁹⁄₁₆ in. (53 x 72.5 cm)
Signed lower left: *Claude Monet*
Private collection

PROVENANCE
Purchased from Monet by Durand-Ruel, November 1872; Hôtel Drouot, Paris, 17 February 1873, no. 58 (Durand-Ruel); Hoentschel, April 1901; Knoedler, 1924; Alex. Reid, Glasgow, 1925; Mme De Goldschmidt-Rothschild, Paris; private collection, France; private collection, United States, ca. 1976.

EXHIBITIONS
Works in Oil and Pastel by the Impressionists of Paris, New York, American Art Galleries, April 1886, National Academy of Design, May–June 1886, no. 283; *Art français*, St. Petersburg, 1899, no. 240; *Art moderne*, Paris, Manzi-Joyant, 1913, no. 82; *Art français*, London, Grosvenor, 1914, no. 40; *Monet*, Paris, Bernheim-Jeune, 1921, no. 6; *Peintres de l'école française du XIXe siècle*, Paris, Knoedler, 1924, no. 19; *Hommage à Claude Monet*, Paris, Grand Palais, 8 February–5 May, 1980, no. 44; *Claude Monet*, Madrid, Museo español de Arte Contemporaneo, 29 April–30 June, 1986, no. 10; *Impressionist and Modern Masters in Dallas: Monet to Mondrian*, Dallas Museum of Art, 3 September–22 October 1989, no. 64.

PLATE 25
Still Life with Melon
Nature morte au melon. 1872
Oil on canvas, 20⅞ x 28¾ in. (53 x 73 cm)
Signed upper left: *Claude Monet*
Calouste Gulbenkian Museum, Lisbon, Portugal

PROVENANCE
Purchased from Monet by Durand-Ruel, 30 September 1872 and sold to Hiltbrunner, Paris; Durand-Ruel, 1882; Ch. Cotinaud, Périgueux; Durand-Ruel, 1903; Hoentschel, Paris, 1903; Galeries Barbazanges, 1924; purchased by C. S. Gulbenkian from Knoedler, London, 15 April 1924; Fundação Calouste Gulbenkian (Inv. No. 450).

EXHIBITIONS
Exposition temporaire des amis du Luxembourg, Paris, Musée du Luxembourg, 1904, no. 39; *Exposition Claude Monet*, Paris, Bernheim-Jeune, 21 January–2 February 1921, no. 5; *Peintres de l'école française du XIX siècle*, Paris, Knoedler, 1924, no. 17; *Claude Monet*, Paris, Musée de l'Orangerie, 1931, no. 38; *Pictures from the Gulbenkian Collection lent to the National Gallery*, London, National Gallery, 1936–50 (except during the war years); *European Paintings from the Gulbenkian Collection*, Washington, D.C., National Gallery of Art, 1950–60, no. 29; *Tableaux de la collection Gulbenkian*, Paris, Centre Culturel Calouste Gulbenkian, 1960, no. 23; *Pinturas da colecção da Fundação Calouste Gulbenkian*, Lisbon, Museu Nacional de Arte Antiga, 1961–63, no. 27; *Artes Plásticas Francesas de Watteau a Renoir*, Oporto, Museu Nacional de Soares dos Reis, 1964, no. 51; *Obras de arte da colecção Calouste Gulbenkian*, Oeiras, Palácio Pombal, 1965–69, no. 272; *Hommage à Claude Monet (1840–1926)*, Paris, Grand Palais, 8 February–5 May 1980, no. 44 bis; *Claude Monet*, Madrid, Museo Español de Arte Contemporáneo, 29 April–30 June 1986; *Only the Best: Masterpieces of the Calouste Gulbenkian Museum, Lisbon*, New York, Metropolitan Museum of Art, 17 November 1999–27 February 2000, no. 68.

PLATE 38
Camille at the Window
Camille à la fenêtre. 1873
Oil on canvas, 23¾ x 19⅝ in. (60.3 x 49.8 cm)
Estate stamp, lower left: *Claude Monet*
Virginia Museum of Fine Arts, Richmond

PROVENANCE

Michel Monet, Giverny; Wildenstein & Co., New York; Paul Mellon, ca. 1968; gift to the Virginia Museum of Fine Arts, Richmond, 1983.

EXHIBITIONS

Claude Monet: exposition rétrospective, Paris, Orangerie, 1931, no. 21; *Centenaire de Claude Monet*, Paris, Galerie André Weil, 30 January–21 February 1940, no. 4; *Claude Monet*, Paris, Galerie Durand-Ruel, 22 May–30 September 1959, no. 10; *Degas*, Richmond, Virginia Museum of Fine Arts, 23 May–9 July 1978.

PLATE 51
Pheasants and Plovers
Faisans et vanneaux. 1879
Oil on canvas, 26¾ x 35½ in. (67.9 x 90.2 cm)
Signed upper left: *Claude Monet*
The Minneapolis Institute of Arts, Gift of Anne Pierce Rogers in memory of John DeCoster Rogers

PROVENANCE

Purchased from Monet by Dubourg, Paris, in 1880 (*Les Faisans*); Durand-Ruel, ca. July 1891; Potter Palmer, Chicago, 1892; Mrs. Palmer Thorne, United States, ca. 1957; Wildenstein; Mrs. Seward Johnson, United States; donated by A. Pierce Rogers in memory of John DeCoster Rogers in 1984 to Minneapolis Institute of Arts (84.140).

EXHIBITIONS

7e exposition des artistes indépendants, Paris, 251, rue St. Honoré, 1882, no. 82; *Claude Monet*, Saint Louis City Art Museum, 25 September–22 October 1957, Minneapolis Institute of Arts, 1 November–1 December 1957, no. 45; *The Sachs Years*, Minneapolis Institute of Arts, June 1–August 4, 1985; *Impressionism: Selections from Five American Museums*, Pittsburgh, Carnegie Museum of Art, Minneapolis Institute of Arts, Kansas City, Nelson Atkins Museum of Art, Saint Louis Art Museum, Toledo Museum of Art, 4 November 1989–25 November 1990, no. 51.

PLATE 41
Still Life: Apples and Grapes
Nature morte: pommes et raisins. 1880
Oil on canvas, 25⅝ x 32⅛ in. (65.1 x 81.6 cm)
Signed and dated upper left: *Claude Monet 1880*
The Art Institute of Chicago, Bequest of Mr. and Mrs. Martin A. Ryerson

PROVENANCE

Purchased from Monet by Cahuzac in November 1880 (?); Durand-Ruel, ca. 1883 (?); Catholina Lambert, Paterson, United States; Durand-Ruel, 1895; M. A. Ryerson, Chicago, 1915; bequeathed by Mr. and Mrs. Martin A. Ryerson in 1933 to Art Institute of Chicago (33.1152).

EXHIBITIONS

(?) *Monet*, Paris, *La vie moderne*, 1880, no. 2 (as *Corbeille de fruits*); *Monet*, New York, Durand-Ruel, 1902, no. 8; *Monet-Rodin*, Boston, Copley Hall, March 1905, no. 2; *Monet*, New York, Durand-Ruel, 1907, no. 17; *Masters of the Modern French School*, Washington, D.C., Corcoran Gallery, 1911, no. 2; *Natures mortes et fleurs*, New York, Durand-Ruel, 1913–14, no. 6; *Paintings by Monet*, Chicago, Art Institute, 15 March–11 May 1975, no. 46.

PLATE 61
Vase of Flowers
Vase de fleurs. CA. 1881–82
Oil on canvas, 39½ x 32¼ in. (100.4 x 81.9 cm)
Signed bottom right: *Claude Monet*
Courtauld Gallery, London, Samuel Courtauld Collection

PROVENANCE

Bernheim-Jeune, Paris; Alex Reid, Glasgow; Samuel Courtauld, May 1923; donated to the Home House Trustees, London, 1932; exhibited at Courtauld Institute Galleries from 1932 (Inv. No. P1932.SC.275).

EXHIBITIONS

French Art, Birmingham, City Museum and Art Gallery, 1947; *Catalogue of the Samuel Courtauld Memorial Exhibition*, London, Tate Gallery, May–June 1948, no. 49; *Claude Monet*, Edinburgh, Royal Scottish Academy, 17 August–15 September 1957, London, Tate Gallery, 26 September–3 November 1957, no. 59; *Samuel Courtauld's Collection of French 19th Century Paintings and Drawings*, London, Courtauld Institute of Art and the Arts Council of Great Britain, 1976, no. 31; *The Impressionists and the Post-Impressionists from the Courtauld Collection. University of London*, Japan (Takashimaya, Tokyo, Kyoto, and Osaka) and Canberra, Australian National Gallery, 1984, no. 65; *Impressionist and Post-Impressionist Masterpieces: The Courtauld Collection*, Cleveland Museum of Art, 14 January–8 March 1987, New York, Metropolitan Museum of Art, 4 April–21 June 1987, Fort Worth, Kimbell Art Museum, 11 July–27 September 1987, Chicago, Art Institute, 17 October 1987–3 January 1988, Kansas City, Nelson-Atkins Museum of Art, 30 January–3 April 1988, no. 12; *London's Monets*, London, National Gallery, 12 March–5 May 1997, no. 13; *The Courtauld Collection: Masterpieces of Impressionism and Post-Impressionism*, Ontario, Art Gallery of Ontario, 10 June–20 September 1998, no. 22.

PLATE 57
The "Galettes"
Les galettes. 1882
25⅝ x 31⅞ in. (65 x 81 cm)
Signed and dated lower left: *Claude Monet 82*
Private collection

PROVENANCE

Paul Graff, Pourville, France, 1882; Knoedler, Paris; Durand-Ruel, 1899; private collection, France, ca. 1959.

EXHIBITIONS

Exposition des oeuvres de Cl. Monet, Paris, Durand-Ruel, 1883, no. 56; *Ausstellung VIII. Jahrgang*, Berlin, Paul Cassirer, 1905, no. 30; *Fleurs et natures mortes*, Paris, Bernheim-Jeune, 1907, no. 47; *Natures mortes*, Paris, Durand-Ruel, 1908, no. 8; *Monet*, Paris, Georges Petit, 1924, no. 37; *Monet*, Paris, Durand-Ruel, 1928, no. 31; *Fleurs et natures mortes*, Paris, Durand-Ruel, 5–19 December 1931, no. 39; *Monet de 1865 à 1888*, Paris, Durand-Ruel, 1935, no. 39; *Centenaire Monet-Rodin*, Paris, Orangerie, 1940, no. 32; *De David à Cézanne*, Brussels, Palais de Beaux-Arts, November 1947–January 1948, no. 110; *Impressionisten*, Basel, Kunsthalle, 1949, no. 130; *La Nature Morte de l'antiquité à nos jours*, Paris, Orangerie, 1952, no. 93; *Vier eeuwen stijleven in Frankrijk*, Rotterdam, Museum Boymans, 10 July–20 September 1954, no. 93; *Exposition Claude Monet, 1840–1926*, Paris, Durand-Ruel, 22 May–30 September 1959, no. 31; *Monet*, Paris, Durand-Ruel, 1970, no. 32; *Monet*, Tokyo, Kyoto, and Fukuoka, 1973, no. 31.

MORISOT

Berthe Morisot, the third daughter of four children, was born in Bourges to upper-middle-class parents on 14 January 1841. The family settled in the Passy section of Paris in 1852, a suburb next to the Bois de Boulogne that was the exclusive haunt of the haute-bourgeoisie. In the nineteenth century, it was expected that young women of Morisot's class would become amateur artists; thus Berthe and her sister Edma began drawing classes in 1857. A year later they were granted permission to copy old master paintings at the Louvre, and in 1861, the sisters began studying with Corot to explore their interest in painting out-of-doors. At the Louvre in 1868, Fantin-Latour introduced Morisot to Edouard Manet, with whom she became close friends. Although Manet was never Morisot's formal tutor, he did advise her about her painting and she admired his work. In December 1874 Morisot married Manet's younger brother Eugène, cementing the ties between the two families.

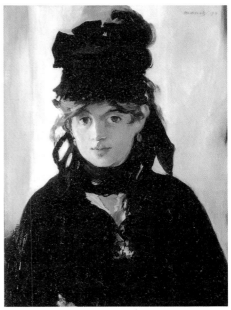

FIGURE 56
EDOUARD MANET.
BERTHE MORISOT WITH A BOUQUET OF VIOLETS. 1872.
OIL ON CANVAS, 21⅜ X 15 IN. (55 X 38 CM)
MUSÉE D'ORSAY, PARIS

Berthe Morisot was anything but the stereotypical lady amateur artist of the time. Unlike her sister Edma, who gave up painting when she got married, Morisot pursued a professional artist's identity throughout her life. In 1864 she debuted at the Salon, where she exhibited landscapes and figure paintings through 1868 before becoming a founding member of the Impressionist exhibitions in the 1870s and 1880s. She participated in seven of the eight Impressionist shows, only missing the 1879 exhibition because of illness following the birth of her only child, Julie. Scholars have suggested that Morisot's decision to ally herself with the Impressionist group indicates her general reluctance to accept the conditions and restrictions of the academic art world epitomized by the Salons.[79]

Still life was never a compelling subject for Morisot, and it is rare in her total oeuvre. Of the 422 paintings that survive, only twenty-five are still lifes, a meager six percent of her body of work. It is interesting to note that she chose not to explore this genre that was thought to be so particularly appropriate for women painters and amateur artists. Although initially interested in landscape, by 1869 Morisot was decidedly more excited by the challenge of painting figures in outdoor light.[80] Still life was considered little more than an exercise. Berthe wrote to Edma in 1869 that she was inspired by her sister's example

"to do my plums and my flowers, the whole thing on a white napkin," although she proclaimed that "this sort of exercise annoys me greatly."[81] Throughout her career Morisot also avoided classical subject matter, ultimately focusing on her family, especially her daughter, in contemporary domestic settings that reflected her own suburban space and life in Passy.

Morisot, who played the dual role of hostess-painter within the Impressionist circle, used her living room as her studio, which required her to put away her canvases in order to receive guests; this forced her to paint on a relatively small scale. Within this intimate domestic space, she occasionally abandoned the figure studies of her daughter and family in order to focus on close-up studies of flowers and tables set with fruit and glassware. Nineteen of Morisot's still lifes are of flowers, sometimes in a vase or basket, sometimes coupled with a fan, a glass, or even a soft bag. Only four still lifes contain fruit and other objects, and two additional ones feature bird-cages, an object that also appears in some of her figurative work and connects her to the painters of the eighteenth century. Like her close friend Renoir, who shared her admiration for Boucher and other rococo painters, Morisot would sometimes include beautiful still-life arrangements in her figurative work, often choosing to emphasize objects like dolls and chinaware that are not included in her pure still-life painting.

Morisot, who suffered an untimely death from influenza on 2 March 1895, only exhibited two still lifes in her lifetime, both at her 1892 solo exhibition at Boussod et Valadon (Paris), *Chrysanthemums or Overturned Basket* from 1885 (private collection) and *Apples* from 1887 (whereabouts unknown).[82] Not until the 1896 retrospective exhibition of her work, exactly one year after her death, did the public have its first real opportunity to see a large number of Morisot's still lifes, when fourteen were featured in the show of 394 works at Durand-Ruel. Even today her still lifes remain little known to the public. SBF

PLATE 42
Dahlias
Les dahlias. CA. 1876
Oil on canvas, 18⅛ x 22 in. (46.1 x 55.9 cm)
Signed with studio stamp lower right: *Berthe Morisot.*
Sterling and Francine Clark Art Institute, Williamstown, Massachusetts

PROVENANCE
M. et Mme Ernest Rouart, Paris; Durand-Ruel, Paris; M. et Mme Denis Rouart, Neuilly-sur-Seine; Jacques Daber, Paris; sold by Galerie Daber, Paris, to Sterling and Francine Clark Art Institute, 1974 (1974.28).

EXHIBITIONS
Berthe Morisot, Paris, Galerie Durand-Ruel, March 1896, no. 163; *Berthe Morisot*, Paris, Galerie Durand-Ruel, 1902, no. 27; *Salon d'automne*, Paris, Grand Palais, 1–22 October 1907, no. 53; *Berthe Morisot*, Paris, Galerie Marcel Bernheim, 1922, no. 20, London, Leicester Galleries, 1930, no. 43; *Fleurs et natures mortes*, Paris, Galeries Durand-Ruel, 5–19 December 1931, no. 41; *Berthe Morisot*, Paris, Orangerie, 1941, no. 23; *Les fleurs et les fruits*, Paris, Galerie Charpentier, 1942–43, no. 111; Copenhagen, Ny Carlsberg Glyptotek, 1949; *Berthe Morisot*, Geneva, Galerie Motte, June 1951, no. 7; Saint-Etienne, Musée de l'Art et d'Industrie, no. 20; *La Nature morte de l'antiquité à nos jours*, Paris, Orangerie, 1952, no. 92; *Vier eeuwen stijleven in Frankrijk*, Rotterdam, Museum Boymans, 10 July–20 September 1954, no. 91; *Berthe Morisot*,

Dieppe, Musée de Dieppe, July–September 1957, no. 14; *Berthe Morisot*, Albi, Musée Toulouse-Lautrec, July–September 1958, no. 12; *Berthe Morisot*, Paris, Musée Jacquemart-André, 1961, no. 23; *Berthe Morisot*, Vevey, Musée Jenisch, 24 June–3 September 1961, no. 16; *Berthe Morisot*, Aix-en-Provence, Galerie Lucien Blanc, 6–28 July 1962. no. 11; *La joie de peindre*, Paris, Galerie Daber, 1974, no. 31; *Twentieth Anniversary Exhibit: Selected Acquisitions since the Founding of the Institute (1955)*, Williamstown, Sterling and Francine Clark Art Institute, 17 May–6 October, 1975; *A Tribute to George Heard Hamilton*, Williamstown, Sterling and Francine Clark Art Institute, 23 May–30 July 1978.

PLATE 43
Tureen and Apple
Soupière et pomme. 1877
Oil on canvas, 22⅛ x 18⅛ in. (56 x 46 cm)
Signed with studio stamp lower left: *Berthe Morisot*
Denver Art Museum, purchase with funds from 1997 Collectors' Choice Benefit, and other donors by exchange

PROVENANCE
Thomas Agnew, London; Lefevre Gallery, London; E. Amvkhanian; JPL Fine Arts, London; private collection, London; Galerie Hopkins-Thomas, Paris; private collection, Geneva, Switzerland; purchased from Galerie Hopkins-Thomas, Paris, by Denver Art Museum, 1997 (1997.218).

EXHIBITIONS
Berthe Morisot. An Exhibition of Paintings and Drawings, London, Arts Council of Great Britain, 1950, no. 16; *Berthe Morisot*, Paris, Galerie Hopkins-Thomas, 1987, no. 6; *Les femmes impressionistes*, Japan, Tokyo, Museum of Art, Isetan, Shinjuku, 2 March–11 April 1995, Hiroshima, Museum of Art, 16 April–31 May 1995, Osaka, Takashimaya Grand Hall, 31 May–13 June 1995, Hakodake, Museum of Art, Hokkaido, 1 July–20 August 1995, no. 4; *Femmes et muses des impressionnistes aux modernes*, Tokyo, Mitsukoshi, 13–25 August 1996, Shimoneseki, Museum of Shimoneseki City, 30 August–20 October 1996, Toyoshina, Museum of Art, 12 November–23 December 1996, Ehime Kenritan Museum, 10 January–23 February 1997, no. 10.

PLATE 66
On the Veranda
Dans la véranda or Sous la véranda. 1884
Oil on canvas, 31⅞ x 39⅜ in. (81 x 100 cm)
Signed at bottom left: *Berthe Morisot*
Collection John C. Whitehead, New York

PROVENANCE
Ernest Chausson, Paris, 1929; *Vente Ernest Chausson*, 5 June 1938, Paris, no. 33; private collection, Paris; Galerie Schmit, Paris; Acquavella Galleries, New York; Achim Moeller Fine Art, New York, 1984.

EXHIBITIONS
Exposition internationale de peinture, Paris, May 1887, no. 99; *Berthe Morisot*, Paris, Boussod, Valadon et Cie, May–June 1892, no. 7; *La libre esthétique*, Brussels, 1894, no. 320; *Berthe Morisot*, Paris, Galerie Durand-Ruel, 5–21 March 1896, no. 28; *Salon d'Automne*, Paris, Grand Palais, 1–22 October 1907, no. 144; *Exhibition of Paintings. Edouard Manet. Pierre Renoir, Berthe Morisot*, Pittsburgh, Carnegie Institute, 15 October–1 December 1924, no. 14; *Paintings by Berthe Morisot*, Chicago, Art Institute, 30 January–10 March 1925, no. 7; *Berthe Morisot au cercle de la renaissance*, Paris, Galerie Bernheim-Jeune, 1929, no. 51; *Berthe Morisot*, London, M. Knoedler & Co., Inc., May–June 1936, no. 1; *Berthe Morisot Impressionist*, Washington, D.C., National Gallery of Art, 6

September–29 November 1987, Fort Worth, Kimbell Art Museum, 14 December 1987–22 February 1988, South Hadley (Mass.), Mount Holyoke College Art Museum, 14 March–9 May 1988, no. 51; *Late XIX and Early XX Century French Masters: The John C. Whitehead Collection*, Montclair, New Jersey, Montclair Art Museum, 30 April–18 June 1989, no. 49.

PLATE 44
The Cage
Cage. 1885
Oil on canvas, 21¾ x 15 in. (55 x 38 cm)
Stamped at bottom left: *Berthe Morisot*
National Museum of Women in the Arts, Washington, D.C., Gift of Wallace and Wilhelmina Holladay

PROVENANCE
M. and Mme Ernest Rouart, Paris; Marc Chadourne, Paris; Cécile de Rothschild, Paris; sold 10 December 1969, London, no. 24; Paul Rosenberg & Co., New York; sold 11 May 1977, New York, no. 16A; Wallace and Wilhelmina Holladay.

EXHIBITIONS
Mme Eugène Manet, exposition de son oeuvre, Paris, Galerie Durand-Ruel, 5–23 March 1896, no. 172; *Berthe Morisot*, Paris, Galerie André Weill, 1947; *A Selection of French Paintings and Drawings of the XIXth Century*, New York, Paul Rosenberg & Co., November 1970–January 1971, no. 16; *The Enchantress: Berthe Morisot*, Birmingham Museum of Art (Ala.), 16 March–12 April 1973, no. 16.

PISSARRO
Camille Pissarro was born on 10 July 1830 in Charlotte-Amalie, the capital of St. Thomas in the Virgin Islands.[83] At the age of twelve, he was sent to study in the Parisian suburb of Passy, where he received painting and drawing lessons. In 1847, Pissarro returned to St. Thomas, assuming a position in the family business. Determined to pursue an artistic career, Pissarro moved to Paris in mid-October 1855. His arrival coincided with the Exposition Universelle of that year, where he encountered paintings by Corot, Courbet, and Delacroix.[84] While studying at the Académie Suisse, Pissarro befriended Cézanne and also met Monet in 1859, who introduced him to Renoir and Sisley. This same year, he was accepted for the first time at the Salon, where he would exhibit regularly throughout the 1860s. In 1863, Pissarro participated in the Salon des refusés at which, notably, many still lifes were shown.

While Pissarro experimented with still life throughout his career, it is nonetheless a genre that is rare in his oeuvre. The twenty still lifes that he created over the course of thirty-five years comprise only 1.5 percent of his entire production of paintings.[85] Pissarro's first, and perhaps most important, still life was painted in 1867, just over a decade after his arrival in France. Monumental in scale, *Still Life* (plate 6) is a masterful canvas with its simple, almost austere composition of objects on a kitchen table rendered with lavish impasto. While reminiscent of Chardin's still lifes, the choice of such rustic subject matter was nevertheless central to Pissarro's enterprise of representing genre scenes of rural France in a modern context.

In 1866, Pissarro retreated from Paris, settling first in Pontoise and then in Louveciennes with his future wife, Julie Vellay, and their two children.[86] During the Franco-Prussian War of 1870–71, the artist took refuge in London. Upon returning to Louveciennes at the end of June 1871, they found that their house had been pillaged by the Prussian army. It is thus possible that Pissarro had painted more still lifes during the 1860s than the few early

paintings that survived the war.

Pissarro produced eight still lifes during the 1870s. Two works, *Still Life with Apples and Pitcher* (plate 30) and *Still Life: Apples and Pears in a Round Basket* (plate 29), display more subtle tonal gradations than his earlier still lifes. Painted about 1873, *Bouquet of Flowers* (plate 36) depicts an interior setting with one of the simple floral bouquets that the artist's wife frequently arranged for him.[87] *Chrysanthemums in a Chinese Vase* (plate 37), one of his most ornate compositions from this time, explores further the subject most characteristic of Pissarro's still-life paintings during this decade. In 1872, Cézanne joined Pissarro in Pontoise, where they worked closely together for five years. Indeed, Pissarro's exploration of still life during this period certainly was influenced by the painters' collaboration and, as has been suggested, by the three still lifes Cézanne exhibited at the third Impressionist exhibition in 1877.[88]

A major figure in the development of modern art, Pissarro was instrumental in organizing the first of the eight Impressionist exhibitions. In addition to playing a pivotal role as a founding member of the group, Pissarro was the only artist to participate in each of the exhibitions from 1874 to 1886.[89] During these years he did not paint or exhibit any still lifes. In the late 1880s, he began to suffer from a serious eye condition that eventually restricted him to working indoors, though it did not hinder his artistic productivity. It was not until 1898 that Pissarro began to experiment with still life again, as he would for the remaining fifteen years of his life. Focusing on interior settings, Pissarro produced ten still lifes in the years 1898–1900 that radicalized the concepts he had explored in the 1870s. He painted his last still life, of a bouquet of roses, in 1902, a year before he died in Paris on 13 November 1903 at the age of seventy-three. AAL

PLATE 6
Still Life
Nature morte. 1867
Oil on canvas, 31⅞ x 39¼ in. (81 x 99.6 cm)
Signed and dated upper right: *C. Pissarro. 1867*
The Toledo Museum of Art, Purchased with funds from the Libbey Endowment, Gift of Edward Drummond Libbey
Boston only

PROVENANCE
Mme Pissarro, Paris; Galerie Georges Petit, Paris, Mme Pissarro sale, 3 December 1928, no. 33; purchased by Georges Viau, Paris; first Viau sale, Hôtel Drouot, Paris, 11 December 1942, no. 108; second Viau sale, Galerie Charpentier, Paris, 22 June 1948, no. 5; Wildenstein & Co., New York; purchased by Toledo Museum of Art, 1949, with funds from the Libbey Endowment. (1949-6).

EXHIBITIONS
Exposition Camille Pissarro organisée à l'occasion du centenaire de la naissance de l'artiste, Paris, Orangerie, February–March 1930, no. 6; *Camille Pissarro: His Place in Art*, New York, Wildenstein & Co., 24 October–24 November 1945, no. 1; *Loan Exhibition C. Pissarro*, New York, Wildenstein & Co., 25 March–1 May, 1965, no. 3; *Camille Pissarro, 1830–1903*, London, Hayward Gallery, 30 October 1980–11 January 1981, Paris, Grand Palais, 30 January–27 April 1981, Boston, Museum of Fine Arts, 19 May–9 August 1981, no. 8 (Boston only); *The Realist Tradition: French Painting and Drawing 1830–1900*, Cleveland Museum of Art, 12 November 1980–18 January 1981, Brooklyn, Brooklyn Museum of Art, 7 March–10 May 1981, Saint Louis Art Museum, 23 July–20 September 1981, Glasgow Art Gallery and

Museum, Kelvingrove, 5 November 1981–11 January 1982, no. 121; Paris and New York 1994–95, no. 157.

PLATE 29
Still Life: Apples and Pears in a Round Basket
Nature morte: pommes et poires dans un panier rond. 1872
Oil on canvas, 18 x 21¾ in. (46.2 x 55.8 cm)
Signed and dated upper right: *C. Pissarro. 1872.*
Collection of Mr. and Mrs. Walter Scheuer

PROVENANCE
Purchased from the artist by Durand-Ruel, Paris, 26 November 1872; (?) Martin Collection, Paris; Alan Stone, New York; Mrs. Dorothy G. Noyes, New York; Sotheby's Park-Bernet, New York, 13 May 1970, no. 8; Henry Pearlman, New York; Mrs. Walter Scheuer, 1974, on loan to Henry and Rose Pearlman Foundation, Inc. (since 1988).

EXHIBITIONS
Summer Loan Exhibition 1971: Paintings from New York Collections: Collection of Mr. and Mrs. Henry Pearlman, New York, Metropolitan Museum of Art, 1971, no. 44; *An Exhibition of Paintings, Watercolours, Sculpture and Drawings from the Collection of Henry Pearlman*, Brooklyn, Brooklyn Museum, 22 May–29 September, 1974, no. 15; *Selections from the Collection of Mr. and Mrs. Henry Pearlman*, Princeton, N.J., Art Museum, Princeton University, 8 December 1974–16 March 1975 (no cat. no.); *Camille Pissarro, 1830–1903*, London, Hayward Gallery, 30 October 1980–11 January 1981, Paris, Grand Palais, 30 January–27 April 1981, Boston, Museum of Fine Arts, 19 May–9 August 1981, no. 21; *Camille Pissarro, Impressionist Innovator*, Jerusalem, Israel Museum, 11 October 1994–9 January 1995, New York, Jewish Museum, 26 February–16 July 1995, no. 46.

PLATE 30
Still Life with Apples and Pitcher
Châtaigniers et faïence. CA. 1872
Oil on canvas, 18¼ x 22¼ in. (46.4 x 56.5 cm)
Signed lower left: *C. Pissarro*
The Metropolitan Museum of Art, New York, Mr. and Mrs. Richard J. Bernhard Gift, by exchange

PROVENANCE
Purchased from the artist by Durand-Ruel, Paris, 26 November 1872; Ernest Hoschedé, Paris, 1873–74; Hôtel Drouot, Paris, Collection Hoschedé sale, 13 January 1874, no. 59; Durand-Ruel, Paris, 1874; Howard B. Davis, by 1898; Erwin Davis, New York, until 1899; Durand-Ruel, New York, 1899–1950; private collection, Switzerland, by 1956; Acquavella (?); Mrs. Constance Mellon, ca. 1970–83; with Acquavella Galleries, New York, 1983; Metropolitan Museum of Art, New York, 1983 (1983.166).

EXHIBITIONS
The Art of Camille Pissarro in Retrospect, New York, Durand-Ruel, 24 March–15 April 1941, no. 25; *Loan Exhibition of Paintings of Still Life from the 18th and 19th Centuries*, Cambridge, Fogg Art Museum, 28 April–24 May 1947 (lent by Durand-Ruel); Santa Barbara Museum of Art, 1947; *French Still Life from Chardin to Cézanne*, New York, Arnold Seligmann-Helft Galleries, 29 October–22 November 1947, no. 27 (lent by Durand-Ruel); *History of Still Life and Flower Painting*, Montclair Art Museum, 22 February–28 March 1948, no. 24 (lent by Durand-Ruel); *Exposition Camille Pissarro*, Paris, Durand-Ruel, 26 June–14 September 1956, no. 18; *Camille Pissarro, 1830–1903*, Bern, Kunstmuseum, 19 January–10 March 1957, no. 25 (lent by a private collection); *C. Pissarro, 1830–1903*, Paris, Durand-Ruel, 29 May–28 September 1962, no. 7; *XIX &*

XX Century Master Paintings, New York, Acquavella Gàlleries, Inc., 17 May–18 June 1983, no. 2.

PLATE 36
Bouquet of Flowers
Bouquet de fleurs. CA. 1873
Oil on canvas, 21⅝ x 18¼ in. (55 x 46.4 cm)
Stamped at lower right: *C.P.*
High Museum of Art, Atlanta, Gift of the Forward Arts Foundation in honor of its first president, Mrs. Robert W. Chambers

PROVENANCE
Paul-Emile Pissarro, London; M. Knoedler & Co., Inc., New York; Edwin C. Vogel, New York; Acquavella Galleries, Inc., New York; High Museum of Art, Atlanta, 1974 (1974.231).

EXHIBITIONS
Exposition Camille Pissarro organisée à l'occasion du centenaire de la naissance de l'artiste, Paris, Orangerie, February–March 1930, no. 25; *Summer Loan Exhibition*, New York, Metropolitan Museum of Art, 1961, no. 72; *Loan Exhibition C. Pissarro*, New York, Wildenstein & Co., Inc., 25 March–1 May 1965, no. 18; *Summer Loan Exhibition*, New York, Metropolitan Museum of Art, 1968, no. 166.

PLATE 37
Chrysanthemums in a Chinese Vase
Chrysanthèmes dans un vase chinois. 1873
Oil on canvas
23¾ x 19½ in. (61 x 50 cm)
National Gallery of Ireland, Dublin
Boston only

PROVENANCE
James Carstairs, London; M. Knoedler & Co., Inc., New York; Josef Stransky, New York; Wildenstein & Co., Inc., New York; Jane Olmstead McMillan; her sale, Christie's, New York, 17 May 1983, no. 7; purchased by the National Gallery of Ireland, Dublin (Inv. No. NGI 4459).

EXHIBITIONS
Rétrospective des oeuvres de C. Pissarro, Paris, Galerie Manzi et Joyant, January–February 1914, no. 75; *Exposition commémorative des oeuvres de C. Pissarro*, London, Leicester Galleries, May 1920, no. 54; *The Painters of Still Life*, Hartford, Wadsworth Atheneum, 25 January–15 February 1938, no. 68; *Acquisitions 1982–83*, Dublin, National Gallery of Ireland, 1984, no. 18; *French 19th and 20th Century Paintings from the National Gallery of Ireland: Corot to Picasso*, Tokyo, Daimaru Museum, 5–17 September 1996, Kyoto, Daimaru Museum, 10–22 October 1996, Yamanashi, Kawaguchiko Museum of Art, 26 October–2 December 1996, Osaka, Daimaru Museum, Umeda, 22 January–9 February 1997, Aomori Municipal Gallery of Art, 3–20 April 1997, no. 31.

RENOIR
Pierre-Auguste Renoir was born into a working-class family in Limoges on 25 February 1841, moving shortly thereafter to Paris with his family in 1844. Because of his family's poor circumstances, Renoir's formal education ended at age thirteen in 1854. He was apprenticed to the Lévy Brothers porcelain manufactory in Paris, where he found himself painting flowers, and later portraits and nudes, onto teacups, plates, and vases.

Throughout these years as a craftsman, Renoir always aspired to become a serious painter. In 1860 he was granted permission to paint copies in the Louvre, which he did for the next four years, and in 1861, having saved up enough money to pursue more formal artistic training, he began lessons in the atelier of Charles Gleyre. In 1862 he was admitted

to the Ecole Impériale et Spéciale des Beaux-Arts.

During the 1860s, Renoir met the artists who would become the most influential and crucial to his development as a painter. He became acquainted with Fantin-Latour who frequented the Louvre. During 1862–64, he formed close friendships with Monet, Bazille, and Sisley, who also were studying at Gleyre's studio. From 1866 until the Franco-Prussian War in 1870, he shared studios and living space with Bazille and others. He was a frequent visitor in the late 1860s at the Café Guerbois, where Manet was the primary attraction. By 1863, Renoir had met Pissarro and Cézanne, who were at the Académie Suisse.

Throughout his long career, still life played a secondary role. Renoir's first formal still-life experiments date from 1864—two large related paintings entitled *Spring Flowers* (plate 10 and Oskar Reinhart Collection at Winterthur). Unlike many of his contemporaries, Renoir was not interested in kitchen still lifes. He preferred, instead, to focus on flowers or fruit and their containers. Rarely did he paint dead game.[90] Although his individual still lifes generally focus on more or less centralized images of flowers and fruit conceived with beautiful brushwork and color harmonies, Renoir did include carefully conceived still-life arrangements of china, glassware, fruit, table linens, and other objects in some of his larger figurative works, particularly in *Luncheon of the Boating Party* (fig. 57), where his complex still life is given featured prominence at the center foreground of this ode to modern life.

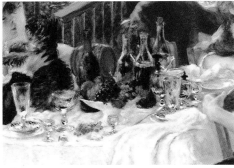

FIGURE 57
PIERRE-AUGUSTE RENOIR.
LUNCHEON OF THE BOATING PARTY (DETAIL). 1880–81.
OIL ON CANVAS, 51¼ x 69⅛ IN. (130 x 201 CM).
THE PHILLIPS COLLECTION, WASHINGTON, D.C.

In these early years, Renoir's determined interest in the figure to the near exclusion of all else is evident in *Frédéric Bazille at His Easel* from 1867 (see fig. 47) wherein Renoir, instead of painting the dead heron that was the focus of Bazille's and Sisley's efforts in the shared studio, chose to paint his studiomate at work on his study of the exotic gamebird. Notably, however, in 1871 when Renoir returned to Paris after being posted in Libourne during the war, he painted perhaps the most complex and ambitious still life of his career, *Still Life with Bouquet* (plate 34).

Despite the fact that Renoir clearly did not accord still life a primary position in his oeuvre, he did submit still lifes to each of the Impressionist exhibitions in which he participated. As financial success came his way in the 1880s, the number of floral and fruit still lifes increased, no doubt because of their appeal to the upper- and middle-class patrons who had become interested in his work.[91] He traveled abroad for the first time in 1881 and did two beautiful although rare vegetable still lifes, *Onions* (plate

50) and *Fruits of the Midi* (1881, Art Institute of Chicago). Renoir also explored more elaborate still-life compositions, such as *Geraniums and Cats* (1881, private collection), perhaps as a response to the reliable market for works that his dealer Durand-Ruel could easily place with collectors in Europe and America.[92]

From the beginning of his career, Renoir understood how still life could be used to explore painterly experiments and color harmonies. His carefully assembled and beautifully rendered still-life subjects place him not only within an eighteenth-century French tradition, but also squarely in the lineage of Gustave Courbet and Edouard Manet, for whom still life provided opportunities for experimentation in arrangements of shape and volume. In the 1880s, however, there is increasing evidence of the influence of Cézanne on Renoir's still lifes, particularly since the two artists worked together from time to time during that decade.[93]

With financial success and a growing public acceptance came a kind of freedom for Renoir with regard to still life. The focus on small format, informal studies of flowers, especially roses, increased in the last decades of his career. Renoir's own statements at the end of his life emphasize his sustained interest in still life and his reliance on it as pure painting in which color and brushwork are the primary elements: "When I am painting flowers I can experiment boldly with tones and values without worrying about destroying the whole painting. . . . The experience I gain from these experiments can then be applied to my paintings."[94]

The artist, who suffered greatly from rheumatism in the last twenty years of his life, died in Cagnes-sur-Mer in the south of France on 3 December 1919.

SBF

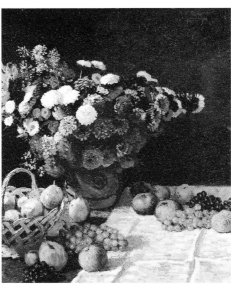

FIGURE 58
CLAUDE MONET.
FLOWERS AND FRUIT. 1869.
OIL ON CANVAS, 39⅜ x 31½ IN. (100 x 80 CM).
J. PAUL GETTY MUSEUM OF ART, LOS ANGELES

PLATE 10
Spring Flowers
Blumen im Gewächshaus. 1864
Oil on canvas, 51⅛ x 38⅝ in. (130 x 98.4 cm)
Signed lower right: *A. Renoir.*
Hamburger Kunsthalle, Eigentum der Stiftung zur Förderung der Hamburgischen Kunstsammlungen

PROVENANCE
Hôtel Drouot, Paris, 29 May 1900, no. 17; Max Liebermann, Berlin, by 1905 (deposited for protection in Kunsthaus Zürich, journal entry 9 May 1933, no. 14, as "Depot Liebermann/Riezler"); by descent to Mrs. Kurt Riezler (died 1952), New York; Dr. Walter Feilchenfeldt, Zürich; acquired by the Hamburger Kunsthalle, 1958 (Inv. no. 5027).

EXHIBITIONS
Französischen Kunst, Dresden, Galerie Arnold, 1914; *Impressionisten*, Berlin, Galerie Perls, no. 49; *Französischen Maler des 19. Jahrhunderts*, Zurich, Kunsthaus, 1933, no. 62; Amsterdam, 1938, no. 196; *Renoir. Centennial Loan Exhibition, 1841–1941, for the Benefit of the Free French Relief Committee*, New York, Duveen Galleries, 8 November–6 December 1941, no. 2; *Vier eeuwen stijleven in Frankrijk*, Rotterdam, Museum Boymans, 10 July–20 September, 1954, no. 98; *Auguste Renoir*, Vevey, Musée Jenisch, 1956, no. 1; *Verkannte Kunst*, Kunsthalle, Recklinghausen, 16 June–31 July 1957, no. 149; *Auguste Renoir*, Munich, Städtische Galerie, 1958, no. 1; *Auguste Renoir*, London, Hayward Gallery, 30 January–21 April 1985, no. 3, Paris, Grand Palais, 14 May–2 September 1985, no. 2, Boston, Museum of Fine Arts, 9 October 1985–5 January 1986 (London and Paris only); Paris and New York 1994–95, no. 168; *Renoir, Gemälde 1860–1917*, Tübingen, Kunsthalle, 20 January–27 May 1996, no. 4; *Max Liebermann und die französischen Impressionisten (Max Liebermann. Werke 1900–1918)*, Vienna, Jüdischen Museum der Stadt Wien, 7 November 1997–18 January 1998.

PLATE 22
Mixed Flowers in an Earthenware Pot
Fleurs dans un vase. CA. 1869
Oil on paperboard mounted on canvas, 25½ x 21¼ in. (64.9 x 54.2 cm)
Signed lower right: *Renoir.*
Museum of Fine Arts, Boston, Bequest of John T. Spaulding

PROVENANCE
Collection Duze; Durand-Ruel, 14 May 1891; Durand-Ruel, New York, 30 March 1897; John Taylor Spaulding, 6 January 1925; bequeathed 3 June 1948 to the Museum of Fine Arts, Boston (48.592).

EXHIBITIONS
The Collection of John T. Spaulding, Boston, Museum of Fine Arts, 25 May 1931–27 October 1932; *The John Taylor Spaulding Collection*, Boston, Museum of Fine Arts, 26 May–7 November 1948, no. 69; *Renoir*, Los Angeles County Museum of Art, 14 July–21 August, 1955, no. 8; *Paintings: the Theme of Still Life*, Atlanta Art Association, 10–29 January, 1958, no. 36; Philadelphia 1963; *Paintings by Renoir*, Chicago, Art Institute, 3 February–1 April 1973, no. 12; Boston 1973, no. 69; *La nature morte de Brueghel à Soutine*, Bordeaux, Galerie des Beaux-Arts, 5 May–1 September 1978, no. 172; *Renoir*, London, Hayward Gallery, 30 January–21 April 1985, no. 14, Paris, Grand Palais, 14 May–2 September 1985, no.13, Boston, Museum of Fine Arts, 9 October 1985–5 January 1986, no. 14; Boston 1992; Chiba, Nara, Yokohama, and Boston 1994–95, no. 35 (exhibited Japan only); Paris and New York 1994–95, no. 176 (New York only).

PLATE 34
Still Life with Bouquet
Nature morte au bouquet. 1871
Oil on canvas, 28¹³⁄₁₆ x 23³⁄₁₆ in. (73.3 x 58.9 cm)
Signed and dated lower right: *A. Renoir-71*
The Museum of Fine Arts, Houston, The Robert Lee Blaffer Memorial Collection, gift of Sarah Campbell Blaffer

PROVENANCE

Unknown before 1906; Bernheim-Jeune, no. 8447; 10 March 1906, Ambroise Vollard invoices the Prince de Wagram for "a Renoir still life with a carpet, books, a Japanese vase, a fan and flowers in the foreground, and a reproduction of an antique painting on the wall in the background. 8000 francs" (Archives Nationales 173 bis AP 430); Recovered by Vollard shortly after with others for which he had not been paid; Ambroise Vollard, Paris, until 1935; Bignou Gallery, New York, 1941 until at least 1944; Knoedler's, New York, by 1947; Mrs. Sarah Campbell Blaffer, Houston, Texas; gift of Sarah Campbell Blaffer to the Museum of Fine Arts, Houston, 26 December 1951, as part of Robert Lee Blaffer Memorial Collection.

EXHIBITIONS

Exposition d'art français, Zürich, 1917; *Paintings from the Ambroise Vollard Collection, XIX–XX Centuries*, New York, Knoedler Galleries, November 1933, no. 23, Detroit, Michigan, Arts and Crafts Club of Detroit, December 1933, no. 22; *Renoir*, London, Reid & Lefevre Galleries, June 1935, no. 1; *Renoir Centenary Exhibition*, New York, Bignou Gallery, 10–29 March 1941, no. 2; *Paintings by Pierre Auguste Renoir*, San Francisco, California Palace of the Legion of Honor, 1–30 November 1944; *French Still Life from Chardin to Cézanne*, New York, Seligmann-Helft Galleries, 29 October–22 November 1947, no. 31; *History of Still Life and Flower Painting*, Montclair, N.J., Montclair Art Museum, 22 February–28 March 1948, no. 28; *Pierre Auguste Renoir*, Los Angeles County Museum of Art, 14 July–21 August 1955, San Francisco Museum of Art, 1 September–2 October 1955, no. 6; *Still Life Painting Since 1470*, Milwaukee Art Museum, September 1956, Cincinnati Art Museum, November 1956, no. 48; *Renoir*, New York, Wildenstein Gallery, 8 April–10 May 1958; *Masterpieces of Art*, Seattle World's Fair, Century 21 Exposition, 21 April–4 September 1962, no. 47; *Texas Collectors*, New York, Marlborough-Gerson Gallery, 19 November–20 December 1964; *Paintings by Renoir*, Chicago, Art Institute, 3 February–1 April 1973, no. 9; *Japonisme: Japanese Influence on French Art 1854–1910*, Cleveland Museum of Art, 9 July–31 August 1975, New Jersey, Rutgers University Art Gallery, 4 October–16 November 1975, Baltimore, Walters Art Gallery, 10 December 1975–26 January 1976, no. 182; *L'Exposition Auguste Renoir au Japan*, Tokyo, Museum of Art, 22 September–6 November 1979, Kyoto Municipal Museum, 11 November–9 December 1979; *A Permanent Heritage: Major Works from the Collection*, Houston, Museum of Fine Arts, 23 October 1980–4 January 1981; *Hearts and Flowers*, Waco, Texas, Art Center, 4 April–9 May 1982; *Renoir*, London, Hayward Gallery, 30 January–21 April 1985, no. 18, Paris, Grand Palais, 14 May–2 September 1985, no.17, Boston, Museum of Fine Arts, 9 October 1985–5 January 1986; *Renoir Retrospective Exhibition*, Nagoya City Art Museum, 15 October–11 December 1988, Hiroshima Museum of Art, 17 December 1988–12 February 1989, Nara Prefectural Museum of Art, 18 February–9 April 1989; *Renoir: Master Impressionist*, Brisbane, Queensland Art Gallery, 30 July–11 September 1994, Melbourne, National Gallery of Victoria, 18 September–30 October, 1994, Sydney, Art Gallery of New South Wales, 5 November 1994–15 January 1995, no. 3; *Renoir, Gemälde 1860–1917*, Tübingen, Kunsthalle, 20 January–27 May 1996, no. 12; *Masterpieces of European Painting from the 15th to 20th Centuries from Museum of Fine Arts, Houston, and the Sarah Campbell Blaffer Foundation*, Ehime, Matsuyama, Japan, Museum of Art, 13 April–30 May 1999, Chiba Prefectural Art Museum, 5 June–11 July 1999, Tsu, Mie Prefectural Art Museum, 17 July–22 August 1999, Fukuoka Art Museum, 27 August–3 October 1999.

PLATE 50

Onions
Nature morte: oignons. 1881
Oil on canvas, 15⅜ x 23⅞ in. (39.1 x 60.6 cm)
Signed and dated lower left: *Renoir. Naples. 81.*
Sterling and Francine Clark Art Institute, Williamstown, Massachusetts

PROVENANCE

Purchased by Durand-Ruel from the artist, May 1882 (?); no longer in Durand-Ruel's possession when he reorganized his stock in 1891; sold to Durand-Ruel by Dr. Soubies, 29 December, 1921; Robert Sterling Clark, 15 April 1922; given to the Sterling and Francine Clark Institute, Williamstown, 1955 (1955.588).

EXHIBITIONS

Renoir one-man exhibition, Durand-Ruel, Paris, 1–25 April 1883 (?); *The Four Great Impressionists*, New York, Durand-Ruel, 27 March–13 April 1940, no. 19; *Nine Selected Paintings by Renoir*, New York, Durand-Ruel, 26 December 1946–11 January 1947; *Exhibition 6: Impressionist Paintings*, Williamstown, Clark Art Institute, 18 September 1956, no. 150; *French Paintings of the 19th Century*, Williamstown, Clark Art Institute, 1963, no. 120; *Treasures from the Clark Art Institute*, New York, Wildenstein, 2–25 February 1967, no. 38; *Renoir*, London, Hayward Gallery, 30 January–21 April 1985, Paris, Grand Palais, 14 May–2 September 1985, Boston, Museum of Fine Arts, 9 October 1985–5 January 1986 (Boston only); *Van Gogh à Paris*, Paris, Musée d'Orsay, 2 February–15 May 1988, no. 103; *Clark as Collector*, Williamstown, Sterling and Francine Clark Art Institute, 18 June–18 August 1988; *A Passion for Renoir: Sterling and Francine Clark Collect, 1916–1951*, Williamstown, Sterling and Francine Clark Art Institute, 3 August 1996–5 January 1997.

SISLEY

Alfred Sisley was born in Paris on 30 October 1839, to parents of British descent.[95] He was to live almost his entire life in France, all the while retaining British citizenship. At the age of eighteen, Sisley moved to London, where he studied commerce from 1857 until 1860. After encountering the work of John Constable and J. M. W. Turner, Sisley, inspired, returned to Paris to study painting. Living with his parents, Sisley began attending the atelier of the Swiss painter Charles Gleyre, where he met Renoir in 1861 and Bazille and Monet in 1862.

Foremost and almost exclusively a painter of landscape, Sisley rarely painted still lifes. Only nine canvases are recorded, comprising 1 percent of his painted oeuvre. Nevertheless, Sisley experimented with the genre throughout the course of his career.[96] Illustrating Sisley's friendship and close artistic collaboration with Bazille and Renoir, the remarkable still life *The Heron* (plate 13), one of four still lifes that Sisley created prior to 1870, was painted in late 1867.[97] An arrangement of dead game consisting of a blue heron, a jay, and a magpie was displayed on a table in Bazille's studio at 20, rue Visconti.[98] Bazille's *The Heron* (plate 14) is likewise the result of a careful study of this subject, while Renoir's portrait of Bazille (fig. 47) depicts Bazille at work on his painting. While Sisley's handling of paint in *The Heron* suggests a stylistic affinity with the approach to still-life subjects employed by his fellow Impressionists, it also reflects prevailing contemporary interest in still life, particularly in the work of the eighteenth-century still-life painters Oudry and Chardin.

During the Franco-Prussian War, most of Sisley's possessions and, it must be assumed, a number of his paintings from his residence in Bougival were destroyed when the town was overrun by the Prussian army in the autumn of 1870. This may account in part for the rather meager record of his artistic development in the 1860s. In 1871, Sisley settled in Louveciennes with former florist Marie Louise Adélaïde Eugénie Lescouezec (1843–98) and their two children.[99] For the remainder of his life, Sisley was to reside in several villages near the confluence of the Seine and the Loing Rivers.

Throughout the 1870s, Sisley experimented further with still life. He painted a still life of a bouquet of flowers in 1875 and produced two of his finest and most complex compositions in 1876. These two canvases, *Grapes and Walnuts on a Table* (plate 40) and *Still Life: Apples and Grapes* (plate 39), were doubtless painted in the same room, employing the same table and still-life arrangement. Sisley exhibited at four of the eight Impressionist exhibitions, in 1874, 1876, 1877, and 1882, but never contributed a still life.[100] By the mid-1880s, his health began to deteriorate and his trips to Paris became even more infrequent. In 1888, Sisley turned again to still life. His final two still lifes are both studies of fish, a subject that he had first explored in the late 1860s. Sisley died of cancer of the throat in Moret-sur-Loing on 29 January 1899. AAL

PLATE 13

The Heron
Le héron. 1867
Oil on canvas, 31⅛ x 38⅛ in. (79 x 97 cm)
Signed lower right: *Sisley*
Musée Fabre, Montpellier, on deposit from the Musée d'Orsay, Paris

PROVENANCE

Tableaux, pastels, dessins par Guillaumin, Luce, Renoir, Sisley, Hôtel Drouot, Paris, 24 November 1903, no. 31; Georges Viau, Paris, until 1907; Galeries Durand-Ruel, Paris, Viau sale, 4 March 1907, no. 68; Joseph Reinach, Paris, until his death in 1921; Mme Pierre Goujon, Paris, until her death in 1971; her bequest to the Louvre, 1971 (inv. no. RF 1971.15); on deposit at the Musée Fabre, Montpellier, from the Musée d'Orsay, Paris, since 1979.

EXHIBITIONS

Alfred Sisley, Bern, Kunstmuseum Bern, 16 February–13 April 1958, no. 3; *Alfred Sisley*, Paris, Durand-Ruel, 10 February–30 March 1971, no. 1; *Naissance de l'impressionnisme*, Bordeaux, Galerie des Beaux-Arts, 3 May–1 September 1974, no. 126; *Trophées de chasse*, Bordeaux, Musée des Beaux-Arts, 1991, no. 53; *Alfred Sisley, 1839–1899*, London, Royal Academy of Arts, 3 July–18 October 1992, Paris, Musée d'Orsay, 28 October 1992–31 January 1993, Baltimore, Walters Art Gallery, 14 March–13 June 1993, no. 7; Paris and New York 1994–95, no. 187.

PLATE 40

Grapes and Walnuts on a Table
Nature Morte: raisins et noix. 1876
Oil on canvas, 15 x 21¾ in. (38 x 55.4 cm)
Signed lower left: *Sisley*
Museum of Fine Arts, Boston, Bequest of John T. Spaulding

PROVENANCE

Purchased from the artist by Durand-Ruel, Paris, 1 October 1881; John T. Spaulding, 6 February 1925; John T. Spaulding, Boston; bequeathed to the Museum of Fine Arts, Boston, 1948 (48.601).

Works of Alfred Sisley, New York, Durand-Ruel, 27 February–15 March 1899, no. 8; *Exhibition of Paintings by the French Impressionists*, Buffalo, Albright-Knox Art Gallery, 31 October–8 December 1907, no. 76; *Exhibition of Paintings by Sisley*, New York, Durand-Ruel, 10–27 April 1912, no. 5; *Still Lifes and Flowers by Manet, Monet, Pissarro and Others*, New York, Durand-Ruel, 20 December 1913–8 January 1914, no. 19; *Still Lifes and Flower Pieces*, New York, Durand-Ruel, 7–24 February 1923, no. 32; Cambridge (Mass.), 1929, no. 84; *The Collections of John T. Spaulding 1870–1948*, Boston, Museum of Fine Arts, 26 May–7 November 1948, no.77; *Alfred Sisley*, New York, Paul Rosenberg & Co., 30 October–25 November 1961, no. 9; *Sisley*, New York, Wildenstein & Co., 27 October–3 December 1966, no. 28; Boston 1973, no. 87; Boston 1979–80, no. 41; *From Neoclassicism to Impressionism: French Art from the Museum of Fine Arts, Boston*, Kyoto Municipal Art Museum, 30 May–2 July 1989, Hokkaido, Museum of Modern Art, 15 July–20 August 1989, Yokohama, Sogo Museum of Art, 30 August–10 October 1989, no. 64; Boston 1992; *Monet and His Contemporaries from the Museum of Fine Arts, Boston*, Tokyo, Bunkamura Museum of Art, 17 October–17 January 1993, Kobe, Hyogo Prefectural Museum of Modern Art, 23 January–21 March 1993, no. 52; Japan and Boston 1994–95, no. 37 (Japan) and no. 42 (Boston).

PLATE 39

Still Life: Apples and Grapes
Nature morte: pommes et raisins. 1876
Oil on canvas, 18⅛ x 24¹⁄₁₆ in. (46 x 61.2 cm)
Signed lower right: *Sisley.*
Sterling and Francine Clark Art Institute, Williamstown, Massachusetts

PROVENANCE

Mrs. Allan Hay, New York; Durand-Ruel, Paris, 2 March 1899; M. Mancini, Paris, 13 November 1899; M. Knoedler & Co., Paris and New York; Robert Sterling and Francine Clark, New York, 28 March 1951; Sterling and Francine Clark Art Institute, Williamstown, 17 May 1955 (1955.543).

EXHIBITIONS

French Paintings of the 19th Century, Williamstown, Clark Art Institute, 8 May 1956, no. 124; *The Life and Work of Sisley,* New York, Wildenstein & Co., 27 October–3 December 1966, no. 29; *Treasures from the Clark Art Institute,* New York, Wildenstein & Co., 2–25 February 1967, no. 50; *Alfred Sisley, 1839–1899,* London, Royal Academy of Arts, 3 July–18 October 1992, Paris, Musée d'Orsay, 28 October 1992–31 January 1993, Baltimore, Walters Art Gallery, 14 March–13 June 1993, no. 43.

VINCENT VAN GOGH

Vincent van Gogh was born on 30 March 1853 in Groot-Zundert, The Netherlands.[101] The eldest son of a Dutch Reformed pastor, van Gogh made his first foray into the art world at the age of sixteen, serving as a clerk in the art galleries of the French art dealers Goupil et Cie. From 1877, driven by a deep compassion for humanity, van Gogh pursued a series of religious endeavors which included studying theology, working as a teacher, and later serving as an evangelist. By 1880, at the age of twenty-seven, he decided to devote himself to becoming an artist.

One of the most celebrated painters in the history of art, van Gogh was involved with still life throughout his entire career. His extraordinary exploration of the genre, in both painting and drawing, was essential to his development. He repeatedly turned to still life at the beginning of new creative periods and employed it to reorient his style as is evidenced in his prolific correspondence.[102]

Of well over 800 paintings, 167 are still-life compositions, comprising nearly 20 percent of van Gogh's painted oeuvre.[103] Essentially self-taught, van Gogh produced compelling but subdued still lifes early in his career in the Netherlands and continued to experiment with still life in resplendent canvases painted in France during the last five years of his life. Often imbued with deeply personal meaning, van Gogh's highly symbolic images, such as his series of sunflowers and of shoes, are sometimes read as self-portraits. The meaning of these images has been vigorously disputed in the voluminous literature on the artist.

Van Gogh produced numerous still lifes each year of his decade-long career, with the exception of his period in The Hague (1882–83) during which he produced none. In 1881, while living with his parents in Etten, van Gogh painted two still lifes, and while in Nuenen (1884–85) he painted forty-one. His choice of rustic subject matter during these years illustrates his deep reverence for peasant life. Van Gogh's fascination with nature is revealed in compositions such as *Three Birds' Nests* (plate 68), one of five painted studies of this subject inspired by the collection of birds' nests he amassed in the autumn of 1885.

Van Gogh's production of still life was at its height during his formative sojourn in Paris, where he moved in March 1886 and where he created nearly ninety still lifes. In response to the advanced ideas of Impressionism, pointillism, and Japanese art, van Gogh turned to still life to transform his style from the dark palette of his Dutch paintings to one of brilliant, contrasting colors. Experimenting with radical color theory and brushwork, he created a series of flower pieces in an effort to forge his own highly personal style. His brother Theo, a successful art dealer, described van Gogh's color exercises to their mother in a letter of 1886: "He is mainly painting flowers—with the object to put a more lively color into his next pictures."[104] Two still lifes from this period, *Study for 'Romans Parisiens'* (plate 70) and *Still Life with a Plaster Statuette and Books* (plate 71), both from 1887, also reveal van Gogh's interest in modern realist literature, namely the novels of the Goncourt brothers, Guy de Maupassant, and Zola. While in Paris, van Gogh was promoting his own work and that of his avant-garde peers. In late 1887, he organized an exhibition where many of his still lifes, including several versions of his sunflower compositions, were shown.[105]

Seeking a more tranquil life and eager to pursue his ambitions as a colorist, van Gogh settled in Arles in February 1888. The clear light and vibrant colors of Provence provided the artist with profound inspiration and precipitated the transformation his art was to undergo for the remaining years of his life. Van Gogh's interest in Japanese art as well as his use of intense color is again evident in the more than twenty still lifes he painted in Arles. *Sprig of Flowering Almond in a Glass* from 1888 (plate 72), for example, depicts a subject that embodied the promise and consolation of new growth in spring for van Gogh.

As the result of recurring bouts of illness generally believed to have been a type of epilepsy, van Gogh left Arles in May 1889 to voluntarily reside in the asylum of St.-Paul-de-Mausole in Saint-Rémy. There he produced about ten still lifes, chief among them the renowned *Roses* (also called *Still Life with Pink Roses*) (plate 79). In May 1890, he left Saint-Rémy to seek medical advice from Dr. Paul Gachet in Auvers-sur-Oise. Still life continued to play a pivotal role in van Gogh's art as he produced another group of floral studies during this time. On 27 July 1890 his prolific—though brief—artistic career ended abruptly with a self-inflicted gunshot wound. Van Gogh died two days later in Auvers.　AAL

PLATE 68

Three Birds' Nests. 1885
Oil on canvas, 13 x 16½ in. (33 x 42 cm)
Signed at lower left: *Vincent*
Kröller-Müller Museum, Otterlo, The Netherlands

PROVENANCE

Kröller-Müller Museum, Otterlo, 1900 (Inv. No. 248–00).

EXHIBITIONS

Vincent van Gogh 143 Werke aus der Sammlung Kröller-Müller im Haag, Basel, Kunsthalle, June–August 1927, Bern, Kunsthalle, September–October 1927, Brussels, 's-Gravenhage, Museum voor Moderne Kunst, November–December 1927, no. 65; *Ausgewählte Kunstwerke aus der Sammlung Frau H. Kröller-Müller, Den Haag,* Düsseldorf, Kunsthalle, August–September 1928, no. 131; *Vincent van Gogh, 150 Werke aus der Sammlung Kröller-Müller im Haag,* Karlsruhe, Badische Kunsthalle, October–November 1928, no. 66; *Vincent van Gogh 143 Werke aus dem Besitz von Frau Kröller-Müller im Haag,* Berlin, National-Galerie, January 1929, no. 74; *Vincent van Gogh Sammlung Kröller-Müller im Haag,* Hamburg, Kunstverein, February–March 1929, no. 32; *Vincent van Gogh en zijn tijdgenooten,* Amsterdam, Stedelijk Museum, 6 September–2 November 1930, no. 162; *Vincent van Gogh,* New York, Museum of Modern Art, December–January 1935–36, Chicago, Art Institute, 1936, Boston, Museum of Fine Arts, 19 February–15 March 1936, Cleveland Museum of Art, 25 March–19 April 1936, Detroit, Detroit Institute of Arts, 6–28 October 1936, Kansas City, William Rockhill Nelson Gallery of Art, 1936, Minneapolis Institute of Arts, 1936, Philadelphia Museum of Art, 1936, San Francisco, 1936, no. 11; *Vincent van Gogh,* Gouda, Het Catharina Gasthuis, April–May 1949; *Vincent van Gogh,* 's-Hertogenbosch, Centraal Noord-Brabants Museum, March 1950, Breda, Stedelijk Museum de Beyerd, April 1950; *Vincent van Gogh dipinti e disegni,* Milan, Palazzo Reale, February–April 1952, no. 55; *Vincent van Gogh,* The Hague, Gemeente Museum, 30 March–17 May 1953, no. 38; *Vincent van Gogh eeuwfeest,* Otterlo, Rijksmuseum Kröller-Müller, 24 May–19 July 1953, Amsterdam, Stedelijk Museum, 23 July–20 September 1953, no. 27; *Vincent van Gogh,* Munich, Haus der Kunst, October–December 1956, no. 90; *Vincent van Gogh from the Kröller-Müller Collection, Otterlo,* Tokyo, Tokyo National Museum, 15 October–25 November 1958, Kyoto, Art Municipal Museum, 3–27 December 1958, no. 77; *Vincent van Gogh Paintings-Drawings,* Montreal Museum of Fine Arts, 6 October–6 November 1960, Ottawa, National Gallery of Canada, 17 November–18 December, 1960, Winnipeg Art Gallery, 29 December 1960–31 January 1961, Art Gallery of Toronto, 10 February–12 March 1961, no. 8; *Vincent van Gogh Paintings, Drawing, Etching* [collection Kröller-Müller, Otterlo], Warsaw, National Museum, 8–18 October 1962, no. 48; *Vincent van Gogh* [collection Kröller-Müller, Otterlo], Tel Aviv, Tel Aviv Museum, Helena Rubenstein Pavilion, January–February 1963, Haifa, Municipal Museum of Modern Art, February–March 1963, no. 49.

PLATE 69

Three Pairs of Shoes. 1886–87
Oil on canvas, 19⅜ x 28½ in. (49.2 x 72.2 cm)
Scratched into the paint surface, lower middle: *Vincent*

Scratched into the paint surface, upper right:
VINCENT
Fogg Art Museum, Harvard University Art Museums. Bequest Collection of Maurice Wertheim, Class of 1906
Boston only

PROVENANCE
Vincent Willem van Gogh, Amsterdam; Johanna van Gogh-Bonger, Amsterdam; sale, Hôtel Drouot, 31 March 1920, Lot 62; Joseph Hessel, Paris; Marcel Kapferer, Paris, about 1925; Wildenstein and Co., New York; Maurice Wertheim, October 1943; Fogg Art Museum, Harvard University Art Museums, bequest of Maurice Wertheim, 1951 (1951–66).

EXHIBITIONS
Vincent van Gogh, Amsterdam, Stedelijk Museum, July–August 1905, no. 72; *Vincent van Gogh*, Berlin, Paul Cassirer Gallery, May–June 1914, no. 40; *Vincent van Gogh, exposition rétrospective de son oeuvre*, Paris, Galerie Marcel Bernheim, 5–24 January 1925, no. 5; *Vincent Van Gogh, l'époque française*, Paris, Galerie Bernheim-Jeune, 20 June–2 July 1927; *Vincent van Gogh en zijn tijdgenooten*, Amsterdam, Stedelijk Museum, 6 September–2 November 1930, no. 20; *Vincent van Gogh, sa vie et son oeuvre*, Paris, Nouveaux Musées, June–October 1937, no. 132; *The Art and Life of Vincent van Gogh. Loan Exhibition in Aid of American and Dutch War Relief*, New York, Wildenstein & Co., 6 October–7 November 1943, no. 7; *The Maurice Wertheim Collection*, Cambridge (Mass.), Fogg Art Museum, 1946; *Six Masters of Post-Impressionism*, New York, Wildenstein & Co., 8 April–8 May 1948, no. 65; *The Maurice Wertheim Collection: Modern French Art, Monet to Picasso*, Raleigh, North Carolina Museum of Art, 17 June–4 September 1960; *The Maurice Wertheim Collection*, Houston Museum of Fine Arts, 1962; *The Maurice Wertheim Collection*, Augusta, Maine State Museum, 1972, no. 38.

PLATE 70
Study for 'Romans Parisiens'
Romans parisiens. 1887
Oil on canvas, 20⅞ x 28⅛ in. (53 x 73.2 cm)
Van Gogh Museum (Vincent van Gogh Foundation), Amsterdam

PROVENANCE
Theo van Gogh, Paris, 1890–91; Johanna van Gogh-Bonger, 1891; Vincent Willem van Gogh, 1925; Van Gogh Foundation, Amsterdam, 1962; on loan to the Stedelijk Museum, Amsterdam, 1962–73; Van Gogh Museum (Vincent van Gogh Foundation), Amsterdam, 1973 (inv. S 21 V/1962).

EXHIBITIONS
Vincent van Gogh, London, Leicester Galleries, 1 December–15 January 1923–24, no. 17; *Vincent van Gogh*, Basel, Kunsthalle, 27 March–4 May 1924, no. 23; *Vincent van Gogh*, Zürich, Kunsthaus, 3 July–10 August 1924, no. 44; *Ausstellung Vincent van Gogh 1853–1890*, Stuttgart, Württembergischer Kunstverein, 12 October–30 November 1924, no. 19; *Exposition rétrospective d'oeuvres de Vincent van Gogh*, Paris, Galerie Marcel Bernheim, 5–24 January 1925, no. 20; *Vincent van Gogh*, The Hague, Pulchri Studio, March–April 1925, no. 9; *I. Allgemeine Kunst-Ausstellung*, Munich, Glaspalast, 1 June–early October 1926, no. 2092; *Vincent van Gogh, l'époque française*, Paris, Galerie Bernheim-Jeune, 20 June–2 July 1927, Paris, Galerie Georges Petit, June 1930, no. 31; *Het stilleven*, Amsterdam, Kunsthandel J. Goudstikker, 18 February–19 March 1933, no. 114; *Vincent van Gogh. Malerier, tegninger, akvareller*, Oslo, Kunstnernes Hus, 3–24 December 1937, Copen-
hagen, Charlottenborg, January 1938, no. 10 (Oslo) and no. 17 (Copenhagen); *Vincent van Gogh*, Amsterdam, Stedelijk Museum, 14 September–1 December 1945; *Vincent van Gogh*, Stockholm, Nationalmuseum, 8 March–28 April 1946, Göteborg, Göteborgs Konstmuseum, 13–16 May 1946, Malmö, Malmö Museum, 29 May–16 June 1946, no. 28; *Vincent van Gogh. Udstilling af malerier og tegninger*, Copenhagen, Charlottenborg, 22 June–14 July 1946, no. 28; *Vincent van Gogh*, Liège, Musée des Beaux-Arts, 12 October–3 November 1946, Brussels, Palais des Beaux-Arts, 9 November–19 December 1946, Mons, Musée des Beaux-Arts, 27 December 1946–January 1947, no. 63; *Vincent van Gogh*, Paris, Orangerie, 24 January–15 March 1947, no. 60; *172 oeuvres de Vincent van Gogh*, Geneva, Musée Rath, 22 March–20 April 1947, no. 61; *Vincent van Gogh*, London, Tate Gallery, 10 December 1947–14 January 1948, Birmingham, City Art Gallery, 24 January–14 February 1948, Glasgow, City Art Gallery, 21 February–14 March 1948, no. 32; *Vincent van Gogh*, Bergen, Kunstforening, 23 March–18 April 1948, Oslo, Kunstnernes Hus, 24 April–15 May 1948, no. 17; *Vincent van Gogh. Collectie Ir. V. W. van Gogh*, The Hague, Gemeente Museum, 12 October–10 January 1948–49, no. 99; *Tentoonstelling Vincent van Gogh*, Hilversum, Hilversum Raadhuis, 7 October–5 November 1950, no. 15; *Vincent van Gogh*, Musée de Lyon, 5 February–27 March 1951, Musée de Grenoble, 30 March–2 May 1951, no. 25; *Vincent van Gogh en Provence*, Saint-Rémy, Hôtel de Sade, 5–27 May 1951, no. 25; *Tentoonstelling schilderijen van Vincent van Gogh*, Nijmegen Waaggebouw, 3–27 November 1951, Alkmaar, Stedelijk Museum, 1 December 1951–1 January 1952, no. 9; *Vincent van Gogh in Zundert*, Zundert Parochiehuis, 30 March–20 April 1953, no. 18; *Vincent van Gogh*, Hoensbroek, Kasteel Hoensbroek, 23 May–27 July 1953, no. 31; *Vincent van Gogh, Exposition in the Canteens of the Royal Netherlands Blast Furnaces and Steelworks*, IJmuiden, Hoogovens, October 1953, no. 17; *Vincent van Gogh in Assen*, Assen Provinciehuis, 6–29 November 1953, no. 15; *Vincent van Gogh*, Zürich, Kunsthaus, 9 October–21 November 1954, no. 33; *Vincent van Gogh*, Willemstad, Curaçaosch Museum, 19 December 1954–15 January 1955, no. 12; *Vincent van Gogh 1853–1890*, Palm Beach, Society of the Four Arts, 21 January–13 February 1955, Miami, Lowe Gallery of the University of Miami, 24 February–20 March 1955, New Orleans, Isaac Delgado Museum, 27 March–20 April 1955, no. 12; *Vincent van Gogh*, Antwerp, Feestzaal Meir, 7 May–19 June 1955, no. 176; *Vincent van Gogh. Paintings & Drawings, Mainly from the Collection of Ir. V.W. van Gogh*, Liverpool, Walker Art Gallery, 29 October–10 December 1955, Manchester, City Art Gallery, 17 December 1955–4 February 1956, Newcastle-upon-Tyne, Laing Art Gallery, 11 February–24 March 1956, no. 34; *Confrontatie noord/zuid*, Breda, Cultureel Centrum, 30 June–29 July 1956, no. 90; *Vincent van Gogh*, Marseilles, Musée Cantini, 12 March–28 April 1957, no. 25; *Paintings from the Stedelijk Museum, Amsterdam*, Boston, Institute of Contemporary Art, 7 January–4 February 1959, Milwaukee Art Center, 12 February–12 March 1959, Columbus (Ohio) Gallery of Fine Arts, 20 March–20 April 1959, Minneapolis, Walker Art Center, 27 April–24 May 1959, no. 4; *Vincent van Gogh Paintings-Drawings*, Montreal, Museum of Fine Arts, 6 October–6 November 1960, Ottawa, National Gallery of Canada, 17 November–18 December, 1960, Winnipeg Art Gallery, 29 December 1960–31 January 1961, Art Gallery of Toronto, 10 February–12 March 1961, no. 34; *Polariteit*, Amsterdam,
Stedelijk Museum, 22 July–18 September 1961, no. 48; *Vincent van Gogh. Paintings, Watercolors and Drawings*, Baltimore Museum of Art, 18 October–26 November 1961, Cleveland Museum of Art, 5 December 1961–14 January 1962, Buffalo, Albright-Knox Art Gallery, 30 January–11 March 1962, Boston, Museum of Fine Arts, 22 March–29 April 1962, no. 34; *Vincent van Gogh. Paintings, Watercolors and Drawings*, Pittsburgh, Carnegie Institute, 18 October–4 November 1962, Detroit Institute of Arts, 11 December 1962–29 January 1963, Kansas City, William Rockhill Nelson Gallery of Art, Mary Atkins Museum of Fine Arts, 7 February–26 March 1963, no. 34; *Vincent van Gogh*, Humlebaek, Denmark, Louisiana Museum, 24 October–15 December 1963, no. 25; *Vincent van Gogh. Paintings, Watercolors and Drawings*, Washington, D.C., Washington Gallery of Modern Art, 2 February–19 March 1964, New York, Solomon R. Guggenheim Museum, 2 April–28 June 1964, no. 25; *Vincent van Gogh, Peintures-aquarelles-dessins*, Charleroi, Palais des Beaux-Arts, 9 January–9 February 1965, Ghent, Museum voor Schone Kunsten, 19 February–21 March 1965, no. 15; *Vincent van Gogh*, Stockholm, Moderna Museet, 22 October–19 December 1965, Göteborg, Göteborgs Konstmuseum, 30 December 1965–20 February 1966, no. 22; *Vincent van Gogh. Gemälde, Aquarelle, Zeichnungen*, Wolfsburg, Stadthalle Wolfsburg, 18 February–2 April 1967, no. 41; *Vincent van Gogh. Paintings and Drawings of the Vincent van Gogh Foundation, Amsterdam*, London, Hayward Gallery, 23 October 1968–12 January 1969, no. 98; *Vincent van Gogh. Paintings and Drawings*, Baltimore Museum of Art, 11 October–29 November 1970, San Francisco, M. H. de Young Memorial Museum, 11 December 1970–31 January 1971, Brooklyn, Brooklyn Museum, 14 February–4 April 1971, no. 22; *Vincent van Gogh. Collection du Musée National Vincent van Gogh à Amsterdam*, Bordeaux, Musée des Beaux-Arts, 21 April–20 June 1972, no. 15; *Vincent van Gogh. Collection du Musée National Vincent van Gogh à Amsterdam*, Strasbourg, Musée d'Art Moderne, 22 October 1972–15 January 1973, Bern, Kunstmuseum, 25 January–15 April 1973, no. 15; *Vincent van Gogh and the Birth of Cloisonism*, Toronto, Art Gallery of Ontario, 24 January–22 March 1981, Amsterdam, Van Gogh Museum, 9 April–14 June 1981, no. 12; *Vincent van Gogh en de moderne kunst, 1890–1914*, Essen, Museum Folkwang, 11 August–4 November 1990, Amsterdam, Van Gogh Museum, 16 November–18 February 1990–91, no. 15; *Vincent van Gogh and Japan*, Kyoto, Kyoto Museum of Art, 18 February–29 March 1992, Tokyo, Setagaya Museum of Art, 4 April–24 May 1992, no. 11; *Van Gogh te gast in het Rijksmuseum. Meesterwerken van het Van Gogh Museum*, Amsterdam, Rijksmuseum, 19 September 1998–2 May 1999.

PLATE 84
Still Life: Basket of Apples
Panier de pommes. 1887
Oil on canvas, 18¼ x 21¾ in. (46.5 x 55.2 cm)
Signed and dated, lower left: *Vincent / 87*
The Saint Louis Art Museum, Gift of Sydney M. Shoenberg, Sr.
Boston only

PROVENANCE
Alexander Reid, Glasgow (from the artist), 1887; Jos Hessel Art Gallery, Paris; Félix Vallotton, Paris, about 1905–25; Paul Vallotton Art Gallery, Lausanne, 1925; Wildenstein & Co., New York, ca. 1935–ca. 1943; Mrs. Millicent Rogers, New York, early 1940s–early 1950s; Mrs. Charles S. Payson, New York, 1954; M. Knoedler & Co., New York;

Mr. and Mrs. Sydney M. Shoenberg, Sr., St. Louis, Saint Louis Art Museum, 1972.

EXHIBITIONS

Vincent van Gogh éxposition rétrospective, Paris, Salon des artistes indépendants, 24 March–30 April 1905, no. 44; *Vincent van Gogh éxposition rétrospective de son oeuvre…*, Paris, Galerie Marcel Bernheim, 5–24 January 1925, no. 17; *One Hundred Years of French Painting 1820–1920*, Kansas City, William Rockhill Nelson Gallery of Art and Mary Atkins Museum of Fine Arts, 31 March–28 April 1935, no. 62; *French Nineteenth Century Paintings*, Chicago, Art Institute, 5 March–3 May 1937, no. 24; *The Painters of Still Life*, Hartford, Wadsworth Atheneum Museum of Art, 25 January–15 February 1938, no. 15; *Flowers and Fruits*, Museum of Modern Art Gallery of Washington, D.C., 29 March–24 April 1938, no. 21; *French and British Contemporary Art*, Adelaide, National Gallery (and other State galleries) 21 August 1939, no. 132; *Aspects of French Painting from Cézanne to Picasso*, Los Angeles County Museum of Art, 15 January–2 March 1941, no. 54; *The Art and Life of Vincent van Gogh*, New York, Wildenstein & Co., 1 October–November 1943, no. 12; *Jardin d'été*, New York, Coordination Council of French Relief Societies, 3–31 May 1944; Albuquerque, Harwood Foundation, University of New Mexico, 1947; *Van Gogh in Arles*, New York, Metropolitan Museum of Art, 18 October–30 December 1984, no. 4; *Impressionism: Selections from Five American Museums*, Pittsburgh, Carnegie Museum of Art, 4 November–31 December 1989, Minneapolis, Institute of Arts, 27 January–25 March 1990, Kansas City, Nelson-Atkins Museum of Art, 21 April–17 June 1990, Saint Louis Art Museum, 14 July–9 September 1990, Toledo Museum of Art, 30 September–25 November 1990.

PLATE 71
Still Life with a Plaster Statuette and Books
Nature morte avec statuette en plâtre et livres. 1887
Oil on canvas, 21½ x 18¼ in. (55 x 46.5 cm)
Kröller-Müller Museum, Otterlo, The Netherlands

PROVENANCE
Johanna van Gogh-Bonger, Amsterdam; Kröller-Müller Museum, Otterlo, 1912 (Inv. No. 265–12).

EXHIBITIONS
Vincent van Gogh, Berlin, Paul Cassirer Art Gallery, 25 October–20 November 1910, no. 29; *Internationale Kunstausstellung des Sonderbundes westdeutscher Kunstfreunde und Künstler zu Köln*, Cologne, 25 May–30 September 1912, no. 23; *Vincent van Gogh Paintings and Drawings*, The Hague, Lange Voorhout, July–September 1913, no. 107; *Kunst van Heden–L'art contemporain*, Antwerp, 7 March–5 April 1914, no. 48; *Vincent van Gogh 143 Werke aus der Sammlung Kröller im Haag*, Basel, Kunsthalle, June–August 1927, Bern, Kunsthalle, September–October 1927, Brussels, 's-Gravenhage, Museum voor Moderne Kunst, November–December 1927, no. 85; *Ausgewählte Kunstwerke aus der Sammlung Frau H. Kröller-Müller, Den Haag*, Düsseldorf, Kunsthalle, August–September 1928, no. 148; *Vincent van Gogh, 150 Werke aus der Sammlung Kröller-Müller im Haag*, Karlsruhe, Badische Kunsthalle, October–November 1928, no. 83; *Vincent van Gogh 143 Werke aus dem Besitz von Frau Kröller-Müller im Haag*, Berlin, National-Galerie, January 1929, no. 91; *Vincent van Gogh Sammlung Kröller-Müller im Haag*, Hamburg, Kunstverein, February or March 1929, no. 42; *Vincent van Gogh en zijn tijdgenooten*, Amsterdam, Stedelijk Museum, 6 September–2 November 1930, no. 203; *Den Haag eert de Nederlandse schilders van de 19e eeuwfeest*, The Hague, Pulchri Studio, 25 August–30 September 1945, no. 66;

Vincent van Gogh, Liège, Musée des Beaux-Arts, 12 October–3 November 1946, Brussels, Palais des Beaux-Arts, 9 November–19 December 1946, Mons, Musée des Beaux-Arts, 27 December 1946–January 1947, no. 64; *Vincent van Gogh*, Paris, Orangerie, 24 January–15 March 1947, no. 65; *172 Oeuvres de Vincent van Gogh*, Geneva, Musée Rath, 22 March–20 April 1947, no. 66; *Vincent van Gogh*, Basel, Kunsthalle, 11 October–23 November 1947, no. 42; *Vincent van Gogh 1853–1890*, London, Tate Gallery, 10 December 1947–14 January 1948, Birmingham, City Art Gallery, 24 January–14 February 1948, Glasgow, City Art Gallery, 21 February–14 March 1948, no. 23; *Vincent van Gogh*, The Hague, Gemeente Museum, 30 March–17 May 1953, no. 88; *Vincent van Gogh eeuwfeest*, Otterlo, Rijksmuseum Kröller-Müller, 24 May–19 July 1953, Amsterdam, Stedelijk Museum, 23 July–20 September 1953, no. 75; *Vincent van Gogh*, St. Louis, City Art Museum, 17 October–13 December 1953, Philadelphia Museum of Art, 2 January–28 February 1954, Toledo Museum of Art, 7 March–30 April 1954, no. 72; *Vincent van Gogh*, Munich, Haus der Kunst, October–December 1956, no. 108; *Vincent van Gogh from the Kröller-Müller Collection, Otterlo*, Vienna, Österreichische Galerie, February–March 1958, no. 74; *Vincent van Gogh from the Kröller-Müller Collection, Otterlo*, Tokyo, National Museum, 15 October–25 November 1958, Kyoto, Municipal Art Museum, 3–27 December 1958, no. 89; *Vincent van Gogh Paintings-Drawings*, Montreal, Museum of Fine Arts, 6 October–6 November 1960, Ottawa, National Gallery of Canada, 17 November–18 December, 1960, Winnipeg Art Gallery, 29 December 1960–31 January 1961, Art Gallery of Toronto, 10 February–12 March 1961, no. 22; *Torso, das Unvollendete als künstlerische Form*, Recklinghausen 1964, no. 112; *Vincent van Gogh Collection Kröller-Müller Otterlo*, Belgrade, Narodni Muzej, 30 October–20 December 1966, no. 57; *Van Gogh à Paris*, Paris, Musée d'Orsay, 2 February–15 May 1988, no. 57.

PLATE 72
Sprig of Flowering Almond in a Glass. 1888
Oil on canvas, 9½ x 7½ in. (24 x 19 cm)
Signed at upper left: *Vincent*
Van Gogh Museum (Vincent van Gogh Foundation), Amsterdam

PROVENANCE
Theo van Gogh, Paris, 1890–91; Johanna van Gogh-Bonger, 1891–1925; Vincent Willem van Gogh, 1925–62; Van Gogh Foundation, Amsterdam, 1962; on loan to the Stedelijk Museum, Amsterdam, 1962–73; Van Gogh Museum (Vincent van Gogh Foundation), Amsterdam, 1973 (inv. S 184 V/1962).

EXHIBITIONS
Vincent van Gogh en zijn tijdgenooten, Amsterdam, Stedelijk Museum, 6 September–2 November 1930, no. 38; *Vincent van Gogh, La vie et l'oeuvre de van Gogh*, Paris, Les Nouveaux Musées, Quai de Tokio, June–October 1937, no. 150; *Vierde collectie Regnault*, Batavia (Dutch East Indies), Museum van den Bataviaschen Kunstkring, 17 May–? 1938; Bandung (Dutch East Indies), Jaarbeursgebouw, 24–31 January 1939, no. 35; *Masterworks of Five Centuries*, San Francisco, Treasure Island, Palace of Fine and Decorative Arts, April–October 1939, no. 173; *Expositie van schilderijen van Vincent van Gogh*, Surabaya (Dutch East Indies), Kunstkringhuis Soerabayische Kunstkring, 13–19 January 1939, no. 9; Cambridge (Mass.), Fogg Art Museum, 18 March–10 April 1940, New Haven (Conn.), Gallery of Fine Arts of Yale University, 14 April–28 May 1940; *Masterpieces of Art from the New York and San Francisco*

World's Fairs, Cleveland Museum of Art, 7 February–7 March 1940, no. 17; *Exhibition of Paintings by Vincent van Gogh*, New York, Holland House, 6 June–19 July 1940, no. 14; Boston, Jordan Marsh Company Galleries, 3–16 March 1941; *Paintings by Vincent van Gogh*, Baltimore Museum of Art, 18 September–18 October 1942, Worcester (Mass.) Art Museum, 28 October–28 November 1942, no. 10; *Fifteen Paintings by van Gogh, Lent by the Netherlands Government*, Providence, Museum of Art at Rhode Island School of Design, 5–30 December 1942; *An Exhibition of Modern Dutch Art. 14 Paintings by Vincent van Gogh and Work by Contemporary Dutch Artists*, Albany, Institute of History & Art, 6–26 January 1943, Pittsburgh, Carnegie Institute, 5 February–1 March 1943, Toledo Museum of Art, 7–28 March 1943, no. 5.G; *The Art and Life of Vincent van Gogh. Loan Exhibition in Aid of American and Dutch War Relief*, New York, Wildenstein & Co., 6 October–7 November 1943, no. 23; *Paintings by Vincent van Gogh/Oils by van Gogh*, Northampton (Mass.), Smith College Museum of Art, 5–22 April 1943, Philadelphia Art Alliance, 30 April–23 May 1943, Montgomery (Ala.) Museum of Fine Arts, 30 May–30 June 1943, no. 5.G (Philadelphia only, no known catalogue for Northampton and Montgomery); *An Exhibition of Modern Dutch Art. 14 Paintings by Vincent van Gogh and Work by Contemporary Dutch Artists*, St. Louis, City Art Museum, 17 July–15 August 1943, no. 5.G; *Paintings by Vincent van Gogh and Contemporary Dutch Artists*, Springfield (Mass.), George Walter Vincent Smith Art Gallery, September 1943; *An Exhibition of Modern Dutch Art. 14 Paintings by Vincent van Gogh and Work by Contemporary Dutch Artists*, Indianapolis, John Herron Art Institute, 8 November–12 December 1943, Cincinnati Art Museum, 5–30 January 1944, Ottawa, National Gallery, 11–27 February 1944, no. 5; *Loan Exhibition of Great Paintings. Five Centuries of Dutch Art*, Montreal, Art Association, 9 March–9 April 1944, no. 121; *An Exhibition of Modern Dutch Art. 14 Paintings by Vincent van Gogh and Work by Contemporary Dutch Artists*, Fort Wayne Art School and Museum, 10–29 May 1944, no. 5; *Paintings by Vincent van Gogh*, Brooklyn, Brooklyn Museum, 28 June–24 September 1944, no. 5; *Modern Dutch Art. Art of Our Allies Series*, Richmond, Virginia Museum of Fine Arts, 1–22 October 1944; *Paintings by Vincent van Gogh*, Charleston, Gibbes Art Gallery, 29 October–26 November 1944, Atlanta, High Museum of Art, 3–27 December 1944, New Orleans, Isaac Delgado Museum, 7–28 January 1945, Louisville (Ky.), J.B. Speed Memorial Museum, 4–25 February 1945, Syracuse, Museum of Fine Arts, 4–25 March 1945, no. 5; *Fourteen Paintings by Vincent van Gogh*, New York, Museum of Modern Art, 3–26 August 1945; *Paintings by Vincent van Gogh*, Toronto, Art Gallery, 6–29 April 1945, Quebec, Musée du Québec, 11 May–3 June 1945; *Vincent van Gogh*, Liège, Musée des Beaux-Arts, 12 October–3 November 1946, Brussels, Palais des Beaux-Arts, 9 November–19 December 1946, Mons, Musée des Beaux-Arts, 27 December–January 1946–47, no. 124; *Vincent van Gogh*, Paris, Orangerie, 24 January–15 March 1947, no. 124; *172 Oeuvres de Vincent van Gogh*, Geneva, Musée Rath, 22 March–20 April 1947, no. 124; *Vincent van Gogh 1853–1890*, London, Tate Gallery, 10 December 1947–14 January 1948, Birmingham, City Art Gallery, 24 January–14 February 1948, Glasgow, City Art Gallery, 21 February–14 March 1948, no. 33; *Vincent van Gogh*, Bergen, Kunstforening, 23 March–18 April 1948, Oslo, Kunstnernes Hus, 24 April–15 May 1948, no. 23; *Vincent van Gogh. Collectie Ir. V.W. van Gogh*, The Hague, Haags Gemeentemuseum, 12 October–10 January

1948–49, no. 112; *Vincent van Gogh Paintings and Drawings. A Special Loan Exhibition*, New York, Metropolitan Museum of Art, 21 October–15 January 1949–50, Chicago, Art Institute, 1 February–16 April 1950, no. 66; *Vincent van Gogh*, Musée de Lyon, 5 February–27 March 1951, Musée de Grenoble, 30 March–2 May 1951, no. 30; *Vincent van Gogh en Provence*, Arles, Musée de Réattu, 5–27 May 1951, no. 30; *Vincent van Gogh in Zundert*, Zundert, Parochiehuis, 30 March–20 April 1953, no. 19; *Vincent van Gogh*, Hoensbroek, Kasteel Hoensbroek, 23 May–27 July 1953, no. 33; *Vincent van Gogh. Exposition in the Canteens of the Royal Netherlands Blast Furnaces and Steelworks*, IJmuiden, Hoogovens, October 1953, no. 19; *Vincent van Gogh in Assen*, Assen, Provinciehuis, 6–29 November 1953, no. 17; *Vincent van Gogh*, Antwerp, Feestzaal Meir, 7 May–19 June 1955, no. 264; *Vincent van Gogh. Paintings and Drawings, Mainly from the Collection of Ir. V.W. van Gogh*, Liverpool, Walker Art Gallery, 29 October–10 December 1955, Manchester, City Art Gallery, 17 December–4 February 1955–56, Newcastle-upon-Tyne, Laing Art Gallery, 11 February–24 March 1956, no. 35; *Vincent van Gogh Collection Ir. V.W. van Gogh*, San Francisco, M.H. de Young Memorial Museum, 6 October–30 November 1958, Los Angeles County Museum, 10 December–18 January 1958–59, Portland, Art Museum, 28 January–1 March 1959, Seattle, Art Museum, 7 March–19 April 1959, no. 42; *Vincent van Gogh. Paintings, Watercolors, and Drawings*, Baltimore Museum of Art, 18 October–26 November 1961, Cleveland Museum of Art, 5 December–14 January 1961–62, Buffalo, Albright Art Gallery, 30 January–11 March 1962, Boston, Museum of Fine Arts, 22 March–29 April 1962, no. 36; *Vincent van Gogh. Paintings, Watercolors and Drawings*, Pittsburgh, Carnegie Institute, 18 October–4 November 1962, Detroit Institute of Arts, 11 December–29 January 1962–63, Kansas City, William Rockhill, Nelson Gallery of Art, Mary Atkins Museum of Fine Arts, 7 February–26 March 1963, no. 36; *Vincent van Gogh. Malerier og tegninger*, Humlebaek, Louisiana Museum, 24 October–15 December 1963, no. 26; *Vincent van Gogh. Paintings, Watercolors and Drawings*, Washington, D.C., Washington Gallery of Modern Art, 2 February–19 March 1964, New York, Solomon R. Guggenheim Museum, 2 April–28 June 1964, no. 26; *Vincent van Gogh Peintures-aquarelles-dessins*, Charleroi, Palais des Beaux-Arts, 9 January–9 February 1965, Ghent, Museum voor Schone Kunsten, 19 February–28 March 1965, no. 16; *Vincent van Gogh*, Stockholm, Moderna Museet, 23 October–19 December 1965, Göteborg, Göteborgs Konstmuseum, 30 December–20 February 1965–66, no. 22; *Vincent van Gogh. Paintings and Drawings*, Baltimore Museum of Art, 11 October–29 November 1970, San Francisco, M.H. de Young Memorial Museum, 11 December–31 January 1970–71, Brooklyn, Brooklyn Museum, 14 February–4 April 1971, no. 25; *Vincent van Gogh. Collection du Musée national Vincent van Gogh à Amsterdam*, Bordeaux, Musée des Beaux-Arts, 21 April–20 June 1972, no. 17; *300 Years of Still Life*, Leeds, City Art Gallery, 18 October–8 December 1985; *Van Gogh's van Goghs. Masterpieces from the Van Gogh Museum, Amsterdam*, Washington, D.C., National Gallery of Art, 4 October–3 January 1998–99, Los Angeles County Museum of Art, 17 January–4 April 1999, no. 43; *Reflecties: Japan en japonisme*, Amsterdam, Van Gogh Museum, 19 May–17 September 2000.

PLATE 79

Roses. 1890
Oil on canvas, 28 x 35½ in. (71 x 90 cm)
National Gallery of Art, Washington, D.C. Gift of Pamela Harriman in memory of W. Averell Harriman

PROVENANCE

Gallimard, Paris, 1905; Bernheim-Jeune, Paris, 1917–26 (published in 1919 as the private collection of Bernheim-Jeune); Reid and Lefevre Gallery, London; Marie Harriman Gallery, New York, by 1930; Mr. and Mrs. W. Averell Harriman, New York, 1930; Pamela C. Harriman; National Gallery of Art, Washington, D.C. Gift of Pamela Harriman in memory of W. Averell Harriman, 1991 (1991.67.1).

EXHIBITIONS

Vincent van Gogh, Paris, Galerie E. Druet, 6–18 January 1908, no. 76; *Französische Kunst des XIX. und XX. Jahrhunderts*, Zürich, Kunsthaus, 5 October–4 November 1917, no. 111; *Les grandes influences au dix-neuvième siècle d'Ingres à Cézanne*, Paris, Galerie Paul Rosenberg, 15 January–7 February 1925, no. 8; *Trente ans d'art indépendant rétrospective 1884–1914*, Paris, Société des Artistes Indépendants, 20 February–21 March 1926, no. 2957; *Vincent van Gogh, l'époque française*, Paris, Galerie Bernheim-Jeune, 20 June–2 July 1927; *Ten Masterpieces by Nineteenth-Century French Painters*, London, Alex Reid-Lefevre, June–July 1929; *Exposition de peintures de l'Ecole Impressionniste et Neo-Impressionniste*, Lucerne, February 1929, no. 24; *Exhibition Commemorating the Twenty-fifth Anniversary of the Opening of the Albright Art Gallery*, Buffalo Fine Arts Academy, 1930, no.66; *Opening Exhibition*, New York, Marie Harriman Gallery, 1930, no. 10; *Still Life*, Cambridge (Mass.), Fogg Art Museum, 1931, no. 18; *Flowers by French Painters XIX–XX Centuries*, New York, Knoedler & Co., November 1932, no. 17; *A Century of Progess*, Chicago, Art Institute, 1 June–1 November 1933, no. 386; *Modern French Masters*, New York, Marie Harriman Gallery, 1939, no. 15; *Masterpieces of Art*, New York World's Fair, May–October 1940, no. 363; *Collectors' Choice: Masterpieces of French Art from New York Private Collections*, New York, Paul Rosenberg & Co., 17 March–18 April 1953, no. 13; *Magic of Flowers in Painting*, New York, Wildenstein, 1954, no. 28; Albany Institute of History and Art, 1955; *Masterpieces of Impressionist and Post-Impressionist Painting*, Washington, D.C., National Gallery of Art, 25 April–24 May 1959; *Paintings, Drawings and Sculpture Collected by Yale Alumni: An Exhibition*, New Haven (Conn.), Yale University Art Gallery, 19 May–26 June 1960, no. 71; *Exhibition of the Marie and Averell Harriman Collection*, Washington, D.C., National Gallery of Art, 15 April–14 May 1961; *Post-Impressionism: Cross-Currents in European and American Painting 1880–1906*, Washington, D.C., National Gallery of Art, 25 May–1 September 1980, no. 77 (as *Still Life, Roses*); *Art for the Nation: Gifts in Honor of the 50th Anniversary of the National Gallery of Art*, Washington, D.C., National Gallery of Art, 17 May–16 June 1991; extended loan for use by ambassador, U.S. Embassy residence, Paris, France, 1993.

FREQUENTLY CITED BIBLIOGRAPHIC REFERENCES

Baumann et al., 2000
Baumann, Felix, et al., eds. *Cézanne: Finished-Unfinished.* Kunstforum Wien and Kunsthaus Zürich: Hatje Cantz Publishers, 2000.

Berhaut, 1994
Berhaut, Marie. *Gustave Caillebotte: Catalogue raisonné des peintures et pastels.* Paris: Wildenstein Institute, 1994.

Berson, 1996
Berson, Ruth, ed. *The New Painting: Impressionism, 1874–1886: Documentation.* 2 vols. San Francisco: Fine Arts Museums of San Francisco, 1996.

Boggs et al., 1988
Boggs, Jean Sutherland, et al. *Degas.* New York: Metropolitan Museum of Art, 1988.

Brettell et al., 1988
Bretell, Richard, et al. *The Art of Paul Gauguin.* Washington, D.C.: National Gallery of Art, 1988.

Cachin and Moffett, 1983
Cachin, Françoise, and Charles S. Moffett. *Manet, 1832–1883.* New York: Metropolitan Museum of Art and Abrams, 1983.

Chu, 1992
Petra ten-Doesschate Chu, ed. and trans. *Letters of Gustave Courbet.* Chicago: University of Chicago Press, 1992.

Clairet, Montalant, Rouart, 1997
Clairet, Alain, Delphine Montalant, and Yves Rouart. *Berthe Morisot, 1841–1895: Catalogue raisonné de l'uvre peint.* Montolivet, France: CERA-nrs editions, 1997.

Da Rosa, 1994
Da Rosa, Raquel A. "Still Life and the Human Subject in Mid-Nineteenth Century France." Ph.D. diss., Columbia University, 1994.

De la Faille, 1970
De la Faille, J.-B. *The Works of Vincent van Gogh, His Paintings and Drawings.* Amsterdam: Meulenhoff International, 1970.

Distel et al., 1995
Distel, Anne, et al. *Gustave Caillebotte: Urban Impressionist.* Chicago: Art Institute of Chicago in association with Abbeville Press, 1994–95.

Druick and Hoog, 1982
Druick, Douglas, and Michel Hoog. *Fantin-Latour.* Paris: Editions de la Réunion des musées nationaux, 1982.

Druick and Hoog, 1982
Druick, Douglas, and Michel Hoog. *Fantin-Latour.* Ottawa: National Gallery of Canada, 1983.

Dumas, 1997
Dumas, Ann, et al. *The Private Collection of Edgar Degas.* New York: Metropolitan Museum of Art, 1997.

Faunce and Nochlin, 1988
Faunce, Sarah, and Linda Nochlin. *Courbet Reconsidered.* Brooklyn: Brooklyn Museum, 1988.

Fernier, 1977
Fernier, Robert. *La vie et l'oeuvre de Gustave Courbet, Catalogue raisonné,* 2 vols. Lausanne and Paris: La Bibliothèque des Arts, 1977.

Hamilton, 1954
Hamilton, George Heard. *Manet and His Critics.* New Haven: Yale University Press, 1954.

Hoog, 1987
Hoog, Michel. *Paul Gauguin, Life and Work.* New York: Rizzoli, 1987.

House, 1986
House, John. *Monet: Nature into Art.* New Haven and London: Yale University Press, 1986.

Hulsker, 1996
Hulsker, Jan. *The New Complete Van Gogh: Paintings, Drawings, Sketches: Revised and Enlarged Edition of the Catalogue Raisonné of the Works of Vincent van Gogh.* Amsterdam: J. M. Meulenhoff, 1996.

Kendall, 1987
Kendall, Richard, ed. *Degas by himself: Drawings, Prints, Paintings, Writings.* London: Macdonald Orbis, 1987.

Koja, 1996
Koja, Stephen. *Claude Monet.* Vienna: Österreichische Galerie, 1996.

Mauner and Loyrette, 2000
Mauner, George, and Henri Loyrette. *Manet: The Still Life Paintings.* New York: Harry N. Abrams in association with the American Federation of the Arts, 2000.

Moffett et al., 1986
Moffett, Charles S., et al. *The New Painting, Impressionism: 1874–1886.* Seattle: University of Washington Press, 1986.

Pissarro, 1993
Pissarro, Joachim. *Camille Pissarro.* New York: Harry N. Abrams, 1993.

Przyblyski, 1995
Przyblyski, Jeannene M. "Le parti pris des choses: French Still Life and Modern Painting." Ph.D. diss., University of California, Berkeley, 1995.

Rewald, 1996
Rewald, John. *The Paintings of Paul Cézanne: A Catalogue Raisonné.* New York: Harry N. Abrams, 1996.

Tinterow and Loyrette, 1995
Tinterow, Gary, and Henri Loyrette. *Origins of Impressionism.* New York: Metropolitan Museum of Art, 1995.

Van Gogh, 1958
van Gogh, Vincent W., ed. *The Complete Letters of Vincent van Gogh.* 3 vols. Greenwich, Conn.: New York Graphic Society, 1958.

Wildenstein, 1964
Wildenstein, Georges. *Gauguin.* Paris: Editions les Beaux-Arts, 1964.

Wildenstein, 1974
Wildenstein, Daniel. *Claude Monet: biographie et catalogue raisonné.* Vol. 1. Lausanne-Paris: La Bibliothèque des Arts, 1974.

Wildenstein, 1979
Wildenstein, Daniel. *Claude Monet: biographie et catalogue raisonné.* Vols. 2 and 3. Lausanne-Paris: La Bibliothèque des Arts, 1979.

Wildenstein, 1996
Wildenstein, Daniel. *Monet: Biographie et catalogue raisonné,* 4 vols. 1–4. Cologne and Paris: Taschen and Wildenstein Institute, 1996.

Paris 1884
Exposition des oeuvres d'Edouard Manet: Paris, Ecole des Beaux-Arts, 1884.

Paris 1894
Exposition rétrospective Gustave Caillebotte: Paris, Galeries Durand-Ruel, June 1894.

Cambridge 1929
Exhibition of French Painting of the Nineteenth and Twentieth Centuries: Cambridge, Fogg Art Museum, 6 March–6 April 1929.

Paris 1951
Rétrospective Gustave Caillebotte: Paris, Galerie Beaux-Arts, 25 May–25 July 1951.

Zürich 1956
Paul Cézanne: Zürich, Kunsthaus, 22 August–7 October 1956.

Santa Barbara 1958
Fruits and Flowers in Painting: Santa Barbara, Santa Barbara Museum of Art, 12 August–14 September 1958.

Chicago and New York 1959
Gauguin: Chicago, Art Institute, 12 February–9 March 1959; New York, Metropolitan Museum of Art, 21 April–31 May 1959.

Philadelphia and Boston 1959–60
Gustave Courbet, 1819–1877: Philadelphia, Museum of Art, 17 December 1959–14 February 1960; Boston, Museum of Fine Arts, 26 February–14 April 1960.

Philadelphia 1963
A World of Flowers: Philadelphia, Philadelphia Museum of Art, 2 May–9 June 1963.

Boston 1973
Impressionism: French and American: Boston, Museum of Fine Arts, 15 June–14 October 1973.

New York, Houston, and Paris 1977–78
Cézanne: The Late Work: New York, Museum of Modern Art, 7 October 1977–3 January 1978; Houston, Museum of Fine Arts, 26 January–19 March 1978; *Cézanne, Les dernières années (1895–1906):* Paris, Grand Palais, 20 April–23 July 1978.

Paris and London 1977–78
Gustave Courbet 1819–1877: Paris, Grand Palais, 1 October 1977–2 January 1978; London, Royal Academy of Arts, 19 January–19 March 1978.

Boston 1979–80
Corot to Braque, French Paintings from the Museum of Fine Arts, Boston: Atlanta, High Museum of Art, 21 April–17 June 1979; Tokyo, Seibu Museum, 28 July–19 September 1979; Nagoya, City Art Museum, 29 September–31 October 1979; Kyoto, National Museum of Modern Art, 10 November–23 December 1979; Denver Art Museum, 13 February–20 April 1980; Tulsa, Philbrook Art Center, 25 May–25 July 1980; Phoenix Art Museum, 19 September–23 November 1980, no. 41.

Paris, Ottawa, San Francisco 1982–83
Fantin Latour: Paris, Grand Palais, 9 November–7 February 1983; Ottawa, National Gallery of Canada, 17 March–22 May 1983; San Francisco, California Palace of the Legion of Honor, 18 June–6 September 1983.

Paris and New York 1983
Manet, 1832–1883: Paris, Galeries nationales du Grand Palais, 22 April–1 August 1983; New York, Metropolitan Museum of Art, 10 September–27 November 1983.

Tokyo, Fukuoka, and Kyoto 1983–84
Masterpieces of European Paintings from the Museum of Fine Arts, Boston: Tokyo, Isetan Museum of Art, 21 October–4 December 1983; Fukuoka, Art Museum, 6–29 January 1984; Kyoto, Municipal Museum of Art, 25 February–8 April 1984.

Brooklyn and Minneapolis 1988–89
Courbet Reconsidered: Brooklyn, Museum of Art, 4 November 1988–16 January 1989; Minneapolis, Institute of Arts, 18 February–30 April 1989.

Boston 1992
European and American Impressionism: Crosscurrents: Boston, Museum of Fine Arts, 19 February–17 May 1992.

Chiba, Nara, Yokohama, and Boston 1994–95
Still-Life Painting in the Museum of Fine Arts, Boston: Chiba, Sogo Museum of Art, 2 April–8 May 1994; Nara, Sogo Museum of Art, 15 May–19 June 1994; Yokohama, Sogo Museum of Art, 26 June–28 August 1994; Boston, Museum of Fine Arts, 14 September 1994–1 January 1995.

Paris and New York 1994–95
The Origins of Impressionism: Paris, Grand Palais, 19 April–8 August 1994; New York, Metropolitan Museum of Art, 27 September 1994–8 January 1995.

Paris, Chicago, Los Angeles 1994–95
Gustave Caillebotte: Urban Impressionist: Paris, Musée d'Orsay, 16 September 1994–9 January 1995; Chicago, Art Institute, 18 February–28 May 1995; Los Angeles County Museum of Art, 22 June–10 September 1995.

Paris, London, Philadelphia 1995–96
Cézanne: Paris, Grand Palais, 26 September 1995–7 January 1996; London, Tate Gallery, 8 February–28 April 1996; Philadelphia, Museum of Art, 26 May–1 September 1996.

Paris 2000
Courbet et la Commune: Paris, Musée d'Orsay, 13 March–11 June 2000.

Vienna and Zürich 2000
Cézanne: Finished-Unfinished: Vienna, Kunstforum, 20 January–25 April 2000; Zürich, Kunsthaus, 5 May–30 July 2000.

Paris and Baltimore 2000–01
Manet: The Still Life Paintings: Paris, Musée d'Orsay, 9 October 2000–7 January 2001; Baltimore, Walters Art Gallery, 30 January–17 April 2001.

NOTES

MANET: THE SIGNIFICANCE OF THINGS
Eliza E. Rathbone

1 Antonin Proust, *Edouard Manet: souvenirs* (Paris: H. Laurens, 1913), 20. Proust tells us that Manet said, "Quand j'arrive à l'atelier, il me semble que j'entre dans une tombe."

2 Paul Mantz, "Salon de 1863," *Gazette des beaux-arts*, v. 14 (1863), 44, "Il y a beaucoup de tableaux de fleurs au Salon; c'est un genre modéré, décent, et la mère en permet la culture à sa fille . . . des pivots, et des pivoines, et des roses. Le Salon est un jardin: les fleurs, les fleurs artificielles surtout, y poussent avec une facilité merveilleuse."

3 The categories of still life as defined in Michel Faré, *La nature morte en France*, (Geneva: Pierre Cailler, 1962), include flowers and fruit, buffets and desserts, rustic tables and kitchen provisions, trophies from the hunt and fishing, military trophies and *vanitas*, the attributes of the arts and of sciences, familiar objects, and trompe l'oeil.

4 See George Mauner, *Manet: Peintre-Philosophe: A Study of the Painter's Themes* (University Park, Penn., and London, 1975). See also Michael Fried, *Manet's Modernism; or, The Face of Painting in the 1860s* (Chicago: University of Chicago Press, 1996), and numerous articles on Manet by Theodore Reff. If we acknowledge that the still-life elements in Manet's *Woman with a Parrot*, 1866 (Metropolition Museum of Art, New York) may in fact constitute the artist's modern treatment of the five senses (a traditional still-life subject), as Mauner suggests, or that Manet intended his modern images to make overt reference to great art of the past, even specific works of art, as Fried suggests, Manet's rich acquaintance with and complex relationship to the art of the past becomes abundantly clear. Mauner also cites John Connelly, "Ingres and the Erotic Intellect," *Art News Annual* 38 (1972): 25.

5 Louis Leroy, "Salon of 1872," *Charivari*, May 16, 1872, quoted in Hamilton, 1954, 156.

6 Paul Mantz, "Le Salon," *L'illustration*, June 6, 1868. "L'intérêt principal appartient non au personnage mais à certains dessins japonais dont les murailles sont couvertes; la tête est indifférente et vague." Quoted in A. Tabarant, *Manet et ses oeuvres* (Paris: Gallimard, 1947), 149 and in Hamilton, 1954, 121.

7 Odilon Redon wrote in his review of the Salon in *La Gironde*, June 9, 1868, "C'est plutôt une nature morte que l'expression d'un caractère humain." Quoted in Roseline Bacou, *Odilon Redon* (Geneva: P. Cailler 1956), 45 and quoted in Hamilton, 1954, 129.

8 Théophile Thoré, "Le Salon" of 1868, quoted in Hamilton, 1954, 124.

9 Paul Mantz, "Salon de 1869," *Gazette des beaux-arts*, vol. 2, 13. "On ne sait pas bien ce que ces honnêtes personnes font à leur balcon." Also quoted in Hamilton, 1954, 136.

10 Jules Castagnary, "Le Salon," *Le siècle*, June 11, 1869, quoted in Hamilton, 1954, 137–38.

11 See Emile Zola, "Edouard Manet, L'Artiste," *La revue du XIXe siècle*, January, 1867; reprinted in Zola's *Edouard Manet, étude biographique et critique*, 1867, and in his *Ecrits sur l'art* (Paris: Gallimard, 1991), 151.

12 Theodore Reff, "Copyists in the Louvre, 1850–1870," *The Art Bulletin*, 46 (December 1954): 556. Reff describes Manet making copies in the Louvre, "Contemporary with the Tintoretto copy of 1854 [*Self-Portrait*], or perhaps as early as the lost Boucher copy of 1852, is the detailed and carefully rendered copy of Titian's *Madonna of the Rabbit*."

13 Cachin and Moffett, 1983, 50. A similar basket (one of the attributes of the Virgin) rests on the floor beside the Virgin in Titian's *Annunciation* in the Scuola Grande di San Rocco, Venice.

14 In his review, "Salon de 1861," *Gazette des beaux-arts*, July 1861, v. 11, 52, Léon Lagrange stated, "M. Manet foule aux pieds des affections plus saintes encore. M. et Madame Manet . . . ont du maudire plus d'une fois le jour qui a mis un pinceau aux mains de ce portraitiste sans entrailles."

15 According to Antonin Proust (*Edouard Manet: souvenirs*, 36) who describes Manet's travels and what he went to see: Anvers (Rubens), Amsterdam (Rembrandt), Brussels (*les primitifs*), Haarlem (Hals), Dresden (Dürer), Basel (Holbein), and Italy (Titian, Tintoretto, Raphael, and Michelangelo).

16 See Michel Laclotte, Introduction, in Lawrence Gowing, *Paintings in the Louvre* (New York: Stewart, Tabori & Chang, 1987), 9–10.

17 See Druick and Hoog, 1982, 84.

18 Between 1859 (the first year of publication of the *Gazette des beaux-arts*) and 1863, numerous articles on Goya appeared in the *Gazette des beaux-arts*. In *Annals of the Artists of Spain* (London, 1848), William Stirling (a.k.a. Sir William Stirling Maxwell) remarked on the paucity of books on Spanish art in English, noting only three, published in 1829 (one brief publication) and 1832 (two). In *Velazquez et ses oeuvres*, which Stirling wrote in English (1855) before collaborating on a French edition with W. Bürger, Bürger states, "L'Ecole espagnole et ses plus grands maîtres . . . furent presque inconnus en France jusqu'au commencement de ce siècle" and, "M. Louis Viardot fut un des premiers à appeler l'attention sur l'école espagnole, un peu après la révolution de 1830." 228.

19 Charles Blanc, "Vélasquez a Madrid," *Gazette des beaux-arts*, 15 (1863): 73. "La verité, voilà l'inséparable compagne de Velasquez, voilà sa muse."

20 Regarding Thoré and his assumed name, Willem Bürger, sometimes called William Burger, see P. Rebeyrol, "Art Historians and Art Critics: Théophile Thoré," *The Burlington Magazine* 94 (July 1952): 196–200. Thoré is credited with the rediscovery of the work of Johannes Vermeer and the revival of interest in Frans Hals.

21 See William Stirling, *Velazquez et ses oeuvres* (Paris: Vve J. Renouard, Libraire, 1865), 229. "Le nom Velasque [sic] est aujourd'hui, non seulement en France, mais dans le monde, un des plus prodigieux peintres qui aient existé," and further on, he wrote, "Velazquez est, à mon sentiment, le plus peintre qui ait jamais existé, plus peintre que Titien, que Corrège, que Rubens. . . ." 235.

22 Ibid., 235.

23 See Hamilton, 1954, 60–61.

24 Théophile Gautier, "Chardin et Greuze," *L'artiste*, (15 October 1861): 174.

25 Gautier wrote, "Qui n'a pas vu Madrid ne connait ce peintre étonnant," *Moniteur*, (24 September 1865).

26 Ibid. Gautier wrote, "maintenant que le chemin de fer rend facile de franchir les Pyrénées, nos jeunes peintres feront bien de l'aller étudier."

27 Manet made several well-known copies of *The Little Cavaliers* in various media. See Jean C. A. Harris, *Edouard Manet, Graphic Works: A Definitive Catalogue Raisonné* (New York: Collectors Editions, 1970), 31–33. He also made etchings after *The Infanta Marguerita* and *Philippe IV* by Velázquez, in the Louvre.

28 Antonin Proust, *Edouard Manet, souvenirs*, 36. "Mais son idée fixe était de voir l'Espagne."

29 Manet quoted in Juliet Wilson-Bareau, *Edouard Manet: voyage en Espagne* (Caen: L'Echoppe, ca. 1988), 15. "Je suis extrêmement pressé de voir tant de belles choses et d'aller demander conseil à maître Velasquez."

30 Manet, letter of 3 September 1865, to Fantin-Latour, quoted in Juliet Wilson-Bareau, ed., *Manet by Himself* (London: Macdonald, 1991), 34.

31 Regarding Manet and Astruc, see Sharon Flescher, *Zacharie Astruc: Critic, Artist, and Japoniste*, Ph.D. diss., Columbia University, 1977, 95–196.

32 This is not to suggest that Manet had not already done paintings before his trip to Spain that reflected his interest in Velázquez and Spanish painting. However, he and Duret probably saw the painting *Pablillos de Vallodolid* by Velázquez in the Prado, which Manet praised for its lack of a background other than air and space and which he took up as an approach to his portrait, *The Tragic Actor* (Cachin and Moffett, 1983, 231). Each of the portraits Manet painted, of Zola, Duret, and Astruc, for example, is entirely individually conceived so that the entire composition reflects the artistic interests of the sitter and, more important, the artist (see note 51).

33 Théodore Duret, *Manet and the French Impressionists* (London: G. Richards; Philadelphia: J. B. Lippincott Company, 1910). Duret relates, "We explored Madrid together. Naturally, we spent a considerable time every day before the paintings of Velázquez in the Prado," 30. Manet and Duret signed the visitors book at the Prado on 1 September 1865, according to Juliet Wilson-Bareau, *Manet by Himself*, 17.

34 See George Mauner, *Manet, Peintre-Philosophe*, 105, 106.

35 In June 1868, Manet wrote to Duret, "I think one could do a small full-length portrait to the size you want (24); a head on its own is always rather dull—as to the rest it will be whatever you are able or willing to make it, there should be no obligations between friends. If you would like to make a start on Sunday, I'll be at my studio from midday onwards." Quoted in Juliet Wilson-Bareau, *Manet by Himself*, 46.

36 George Mauner believes that the book, tossed under the chair, is not merely there to provide an accent of blue-green, but also was intended by Manet to

make reference to Duret's recently published *Les peintres français en 1867*, in which Manet's own work is not given unequivocal support. See Mauner, "How Manet Got Even with a Critic," *Art News*, 100 (January, 2001): 112–13.

37 Charles Blanc, "Don Diego Velázquez," *Histoire des peintres de toutes les écoles* (Paris: Librairie Renouard, 1861–76). This article illustrates both *Water Seller of Seville* as well as *The Drinkers (Los borrachos)*. See also Theodore Reff, "Manet and Blanc's 'Histoire des Peintres,'" *The Burlington Magazine* 112, no. 108 (July 1970): 456–58.

38 This work is also reminiscent of Degas's *Millinery Shop* (plate 60), given the commanding presence of the still life and the figures' engagement in what they're doing rather than addressing the spectator.

39 Naturally, there are other instances in Manet's still lifes where a whole lemon brings a critical color note to the composition, but no other work shows that same degree of deliberate artfulness combined with informality. There are also instances in Chardin's still lifes where the artist has posed a whole orange in an unexpected part of the image, as in his *Cat Stalking a Partridge and Hare Left Near a Soup Tureen*, a painting that was shown in Paris in 1860, but here the effect is entirely different. I have not yet found specific evidence to prove that Manet did know Velázquez's painting *Two Young Men Eating at a Humble Table*.

40 A comparison of Velázquez's *Water Seller of Seville* with the face of the third figure just emerging from the penumbra of the dark background foreshadows Manet's treatment of the boy in the dark background of Manet's *The Balcony*. Regarding the rose in Manet's *The Brioche*, it could be the first hybrid tea rose, "La France," which appeared in 1867, and thereby signals another instance of Manet's contemporaneity and wit.

41 See Théodore Duret, *Histoire d'Edouard Manet et de son oeuvre* (Paris: Charpentier et Fasquelle, 1906), and translation by Henri Loyrette, in Mauner and Loyrette, 2000, 159.

42 Emile Zola, *Edouard Manet, étude biographique et critique*, 1867, reprinted in Emile Zola, *Ecrits sur l'art*, 154. "On lui a reproché d'imiter les maîtres espagnols. J'accorde qu'il y ait quelque resemblance entre ses premières oeuvres et celles de ces maîtres: on est toujours fils de quelqu'un. . . . ses toiles ont un accent trop individuel pour qu'on veuille ne trouver en lui qu'un bâtard de Velázquez et de Goya." Also regarding Manet's reputation as a modern Velázquez, see Paul Mantz, "Salon de 1869," 13: "Les amateurs d'effets inédits ont un instant mis leur espoir en M. Manet. L'idée qu'un Vélasquez nous était né avait quelque chose de consolant . . .".

43 In Manet's portrait of Duret, Duret's gloved hand holding the other glove is reminiscent of Titian's *The Man with the Glove* in the Louvre, which might have been a source of inspiration to Manet.

44 For a detailed discussion of the elements in Zola's portrait, see Theodore Reff, "Manet's Portrait of Zola," *The Burlington Magazine* 117 (1975): 39. Reff identifies the subject of the print as "The Wrestler Onaruto Nadaemon of Awa province by Kuniaki II, a later Ukiyo master." Reff drew upon E. P. Wiese, "Source Problems in Manet's Early Painting," Ph.D. diss., Harvard University, 1959, and Kloner (see Reff, note 33). See also Henri Loyrette's interpretation of the painting in Mauner and Loyrette, 2000, 158. Loyrette states, "In my opinion, the *Portrait of Emile Zola* is not a shrewd and arrogant self-portrait but, on the contrary,

Manet's homage to the writer's reading of his own work."

45 In the case of Zola's portrait, Manet includes a Japanese print and a Japanese screen. Manet's conception of this portrait itself suggests the flatness of Japanese prints, while the isolation of the still life in Manet's portrait of Duret could also reflect the inspiration of Japanese sources.

46 Odilon Redon, in *La Gironde*, quoted in Hamilton, 1954, 129.

47 See Françoise Cachin, in Cachin and Moffett, 1983, 282.

48 Consider, for example, van Gogh's *Portrait of Père Tanguy* or Gauguin's *Self Portrait: Les Misérables*, and other occasions when Gauguin makes overt reference to another artist's work in his own. Van Gogh's *Portrait of Père Tanguy* (of which three different versions are included in De la Faille, 1970) is reminiscent conceptually of Manet's *Portrait of Emile Zola*. Like Manet, van Gogh created portraits that can be seen to refer primarily to his own identity and interests. See Joanna Woodall, introduction to *Portraiture: Facing the Subject*, ed. J. Woodall (Manchester: Manchester University Press, 1997), 7.

49 The direct use of *cartes de visite* by Manet has been explored in detail by Elizabeth Anne McCauley. In discussing the "eclecticism of his borrowings," McCauley suggests that "Manet turned repeatedly to photography not only for poses and likenesses but also for a new kind of image which had the authority of reality and the mystery of an advanced technology." Elizabeth Anne McCauley, *A.A.E. Disdéri and the Carte de Visite Portrait Photograph* (New Haven and London: Yale University Press, 1985), 173. That Manet and Nadar were friends is suggested by the many photographic portraits of Manet that Nadar made as well as by surviving correspondence (from 1866 and 1867) including the letter from 10 September 1867 from Manet to Nadar after their mutual friend Baudelaire died, which closes with the salutation "with my warmest regards, my dear Nadar." See Juliet Wilson-Bareau, *Manet by Himself*, 44.

50 Manet's friend Philippe Burty had recently (1859) praised Nadar's photographs, writing, "It is indisputable that M. Nadar has made of his portraits works of art in every sense of the word." Philippe Burty, "Exposition de la Société française de photographie," *Gazette des beaux-arts* (1859): 215.

51 In his *Portrait of Zacharie Astruc* (1864–66, Kunsthalle, Bremen), Manet appears to use a pictorial device that can be found in two paintings by Velázquez, *Christ in the House of Martha and Mary* and *Christ at Emmaus,* in which a secondary scene is included in the painting in such a way that its relationship to the whole image is left deliberately ambiguous. Is the secondary scene a view into another room or a reflection in a mirror or a painting? All three interpretations have been brought to the secondary scene in Manet's *Portrait of Zacharie Astruc,* with its view of a woman seen from behind in an interior. A similar view into another space is included in Titian's *Venus of Urbino*, a source for Manet's *Olympia*. I believe Manet made just such a deliberately ambiguous reference (and with works by Velázquez and Titian in mind) in his portrait of Astruc. A similar kind of ambiguity can be found in certain paintings by Gauguin.

52 Manet's objects are never simply an object to paint in a realist style, nor are they aspects of a setting so

much as players themselves in the drama he presents.

53 See Jean Seznec, "Flaubert and the Graphic Arts," *Journal of the Warburg and Courtauld Institute*, v. 8 (1945), 175–90. Meyer Schapiro relates Flaubert to Impressionism in "Impressionism and Literature," in *Impressionism, Reflections, and Perceptions* (New York: George Braziller, 1997), 272.

54 Regarding Flaubert's opinion of Manet, see Pierre Sorlin, *L'art sans règles: Manet contre Flaubert* (Saint-Denis: Presses universitaires de Vincennes, 1995), 8.

55 See Charles Sterling, *Still Life Painting from Antiquity to the Twentieth Century*, 2nd rev. ed. (New York: Harper and Row, 1981 [1952]), 120.

56 Renoir quoted in T. A. Gronberg, ed., *Manet: A Retrospective,* (New York: Park Lane, 1990), 312.

57 In selecting works for this exhibition, Roger Fry owed some of his views to Julius Meier-Graefe, including "the connection established between Manet and the triumvirate of Cézanne, Gauguin and Van Gogh. The German critic calls the artists 'expressionists.'" Alan Bowness, Introduction, *Post-Impressionism* (London: Royal Academy of Arts, 1979–80), 9.

58 See Françoise Cachin, *Gauguin* (Paris: Flammarion, 1988), 136–37. Manet's *Olympia* was aquired by the Musée du Luxembourg in 1890. Gauguin's copy of Manet's painting (1891) (once in the collection of Degas) is cited by Cachin in a private collection in London. Cachin notes that Gauguin took a photograph of Manet's *Olympia* with him to Tahiti.

59 See Françoise Cachin, *Gauguin*, 222.

60 See *Manet and the Post-Impressionists* (London: Ballantyne & Company, 1910?)

61 Ibid., 7–9.

62 Manet quoted in Etienne Moreau-Nelaton, *Manet raconté par lui-même,* vol. 2 (Paris: Henri Laurens, 1926), 71.

63 Also consider the idea of an object or an abstraction as a portrait, as, for example, in works by Marius de Zayas, Francis Picabia, or Charles Demuth.

IMPRESSIONISM AND THE STILL-LIFE TRADITION
George T. M. Shackelford

1 Quoted in John W. McCoubrey, "The Revival of Chardin in French Still-Life Painting, 1850–1870," *The Art Bulletin* 46 (March 1964): 39. McCoubrey's text is an important source for the discussion of still-life history that follows here.

2 *Tableaux et dessins de l'école française, principalement du XVIIIe siècle, tirés des collections d'amateurs* (Paris: Galerie Martinet, 1860).

3 See McCoubrey, "Revival of Chardin;" see also Przyblyski, 1995, especially her chapter 1: "Finding the Words to Begin: Chardin and the Chardin Revival," 19–82. I am indebted also to Pierre Rosenberg's discussion of the "Critical Evaluation of Chardin" in *Chardin, 1699–1779* (Cleveland: Cleveland Museum of Art, 1979), 79–96, especially 85–86 and 89–90.

4 See the Goncourts as quoted in Rosenberg, "Critical Evaluation of Chardin," 90.

5 Thoré is cited in Przyblyski, 1995, 9.

6 Jules Castagnary, cited in Przyblyski, 1995, 3, note 6.

7 See Rosenberg, *Chardin, 1699–1779*, 163–66, and Pierre Rosenberg et al., *Chardin* (London: Royal

Academy of Arts; New York: Metropolitan Museum of Art, 2000), 176–79.

8 The precise model for Bonvin's canvas may have been the *Preparations for the Pot-au-Feu* by Michel-Honoré Bounieu, which was in the La Caze collection, and was one of the many paintings by other artists then thought to be by Chardin. See Pierre Rosenberg et al., *Musée du Louvre, Catalogue illustré des peintures, école française XVIIe et XVIIIe siècles*, vol. 1 (Paris: Editions des musées nationaux, 1974), cat. no. 67, 41 and 259.

9 See Rosenberg, *Chardin, 1699–1779*, 354.

10 See Alexandra R. Murphy, *Jean-François Millet* (Boston: Museum of Fine Arts, 1984), 160–61, who proposes a direct source for Millet's *Pears* in Chardin's *Three Pears, Walnuts, Glass of Wine, and Knife* (Musée du Louvre, Paris).

11 Goncourts, quoted in Rosenberg, "Critical Evaluation of Chardin," 90.

12 Another Delacroix still life exhibited in 1849, 1855, and then again at the Delacroix atelier sale of 1864 was the *Still Life with Flowers and Fruit* (1848–49, Philadelphia Museum of Art), which offers significant parallels with Courbet's *Still Life: Fruit* of 1871–72 (plate 28). See Joseph J. Rishel et al., *Delacroix: The Late Work* (Philadelphia: Philadelphia Museum of Art, 1998), 357–58.

13 The young painters might also have been inspired by less finished works they could have seen at this time. See also the remarkable watercolor studies of flowers exhibited at the 1864 atelier sale in Rishel et al., *Delacroix: The Late Work*, cat. nos. 25, 33, and 35, as well as other oil paintings, cat. no. 31—which shows significant parallels with Bazille's 1868 *Flowers* (plate 21)—and cat. no. 32.

14 See C. de Malte, quoted in Berson 1996, vol. 1, 27–28.

15 See Jeannene M. Przyblyski's essay in this volume.

16 See Rosenberg, *Chardin, 1699–1779*, repr. in cat. nos. 111, 316–18.

17 Monet's letter to Bazille and Corot's remark are quoted in Joel Isaacson's remarkable article, "Constable, Duranty, Mallarmé, Impressionism, Plein Air, and Forgetting," *The Art Bulletin* 76 (September 1994): 427–50.

18 Fantin-Latour to his friend Otto Scholderer, 25 January 1874, quoted in Druick and Hoog, 1983, 261.

19 Georges Jeanniot, "Souvenirs sur Degas," *La revue universelle* (October 1933): 158.

20 See Duranty, quoted in Moffett et al., 1986, 45.

21 Isaacson, "Constable, Duranty, Mallarmé," 428, note 3.

22 Louis Leroy, quoted in Berson 1996, vol. 1, 402.

23 Mallarmé, quoted in Isaacson, "Constable, Duranty, Mallarmé," 430.

24 Sam Segal, *Jan Davidsz. de Heem en zign kring* (The Hague: Sdu Uitgeverij, 1991), cat. no. 3, 128–29.

THE MAKINGS OF MODERN STILL LIFE IN THE 1860s
Jeannene M. Przyblyski

1 "Il traite les tableaux de figures comme il est permis, dans les écoles, de traiter les tableaux de nature morte; je veux dire qu'il groupe les figures devant lui, un peu au hasard, et qu'il n'a ensuite souci que de les fixer sur la toile telles qu'il les voit, avec les vives oppositions qu'elles font en se détachant les unes sur les autres. Ne lui demandez rien autre chose qu'une traduction d'une justesse littérale. Il ne saurait ni chanter, ni philosopher. Il sait peindre, et voilà tout." Emile Zola, "Une nouvelle manière en peinture: Edouard Manet," *Mes haines*, in *Oeuvres complètes*, Maurice Le Blond, ed. (Paris: Bernouard, 1928), 25: 259–60. All translations by the author unless otherwise noted.

2 "Je voudrais que ce jeune homme, habile entre les habiles, pût dépouiller je ne sais quelle timidité qui le retient et l'enchaîne." Jules Castagnary, *Salons* (Paris: Charpentier et Fasquale, 1892), vol. 1: 166–67.

3 Letter excerpted in Druick and Hoog, 1983, 117.

4 See Michael Fried's important essay, "The Generation of 1863" in *Manet's Modernism or, The Face of Painting in the 1860s* (Chicago: University of Chicago Press, 1996), 185–261.

5 Louis-Edmond Duranty, *Le peintre Louis Martin* in *Le pays des arts* (Paris: Charpentier, 1881), 334–35.

6 "Louis révolutionna la *nature morte*. Au lieu de ces entassements d'objets, sans autre raison d'être ensemble que le soi-disant goût pittoresque et décoratif du peintre, il prenait de véritables fragments d'un intérieur, significatifs, exprimant bien un genre de vie où les objets gardaient enfin la place et la physionomie que leur assignent les habitudes, les goûts de celui qui habite cet intérieur." Ibid. 347.

7 The essential article on this subject remains John W. McCoubrey, "The Revival of Chardin in French Still Life Painting, 1850–1870," *The Art Bulletin*, 46 (March 1964): 39–53.

8 "Qu'est-ce qui constitue le maître? C'est à la fois un sentiment original de la nature et une exécution particulière. Quand un peintre a ces deux qualités, ne s'appliqueront-elles qu'à des objets très inférieurs, il est maître de son art et dans son art." Théophile Thoré (writing as W. Bürger), "Salon de 1861," *Salons de W. Bürger, 1861–1868* (Paris: J. Renouard, 1870), vol. 1: 92.

9 See, for example, Philippe Rousseau's oppressive accumulation of Chardinesque bibelots in his painting *Chardin et ses modèles* of 1867 (Musée d'Orsay, Paris). For more on Chardinesque painting during this period, see Gabriel P. Weisberg with William Talbot, *Chardin and the Still-Life Tradition in France* (Cleveland: Cleveland Museum of Art, 1979).

10 Druick and Hoog, 1983, 87, 119.

11 Denis Diderot, "Salon of 1765," in *Diderot on Art*, John Goodman, trans. (New Haven: Yale University Press, 1995), vol. 1: 61.

12 For a fuller analysis of Courbet's still lifes, see Jeannene M. Przyblyski, "Courbet, the Commune, and the Meanings of Still Life in 1871," *Art Journal*, 55, 2 (summer 1996): 28–37. The most complete discussion of Courbet's realism as a representational regime of the body can be found in Michael Fried, *Courbet's Realism* (Chicago: University of Chicago Press, 1990).

13 "[Le couteau] . . . garde sa souillure héréditaire, qui est de matérialiser tout ce qu'il touche." Camille Lemmonier, *G. Courbet et son oeuvre* (Paris: Lemeur, 1878), 62.

14 Jonathan Crary, *Techniques of the Observer: On Vision and Modernity in the Nineteenth Century* (Cambridge: MIT Press, 1990), 70.

15 "Si ce petit groupe pouvait constituer une école, on devrait l'appeler 'l'école des yeux.'" Marc de Montifaud, "Exposition du boulevard des Capucines," *L'artiste* (1 May 1874): 307–14, quoted in Fried, *Manet's Modernism*, 18.

16 Fried is particularly acute on this point. See his essay "Between Realisms" in *Manet's Modernism*, especially 379–80.

17 "L'intérieur s'en va. La vie retourne à devenir publique. Le cercle pour en haut, le café pour en bas, voilà où aboutissent la société et le peuple. . . . Je suis étranger à ce qui vient, à ce qui est, comme à ces boulevards nouveaux, qui ne sentent plus le monde de Balzac, qui sentent Londres, quelque Babylone de l'avenir. Il est bête de venir ainsi dans un temps en construction: l'âme y a des malaises, comme un homme qui essuierait des plâtres." Edmond and Jules de Goncourt, *Mémoires de la vie littéraire* (Paris: Charpentier, 1888–1898), vol. 1, 835. Translated in T. J. Clark, *The Painting of Modern Life: Paris in the Art of Manet and His Followers* (Princeton: Princeton University Press, 1984), 34–35. Clark's book remains the seminal study on modern painting and the modernization of Paris.

18 *Charles Baudelaire, The Painter of Modern Life* (1863), Jonathan Mayne, trans. (New York: Da Capo, 1964), 9–10. For one of the most interesting formulations of the relationship between the *flâneur* and the *homme de l'intérieur*, see Walter Benjamin, "Paris—the Capital of the Nineteenth Century," in *Charles Baudelaire: A Lyric Poet in the Era of High Capitalism*, trans. Harry Zohn (London: Verso, 1983), 155–76.

19 The essential source on Dutch painting and seventeenth-century ways of seeing is Svetlana Alpers, *The Art of Describing: Dutch Art in the Seventeenth Century* (Chicago: University of Chicago Press, 1983).

20 "Je lève donc discrètement le voile de la vie intime. Edouard Manet est un homme du monde, dans la meilleure acception de ces mots. Il a épousé, il y a trois ans, une jeune Hollandaise, musicienne de grand talent, et il vit ainsi en famille, au fond d'un désert heureux où les cris de la foule ne lui arrivent pas toujours. Il se repose là dans l'affection et dans les petits bonheurs de l'existence. . . ." Emile Zola, *Mes haines*, 251.

21 Letter from Fantin-Latour to Otto Scholderer, 25 January 1874, reprinted in Druick and Hoog, 1983, 261.

22 "J'en dis autant de cette nature morte, qui est littéralement assassinée par le fond. D'abord le tableau est trop grand pour son contenu; ensuite ce fond neutre fait tort aux fleurs, aux fruits, au livre, à la tasse, à tous ces objets si bien dessinés, si finement peints, d'un ton si vrai et si précis." Edmond About, *Salon de 1866* (Paris: Hachette, 1867), 211.

23 This term is borrowed from James H. Rubin's sustained study of Manet's flower paintings. See *Manet's Silence and the Poetics of Bouquets* (Cambridge: Harvard University Press, 1994).

24 Emile Zola, *Le ventre de Paris* (1873), in *Oeuvres complètes*, 47.

25 On Benjamin's dialectical pairing of the *flâneur* and the vagabond, see Susan Buck-Morss, "The Flâneur, the Sandwichman and the Whore: The Politics of Loitering," *New German Critique* 29 (fall 1986): 99–140.

CÉZANNE'S DIFFERENCE
John McCoubrey

1 Thadée Natanson, "Paul Cézanne," *La revue blanche* (1 December 1895): 499–500.

2 The indispensable source for this essay was John Rewald in collaboration with Walter Feilchenfeldt and Jayne Warman, *The Paintings of Paul Cézanne*, 2 vols. (New York: Harry N. Abrams, 1996). For specific information on individual paintings it was the text, vol. 1, and, for Cézanne's development, which was not traced in the text, the plates in vol. 2.

3 Emile Bernard, *Souvenirs sur Paul Cézanne* (Paris: Société des Trente, 1912), 35.

4 The painters are Redon, Vuillard, Roussel, Denis, Sérusier, Mellerio, Ranson, and Bonnard. Mme Denis and the dealer Vollard are also included.

5 Roger Fry, *Cézanne: A Study of His Development* (New York: Macmillan, 1927).

6 Selections of these writings appear in Judith Weschler, ed., *Cézanne in Perspective* (New York: Prentice-Hall, 1975), 65–69, 87–93, 120–24. Meyer Schapiro's article is reprinted in his *Modern Art, 19th & 20th Centuries; Selected Papers* (New York: George Braziller, 1978), 1–38.

7 Bonvin and other painters who played a part in the revival of Chardin are studied by Gabriel P. Weisberg with William Talbot in *Chardin and the Still-Life Tradition in France* (Cleveland: Cleveland Museum of Art, 1979).

8 Reprinted from Jules Borély's article "Cézanne à Aix," (*L'art vivant*, no. 2, 1926), in P. M. Durand, ed., *Conversations avec Cézanne* (Paris: Macula, 1978), 18–22.

9 Cézanne as quoted by Emile Bernard in *L'occident* (July 1904): 17–30, excerpted in Wechsler, *Cézanne in Perspective*, 42.

10 For a discussion of Chardin's influence on Cézanne, see Theodore Reff's essay "Chardin et Cézanne" in *Cézanne aujourd'hui: actes du colloque organisé par le Musée d'Orsay 29 et 30 Novembre 1995* (Paris: Réunion des musées nationaux, 1997), 11–28. Pissarro, whose still life, plate 30, of ca. 1872 is clearly indebted to Chardin, probably pointed Cézanne in that direction.

11 The specific source was probably a still life of Jacob's discarded clothing in his decoration in the church of St. Sulpice in Paris, which became a school for Impressionists when it opened in the 1860s.

12 The chronology of these late still lifes is discussed by Theodore Reff in his essay, "Painting and Theory in the Final Decade," in Theodore Reff et al., *Cézanne, The Late Work* (New York: The Museum of Modern Art, 1977), 13–53.

13 Emile Zola, "Notes parisiennes sur une exposition: peintres impressionistes," *Le sémaphore de Marseille*, 19 April 1877. Reprinted in *Emile Zola, écrits sur l'art* (Paris: Gallimard, 1991), 355–59.

14 D. H. Lawrence, "Introduction to These Paintings," in *The Paintings of D. H. Lawrence* (1929) excerpted in Wechsler, *Cézanne in Perspective*, 87–93.

APPLES AND ABSTRACTION
Richard Shiff

1 See Merete Bodelsen, "Gauguin, the Collector," *The Burlington Magazine* 112 (September 1970): 606; Maurice Denis, "L'aventure posthume de Cézanne," *Prométhée* 6 (July 1939): 195.

2 See Gauguin, letter to Emile Schuffenecker, 14 January 1885, in Victor Merlhès, ed., *Correspondance de Paul Gauguin (1873–1888)* (Paris: Fondation Singer-Polignac, 1984), 87–89.

3 Gustave Geffroy, "Paul Cézanne" (1894), *La vie artistique*, 8 vols. (Paris: Dentu [vols. 1–4]; Floury

[vols. 5–8], 1892–1903), vol. 3, 259. (All translations are the author's.)

4 Barnett Newman, "Interview with Emile de Antonio" (1970), in John P. O'Neill, ed., *Barnett Newman: Selected Writings and Interviews* (Berkeley: University of California Press, 1992), 303. Francis Jourdain, who met Cézanne in 1904, recalled a half century later—that is, from the perspective of Newman's era—that the "apples were explosive," and, because of the extraordinary attention they brought, "the most shocked by the explosion was Cézanne" (statement in *Tombeau de Cézanne* [Paris: Société Paul Cézanne, 1956], 34).

5 Harold Rosenberg, "The American Action Painters," *Art News* 51 (December 1952): 22–23, 48–50.

6 C. J. Bulliet, *Apples & Madonnas: Emotional Expression in Modern Art* (Chicago: Pascal Covici, 1927), 1.

7 By investigating the traditional resonances of the image of the apple, as well as psychoanalyzing its form and place in Cézanne's art, Meyer Schapiro resisted the common view ("The Apples of Cézanne: An Essay on the Meaning of Still-Life" [1968], in *Modern Art: 19th and 20th Centuries, Selected Papers*, [New York: George Braziller, 1978], 1–38). The subsequent fame of his essay deflected scholarship from the culturally specific, public meaning that apples and still life held for Cézanne's generation: no "meaning." No meaning was surely of more historical importance than the various other meanings Schapiro's counterintuitive study uncovered, as his own writing elsewhere indicates; see below, note 10.

8 The correspondence between still life and portraiture could be viewed positively, as when Théodore Duret remarked that in Cézanne's art "some apples and a napkin on a table assume the same grandeur as a human head," or negatively, as when Charles Morice concluded that the painter "took no more interest in a human face than in an apple." Théodore Duret, *Histoire des peintres impressionnistes* (Paris: Floury, 1906), 180; Charles Morice, "Le XXIe Salon des Indépendants," *Mercure de France* 54 (15 April 1905): 552. When Cézanne was at work on his dealer Ambroise Vollard's portrait, he requested that his model "be still like an apple." Ambroise Vollard, *Paul Cézanne* (Paris: Crès, 1919 [1914]), 124. Even if inaccurate—for Vollard often embellished his anecdotes—this account reinforces the importance of the association of Cézanne and apples, as do numerous other bits of documentation that might be cited, including Cézanne's quip that he would "astonish [the city of] Paris with an apple." (See Gustave Geffroy, *Claude Monet: sa vie, son oeuvre*, 2 vols. (Paris: Crès, 1924), vol. 2, 68.

9 Rosenberg, "The American Action Painters," 23.

10 Meyer Schapiro applied a sense of history similar to Rosenberg's when he assigned Cézanne to a position "between the old kind of picture, faithful to a striking or beautiful object, and the modern 'abstract' kind of painting, a moving harmony of colored touches representing nothing." Meyer Schapiro, *Paul Cézanne* (New York: Abrams, 1962 [1952]), 9–10. Although abstract art "represent[ed] nothing," it marked "the occasion of spontaneity or intense feeling. [Abstract] painting symbolizes an individual who realizes freedom and deep engagement of the self within his work" (Schapiro, "The Liberating Quality of Avant-Garde Art," *Art News* 56 (summer 1957): 38. To mid-twentieth-century critics like Rosenberg and Schapiro,

humanistic content could be entirely independent of subject matter.

11 Cézanne, letter to Bernard, 26 May 1904, in John Rewald, ed., *Paul Cézanne: Correspondance* (Paris: Grasset, 1978), 303.

12 Charles Baudelaire, "Salon de 1846," *Oeuvres complètes*, ed. Claude Pichois, 2 vols. (Paris: Gallimard, 1975–76), vol. 2, 493.

13 See Richard Shiff, "Sensation, Movement, Cézanne," in Terence Maloon, ed., *Classic Cézanne* (Sydney: Art Gallery of New South Wales, 1998), 13–27.

14 For more extensive analysis of *Nature morte avec l'amour en plâtre* (in the context of Cézanne's convergence of touch and vision), see Richard Shiff, "Cézanne's Physicality: The Politics of Touch," in Salim Kemal and Ivan Gaskell, eds., *The Language of Art History* (Cambridge: Cambridge University Press, 1991), 129–80.

15 See Gauguin, letter to Camille Pissarro, July 1881, in *Correspondance de Paul Gauguin (1873–1888)*, 21; P.-L. Maud (Maurice Denis), "L'influence de Paul Gauguin," *L'occident* 4 (October 1903): 164. By 1907, with both Cézanne and Gauguin deceased, younger artists were contesting the relative merits of their two styles. Attempting to settle the dispute, Charles Morice argued that Cézanne had indicated the way, whereas Gauguin eventually realized its full potential. Morice, "Art moderne: la grande querelle," *Mercure de France* 70 (1 December 1907): 547.

16 Compare commentary in Geffroy, "Paul Cézanne," vol. 3, 259.

17 Emile Bernard, "Paul Cézanne," *L'occident* 6 (July 1904): 21.

18 Sérusier, quoted in Maurice Denis, "Cézanne," *L'occident* 12 (September 1907): 125 (original emphasis). Denis himself commented that "facing [a] Cézanne, we think only of the painting," the form as opposed to the subject matter (ibid., 120). Compare Denis, "Le peintre Paul Sérusier," *L'occident* 14 (October 1908): 279. The cultural specificity of subject matter, as opposed to the professed universality of form, was a reason to privilege the latter: form seemed liberating; subject matter seemed restrictive in its hierarchies of signification. See Richard Shiff, *Cézanne and the End of Impressionism*, (Chicago: University of Chicago Press, 1984), 39–52; "Sensation, Movement, Cézanne," 22.

19 Compare Thadée Natanson's remark of 1895: "[Cézanne] makes apples his own. . . . They belong to him as much as an object belongs to its creator." Natanson, "Paul Cézanne," *La revue blanche* 9 (1 December 1895): 500.

20 On the "motif," see Shiff, "Sensation, Movement, Cézanne," 18–22.

21 Significantly, Sérusier is shown "explaining" the still life once owned by Gauguin in Denis's painting *Hommage à Cézanne*, exhibited at the Paris Salon of 1901.

22 For insight into Newman's antiformalist attitude, see his "The Anglo-Saxon Tradition in Art Criticism" (ca. 1944–45) and "Ohio, 1949" (1949), in O'Neill, *Barnett Newman*, 83–86, 174–75; for de Kooning, see his "What Abstract Art Means to Me," *The Museum of Modern Art Bulletin* 18 (spring 1951): 4–8.

23 Cézanne's words, as remembered or reconstructed by Joachim Gasquet, *Cézanne* (Paris: Bernheim-Jeune, 1921), 81. Compare Cézanne, letters to Charles Camoin (13 September 1903), Emile

Bernard (12, 26 May 1904, undated 1905, 23 October 1905), and his son Paul (13, 26 September 1906), *Paul Cézanne: Correspondance*, 296, 301–03, 313–15, 325, 328–29.

24 "Abstraction" had been regarded in this way by Stéphane Mallarmé, an inspiration for Gauguin and other symbolists. He linked abstraction to artistic naïveté when addressing Edouard Manet's painting in 1876 (in an essay that exists only in English): "[The eye] should abstract itself from memory, seeing only that which it looks upon, and that as for the first time; and the hand should become an impersonal abstraction guided only by the will, oblivious of all previous cunning [skill at representational rendering]." Stéphane Mallarmé, "The Impressionists and Edouard Manet," *Art Monthly Review* 1 (30 September 1876): 118. When abstraction is associated with obliviousness, it verges on mental and sensory distraction, both of which (mild paradox) can result from an intensification and concentration of energies.

25 Maurice Denis, "A propos de l'exposition de Charles Guérin" (1905), *Théories, 1890–1910: Du symbolisme et de Gauguin vers un nouvel ordre classique* (Paris: Rouart et Watelin, 1920), 143–44. Elsewhere Denis argued that Cézanne's decorative form, beautiful by any standard, would express "inner life" by conveying "emotions or states of mind" induced by nature, "without the need of furnishing [its illusionistic] *copy*," that is, without specificity of subject matter. Maurice Denis, "De Gauguin et de van Gogh au classicisme" (1909), *Théories*, 267–68, 271 [original emphasis].

26 Denis, statement in Charles Morice, "Enquête sur les tendances actuelles des arts plastiques," *Mercure de France* 56 (1 August 1905): 356.

27 Denis, "Cézanne," 132.

28 Denis, "L'aventure posthume de Cézanne," 194, 196; see also Denis, "L'influence de Cézanne" (1920), *Nouvelles théories: Sur l'art moderne, sur l'art sacré 1914–1921* (Paris: Rouart et Watelin, 1922), 284. Compare Louis Vauxcelles, who in 1906 warned Matisse to distrust "theories, system, and the abstract" and complained that André Derain was "immersing himself in the abstract and casting himself outside of nature." Vauxcelles, "Le Salon des Indépendants," *Gil Blas* (20 March 1906), n.p.

29 Charles Morice, "Paul Cézanne," *Mercure de France* 65 (15 February 1907): 577. The prevalence of studio themes (still lifes, images of models, views from windows) in early-twentieth-century painting resulted, at least in part, from isolation being regarded as a suitable response to conditions of modernity. The studio, like the bourgeois home, could be a place of withdrawal. Artists represented the nude—traditionally, much more than a studio object—"as if they were making a [mere] still life, interested only in [abstract] relations of line and color [and turning the model into] a decorative accessory." Charles Morice, "Art moderne: nus," *Mercure de France* 85 (1 June 1910): 546.

30 Morice, "Paul Cézanne," 593.

31 See Cézanne, letter to Paule Conil, 1 September 1902, *Paul Cézanne: Correspondance*, 290.

32 Morice, "Le XXIe Salon des Indépendants," 552; Charles Morice, "Le Salon d'automne," *Mercure de France* 58 (1 December 1905): 390.

33 Morice, "Paul Cézanne," 593–94.

34 Rosenberg, "The American Action Painters," 23 (original ellipsis; typographic emphasis eliminated).

THE PAINTINGS

1 See Pierre Conil, "L'Exposition de peinture de Saintes, G. Courbet," *Courrier des deux Charentes* (Saintes), 19 February 1863, cited in Tinterow and Loyrette, 1995, 358–59.

2 See Sarah Faunce and Abigail Solomon-Godeau in Faunce and Nochlin, 1988, 146.

3 See Henri Loyrette in Boggs et al., 1988, 114–16, and in Tinterow and Loyrette, 1995, 370–71.

4 Quoted by Charles S. Moffett, "Manet and Impressionism," in Cachin and Moffett, 1983, 32.

5 Albert Wolff, "Salon de 1870," *Le figaro*, 13 May 1870, and Emile Zola, *Ecrits sur l'art*, 1867, quoted in Henri Loyrette, "Manet, la nouvelle peinture, la nature morte," in *Manet: les natures mortes* (Paris: Editions de la Martinière, 2000), 13, 15.

6 See, for example, Bonvin's comparably sized *Still Life with Lemon and Oysters* (1858, private collection, formerly in the collection of Joey and Toby Tanenbaum, Toronto); see Tinterow and Loyrette, 1995, cat. no. 16, fig. 189.

7 See Gabriel P. Weisberg, *Chardin and the Still-Life Tradition in France* (Cleveland: Cleveland Museum of Art, 1979); M. Virginia B. Bettendorf, "Cézanne's Early Realism: 'Still Life with Bread and Eggs' Reexamined," *Arts Magazine* 56 (January 1982):138–41.

8 *Still Life with Fish* was on the list of paintings to be exhibited at Martinet's gallery in February 1865 but may not have been shown until the spring, when it was presented at the gallery of the dealer Cadart. For the early exhibition history of this work and *The Salmon's* pendant, *Still Life with Melon and Peaches*, see Charles S. Moffett in Cachin and Moffett, 1983, 214–18. In spite of the traditional dating of *The Salmon* to 1866, a Metropolitan Museum of Art curatorial file suggests that *The Salmon* may be the work described in an April 1864 article about Martinet's exhibition of the Société nationale des beaux-arts.

9 Rainer Maria Rilke, *Letters on Cézanne* (London: Jonathan Cape, 1988), 96.

10 Charles de Sarlat, "Exposition de peinture," *L'avant-scène*, 21 June 1866, quoted in Aleth Jourdan et al., *Frédéric Bazille, Prophet of Impressionism* (Brooklyn: Brooklyn Museum, 1992), 93.

11 Bazille to his mother, between 29 November and 15 December 1866, cited in ibid., 161, and *Correspondance: Frédéric Bazille*, comp. Didier Vatuone, ed. Guy Barral and Didier Vatuone (Montpellier: Les Presses du Languedoc, 1992), cited in Tinterow and Loyrette, 1995, 156–57.

12 Christopher B. Campbell, "Pissarro and the Palette Knife: Two Pictures from 1867," *Apollo* 136 (November 1992): 311.

13 Adolphe Tabarant, *Manet et ses oeuvres* (Paris: Gallimard, 1947), 93; and Mikael Wivel in collaboration with Juliet Wilson-Bareau and Hanne Finsen, *Manet* (Copenhagen: Ordrupgaard, 1989), 72. See also Cachin and Moffett, 1983, 210, regarding the date of this work.

14 Françoise Cachin, in Cachin and Moffett, 1983, 210, associates this painting with *Peonies in a Vase on a Stand* (1864, Musée d'Orsay, Paris), stating, "It might pass for an enlarged detail."

15 See, for example, Velázquez's *Portrait of the Infanta Marguerita* (1653), once in the Belvedere and now in the Kunsthistorisches Museum in Vienna.

16 Françoise Cachin, in Cachin and Moffett, 1983, 210.

17 See J. Rishel, *The Second Empire, 1852–1870: Art in France under Napoleon III* (Philadelphia: Philadelphia Museum of Art, 1978), who writes of this painting by Monet, "Its sources are numerous and at this date, it is almost certain that the reference here is to Courbet, whom he [Monet] met in Paris in the spring of 1864." Gary Tinterow cites Rishel on this fact in Tinterow and Loyrette, 1995, 370–71. In House, 1986, John House states "Courbet's recent flower paintings were his [Monet's] most obvious model"; 40.

18 See, for example, the *Large Milan Bouquet* by Jan Breughel the Elder (1606, Milan, Pinacoteca Ambrosiana). Like Courbet's, Breughel's bouquet fills the canvas and displays a profusion of many different varieties of flowers. The difference between the two is that Courbet derived his composition entirely from nature.

19 Henry S. Francis, " 'Spring Flowers' by Claude Monet," *Bulletin of the Cleveland Museum of Art* 41 (February 1954): 24.

20 Monet to Bazille, 15 July 1864, in Wildenstein, 1974, vol. 1, 420, letter no. 8.

21 *Monet* Wildenstein, 1996, vol. 2, 17–24.

22 Monet to Bazille, 26 August 1864, in ibid., letter no. 9, 421.

23 The painting in the Oskar Reinhart Collection has also been called *Calla and Hothouse Plants*; the version in the Hamburger Kunsthalle, *Spring Flowers in a Hothouse*; see Götz Adriani, *Renoir: Kunsthalle Tübingen* (Cologne: DuMont, 1996), 67.

24 See Dianne W. Pitman, *Bazille: Purity, Pose and Painting in the 1860s* (University Park, Penn.: Pennsylvania State University, 1998) 77, 78, 80, 82. Pitman refers to Bazille's painting as *Potted Plants*.

25 See François Daulte, *Frédéric Bazille et les débuts de l'impressionnisme: catalogue raisonné de l'oeuvre peint* (Paris: La Bibliothèque des Arts, 1992), 161, cat. no. 20; and Michel Sculman, *Frédéric Bazille, 1841–1870: Catalogue raisonné, peintures, dessins, pastels, aquarelles* (Paris: Editions de l'amateur: Editions des catalogues raisonnés, 1995), 142.

26 Monet decried how his painting was hung at Rouen: "I am terribly badly placed against the light and it is completely impossible to see anything there!" Monet to Bazille, 16 October 1864, in Wildenstein, 1974, vol. 1, 421, letter no. 12.

27 No history of the exhibition of either painting by Renoir in his lifetime has been discovered by the museums that own these works.

28 Courbet to Charles-Paul Desavary, 27 July 1869, published in *Les amis de Gustave Courbet* 31 (1964): 15, quoted in Tinterow and Loyrette, 1995, cat. no. 43, note 1. See also Colta Ives, with Elizabeth E. Barker, *Romanticism and the School of Nature: Nineteenth-Century Drawings and Paintings from the Karen B. Cohen Collection* (New Haven, Conn.: Yale University Press and the Metropolitan Museum of Art, 2000), 216. The painting is also discussed by Ann Dumas in Faunce and Nochlin, 1988, cat. no. 58.

29 For all three, see Faunce and Nochlin, 1988, pl. 6, cat. nos. 27, 33.

30 See, for example, Tinterow and Loyrette, 1995, cat. no. 43, and Ives, *Romanticism and the School of Nature*.

31 Courbet to his family, 17 November 1865, quoted in Chu, 1992, 269, letter 65–16, quoted in Richard Dorment et al., *James McNeill Whistler* (New York: Harry N. Abrams, 1995), 111.

32 For the Courbet portraits of Jo (Joanna Hiffernan), see Faunce and Nochlin, 1988, cat. nos. 53–57; for the paintings by Whistler, see ibid., cat. nos. 14, 60.

33 See Tinterow and Loyrette, 1995, cat. no. 172, 453–54, cat. no. 8, 332–33, cat. no. 187, 462. See also Jourdan, *Frédéric Bazille, Prophet of Impressionism*, cat. no. 14.

34 See Cachin and Moffett, 1983, cat. nos. 73–74. Both paintings were exhibited at the Salon of 1864 and at Manet's exhibition of 1867.

35 Because of a similarity to *White Cup and Saucer* in terms of size and a simple purity of subject and conception, it is tempting to think that Fantin-Latour might have known *Cup of Water and a Rose on a Silver Plate* (n.d., National Gallery, London) by Francisco de Zurbarán. This small still life depicts one of the elements—a cup of water—included in the only undisputed still life by de Zurbarán, *Still Life with Lemons, Oranges and a Cup of Water* (1633, Norton Simon Foundation, Pasadena). See William B. Jordan, *Spanish Still Life in the Golden Age, 1600–1650* (Fort Worth, Tex.: Kimbell Art Museum, 1985), 222–23.

36 See Craig Hartley, in *Treasures from the Fitzwilliam* (Cambridge, England: Cambridge University Press, 1989), 160. Hartley speculates that this painting may have been painted while the artist was staying with the Edwardses, but he does not indicate whether the work was a gift or purchased from Fantin-Latour by its first owner, Ruth Edwards. The Fitzwilliam Museum also has in its collection Fantin-Latour's *White Candlestick* (1870), of similar dimensions and also first owned by Mrs. Edwin Edwards.

37 Wildenstein, 1996, vol. 2, 42, cat. no. 77.

38 See ibid., 27, cat. nos. 51–52. For a discussion of this period in Monet's work, see Joel Isaacson, *Observation and Reflection: Claude Monet* (Oxford, England: Phaidon, 1978), 12–18.

39 It is not certain exactly which of Chardin's paintings Diderot was describing, but it may have been *Jar of Olives*, which was shown at the Galerie Martinet, Paris, in 1860 and which entered the Louvre from the La Caze Collection in 1869. The painting contains, in fact, many other elements of still life besides the jar of olives after which it was named. See Pierre Rosenberg, *Chardin* (Paris: Grand Palais, 1979), 322.

40 See Cachin and Moffett, 1983, chronology pages 504–17.

41 See Pierre Rosenberg in *Chardin, 1699–1779* (Cleveland: Cleveland Museum of Art, 1979), 354. Rosenberg cites an article in which Jacques Mathey attributes to Manet a copy of this painting, but the copy appears to be by another hand.

42 Edmond de Goncourt, quoted in ibid., 354.

43 For help in identifying the flowers in the painting, I am indebted to Monique Reed, herbarium botanist in the biology department of Texas A&M University.

44 Druick and Hoog, 1983, 14. See also 134–35 for a description of the flowers in the bouquet.

45 Hélène Adhémar, ed., *Hommage à Claude Monet* (Paris: Galeries Nationales du Grand Palais, 1980), 138.

46 House, 1986, 40.

47 Ibid. House suggests that Monet's 1872 paintings showed him "looking to Fantin-Latour's delicate and refined reworking of the Chardin tradition." The plate, according to Wu Tung, Matsutaro Shoriki Curator of Asiatic Art at the Museum of Fine Arts, Boston, is most likely the Japanese Arita variant of a Chinese porcelain known as "kraak," imported to Europe since the seventeenth century. Tracey Albainy, Russell B. and Andrée Beauchamp Stearns Curator of Decorative Arts and Sculpture at the Museum of Fine Arts, Boston, suggests that the plate might be Delft. Given that Monet had recently returned to France from Holland, the latter is an intriguing possibility.

48 Monique Reed has suggested that this plant is perhaps *Salvia argentea*. The painting was purchased from Monet by Durand-Ruel in early November 1872. Monet recorded the sale of a *Nature morte* at four hundred francs, and the work entered Durand-Ruel's stockbook as *cafetière, tasse à café*. See Adhémar, *Hommage à Claude Monet*, 138.

49 See Druick and Hoog, 1983, cat. no. 97, for a discussion of *Still Life: Corner of a Table*; for Durand-Ruel's 1872 purchases of Fantin's still lifes, 256. The description of his painting comes from Fantin-Latour's letter to Otto Scholderer of 25 January 1874.

50 Courbet to Emile Joute, 3 July 1871, quoted in Chu, 1992, letter 71–21.

51 Courbet was sentenced on 2 September 1871. See ibid., letter 71-32. Although Courbet drafted a letter (70-27) to the Government of National Defense requesting the "unbolting" of the Vendôme Column on 14 September 1870, he wrote another letter (70-32) to the same agency the following month saying that he "did not request that the Vendôme Column be broken." In May 1871, a letter that was published in the *Times* (71-16) affirms Courbet's "purity of motives": "I am accused of having destroyed the Vendôme Column, when the fact is on record that the decree for its destruction was voted on the fourteenth of April, and I was elected to the Commune on the twentieth, six days afterwards. I warmly urged the preservation of the bas-reliefs, and proposed to form a museum of them in the courtyard of the Invalides." See Chu, 1992, note 4, 419–20 for the sequence of events that led to the column's destruction.

52 "Everyone agrees that I am the foremost man in France," Courbet wrote to his family on 15 July 1870. "I have so many commissions at the moment that I cannot see the end of it." Chu, 1992, letter 70-21.

53 See Przyblyski, 1995, 255–56, for a more detailed discussion of Sainte-Pélagie.

54 In a letter to Juliette Courbet dated 29 September 1871, Courbet wrote, "I'll try to get my paints and work a little." Chu, 1992, letter 71-38.

55 Przyblyski, 1995, 259.

56 See Faunce and Nochlin, 1988, cat. nos. 53–56. We are given a similar three-quarter view of the woman's face. She has long, wavy tresses reminiscent of Hiffernan's and the suggestion of a white collar as in the portrait group.

57 Chu, 1992, letter 72-1.

58 Ibid., letter 72-2. Courbet's mother died during his time in Sainte-Pélagie.

59 Przyblyski, 1995, 251.

60 Ibid., 270, makes this point.

61 See Pissarro, 1993, 268–76, for an illuminating discussion of Pissarro's involvement with still life.

62 Ibid., 271.

63 The painting is *Landscape at Pontoise: Trees in Blossom* (1877, Musée d'Orsay, Paris). See entry for cat. no. 21 in Françoise Cachin et al., *Camille Pissarro 1830–1903* (Paris: Editions de la Réunion des Musées Nationaux, 1981), 88.

64 *Self-Portrait* (1873, Musée d'Orsay, Paris).

65 It is uncertain exactly when Manet and Morisot first met. In Cachin and Moffett, 1983, the year given is 1867 (302), based on Monique Angoulvent, *Berthe Morisot* (Paris: A. Morancé [1933?]), 22. This source maintains that Morisot was working on a copy after Rubens in the Louvre when Fantin-Latour introduced Berthe and Edma Morisot to Manet. However, the chronology compiled in Clairet, Montalant, and Rouart, 1997, 81, assigns their first encounter to 1868.

66 Clairet, Montalant, Rouart, 1997, 41.

67 See Antonin Proust, *Edouard Manet, souvenirs* (Paris: H. Laurens, 1913), 57.

68 Manet, quoted by Juliet Wilson-Bareau, ed., *Manet by Himself: Correspondence and Conversation, Paintings, Pastels, Prints and Drawings* (London: MacDonald & Co., 1991), 161.

69 Paul Valéry describes Morisot's eyes, "They were almost too enormous, and so powerfully deep that Manet, in the many portraits he made of her, in order to capture their full dark and magnetic force, painted them black instead of the greenish that they were." Paul Valéry, *Triomphe de Manet, suivi de "Tante Berthe"* (Paris: Editions des Musées Nationaux, 1932), 30–31.

70 Germain Bazin, *A Gallery of Flowers*, trans. Jonathan Griffin (New York: Appleton-Century, 1964), 170–73.

71 See Margaret Shennan, *Berthe Morisot, The First Lady of Impressionism* (Thrupp, Stroud, England: Sutton Publications, 1996), 8, 98–124.

72 See Carol Jane Grant, "Eva Gonzalès (1849–1883): An Examination of the Artist's Style and Subject Matter," Ph.D. diss., Ohio State University, 1994, 74. An example of Guérard's shoe prints is the etching *The Assault on the Shoe* (fig. 51), which seems to feature the same shoe as in Gonzalès's *Pink Shoes*.

73 The square toe came into fashion by 1830 and remained stylish for the next fifty years. After the French Revolution, heels shrank and even disappeared, suggesting, in accordance with the egalitarian nature of the times, that everyone was born on the same level. Although they were slow to return to women's footwear, by the 1870s heels were a standard addition to fashionable women's shoes. A somewhat similar type of square-toed shoe is seen in Berthe Morisot's *Madame Hubbard* (1874, Ordrupgaardsamlingen, Copenhagen).

74 Da Rosa, 1996, 252. See also Mauner and Loyrette, 2000, 24–25.

75 Edward Lucie-Smith, *Henri Fantin-Latour* (Oxford, England: Phaidon, 1977), 12.

76 Wildenstein, 1996, vol. 1, 50. See also Gabriel P. Weisberg, "Fantin-Latour and Still Life in *Un Atelier aux Batignolles*," *Gazette des beaux arts* 90 (December 1977): 205–15.

77 Ernest Chesneau, quoted in "Le Japon à Paris," *Gazette des beaux arts* 18 (September 1878): 386.

78 Druick and Hoog, 1983, 264.

79 The most thorough discussion of this painting is S. Lane Faison, Jr., "Renoir's Hommage à Manet," *Intuition und Kunstwissenschaft, Festschrift Hans Swarzenski* (Berlin: Mann Verlag, 1973), 571–78.

80 Manet exhibited his etching of the *Little Cavaliers* at the Salon des refusés (1863), in his one-man exhibition of 1867, and in the Salon of 1869. The painting, which was also called *A Gathering of Artists* during the nineteenth century, is no longer attributed to Velázquez.

81 Fantin-Latour to Scholderer, 25 January 1874, quoted in Druick and Hoog, 1983, 261.

82 See "Fantin-Latour: Coin de Table," in *Les dossiers du musée d'Orsay* 18 (Paris: Editions de la Réunion des Musées Nationaux, 1987). Fantin-Latour also painted a group portrait called *The Toast* (1865), which he subsequently destroyed.

83 According to Lucie-Smith, *Fantin-Latour,* 12, Titian's *Supper at Emmaus* was one of the works in the Louvre that Fantin-Latour copied.

84 See Henri Loyrette, "Still Life," in Tinterow and Loyrette, 1995, 156.

85 Paul Mantz, "Le Salon VII," *Le temps* (18 June 1873): 1, quoted in Przyblyski, 1995, 209. See also Druick and Hoog, 1983, 259.

86 John Rewald, *Camille Pissarro* (New York: Harry N. Abrams, 1963), 90.

87 For the still lifes exhibited by Cézanne in 1877, see Pissarro, 1993, 271; Moffett et al., 1986, 204.

88 In Ludovic Rodo Pissarro and Lionello Venturi, *Camille Pissarro: son art—son oeuvre,* 2 vols. (Paris: Paul Rosenberg, 1939), see the following still lifes—two from 1898 (cat. nos. 1063–64), 1899 (cat. no. 1069), ca. 1899–1900 (cat. no. 1070), and 1900 (cat. no. 1116). Pissarro painted five floral bouquets in 1900 (cat. nos. 1117, 1119–22). The last still life is dated 1902 (cat. no. 1273).

89 Wildenstein, 1996, vol. 2, cat. no. 202, 92; see also Monet's *House at Argenteuil* (1873, Art Institute of Chicago), cat. no. 284, 121.

90 Regarding the date of this painting, see E. Rathbone, "The Red Cape," in Charles Moffett et al., *Impressionists in Winter* (Washington, D.C.: The Phillips Collection in collaboration with Philip Wilson Publishers, 1998), 86.

91 See François Daulte, *Alfred Sisley: catalogue raisonné de l'oeuvre peint* (Lausanne: Editions Durand-Ruel, 1959), cat. nos. 5–8, 186, 233–34, 661–62. See also MaryAnne Stevens, ed., *Alfred Sisley* (New Haven: Yale University Press, 1992), 174, for an overview of Sisley's still lifes.

92 Joris-Karl Huysmans, "Appendice," in *L'art moderne* (Paris: G. Charpentier, 1883), 261, 277, cited in Lucy MacClintock, *From Neoclassicism to Impressionism: French Paintings from the Museum of Fine Arts, Boston* (Kyoto: Kyoto Municipal Museum of Art, 1989), cat. no. 64.

93 See Charles F. Stuckey, *Claude Monet, 1840–1926* (Chicago: Art Institute of Chicago, 1995), 206.

94 *Still Life with Honeydew Melon* (1879, formerly Kimbell Art Museum, now private collection), *Apples and Grapes* (1879, Metropolitan Museum of Art, New York), *Still Life: Apples and Grapes* (1880, Art Institute of Chicago), *Basket of Apples* (1880, private collection), and *Pears and Grapes* (1880, Hamburger Kunsthalle, Hamburg). See Wildenstein, 1996, vol. 2, cat. nos. 544–46, 630–31.

95 See Henri Loyrette in Tinterow and Loyrette, 1995, 156.

96 Ibid.

97 Alfred Sisley to Adolphe Tavernier, 18 March 1893, in R. Goldwater and M. Treves, eds., *Artists on Art from the Fourteenth to the Twentieth Century* (London: Kegan Paul, 1947), 308–10.

98 Berthe Morisot married Eugène Manet, brother of the painter Edouard Manet, on 22 December 1874. Her only child, Eugènie Julie Manet, was born on 14 November 1878. *Dahlias* was probably painted in the apartment at 7, rue Guichard in Passy, where the Morisot family had moved to by 1872 and which Morisot's mother had vacated to make way for the newly married Berthe. After Madame Morisot's death in December 1876, Berthe and Eugène rented a new apartment near the place de l'Étoile at 9, avenue d'Eylau (now the avenue Victor Hugo). It was at this new apartment that *Tureen and Apple* was probably painted in 1877. See "Biographie," in Clairet, Montalant, Rouart, 1997, 87–89.

99 See ibid., 92.

100 In her notebooks Morisot explained, "The eternal question of drawing and color is futile because color is only an expression of form." Quoted by William P. Scott, "Morisot's Style and Technique," in Charles F. Stuckey et al., *Berthe Morisot, Impressionist* (New York: Hudson Hills Press, 1987), 189.

101 Quoted in ibid., 70.

102 Mauner and Loyrette, 2000, 47.

103 Born in Odessa, Ukraine, in 1849, Charles Ephrussi moved to Paris at age 22 in 1871. He ultimately became co-owner and publisher of the *Gazette des beaux-arts.* See particularly the history of Ephrussi in Hans Haake, *Manet-Projekt '74,* as reproduced in T.A. Gronberg, ed., *Manet, A Retrospective* (New York: Park Lane, 1990), 346; and Beth Archer Brombert, *Edouard Manet: Rebel in a Frock Coat* (Chicago: University of Chicago Press, 1997), 439.

104 Adolphe Tabarant, *Manet et ses oeuvres* (Paris: Gallimard, 1947), 387–88. See also Gronberg, ed., *Manet: A Retrospective,* 346; and James H. Rubin, *Manet's Silence and the Poetics of Bouquets* (Cambridge, Mass.: Harvard University Press, 1994), 192–93.

105 Marcel Proust, *Swann's Way,* trans. C. K. Scott Moncrieff (1926; reprint, New York: Modern Library, 1956), 153–54. Charles Ephrussi is said to have been one of the inspirations for Charles Swann in Marcel Proust's *Remembrance of Things Past.* For a discussion of Manet's painting and literature, including Proust, see Gert von der Osten, "Nachtrag zu Manets Spargelbündel," in *Wallraf-Richartz-Jahrbuch: westdeutsches Jahrbuch für Kunstgeschichte,* vol. 33, (1971), 253–58.

106 S. Adriaen Coorte, a seventeenth-century Dutch painter, is one of the few who painted iconic images of nothing more than firm, white bunches of asparagus placed on simple ledges and illuminated with dramatic lighting. George Mauner's recent essay states, however, that Manet could not have known Coorte's work. See Mauner and Loyrette, 2000, 48. Coorte's work was compared with Manet's in Gert von der Osten, "Manets Spargelbündel 'Bei Liebermann' jetzt in Köln," in *Wallraf-Richartz-Jahrbuch: westdeutsches Jahrbuch für Kunstgeschichte,* vol. 31, (1969), 141.

107 Jane Grigson, *Jane Grigson's Vegetable Book* (London: Penguin Books, 1980), 34. See also Alan Davidson, *The Oxford Companion to Food* (Oxford, England: Oxford University Press, 1999), 38; and Jenifer

108 See this informative discussion in von der Osten, "Manets Spargelbündel 'Bei Liebermann,'" 141–42.

109 Rewald, 1996, vol. 1, 232, cat. no. 347, dates *Pears and Knife* from 1877–78, but Venturi assigns the work a date of 1879–82 (Rewald, 1996, 232).

110 When Cézanne showed seventeen works in the third Impressionist exhibition in 1877, their heavily impastoed surfaces and bold use of color made them difficult for the public to accept. His work was also not well received by the critics, one of whom called them "detestable jokes." Ernest Fillonneau, "Les Impressionistes," *Moniteur des Arts* 20 (April 1877), quoted in Berson, 1996, vol. 1, 146. Another critic said of the artist, "He has had such visions this year that corrective lenses have become indispensable for him." *La petite république Française,* 10 April 1977, quoted in Moffett et al., 1986, 215.

111 Rewald, 1996, vol. 1, 217–18.

112 Ibid., cat. no. 480.

113 This was one of Chardin's paintings that was part of the La Caze bequest to the Louvre in 1869.

114 Rewald, 1996, vol. 1, 330–36, 339–42, 344–47.

115 See William Rubin, in William Rubin and Matthew Armstrong, *The William S. Paley Collection* (New York: Museum of Modern Art, 1992), 22.

116 Cézanne participated in the Impressionist exhibitions on only two occasions, both in the 1870s—the first exhibition in 1874 and the third in 1877. Probably among the works shown in 1877 was the first still life Cézanne made that included the wood chest and white fruit bowl. See Rewald 1996, vol. 1, 223, cat. no. 329.

117 Ibid., 280, states in reference to the painting in the Ny Carlsberg Glyptotek, cat. no. 419: "There can be no doubt that the three still lifes with the white fruit bowl, assembled on the brown chest and set against the same bluish wallpaper (nos. 418–20) were composed and painted in the same place, but their sequence seems almost impossible to ascertain. . . . These three still lifes, as well as nos. 417, 427 and 431, have been assembled on the wooden chest already used by Cézanne in Auvers and Paris; it seems to have followed him through many moves."

118 See ibid., for an extensive discussion of the dating of these works. The entry for cat. no. 420 (280) reads, "The bluish wallpaper with sprays of leaves, found in the background of this still life, has been identified by Gowing with Cézanne's 67, rue de l'Ouest apartment in Paris (1877–79) but by Venturi with Cézanne's lodgings in Melun (1879–80) or in Paris, 32, rue de l'Ouest (1880–82). . . . It is most unlikely that the wallpaper with sprays of leaves decorated the painter's first, very small 67, rue de l'Ouest apartment. . . . Various authors have also pointed out that in 1879 Cézanne spent only one month in this apartment between his arrival from Aix and his departure for Melun."

119 See ibid., 282, cat. no. 421, which suggests that the portrait could have been painted at Melun or later but probably cannot be assigned to Cézanne's first apartment on the rue de l'Ouest on stylistic grounds. It is possible, however, that Louis Guillaume visited the Cézanne family in Melun, since he was a friend and contemporary of Cézanne's son, Paul. Moreover, since the wallpaper is more

Harvey Lang, ed., *Larousse Gastronomique* (1988; reprint, New York: Crown Publishers, 1998), 41–42.

minimally described in the portrait, its reference to a specific location becomes more tenuous.

120 William Rubin observes that the "antinaturalistic patterning of the latter [the tablecloth] virtually forms a monumental 'landscape' of its own in the center of the picture; less like cloth than a mountain range, it locks the forms of the fruit in place at its feet, much as Mont Sainte-Victoire does in many of Cézanne's landscapes, in which the mountain unites at its base the nearby houses and trees." Rubin and Armstrong, *The William S. Paley Collection,* 22.

121 In addition to the apples there is a piece of bread in the foreground, a shape Cézanne used in another related still life of this period.

122 Rewald, 1996, vol. 1, 277. Also see Merete Bodelsen, "Gauguin's Cézannes," *Burlington Magazine* 710 (May 1962): 208.

123 Roger Fry, *Cezanne, A Study of His Development* (New York: Noonday Press, 1968), 43–44.

124 Barbara Ehrlich White, "Renoir's Trip to Italy," *Art Bulletin* 51 (December 1969): 333–51. Not only did Renoir look to the old masters, but he was also fascinated by ancient Roman wall painting, especially the still-life frescoes from Pompeii at the Museo Nazionale in Naples. See Karyn Esielonis, "Still Life," in Steven Kern et al., *A Passion for Renoir: Sterling and Francine Clark Collect, 1916–1951* (New York: Harry N. Abrams, 1996), 93.

125 White, "Renoir's Trip to Italy," 347, letter 5.

126 Esielonis, "Still Life," 93.

127 Françoise Cachin et al., *Van Gogh à Paris* (Paris: Musée d'Orsay, 1988), 160, 272, cat. nos. 61, 103. It seems that Durand-Ruel may have purchased Renoir's *Onions* as early as 1882, exhibited the work in 1883, and kept it in his inventory in the 1880s.

128 See Anne Distel, "Chronology," in Anne Distel et al., 1995, 310–18 for specific dates of these advances, purchases, and payments.

129 See letters 15, 17, 19–20, 29, 31–32, 35–36, 40–44, 46–47 in Berhaut, 1994.

130 House, 1986, 42, comes to this conclusion.

131 Marc S. Gerstein, *Impressionism: Selections from Five American Museums* (St. Louis: Saint Louis Art Museum, 1989), 124, suggests that the Minneapolis Institute of Arts painting was the work, then unsold, that Monet exhibited at his 1880 solo exhibition and then again at the 1882 Impressionist exhibition. The entry for the painting in Wildenstein, 1996, vol. 2, 214, affirms that it was indeed the one exhibited in 1882, although Berson, 1996, vol. 2, 206, suggests that the work exhibited may have been another of the versions, Wildenstein, vol. 2, 1996, no. 549. See Wildenstein, 1996, vol. 2, cat. nos. 7, 10, 10a, 102, 141, 246 for the early gamebird paintings (the earliest of which are most closely aligned to the tradition of Chardin), cat. nos. 549, 550–51 for the trio from 1879, and cat. no. 814 for the painting from 1882–83.

132 Theulier, Paris, purchased the vertically oriented canvas in December 1879; Georges Petit purchased the horizontally oriented canvas in which the table's right foreground corner can be seen in February 1880; and Wildenstein speculates that Dubourg, Paris, purchased the Minneapolis painting in 1880 before Durand-Ruel acquired it circa July 1891. See Wildenstein, 1996, vol. 2, cat. nos. 549–51.

133 Caillebotte painted two other, similarly arranged, gamebird paintings that year. See Berhaut, 1994, cat. nos. 281 and 283. The year before he painted five game pictures, three of which depict birds (Berhaut, 1994, cat. nos. 246–48) and one marketplace scene depicting chickens, hares, and gamebirds (plate 59). The year before that, Caillebotte painted one picture of dead partridges (Berhaut, 1994, cat. no. 194). The artist's first foray into the subject occurred in 1873 with a painting of a duck splayed out on a wooden table (Berhaut, 1994, cat. no. 13).

134 See Barbara Stern Shapiro, *Mary Cassatt: Impressionist at Home* (New York: Universe, 1998), 30, 32.

135 Paul Mantz, in Berson, 1996, vol. 2, 297 (I am grateful to Jean Coyner for providing this translation). Most commentators recognized that Cassatt was not French. Many assumed that she was English, comparing her paintings to English works they had seen at the World's Fair of 1879. See Charles Ephrussi and Joris-Karl Huysmans in ibid., 278, 290.

136 J.-K. Huysmans, "L'exposition des indépendants en 1880," in *L'art moderne* (Paris: Galerie Charpentier, 1883): 85–123, cited in Moffett et al., 1986, 320. Huysmans was describing *Nature morte* (1879, private collection), cat. no. 133 in Berhaut, 1994.

137 In his entry on the painting in Distel et al., 1994–95, 241, Douglas Druick notes that the signature just left of the chair suggests that the place is reserved for the artist himself.

138 Ibid. 242.

139 *"À la renommée des galettes."* See Wildenstein, 1996, vol. 2, cat. no. 746, 279.

140 Quoted in Wildenstein, 1979, vol. 2, 214, letter 242.

141 Although Koja, 1996, writes that the flask holds water, Gustave Geffroy, a close friend of the artist's, affirms the liquid to be cider in Gustave Geffroy, *Claude Monet: sa vie, son temps, son oeuvre,* 2 vols. (Paris: G. Crès, 1922), 306.

142 Druick, in Distel et al., 1995, 242.

143 Distel, in her chronology of Caillebotte's life in Distel et al., 1995, 316, notes that Caillebotte shared a ground-floor apartment at 20, rue Vintimille with Monet in 1882 and possibly as early as the end of 1881.

144 For Monet's letter to Durand-Ruel conveying his desire to request the painting from Pourville, see Lionello Venturi, *Les archives de l'impressionisme,* vol. 1 (Paris: Durand-Ruel, Editeurs, 1939), 246–47, cat. no. 48.

145 See the anonymous cartoon as reproduced in Distel et al., 1995, 39.

146 The painting has been analyzed by Varnedoe in J. Kirk T. Varnedoe and Thomas P. Lee, *Gustave Caillebotte: A Retrospective Exhibition* (Houston: Museum of Fine Arts, 1976–77), cat. no. 59, and by Douglas Druick in ibid., cat. no. 93.

147 J.-K. Huysmans, "Appendice," *L'art moderne* (Paris: G. Charpentier, 1883), quoted in Berson, 1996, vol. 2, 397. I am grateful to Jean Coyner for providing this translation.

148 See Berson, 1996, vol. 1, cat. nos. 2, 10–11, 377. These are also reproduced in Distel et al., 1995, cats. 65, 67, and 69.

149 See Distel et al., 1995, cat. nos. 95–96.

150 See Kirk Varnedoe, *Gustave Caillebotte* (New Haven: Yale University Press, 1987), 160.

151 The referenced works are all reproduced in Boggs et al., 1988: *The Collector of Prints* (1866, Metropolitan Museum of Art, New York), 122; *Sulking* (ca. 1869–71, Metropolitan Museum of Art, New York), 147; *Portraits in an Office (New Orleans)* (1873, Musée des Beaux-Arts, Pau), 186–87; and *Diego Martelli* (1879, National Gallery of Scotland, Edinburgh), 201.

152 See Degas notebook 30, quoted in ibid., 201.

153 See ibid., for *Interior* (ca. 1868–69, Philadelphia Museum of Art), 144; *Women Ironing* (ca. 1884–85, Norton Simon Art Foundation, Pasadena), 426, fig. 233; and *Woman before a Mirror* (ca. 1885–86, Hamburger Kunsthalle, Hamburg), 447, fig. 248.

154 For the *Little Dancer* and its costume, see Richard Kendall, *Degas and the Little Dancer* (New Haven, Conn.: Yale University Press, in association with the Joslyn Art Museum, 1998), 40. For the Zola anecdote, see Berthe Morisot, *Correspondance* (Paris: Quatre Chemins Editart, 1950), 165; also cited in Boggs et al., 1988, 397.

155 For the 1882 exhibition, see the critic of the London *Standard,* quoted in Boggs et al., 1988, 397; for the 1886 exhibition, see Jean Ajalbert, quoted in Berson, 1996, vol. 1, 430.

156 Berson, 1996, vol. 1, 430.

157 Charles Stuckey, "Love, Money, and Monet's *Débâcle* Paintings of 1880," 56, and Annette Dixon, "The Marketing of Monet: The Exhibition at *La vie moderne,*" 95, 109, in Annette Dixon et al., *Monet at Vétheuil: The Turning Point* (Ann Arbor: University of Michigan Museum of Art, 1998).

158 This number does not include Monet's 1882 commission from Durand-Ruel for thirty-six decorative still-life panels for the dealer's six dining-room doors. Ultimately Monet completed twenty-nine flower paintings for the doors. There are no paintings of mallows in this decorative series.

159 See House, 1986, 41, and Monet to Durand-Ruel, 5 June 1883, in Wildenstein, 1996, vol. 2, letter 356.

160 Monet only did one other painting of mallows, a large vertical work that is dated to 1882 and that may have been one of the initial studies for the large decorative panels commissioned for Durand-Ruel's dining room.

161 In a letter to his brother, Theo, in December 1888, van Gogh wrote from Arles: "Gauguin was telling me the other day that he had seen a picture by Claude Monet of sunflowers in a large Japanese vase, very fine, but—he likes mine better. I don't agree." Quoted in Robert Gordon and Andrew Forge, *Monet* (New York: Harry N. Abrams, 1983), 215.

162 *Vase of Flowers* is visible in pictures of Monet's house in Giverny as late as 1920. See John House et al., *Impressionism for England, Samuel Courtauld as Patron and Collector* (London: Courtauld Institute Galleries by Yale University Press, 1994), 122.

163 Ibid.

164 Mauner and Loyrette, 2000, 144. Many of these floral works rapidly found buyers, and some may have been gifts to friends and patrons.

165 Anne Coffin Hanson, "A Tale of Two Manets," *Art in America* (December 1979): 66.

166 A discussion of the special qualities of these last flower paintings can be found in Robert Gordon

167 and Andrew Forge, *The Last Flowers of Manet* (New York: Harry N. Abrams, 1986), 13–15.

167 Mauner describes another late work looted during the occupation of Paris in 1944 and now lost that also had the "fallen flower as an independent motif." See Mauner and Loyrette, 2000, 144–45. Eugène Pertuiset was the subject of Manet's monumental 1881 Salon submission that was heavily ridiculed by the critics—*Eugène Pertuiset, the Lion-hunter* (1881, Museu de Arte de São Paulo, São Paulo, Brazil).

168 Ronald Pickvance, *Manet* (Martigny, Switzerland: Fondation Pierre Gianadda, 1996), 243–44.

169 Entry by Matthew Armstrong in Rubin and Armstrong, *The William S. Paley Collection*, 76.

170 Mauner and Loyrette, 2000, 144.

171 It is unclear whether the work was a gift to Dr. Evans or was purchased by him. See Hanson, "A Tale of Two Manets," 66.

172 Kathleen Adler, *Manet* (Oxford, England: Phaidon, 1986), 194.

173 Méry Laurent was Dr. Evans's mistress, and he was her protector. Laurent claimed to have put the first lilacs of the season on Manet's grave for years after his death. See Hanson, "A Tale of Two Manets," note 63. The article as a whole has an excellent discussion of Dr. Evans, his collection, Méry Laurent, and their relationship with Manet.

174 Edmond Bazire, Manet's first biographer, wrote in 1884 of the last flower paintings found in Manet's studio after his death on 30 April 1883 and described one as dated 28 February and the other as 1 March. See the quote from Bazire in Gordon and Forge, *The Last Flowers of Manet*, 46.

175 This was allegedly said to the painter Charles Toché in Venice. See Mauner and Loyrette, 2000, 12.

176 I am indebted to Charles F. Stuckey's work on both Morisot and Gauguin. Regarding the Morisot painting, see "Introduction to The Whitehead Collection," in *The Whitehead Collection, Late Nineteenth and Twentieth Century French Masters* (New York: Achim Moeller Fine Art, 1997), 10, cat. no. 35, 44–47.

177 Julie Manet was the daughter of Morisot and Eugène Manet, the younger brother of the painter Edouard Manet, Morisot's colleague and close friend. Morisot married Eugène Manet in 1874.

178 See Charles F. Stuckey's illuminating entry on this painting, cat. no. 13 in Brettell et al., 1988, 36–37.

179 Wildenstein, 1964, vol. 1, cat. nos. 131–34.

180 Stuckey, "Introduction to The Whitehead Collection," 11.

181 *Les Pivoines (II)* (1884, location unknown); see Wildenstein, 1964, vol. 1, cat. no. 132.

182 See Stuckey's entry on this painting, cat. no. 8 in Brettell et al., 1988, 28.

183 See Charles F. Stuckey with Peter Zegers, "The Impressionist Years," in ibid., 13–14.

184 Ibid., 14.

185 Stuckey, "Introduction to The Whitehead Collection," 11.

186 Letter 425, 4 October 1885, and letter 428, second half of October 1885, in van Gogh, 1958.

187 Letters 425 and 429, late October 1885, in ibid.

188 Anton Kerssemakers, "Reminiscences of Vincent van Gogh," *De Amsterdamer*, 14 and 21 April 1912,

189 cited in Susan Alyson Stein, ed., *Van Gogh: A Retrospective* (New York: Hugh Lauter Levin Associates, 1986), 51.

189 See letters 429 and 430, late October and early November 1885, respectively, in van Gogh, 1958, vol. 2. Van Gogh's *Still Life with Open Bible, Extinguished Candle, and Novel* is in the collection of the Van Gogh Museum, Amsterdam; see de la Faille, 1970, cat. no. 117; Hulsker, 1996, cat. no. 46.

190 Each of the three smaller paintings in question is called *A Pair of Shoes*. Two are in the collection of the Van Gogh Museum, Amsterdam; see de la Faille, 1970, cat. nos. 255 and 331; Hulsker, 1996, cat. nos. 1124, 1235. Another is in a private collection (de la Faille, 1970, cat. no. 332a; Hulsker, 1996, cat. no. 1233). The painting of six shoes is in the Harvard University Art Museums (de la Faille, 1970, cat. no. 332; Hulsker, 1996, cat. no. 1234), and the fourth, later painting of a pair of shoes is at the Baltimore Museum of Art (de la Faille, 1970, cat. no. 333; Hulsker, 1996, cat. no. 1236).

191 François Gauzi, *Lautrec et son temps* (Paris: David Perret et Cie, 1954), cited in Stein, *Van Gogh: A Retrospective*, 71; Paul Gauguin, "Natures mortes," *Essais d'art libre* 4 (January 1894), reprinted in *Essais d'art libre, revue mensuelle* (Geneva: Slatkine Reprints, 1971), 274.

192 Letter 550, 17 October 1888, in van Gogh, 1958, vol. 3. The view of van Gogh's bedroom is in the Van Gogh Museum, Amsterdam; see de la Faille, 1970, cat. no. 482; Hulsker, 1996, cat. no. 1608.

193 The earliest study of van Gogh's interest in literature is Carl Nordenfalk, "Van Gogh and Literature" *Journal of the Warburg and Courtauld Institutes* 10 (1947): 132–47. I am indebted to Judy Sund's interpretation of the still lifes discussed here as published in *True to Temperament: Van Gogh and French Naturalist Literature* (New York: Cambridge University Press, 1992), 144–52.

194 Letter 463, 21 February 1888, and letter 466, ca. 3 March 1888, in van Gogh, 1958, vol. 2.

195 Evert van Uitert, Louis van Tilborgh, Sjraar van Heugten, *Vincent van Gogh, Paintings* (Milan: Arnoldo Mondadori Arte, 1990), 252.

196 When Emile Schuffenecker offered to purchase the Cézanne from him, Gauguin was reported to have exclaimed, "This Cézanne . . . is an exceptional pearl and I have already refused 200 francs for it; I cherish it and, except in case of absolute necessity, I will only part with it when my last shirt is gone." Quoted in Hoog, 1987, 137.

197 Colocynth or Bitter-apple (*Citrillus colocynthis*), a widely cultivated plant of the gourd family, the fruit of which is about the size of an orange. *The Compact Edition of the Oxford English Dictionary* (New York: Oxford University Press, 1971), vol. 1, 468.

198 The use of images by Hokusai, Hiroshige, or other Japanese printmakers in contemporary work was a device employed by several of Gauguin's contemporaries, including Vincent van Gogh (for example, *Portrait of Père Tanguy*, 1887, Musée Rodin, Paris).

199 Christopher Gray, *Sculpture and Ceramics of Paul Gauguin* (Baltimore: John Hopkins Press, 1963), 22.

200 Gauguin completed over 350 pots, a number of which were collaborations with the ceramicist Ernest Chaplet after their introduction in May 1886. Clay always represented the earthy and

primitive for Gauguin, who despised the porcelains of Sèvres or Meissen, considering them ostentatious. The ceramic jug in *Still Life with Apples, Pear, and a Ceramic Jug* was probably made by Gauguin. Gray, *Sculpture and Ceramics of Paul Gauguin*, 304, cat. no. A-5.

201 *Correspondance de Paul Gauguin: documents, témoignages / édition établie par Victor Merlhès* (Paris: Fondation Singer-Polignac, 1984), letter 139.

202 Gauguin to Emile Schuffenecker, end of February or early March 1888, quoted in Brettell et al., 1988, 55.

203 Mark W. Roskill, *Van Gogh, Gauguin and the Impressionist Circle* (Greenwich, Conn.: New York Graphic Society, 1970), 53.

204 Brettell et al., 1988, cat. no. 63.

205 Gauguin quoted from "Diverses choses, 1896–1897," in Jean de Rotonchamp, *Paul Gauguin, 1848–1903* (Paris: Crès, 1925), 216.

206 Hoog, 1987, 137.

207 Mme Gloanec refused to accept the painting at first, not wanting to hang it in her dining room as Gauguin suggested, since she did not agree with Gauguin's synthetism. Only when Gauguin signed it as "Madeleine B" (Madeleine Bernard), passing off the work as that by an amateur, would Mme Gloanec accept the work. (Madeleine Bernard was the sister of Gauguin's close friend and colleague, Emile Bernard. Gauguin tried without success to court her in August and September 1888 in Pont-Aven.) When Maurice Denis purchased the work from Mme Gloanec many years later, she assured him that she "had not been taken in for a moment." Quoted in Bretell et al., 1988, 107.

208 Ibid.

209 Paul Gauguin, *Notes synthétiques* (1888), quoted in Herschel B. Chipp, *Theories of Modern Art* (Berkeley: University of California Press, 1968), 63.

210 Letter 622a, 30 or 31 December 1889, in van Gogh, 1958.

211 Besides *Roses*, the paintings are *Vase with Pink Roses*, 1889, Metropolitan Museum of Art, New York (de la Faille, 1970, cat. no. 682, Hulsker, 1996, cat. no. 1979), *Vase with Violet Irises against a Pink Background*, 1889, Metropolitan Museum of Art, New York (de la Faille, 1970, cat. no. 680, Hulsker, 1996, cat. no. 1978), and *Vase with Violet Irises against a Yellow Background*, 1889, Van Gogh Museum, Amsterdam (de la Faille, 1970, cat. no. 678, Hulsker, 1996, cat. no. 1977).

212 Letter 633, 11 or 12 May 1890, in van Gogh, 1958.

213 Letter 634, 13 May 1890, in ibid.

214 Letter W 21, ca. 20 May 1890, unfinished draft, in ibid. See Joseph R. Rishel in Colin B. Bailey, Joseph J. Rishel, and Mark Rosenthal, *Masterpieces of Impressionism and Post-Impressionism: The Annenberg Collection* (New York: Harry N. Abrams in association with the Philadelphia Museum of Art, 1989), 109.

215 Richard Kendall, ed., *Cézanne by Himself* (London: Macdonald Orbis, 1988), 297.

216 Regarding *Ginger Pot with Pomegranate and Pears*, see Rewald, 1996, vol. 1, cat. no. 735, who assigns this painting a date of 1893–95. According to Rewald, Lionello Venturi originally dated the work 1895–1900 before revising the date to 1893–95. Rewald, 454.

217 Quoted in Stein, *Van Gogh: A Retrospective*, 82.

218 See Debora Silverman, *Van Gogh and Gauguin: The Search for Sacred Art* (New York: Farrar, Straus and Giroux, 2000), 139–43, for a discussion of van Gogh's box of yarns and its meaning in his art.

219 See, for example, his *Harvest at La Crau* (1888, Van Gogh Museum, Amsterdam), *The Sower* (1888, Kröller-Müller Museum, Otterlo), *Portrait of Eugène Boch* (1888, Musée d'Orsay, Paris), and *Night Café* (1888, Yale University Art Gallery, New Haven); see, respectively, de la Faille, 1970, cat. nos. 412, 422, 462, 463; Hulsker, 1996, cat. nos. 1440, 1470, 1574, 1575.

220 Gauguin, "Natures mortes," 273–75.

221 See Ronald Pickvance, *Gauguin* (Martigny: Fondation Pierre Gianadda, 1998), cat. no. 87.

222 For the events of Gauguin's period in France, 1893–95, see the chronology in Brettell et al., 1988, 291–95.

223 Joachim Gasquet, *Cézanne* (Paris: Les Editions Bernheim-Jeune, 1926), 200, trans. by Isabelle Cahn in her entry on the work in Françoise Cachin et al., *Cézanne* (Philadelphia Museum of Art, 1996), 389.

224 The statuette is now thought to be the work of François Duquesnoy or possibly Nicolas Coustou.

225 Cézanne, quoted in Baumann et al., 2000, 214.

226 See John Rewald, *Paul Cézanne: The Watercolors* (Boston: Little, Brown and Company, 1983), cat. nos. 556–58, 560, 566; Adrien Chappuis, *The Drawings of Paul Cézanne: A Catalogue Raisonné*, vol. 2 (Greenwich: New York Graphic Society, 1973), cat. nos. 980–90; Rewald, 1996, vol. 2, cat. nos. 33, 782–84, 786.

227 Gabriel P. Weisberg, "Fantin-Latour and Still Life Symbolism in *Un atelier aux Batignolles*," *Gazette des beaux-arts* 90 (December 1977): 212.

228 Baumann et al., 2000, 214.

229 See Berhaut, 1994, cat. no. 10; Paul-André Lemoisne, *Degas et son oeuvre* (New York: Garland Publishing, 1984), cat. no. 9.

230 Pierre Rosenberg, *Chardin, 1699–1779*, cat. no. 123. For Vallayer-Coster, see Sybille Ebert-Schifferer, *Still Life: A History* (New York: Harry N. Abrams, 1998), fig. 187.

231 Entry for no. 782 in Rewald, 1996, vol. 1, 472.

232 Rewald 1996, vol. 1, cat. no. 804, describes the green fruit in the bowl as plums. Birgit Schwarz in Baumann et al., 2000, describes them as figs.

233 This heavy drapery with green leaves against a tan ground can be seen in Cézanne's works beginning in the late 1880s. See, for example, cat. nos. 846–48, 933, 935–36 in Rewald, 1996, vol. 2. A similar milk pitcher appears in cat. nos. 662–64, 849.

234 For early works in a Chardinesque kitchen still-life vein, see Rewald, 1996, vol. 2, cat. nos. 82, 137–38.

235 See Rewald, 1996, vol. 2, cat. nos. 734, 824–25 (Barnes Foundation, Merion, Pennsylvania), 821 (Detroit Institute of Arts), 822 (private collection, Stuttgart), 823 (Staatsgalerie, Stuttgart). For the watercolors, see John Rewald, *Paul Cézanne: The Watercolors*, cat. nos. 232, 611–13. A fifth watercolor, cat. no. 231, dated by Rewald to ca. 1885, does not seem markedly different from these four, which have been variously dated between 1890 and 1906.

236 Cachin et al., *Cézanne*, 490. Cézanne's observation was recorded by Ambroise Vollard.

237 Of sixty-six still lifes that Rewald dates after about 1890, only thirteen are vertical in format.

238 See Birgit Schwarz's entry in Baumann et al., 2000, 242, cat. no. 57.

239 See Cachin et al., *Cézanne*, 490. See also Theodore Reff, "Cézanne: The Severed Head and the Skull," *Arts Magazine* 59 (October 1983): 84–100.

CATALOGUE WITH BIOGRAPHIES OF THE ARTISTS

1 Bazille's *Still Life with Fish* did generate a commission from a young woman for two still lifes that was then changed to a portrait commission. The patron's identity is unknown, and the commission ultimately fell through. Patrice Marandel, "A Note on Bazille's *Still Life with Fish* of 1865," *Bulletin of the Detroit Institute of Arts*, 65, no. 4, 1990, 10.

2 Quoted in Henri Loyrette, "Still Life," 156–67, in Tinterow and Loyrette, 1995. See also Appendix II in Dianne W. Pitman, *Bazille: Purity, Pose, and Painting in the 1860s* (University Park, Pennsylvania: Pennsylvania State University Press, 1998), 218.

3 Wildenstein, 1974, vol. 1, Letter 9: "Je vous annoncerai que j'envoie mon tableau de fleurs à l'Exposition de Rouen: il y en a de bien belles en ce moment, malheureusement j'ai tellement à travailler à mes études de dehors que je n'ose pas me mettre à faire des fleurs, et pourtant je voudrais peindre ces belle marguerites. Faites-en donc car c'est, je crois, une excellente chose à peindre."

4 Caillebotte exhibited at the Impressionist exhibitions of 1876, 1877, 1879, 1880, and 1882. Unless otherwise noted, biographical details have been gleaned from Marie Berhaut's essay on Caillebotte in *The Grove Dictionary of Art*, vol. 5 (New York: Macmillan, 1996), 389–92.

5 See *Gustave Caillebotte, dessins, études, peintures*, (Paris: Galerie Brame et Lorenceau, 1989), nos. 39–46 for examples of some of his early work. See also Berhaut, 1994, nos. 11–15 and 552–58.

6 See Moffett et al., 1986, 161.

7 See Douglas Druick's essay on Caillebotte's still lifes, 232–37 and his entries for nos. 94–97 in Distel et al., 1995, for an illuminating discussion of these works.

8 *Still Life* was shown in 1880 and *Fruits* was completed in 1881. For the English translation of Huysmans's quote on *Fruits*, see Pierre Wittmer, *Caillebotte and His Garden at Yerres* (New York: Harry N. Abrams, 1991), 99.

9 Douglas Druick, "Still Lifes," in Distel et al., 1995, 232. The thirty-eight pictures that were accepted of his gift of sixty-seven Impressionist works now form the core of the Impressionist collection at the Musée d'Orsay. For more on this, see Berhaut's entry on Caillebotte in the *Grove Dictionary of Art*, 391.

10 Of the approximately three hundred paintings made between 1882 and 1894, sixty-three depict flowers.

11 For biographical details see Nancy Mowll Mathews, *Mary Cassatt* (New York: Harry N. Abrams, 1987), *Mary Cassatt: A Life* (New York: Villard Books, 1994) and *Cassatt: A Retrospective*, edited by Nancy Mowll Mathews (Southport, Conn.: Hugh Lauter Levin Associates, 1996). See also Frederick Sweet, *Miss Mary Cassatt: Impressionist from Pennsylvania* (Norman: University of Oklahoma Press, 1966).

12 See George T. M. Shackelford's essay, "*Pas de deux*: Mary Cassatt and Edgar Degas," in *Mary Cassatt: Modern Woman*, (Chicago: Art Institute of Chicago in association with Harry N. Abrams, 1998), 109–43, for an illuminating discussion of their relationship.

13 See Moffett et al., 1986, for works exhibited by Cassatt in 1879, 1880, 1881, and 1886.

14 See Adelyn D. Breeskin, *Mary Cassatt: A Catalogue Raisonné of the Oils, Pastels, Watercolors, and Drawings* (Washington: Smithsonian Institution Press, 1970), cat. nos. 163 and 164.

15 Exhibited as *Le Thé* in 1880. Ibid., no. 78.

16 Clement Greenberg, "Cézanne and the Unity of Modern Art," *Partisan Review* (May–June 1951): 324.

17 Ibid.

18 *Portrait of a Man* was exhibited at the 1882 Salon only because Cézanne's friend, Antoine Guillemet, who sat on the jury that year, posed as his teacher. The opportunity for Salon jury members to exhibit the work of their students was withdrawn that same year. Unless otherwise noted, biographical details have been drawn from Geneviève Monnier's entry on Cézanne in the *Grove Dictionary of Art*, vol. 6 (New York: Macmillan, 1996), 366–76.

19 Przyblyski, 1995, however, finds a link between Cézanne's early technique and Chardin's late style. She writes, Cézanne's paint application parallels "in some strangely overdetermined way the application of closely-knit mosaic-like strokes of paint that lent the surfaces of Chardin's still lifes their carefully tended aura of concentration." For examples of these early works see Rewald, 1996, vol. 2, nos. 19, 22, 33, 80–83, 93, 129, 136–38 and John Rewald, *Paul Cézanne, the Watercolors: A Catalogue Raisonné* (Boston: Little, Brown, 1983), no. 8.

20 Cézanne submitted sixteen works to the third Impressionist exhibition in 1877. His portrait of Victor Chocquet from 1876–77 (no. 292 in Rewald, 1996, vol. 2) was particularly disliked by critics. The artist did not participate in the second Impressionist exhibition because he was working at the time in Aix-en-Provence.

21 Meyer Schapiro, "The Apples of Cézanne: An Essay on the Meaning of Still-life" reprinted in Meyer Schapiro, *Modern Art 19th & 20th Centuries: Selected Papers* (New York: George Braziller, 1978), 1–38.

22 Still life was also a prominent feature of Cézanne's work in watercolor beginning in the 1880s. That decade he made more than forty still lifes, producing about the same number between 1890 and his death in 1906. Still life makes up 13 percent of Cézanne's total body of watercolors.

23 Cézanne eventually turned to artificial flowers to remedy the problem.

24 "Ils aiment qu'on fasse leur portrait. Ils sont là comme à vous demander pardon de se décolorer." Quoted in Joachim Gasquet, "Cézanne à l'atelier," *L'Amour de L'Art* 2 (1921): 335.

25 Quoted in Przyblyski, 1995, 283–84.

26 Pissarro, quoted in Denis Thomas, *The Age of the Impressionists* (Twickenham, Middlesex: Published for Marks and Spencer by the Hamlyn Publishing Group, 1987), 161–65.

27 Greenberg, "Cézanne and the Unity of Modern Art," 324.

28 Unless otherwise noted, biographical details have been drawn from Klaus Herding's entry on Courbet in *The Grove Dictionary of Art*, vol. 8 (New York: Macmillan, 1996), 50–61.

29 It is worth noting that some critics, such as Emile Zola and Courbet's lifelong friend, the philosopher Pierre-Joseph Proudhon, admired the "vulgarity" of the artist's pictures. "There is no posing, no flattery, not the slightest suggestion of an idealized figure," wrote Proudhon of *Peasants of Flagey*. "Everything is true, caught in nature." Quoted in *A Loan Exhibition of Gustave Courbet*, (New York: Wildenstein, 1948), 27.

30 Eleven other of Courbet's paintings were accepted to the Exposition Universelle.

31 See Fernier, 1977, vol. 1, nos. 182, 185, 247. Flower still lifes also occasionally play a role in female figure studies from this period, such as *La mère grégoire* from 1855 (no. 167), *Les demoiselles des bords de la Seine* from 1856 (no. 203), and *Baigneuses* from 1858 (no. 229).

32 *A Loan Exhibition of Gustave Courbet*, (New York: Wildenstein, 1948), 18.

33 See Fernier, 1977, vol. 1, nos. 299–304, 306–7, 357, 360–69 for the nineteen extant flower paintings. Roger Bonniot, *Gustave Courbet en Saintonge, 1862–1863* (Paris: Librairie C. Klincksieck, 1973) is a useful, indeed the only, source on this period of the artist's career. Courbet arrived with Castagnary at Baudry's estate on 31 May 1862 and stayed until September. From October to December, Courbet settled not far from Rochemont in Port-Berteau and then moved to Saintes in January 1863 until May. See Henri Loyrette's entry for no. 40 in Tinterow and Loyrette, 1995, 358.

34 Courbet exhibited forty-eight paintings at this January 1863 exhibition in Saintes, forty-three of which were produced during his stay in the Saintonge region. He showed only a few flower paintings. For an English translation of the critic Pierre Conil's assessment of Courbet, see Henri Loyrette's entry for no. 41 in Tinterow and Loyrette, 1995, 359.

35 Michel Faré and Fabrice Faré, "Survivances de la nature morte chez Gustave Courbet," *L'Oeil* (October 1977): 13.

36 Jeannene M. Przyblyski, in Przyblyski, 1995, 268, notes that Courbet was so comfortable at the clinic that he remained there for several weeks after his prison term had ended.

37 Ibid., 231, divides the series into three categories—those painted in his cell at Sainte-Pélagie prison at the end of 1871, those produced at Neuilly in early 1872, and those made in both locations depicting fruit situated in a landscape setting.

38 Jeannene M. Przyblyski comes to this conclusion in "Courbet, the Commune, and the Meanings of Still Life in 1871," *The Art Journal* 55 (summer 1996): 30.

39 Unless otherwise noted, biographical details have been gleaned from Geneviève Monnier's entry on Degas in *The Grove Dictionary of Art*, vol. 8 (New York: Macmillan, 1996), 619–26.

40 The advice Ingres gave Degas upon their first meeting is recounted in the diaries of Daniel Halévy. " 'Draw lines, young man,' Ingres instructed Degas, 'draw lines; whether from memory or after nature. Then you will be a good artist.'" See the entry of 22 January 1891, translated in Kendall, 1987, 216. Ambroise Vollard, in *Degas: An Intimate*

Portrait, translated by Randolph T. Weaver (New York: Crown, 1937), affirms the artist's predilection for line: "Degas used to say that if he had let himself follow his own taste in the matter, he would never have done anything but black and white. 'But what can you do,' he would ask with a gesture of resignation, 'when everybody is clamouring for colour?' " Cited in Kendall, 1987, 309.

41 Degas, as quoted by Vollard, *Degas: An Intimate Portrait*, cited in Kendall, 1987, 306.

42 Frank Milner, *Degas* (London: Bison Books, 1990), 47.

43 Huysmans in 1883, as translated by Geneviève Monnier, "Edgar Degas," 621.

44 Dumas, 1997, 9.

45 Degas, as quoted by Dumas, 1997, 12.

46 Degas purchased Pierre Andrieu's *Still Life with Fruit and Flowers* from ca. 1850–64 thinking it was a Delacroix. The painting, interestingly, was later acquired by Renoir. See Dumas, 1997, 12.

47 "This was how Chardin worked," Degas once said, "who while treating the most vulgar motifs with admirable conscientiousness, nonetheless succeeded in lending them elegance, grace and distinction." Degas, as quoted in the memoirs of Thiebault-Sisson, cited in Kendall, 1987, 244.

48 Unless otherwise noted, details of Fantin-Latour's life have been taken from Valérie M. C. Bajou's entry in *The Grove Dictionary of Art*, vol. 10 (New York: Macmillan, 1996), 796–98.

49 Edward Lucie-Smith, *Fantin-Latour* (Phaidon, Oxford, 1977), 14–15.

50 Ibid., 22.

51 George Harold Edgell, *French Painters in the Museum of Fine Arts; Corot to Utrillo* (Boston: Museum of Fine Arts, 1949), 47.

52 Quoted in Druick and Hoog, 1983, 338.

53 M. A. Bessonova, *K istorii sozdaniya natyurmorta P. Gogena "Frukty"* Soobshcheniya gosudarstvennogo muzeya izobrazitel'nykh iskusstv imeni A. S. Pushkina, Sovetskii khudozhnik, Moscow, 1989, 218–31. Shipped to Kraushaar via Frans Bulta and Zonen Amsterdam on the Holland-America Line, 28 July 1921.

54 According to Paul Sérusier, Gauguin would exclaim, "Let's do a Cézanne!" when he felt like painting a still life. Quoted in Charles Chassé, *Gauguin et son temps* (Paris: Bibliothèque des arts, 1955), 50.

55 Letter XLI, April 1899. *The Letters of Paul Gauguin to Georges Daniel de Monfreid*, translated by Ruth Pielkovo (New York: Dodd, Mead, 1922).

56 Rewald, John, ed. *Paul Gauguin: Letters to Ambroise Vollard and André Fontainas* (San Francisco: Grabhorn Press, 1943), 32. Quoted in Brettell et al., 1988, 456, no. 254.

57 The current location and dimensions of the work that she exhibited at the 1878 Salon, *Rosy Apples*, are unknown; its existence is confirmed only through a photograph taken at the 1885 Gonzalès retrospective exhibition. See Marie-Caroline Sainsaulieu and Jacques de Mons, *Eva Gonzalès, 1849–1883, Etude critique et catalogue raisonné* (Paris: La Bibliothèque des Arts, 1990), no. 89.

58 Recorded by Philippe Burty, the comments probably date from 1868–70. Quoted in Juliet Wilson-Bareau, ed., *Manet by Himself* (London:

Macdonald, 1991), 52, and also in Da Rosa, 1994, 252.

59 Gonzalès's son, Jean Raymond, was born 19 April 1883. Manet died 30 April 1883 and it is thought that perhaps the embolism that killed Gonzalès was aggravated by her attendance at his funeral on May 3. See Carol Jane Grant, "Eva Gonzalès (1849–1883): An Examination of the Artist's Style and Subject Matter," Ph.D. diss., Ohio State University, vol. 1, 1994, 48.

60 Gonzalès's widower, the engraver Henri-Charles Guérard, organized a posthumous retrospective of her work in January 1885 in the Salons of *La Vie moderne*. Four still lifes were counted among the eighty-eight oils and pastels shown. The following month there was a sale of eighty of her works at the Hôtel Drouot that included twelve still lifes. The family had to buy back most everything at the auction. The only still life to sell was the above-mentioned *Rosy Apples*. See Carol Jane Grant, "Eva Gonzalès," 49.

61 Manet made this comment to the painter Charles Toché, reacting against the religious and allegorical paintings of the Italian old masters. Cited in Mauner and Loyrette, 2000, 12.

62 Biographical details from Beatrice Farwell, "Edouard Manet," in *The Grove Dictionary of Art*, vol. 20 (New York: Macmillan, 1996), 254–62.

63 Manet, seated before his easel, is surrounded by his admirers Monet, Bazille, Zola, and Renoir, among others. In 1880 Fantin-Latour called the painting "le tableaux de Manet et ses disciples." See Druick and Hoog, 1983, no. 73.

64 Da Rosa, 1994. 216. See especially the chapter "The Painter's Touchstone" for the discussions about Manet and still life.

65 Martinet's 1860 exhibition was organized by Philippe Burty, a friend of Manet's.

66 With the hope of attracting crowds from the nearby World's Fair, Manet showed fifty works in 1867 in a wooden pavilion he had built on the Place de l'Alma.

67 Although a champion of Manet's art, Emile Zola echoed the criticism of many when he wrote in 1867 that Manet "treats figure subjects in just the same way as still life subjects are treated in art schools; what I mean to say is that he groups figures more or less fortuitously, and after that he has no other thought than to put them down on canvas as he sees them, in strong contrast to each other." Translated in T. A. Gronberg, ed., *Manet: A Retrospective* (New York: Park Lane, 1988), 70.

68 In 1881 Manet told Jacques-Emile Blanche to "bring a brioche, I want you to paint one: still life is the touchstone of painting." Quoted in Da Rosa, 1994, 213.

69 Cited in Robert Gordon and Andrew Forge, *Monet* (New York: Harry N. Abrams, 1983), 199.

70 The 1882 commission from Durand-Ruel to decorate his six dining room doors with still-life subjects is not included in this number. That commission, resulting in forty-two individual panels, is treated separately. Thirty-six of the panels were installed, six per door.

71 Unless otherwise noted, biographical details have been drawn from Joel Isaacson's entry on Monet in *The Grove Dictionary of Art*, vol. 21 (New York: Macmillan, 1996), 861–68.

72 The two landscapes accepted to the exhibition were *Mouth of the Seine at Honfleur* (Norton Simon

Museum, Pasadena) and *The Pointe de La Hève at Low Tide* (Kimbell Art Museum, Fort Worth), both from 1865. While Monet would exhibit again at the Salon in 1866 and 1868, his work was rejected in 1867, 1869, and 1870. He submitted works only once more in 1880. That year his landscape, *Lavacourt* (Dallas Museum of Arts), was accepted for exhibition.

73 House, 1986, 40, discusses Monet's experimentation with contemporary still-life styles. He compares the "crisp incisive brushwork" of Monet's tabletop scenes from the late 1860s to Manet's idiom and the "fine and delicate" brushwork of works such as *The Tea Set* from 1872 to the technique of Fantin-Latour. One of the more innovative of these early works—*Jar of Peaches* from 1866—echoes Chardin's *Jar of Olives*, a painting that Monet would have had the occasion to see at the landmark 1860 Galerie Martinet exhibition of French art from the eighteenth century, *Tableaux et dessins de l'école française, principalement du XVIIIe siècle, tirés de collections d'amateurs.* See Wildenstein, 1996, vol. 2, nos. 63, 132, and 285 for the *Déjeuner* paintings of 1865, 1868, and 1873. *Le Déjeuner* of 1873, which features a tabletop still-life arrangement, was exhibited at the second Impressionist exhibition of 1876 as *Panneau decoratif* and purchased by Caillebotte.

74 Only once before, in 1879, did Monet exhibit still life at the Impressionist show. House, 1986, 41, has suggested that still life may have also served the function in these years of occupying Monet when the weather was too harsh for him to paint outdoors.

75 See Wildenstein, 1996, vol. 2, nos. 919–54.

76 The water lily murals that Monet donated to the French State form a decorative environment in the oval rooms on the ground floor of the Orangerie in Paris.

77 Distel et al., 1995, no. 114. See Berhaut, 1994, letter no. 43, 278, for mention of chrysanthemums in a letter from Monet to Caillebotte.

78 He made just two more still lifes in interiors, a pair of *Still Life with Eggs* pictures from 1907. See Wildenstein, 1996, vol. 4, nos. 1692–93.

79 Kathleen Adler, "The Suburban, the Modern and 'Une Dame de Passy,'" *The Oxford Art Journal*, 12, no. 1 (1989), 11.

80 In a 5 May 1869 letter to her sister Edma on the Salon, Berthe remarked: "*Le grand Bazille* has painted something that I find very good. It is a little girl in a light dress seated in the shade of a tree There is much light and sun in it. He has tried to do what we have so often attempted—a figure in the outdoor light—" See Clairet, Montalant, Rouart, 1997, 83.

81 Ibid., 85.

82 On the occasion of the 1896 exhibition at Durand-Ruel, Julie Manet gave Renoir one of her mother's still lifes, *Apples* (1887). It depicted a marble-top table set with a decanter, a compote filled with apples, and a knife and two apples set on a napkin. Clairet, Montalant, Rouart, 1997, no. 218.

83 For biographical details see Kathleen Adler, *Camille Pissarro—A Biography* (London: B.T. Batsford, 1978), and Christopher Lloyd, *Pissarro* (London: Phaidon Press, 1992). See also Ralph E. Shikes and Paula Harper, *Pissarro: His Life and Work* (New York: Horizon Press, 1980).

84 See Pissarro's letter to Paul Durand-Ruel, Eragny, 6 November 1886, cited in Linda Nochlin, *Impressionism and Post-Impressionism 1874–1904, Sources and Documents* (Englewood Cliffs: Prentice-Hall, 1966), 55, for his own biographical summary.

85 Of the 1,316 paintings recorded in Ludovic Rodo Pissarro and Lionello Venturi, *Camille Pissarro: son art—son oeuvre* (Paris: Paul Rosenberg, 1939), 2 vols., twenty are still lifes created in the years 1867, ca. 1870, ca. 1872, 1876, ca. 1878, 1898, 1899, 1900 and 1902. See also Pissarro, 1993, 268–76, for a discussion of Pissarro's involvement with still life.

86 The couple married on 14 June 1871 in London and had eight children. Julie Vellay, a onetime florist, formerly served as a maid to Pissarro's mother.

87 John Rewald, *Camille Pissarro* (New York: Harry N. Abrams, 1963), 90.

88 See Pissarro, 271, and also Moffett et al., 1986, 204, for the still lifes exhibited by Cézanne in 1877.

89 For listings of the works Pissarro exhibited in each exhibition, see Moffett et al., 1986.

90 In 1868–70 Renoir painted a *Still Life: Partridge* (private collection, Paris) that was given to his friends the Le Coeurs. Some ten years later, in 1879, Renoir completed a *Pheasant on Snow* (private collection, Geneva) for Paul Bérard, as well as decorations for wooden panels in the Bérard dining room at Wargemont—*The Fall Hunt* (rabbit, pheasant, and woodcock) and *The Summer Hunt* (hare, partridge, and quail); in 1880 Renoir did two game pieces, *Three Partridges* (private collection) and another, *Fish* (Kunsthaus, Zürich), and in 1902 he painted what appears to be his last game piece, *Pheasants, Bustard and Thrushes* (Private Collection?). See Barbara Ehrlich White, *Renoir: His Life, Art and Letters* (New York: Harry Abrams, 1984), 92. Also Elda Fezzi and Jacqueline Henry, *Tout l'oeuvre peint de Renoir, période impressionniste 1869–1883* (Paris: Flammarion, 1985), nos. 17, 357, 380, 425, 642.

91 See Fezzi and Henry, *Tout l'oeuvre peint de Renoir*, nos. 451 and 452 for fruit still lifes done for the Bérards at Wargemont, as well as no. 528, which was probably painted in 1882 at Wargemont alongside Caillebotte. No. 527 (*Plate of Prunes*) was owned at one time by Durand-Ruel and is documented in a photograph of the dealer's dining room. In addition, the novelist and critic for *Figaro*, Robert de Bonnières, commissioned a still life of a vase of flowers from Renoir in 1885 in which the background reflected a corner of his living room. See Fezzi and Henry, no. 577. Also see Berhaut, 1994, no. 238.

92 *Geranium and Cats* was among the first Renoir works for which Durand-Ruel found an American buyer, A. W. Kingman in New York in 1886. See John House et al., *Renoir* (London: Arts Council of Great Britain, 1985) no. 59.

93 Renoir and Cézanne worked together in l'Estaque in 1882; in 1885 Cézanne visited Renoir in La Roche-Guyon; and Renoir returned to Aix-en-Provence in 1888, 1889, and 1891.

94 Georges Rivière, *Renoir et ses amis* (Paris: Floury, 1921), 81. For an English translation, see John House et al., *Renoir* (London: Arts Council of Great Britain, 1985), 183.

95 For biographical details see Richard Shone, *Sisley* (New York: Harry N. Abrams, 1992) and Shone, *Sisley* (London: Phaidon Press, 1994).

96 See François Daulte, *Alfred Sisley: Catalogue raisonné de l'oeuvre peint* (Lausanne: Editions Durand-Ruel, 1959). Of the 884 recorded paintings, the following nine are still lifes: nos. 5, 6, 7, 8, 186, 233, 234, 661, and 662. See also MaryAnne Stevens, *Sisley* (London: Royal Academy of Arts, 1992), 174.

97 The earliest group of still lifes includes, in addition to *The Heron* (Daulte 5), *Fish on a Platter* (Kunstmuseum Basel; Daulte 6) and *Still Life with Apples* (private collection; Daulte 7) both dated ca. 1865–67, and *The Pheasant* (private collection; Daulte 8) dated ca. 1867–69.

98 See Tinterow and Loyrette, 1995, 462 for a discussion of Sisley's painting. At the end of the 1860s, Sisley often worked in Bazille's studio. Bazille moved to his new studio on the rue de la Paix (renamed the rue La Condamine in 1868) at the end of December 1867. As Gary Tinterow notes, it has been previously and erroneously stated that these works were painted in Bazille's studio in the rue de la Paix.

99 Eugénie Lescouezec became Sisley's companion in the 1860s and his wife in 1897. Their children—a son, Pierre, and a daughter, Jeanne—were born on 17 June 1867 and 29 January 1869, respectively.

100 See Moffett et al., 1986, 206 for listings of the works that Sisley exhibited.

101 For biographical details see Jan Hulsker, *Vincent and Theo van Gogh, A Dual Biography* (Ann Arbor: Fuller Technical Publications, 1990). Also see Sjraar van Heugten, "The Life of Vincent van Gogh," in Richard Kendall, *Van Gogh's Van Goghs: Masterpieces from the Van Gogh Museum, Amsterdam,* (Washington, D.C.: National Gallery of Art, 1998), 145–47.

102 For the complete correspondence of van Gogh, see van Gogh, 1958.

103 See the two catalogues raisonnés, de la Faille, 1970, and Hulsker, 1996.

104 See Theo's letter to his mother of June 1886, cited in Susan Alyson Stein, ed., *Van Gogh: A Retrospective* (New York: Hugh Lauter Levin, 1986), 105.

105 See Ronald Pickvance, *Van Gogh in Arles,* (New York: The Metropolitan Museum of Art, 1984), 36–37.

PHOTOGRAPH CREDITS

Images are supplied by the owners and are reproduced by their permission, with the following additional credits.